Calligraphy as Art and Meditation

A NEW APPROACH

Calligraphy as Art and Meditation

A NEW APPROACH

GINA JONAS

Calligraphic Arts Press

Pao-yu found life in the Takuanyuan all that he could wish.
He studied a little and did exercises in calligraphy.
 Dream of the Red Chamber, Tsao Hsueh-chin

My first morning periods in class began with relaxation,
breathing, and concentration exercises to establish the
intellectual and physical readiness which make intensive
work possible. The training of the body as an instrument
of the mind is of great importance to a creative person.
How can a hand express a characteristic feeling in a line,
when hand and arm are cramped? The fingers, the hand,
the arm, the whole body can be prepared for the task by
exercises of relaxation, strengthening and sensitization.
 *Design and Form, The Basic course at the Bauhaus
 and later.* Johannes Itten

Contents

Website: www.ginajonascalligrapher.com
Publications section, for short videos on the above topics, articles, & other information related to this book.

The letter "a" at play. In the course of warming up, before writing exercises/pieces, a mood of play may ignite the spirit of calligraphic adventure. Here, I chose a non-traditional cola pen for experimentation.

Preface

This book introduces you to a new approach to calligraphy. It presents calligraphy as an art uniquely suited to our times. Through the exercises in this manual, you engage in a holistic approach, one that integrates mind, body and feeling to create living letterform. Here, the values of meditation infuse calligraphic exercises to enrich creativity and enhance well-being. Today, as we recognize the importance of exercising the brain (as well as the body), you can stimulate this vital organ while also enjoying a creative endeavor. As an embodied approach, this book emphasizes the pleasure of awakening the senses of touch and rhythmical movement to direct strokes and shape calligraphic letterforms. As objects of meditation, strokes and forms become the basis for meditation in motion. In the process of stroke making, a moment-by-moment experience, you have the opportunity to develop awareness, relax your mind, and open the door to artistic expression.

Since this manual presents a new approach to calligraphy, you will encounter practices unfamiliar even to the advanced calligrapher. These are described in greater detail in the Introduction, but I briefly mention some of them now to spark your interest. Warming up exercises to awaken and energize bodily movement. Sensitization exercises to aid the shoulder-arm, hand and fingers to guide the tool. Incorporation of the breath while making letters to unite mind, body and feeling with the tool. A "partnering" technique to help you connect to the pen, mentally and physically. A "tool-centered" approach which offers a guided progression beginning with the "prototool" – your index finger – and continuing from one-point tools to two-point tools, and finally to the edged pen. Excercises that explore each tool category for its essential calligraphic qualities through "training alphabets." A new approach to ductus (order and direction of strokes) incorporates "target practice" to more actively engage the eye in directing strokes. To make strokes an embodied experience, to make them vital, rhythmic extensions of your full self, I offer a "dynamics" stroke technique to accompany ductus.

This book is also part of an ongoing investigation into the potential of Western alphabetic writing as art. How can we transform the conventional symbols, those that carry our deepest thought and feeling, into symbols that convey expressive, living form? Such a quest implies personal exploration as well. I now welcome you to such a journey, one in which you may discover your own unique creative and artistic potential. Let me be your guide as you pioneer new territory for calligraphy and meditation.

To my students and readers

I sincerely encourage you to take up a tool and engage in calligraphic exercises. I also welcome those, with or without calligraphic experience, who are curious and wish to encounter a new approach to calligraphy.

Adult learners. I invite you to think of calligraphy as a way to self-discovery, enjoyment, and health. Your enhanced energy and happiness also contribute to the social environment around you. Making things for yourself and for others brings meaning and happiness to both. These words are offered as encouragement. If you have read this far, I know you are interested!

Adolescents and children. I feel the lessons in this book, with some adaptation by an adult, could provide a fun and meaningful educational experience for adolescents and children.

Meditators. I hope you will discover the calligraphic practice of our Western writing system as a joyful way to enhancing your meditation practice.

Teachers. I invite you to use this book as is, or to adapt it for your own pedagogic purposes.

Therapists. I deeply hope that the therapeutic community – e.g. counselors, as well as art, occupational/physical, and psychotherapists – will explore the potential of my approach to calligraphy as a healing modality.

Graphic designers. In this book, you'll experience letterform. This allows you to develop, first-hand, a feeling for the spirit of such forms and the space they inhabit.

Art students. Calligraphy trains the eye and the hand as creative tools. Through an embodied approach, you develop an empathy with the graphic elements of line, shape, space and weight.

You appear before me
as a goddess of the night,
Dark hair falling brilliantly
across your skin, so light.
Eyes of burning coals
That transfix me with their gaze,
A Phoenix from another world
You consume me in your flames!

Creating a calligraphic work of "Phoenix," a song by
singer-songwriter Mick Read, I sought a stroke quality
that would convey the passionate intensity of the lyrics
and also fulfill my husband's demand for legibility!

Introduction

For those who are interested in reading about my approach in greater detail, the following pages are offered. They are not necessary, though, for going forward.

Calligraphy as Art

Since my book boldly declares calligraphy to be art, I'd like to begin with a working definition: Art is a skilled, creative process that generates meaning and pleasure in the maker and in the product's viewer. In this book, calligraphy – expressive, living letterform – is based on a thorough understanding of its tools and materials and on learning techniques for using them. With this knowledge, vital forms may be created in a process of wedding skill to imagination. In this approach, skill and imagination are developed through guided exercises rooted in play and experimentation. Whether your aim is to make practical or artistic pieces, you will engage in the deeply personal experience of creativity – in making something meaningful with pleasure and confidence.

Cultural diversity. In our global age, it's natural to inquire into other calligraphic traditions. Let's turn to Chinese calligraphy, where calligraphy is among the most esteemed of China's arts. Whether or not this status is a result of its brush-written, character-based writing system – in contrast to our pen-written, alphabetic one – may be debated. Regardless, the Western eye responds to these written forms as art, placing them in exhibits for our appreciation and enjoyment. But why do we respond to these unreadable forms as art? To explore this question, I offer some clues below that have helped me develop a new approach to calligraphy.

Modern art. When viewing works of modern art, we can see the elements of line, shape and space abstractly, apart from their traditional pictorial reference. Artists such as Jackson Pollack and Franz Kline explored the potential of these elements to communicate as symbols of energy and movement. Undoubtedly, we appreciate these attributes in Chinese calligraphy. The approach taken in this book is one which aims to imbue alphabetic letterform with these symbols of living form.

Arts of movement. Through our appreciation of rhythmical movement, whether in dance, ice skating or gymnastics, we respond to the energy, grace, and expressive power of the human body in motion. In this book, calligraphy is approached as an art of movement – one distinguished by leaving a trace of this movement. The quality of contact needed for making a calligraphic trace results from a fruitful interaction of mind, body, tool, and surface. When the muscular, kinesthetic power of the shoulder and arm combine with the tactile sensitivity of the fingers, we can transmit energy and feeling to our strokes and letterforms.

To make this possible, my book provides special training. Here, calligraphy, like other arts of movement, begins with warming up exercises to awaken the body and arouse its energy. Next, you'll engage a stroke technique specially designed to sensitize the arm muscles and fingers for skillful calligraphic contact. This technique helps you develop the pleasure of moving rhythmically as you direct letter strokes. To cultivate feeling, there are exercises for developing the stroke as gestural movement. This gradually leads to calligraphic empathy: the use of the calligraphic elements of line, shape and space to express the meaning of words and texts through living letterform. (See Graphopoeia, pages 72-3) Reminder: the training in this book is presented in a spirit of play and experimentation to be engaged at your own pace for your own purposes.

Beauty. While my approach to calligraphy does not focus specifically on beauty, the living stroke – when expressed as graceful and flowing – is naturally at the heart of beautiful letterform. Although one of the roots of the term calligraphy is the Greek callos, meaning beauty, the spirit of our time does not show much esteem, if any, for this value. For me, beauty is part of our human, cultural, and calligraphic inheritance. Consequently, the calligrapher may explore its significance for our lives today.

Calligraphy as Meditation

In support of my book's title, I'd like to begin with a working definition. Meditation is a practice for calming the mind for the benefit of oneself and others. Today, there is a growing appreciation of meditation as a way to reduce stress, improve health, and enjoy life. Daniel Goleman, noted psychologist, writer and author of *The Meditative Mind*, firmly believes that "a relaxed, alert state is optimum for any performance in any field." In my approach to calligraphy, we cultivate such a state of mind to generate energy for creating vital letterform and to enhance the pleasure of learning this art. In the Zen tradition of meditation, novices have often been assigned an art, such as calligraphy, as a tool to help calm the mind. I've discovered Western calligraphy can also play this role for meditators and calligraphers alike.

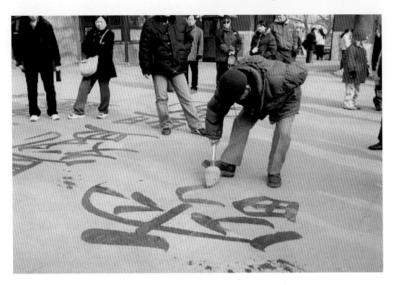

In China, the sidewalk calligrapher is both performance artist and meditator. Dancing a large brush charged with water across the pavement, he enacts the gestures of stroke making – moment-by-moment – through a moving meditation.

Attitude. As students of a new approach to calligraphy, whether you are a beginner or seasoned practitioner, you may be experiencing some apprehension and physical tension. As in meditation, becoming aware of such obstacles is the key to letting them go, which lays the groundwork for creating an open mind. With an open mind you are free to pioneer new territory and enjoy your experience to the fullest. To develop an open mind, the field of meditation offers a number of helpful strategies. The first asks you to become aware of goals and expectations, of preconceived ideas or past experiences that may close the mind to exploration. Another emphasizes cultivating patience and a non-judgmental attitude which, in the practice of calligraphy, can help to overcome self-defeating frustration. As in any art, the development of calligraphic skill and creative imagination unfolds gradually. With patience, your hand and eye will learn to direct strokes that combine to create living, expressive letterform.

The breath. Meditators develop this sense of vitality in themselves, and calligraphers in their forms as well as in themselves, by an integration of mind, body and feeling. For the calligrapher to experience this sense of wholeness, I introduce conscious use of the breath as a method for uniting mind, body and feeling with a tool. In my approach, this interactive process begins with an unmediated contact between a tool and a surface. By first using the index finger, what I call the "prototool," you will awaken a connection between breath, mind, body and movement. You will open perceptual channels that allow feedback from the senses – vitalizing agents by which calligraphy becomes rhythmic experience. From the beginning, the calligrapher learns to make strokes and letters as an extension of her wholeness. By coordinating tool movement with the movement of the breath, your calligraphic practice is deeply rooted in a state of relaxed alertness.

Focus. Having entered this state with the prototool – having taught the mind to pay attention to the body – you are ready to focus on holding and moving an actual tool to create strokes. Focusing on making these strokes, however, does not mean tensing, either bodily or mentally. In a relaxed, open state, you take up a tool and begin the quintessential calligraphic act: stroke making. Each stroke is composed of many intertwined facets – visual, tactile, and kinesthetic – which unite to create letters with energy and life. To develop the ability to focus on the multi-faceted stroke, you work incrementally, focusing on one or two as you begin. In this book, through warm up exercises and training alphabets, skill and concentration grow together.

A moving meditation. Calligraphy cultivates the pleasure of movement through warming up exercises, as well as exercises in guided play. Play, I've discovered, is a mental state conducive to both experimentation and creativity. It develops confidence and a willingness to enter new territory. For this quiet adventure, I recommend a quiet space. If at all possible, find a place where you can practice undistracted from outside, or even internal, demands. As you enter and begin your practice, smile!

Learning calligraphy

Conventional manuals and classes focus almost exclusively on letterform: on constructing the strokes of an alphabet model by following directional arrows in a numbered sequence. In this approach, calligraphy is largely taught as a training for the eye – as if the eye holds the pen! But calligraphy is far more than a visual experience – here it is a fully embodied one. It includes the body, the senses, and the eye in a lively exchange of mental and sensory feedback. Here, exercises develop your ability to hold the tool while moving it on a surface – enhancing the eye's ability to guide it successfully. Only through tactile and kinesthetic sensitivity can you find the rhythm of a stroke and thereby engage its inherent pleasures in calligraphic letter making.

I believe developing living letterform is a journey directly experienced. It fully engages the mind and the senses in an interplay with tool, surface and form. Calligraphy, here, is about enjoying a process that cultivates your skill, your taste and your creative self. I will now present the key features of my manual and discuss them briefly.

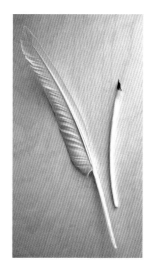

A developmental approach

Calligraphy consists of many facets, which include holding the tool, directing the stroke, and applying stroke technique. This book offers a program for developing each one, separately, in a process of building skill incrementally. A guided progression of exercises leads to an expanded attentive capacity – one that enables you to integrate calligraphy's many facets simultaneously. I hope you will enjoy discovering each new facet, developing it, and watching your skill and confidence grow in the process.

A tool-centered approach

Unlike the conventional teaching of calligraphy, a tool-centered approach provides a framework for learning calligraphy developmentally. In my manual, practicing letterforms is inseparable from wielding the tool that makes them. Fundamentally, it is through the use of tools that one infuses letterform with energy, rhythm, and the felt quality of gesture.

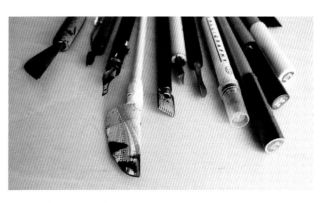

Tool categories

Three tool categories are presented. Sequenced exercises with these tools lay the foundation for creating expressive or beautiful letterform. Each tool category begins with an introduction that features the tool's particular qualities and uses. Each tool introduction is followed by training alphabets for developing the calligraphic potential of the tool. Below are the three tool categories.

One-point tools include the "prototool" (my own invention) and the familiar pencil, roller ball and ballpoint. Such tools, generally used for drawing, are here used to develop the essential calligraphic qualities of energy and movement. Through one-point tools you discover, or rediscover, the joy of rhythmical movement and the pleasure of sensitive contact. The exercises aim to develop tactile and kinesthetic awareness and to coordinate your movements with the breath. The one-point tool training alphabets – Playball and Jumprope – invite you to explore the senses of movement and touch with childlike openness and adult sensibility.

Two-point tools consist of two one-point tools banded together. This tool's unique nib, composed of two points, is analogous to the two-cornered nib of the edged pen. Working first with two-point tools – without the challenges of loading ink – helps you develop skill and confidence with the operations underlying both. The training alphabet for two-point tools – Trapeze – again begins with warm ups to help you relax. As its name implies, Trapeze also cultivates the sense of freedom, in this instance, through the discipline of a unique tool.

The edged pen comprises a nib and single shaft. The nib is often referred to as "square" or "chisel edged" to convey an image of its uncommon design: an edge bounded by two corners. A reservoir for carrying ink attaches to the nib. I present methods with accompanying exercises to develop the skill of feeding ink to strokes and letterforms. The exercises include ones that focus on the meditative integration of breath, body and ink flow. They prepare you for work with letterform by helping you to awaken a relaxed, alert state of mind. The edged-pen training alphabets – Moto, Satisfaction, Upright Italic, and Proteus – build on the lessons of previous tool categories.

The two-point tool prepares you for using the edged pen.

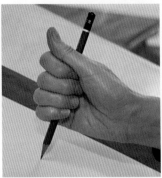

a

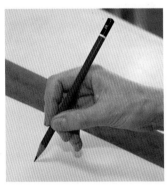

b

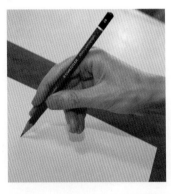

c

Three tool holds:

a – the power grip

b – the 3-finger grip

c – the 2-finger grip

Training alphabets

After being introduced to a tool, the next step, as is customary in learning calligraphy, is making letters from an alphabet model. Although students of calligraphy usually begin with a historically-rooted alphabet, to facilitate training, the alphabets in this book are specially designed to develop the calligraphic facets of a featured tool. While the first nine models have no historical referent; the last two are based on the Italic style of Renaissance Italy.

Note: For the contemporary calligrapher, I believe our heritage – the evolution of Western alphabet styles – offers lessons rich in formal possibilities. It also shows us letterform as an expression of a culture's unique historical moment. As our inheritance, it remains for us to know it and to use it to suit our own needs and spirit. I strongly recommend a study of the history of alphabetic letterform when you are ready.

The three Ds: design, ductus and dynamics

The training alphabets are designed to teach calligraphy as an embodied art, holistically – as an integration of mind, body and feeling. By sensitizing hand and eye, we educate a felt response to stroke, letterform and space. To achieve this purpose, each alphabet is presented in terms of the three major calligraphic facets of design, ductus, and dynamics.

Design. This facet focuses on training the eye to see alphabets artistically. This means giving the eye tools for understanding calligraphic letterform as a visual language – in terms of the language of design. The calligrapher uses such basic design terms as contrast, repetition, unity and proportion to understand and create letterforms, words, and texts. This fundamental education prepares you to study other alphabets – historical and/or contemporary designs – or to create your own.

This approach teaches you to appreciate alphabets and letters as compositions comprised of line, shape and space. In calligraphy, these design elements translate into stroke, letterform, and space (within and between letters). Viewing these elements of letterform abstractly, as visual components, frees you to use them as plastic, rather than prescribed, elements. Although a written letter may appear set, like type, it's not type. In calligraphy, letters are the result of a formative process that takes place in the act of writing, of relating one letter to another in words, lines, and texts.

Ductus. Essentially, ductus refers to directing letter strokes in a particular sequence. An alphabet model displays this information with small numbered arrows. But an arrow, which indicates the direction of a stroke, also implies a target. To more actively engage the eye, in aiming the stroke rather than just following a course, I have developed "target practice." In this method, the eye gets its bearings at the start point of a stroke, sights the end point, and then begins its trajectory. ("Target practice" is introduced in spacing.)

As you begin, arrows and actual target points are useful; but as eye and hand develop, you'll be able to internalize this process. (This ability is helpful if you wish to study the letterforms of contemporary masters and/or the manuscripts of our scribal ancestors.) Since the information that ductus provides is limited to the eye in conventional calligraphic instruction, the hand goes uninstructed. To address this critical oversight, I have developed "dynamics" to accompany ductus.

Dynamics. In this book, dynamics refers to a technique for embodying calligraphy through its most basic element: the living stroke. Such a stroke results from pressure applied to a tool in motion and in contact. This creates a vital tension, felt as drag/friction, through which you can vividly engage in pulling or pushing the stroke from start to end point. The shoulder-arm provides the power of contact and the muscle for applying pressure to the tool. The fingers, like antennae, provide feedback on surface conditions and supply refined motor movements for steering the stroke. Calligraphic stroke making becomes a mind-body loop of activating, sending and receiving sensory feedback.

Through sensitization exercises focusing on surface contact, you awaken the shoulder-arm and fingers for their appropriate roles in using the tool. These stroke exercises build awareness and attention. To help support attention, in this book the calligrapher also uses the breath for what I call "staying with the stroke." This means experiencing each moment of the stroke as you move with it along a directional course. It means being alert to changes in stroke pressure which, in the course of a stroke's progress, enables you to participate in the fullness of its rhythm and flow.

Spacing. Flow implies a channel for movement which, in calligraphy, is the space where hand and tool move from letter to letter. We call this act of moving across space, spacing. Like making strokes, it's directional movement: either visible, with a trace of the movement joining letters, or invisible, when the tool moves above the writing surface to the next letter. In either case, you

connect letters by distributing the space between them as you move from the end of one to the start of the next. Not only the clarity of letterforms, but the amount of space between them, determines the legibility of a word, line, or text. For the calligrapher, whether creating legible texts or artistic pieces, spacing is as important as letterform. Therefore, in this approach, unlike that in conventional instruction, spacing is practiced in the course of learning an alphabet, organically, as an integral part of its expressive character.

The exercises

The first aim of the exercises is to develop the interplay of two basic calligraphic qualities – form and flow. Exercises with form emphasize structure and accuracy; exercises with flow emphasize energy, rhythm and movement. Gradually, sensory feedback develops flow and merges with analytical feedback to create living letterform. Gradually, by exercising the distinct but intimately related qualities of form and flow, we can develop "disciplined freedom," a phrase aptly coined by noted 20th century calligrapher Ray DaBoll to describe the essence of calligraphy. The second aim of the exercises is to develop skill and sensitivity for organizing letters into calligraphic pieces – whether a single word, line of words, or multiline text.

Flow exercises. These exercises serve as a transition between the everyday mind, which meditators often call the "monkey mind," and a relaxed, alert mind, one that's open and ready to focus. In the tool introductions, the exercises feature getting the feel of the tool. In the training alphabets, warming up exercises are designed to loosen up the body. They also activate the mind for its dual role: directing strokes and responding to sensory signals. Flow exercises awaken the mind-body-feeling feedback loop. In addition, they prepare you for success with letterform.

Letterform exercises. These exercises call for executive mental function. In ductus, this means directing and positioning the stroke; in dynamics, patterning the application of pressure-release in strokes. In these exercises you learn firsthand letter proportion and structure, and the plastic nature of calligraphic letterform. As soon as you finish studying a letter family, you proceed to spacing and word image exercises.

Word as image. This book focuses on calligraphy's special intermingling of verbal and visual meaning. Through word exercises you explore the design elements of size, weight, proportion, line/stroke, shape and space for their capacity to express verbal meaning visually. In translating from verbal to visual, you develop your sensitivity to the interaction between one kind of meaning and another. This training invites the imagination as you experiment with calligraphic elements to create word images. If you're unfamiliar with such a process of experimentation, you might consider it as the adult equivalent to a child at play: trying things with a fresh, open mind and noting your discoveries without judgment.

Making: small pieces, practice texts, and a finished piece. The exercises in making are also developmental: using one-point tools you make two pieces with a single word; with two-point tools, a piece with a few words; and with the edged pen, multiline practice texts. All of these pieces engage a design process of preparation, testing and composition. As exercises, they continue your design education, introducing the principle of balance. In calligraphy, balance addresses the distribution of space around an image: the margins. In these exercises you will learn methods for the practical skills of measuring, ruling and cutting. These pieces prepare you with the confidence and knowledge needed to make a finished piece – for yourself or others.

Learning strategies

No doubt you consider yourself a student as you take up this manual. But the process of learning from a manual involves a more active role than when learning from a live teacher. It asks you to become a teacher as well as a student. Below, you will find some thoughts and tips for starting and enjoying this dual role. At the outset, though, let me remind you to work slowly – to take the advice of one of my most influential teachers, "slowly, turtle, slowly." What's the rush anyway?!

First, my role as your teacher. It is my intention to serve as your guide, not your dictator. As a guide to your own experience, and an encouraging support for your efforts, I hope you will put your energy into the process of learning. Without a live instructor to answer your questions, I hope you will give the process a chance. Give yourself permission not to know, to live with uncertainties and patiently await discoveries that may dispel them. Like an explorer in new territory, you have a guide, but the adventure is yours.

A practice

The above exercises provide raw material for learning calligraphy. To use them effectively, I highly recommend creating your own calligraphic practice. Such a practice, like a meditation practice, is engaged in regularly, often at a specific time and place. In this way, a calligraphic practice enables you to develop the values of a meditation practice; to reduce stress; and, to exercise mind and body through the pleasures of creative endeavor.

Since learning any skill requires practice, one needs to make a commitment. Once made, you're free of internal debate about whether or not to practice today. Naturally, you may not be ready to commit on page one, but the idea of setting up a practice is worth keeping in mind. Remember, calligraphy gives you energy when you work slowly, free of deadlines or performance expectations.

A dedicated place: No matter its size, this provides you with a space in which to keep your tools and materials and to practice. If possible, you'll make it one that's quiet and invites a retreat from daily affairs and preoccupations. A physical space is also a mental space.

Practicing

Most likely the time available for your practice is limited: therefore, the approach to practicing is important. I suggest you begin by selecting a few exercises before each practice session. At the session itself, follow the program or consult your time or mood to help determine the ratio of flow to form – warming up to ductus and dynamics exercises. What will nourish you the most? If a practice is not personally meaningful, there's little chance you'll continue. (If you're making a piece, take care in choosing the word or text and allow yourself time to experiment.)

Working with the exercises

1. Organize the tools and materials you'll need in advance, such as the night before.

2. For each exercise, before you pick up a tool, read the exercise in full.

3. Because, as noted earlier, many things happen simultaneously in calligraphy, decide in advance which facet/s will be your initial focus: usually, coordinating directional movement and breathing.

4. At this point, you may wish to record the exercise. Listening to the instructions, rather than looking back and forth from book to paper, enables you to focus without interruption.

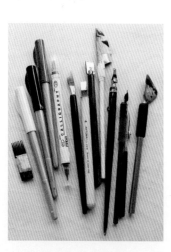

A padded writing board

5. To get the idea of an exercise, use the prototool before taking up an actual tool.

6. When you are using a tool, check your grip from time to time.

7. Note: Due to the length of the descriptions in some of the exercises – you may run out of breath before the next exhale – try to familiarize yourself with the breath before beginning.

Practicing methods

The following methods are offered to help train your hand and coordinate it with your eye.

Tracing. In this book, most letterform exercises begin with tracing. This allows you to see the form you wish to make emerge from the movements needed to make it – the better to reveal form to the eye. In Asian calligraphy, the teacher holds the student's hand and guides hand and brush to make a character. In this method, the student directly participates in the process of formation, through a master's gestural motion. Here, tracing and written instructions (ductus and dynamics) are offered as a kind of invisible guiding hand. Through tracing, you enter the reciprocal process of embodying letterform: as the eye guides the hand, the hand develops the eye.

I used the non-traditional cola pen (fifth from right) to make the image facing the Preface.

Working large. By engaging the arm-shoulder muscles you sensitize them to variations in pressure, which encourages rhythmical movement. This frees the fingers for the fine motor movements of letterform: directing the stroke accurately as well as making refinements and developing more sophisticated techniques.

Exaggerating. This method helps you see a form, or part of form, more clearly.

Mindful repetition. To achieve form requires repetition. Only if it is done mindfully, though, will it get closer and closer to the desired quality. Staying alert to your experience, repetition also becomes a way to discovery – where new aspects may enter your awareness and spark your interest. Before each repetition, review what you're trying to accomplish; after the repetition, analyze the form: where and why does it succeed, where and why does it fall short?

Play. Play can be guided – the rules of the playground – or free. (This does not exclude giving the hand a hint or two.) Either way, you may use it to refresh and energize yourself at any time. Play can also produce a relaxed, alert state of mind, one conducive to experimentation and creativity.

Analogy. To use analogy as a learning strategy, I've given some exercises the name of an activity with which you're most likely familiar. Making associations connected with this activity (whether or not you've actually done it), may help guide you in performing an unfamiliar calligraphic action. From the ski slopes: a slalom to suggest a rhythmic zigzag pattern of movement; from music: bowing a stringed instrument to help you enact the stroke as a felt gesture; from the everyday act of driving: a pattern of giving gas to the pedal in turning a street corner to help you to apply pressure to the tool in negotiating calligraphic curves.

In calligraphic parlance, the act of wielding the pen is often referred to as "the dance of the pen." However, since no method currently exists for training students to dance calligraphically, I've developed "partnering." Here, the body and pen are partnered, physically and mentally, to better guide a tool in the choreographed steps of letterform.

Learning from the masters. By following the developmental course in this book, you'll be well-prepared to study both historical manuscripts and the work of modern masters. In the Bibliography, you'll find books displaying both types of work. Begin by enlarging the manuscript/modern calligraphic images to a size large enough to trace with a good-size nib, such as a 3mm Brause.

In conclusion

This book recognizes the human desire to create. With so much made by machine, how do we satisfy this desire today? I hope this book will be of some help in fulfilling the desire to engage creatively with the fundamental human facets of mind, body, feeling and spirit.

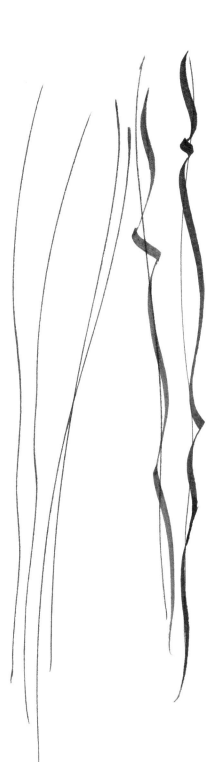

In this play session, I began by riding the pen's thin edge in gently curving long lines. Then, the full edge called for attention and I danced around the thins in graduated full-edge strokes.

And you who want to demonstrate with words the form of man with all the aspects of his limbs, put aside such an idea, because the more minutely you describe it, the more you will confound the mind of the reader, and the further you will remove him from understanding of the thing described—therefore it is necessary both to depict and to describe.

The muscle *ab* and the muscle *dc* (not visible here) serve to press the arm towards the ribs, with the result that impetus in the hands is taken from the arms, and thus they are such large muscles.

Tracing of a drawing by Leonardo da Vinci.

This book presents calligraphy as an embodied art, where creation takes place holistically—as an interplay of mind, body, and feeling. Here, an approach to the body as a seeing, moving, sensing instrument provides a way to developing confidence with a writing tool. (See "The Prototool," next page.) In *Calligraphy as Art and Meditation* you'll explore written symbols as vehicles for artistic expression and self-discovery.

The Prototool

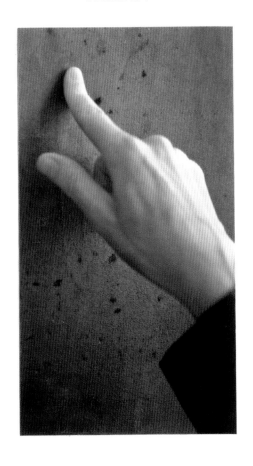

Protool 1: features the index finger, which awakens you to the basic calligraphic interplay of a tool and a surface. Through it, you make a direct connection between the body's movements, stroke direction, and the fundamental rhythm of the breath. You also discover the finger as an extension of the shoulder—how its exertion or restraint promotes or hinders tactile feedback. (See drawing at left.)

With the finger(s) as a tool, you can easily pair movement and breath, inhaling with the upstroke and exhaling with the downstroke. This direct, unmediated contact with a surface quickly awakens a mind-body integration of senses, thoughts, and feelings. Furthermore, you can use the prototool at any time to promote relaxation.

The prototool exercises below prepare you for using an actual tool by sensitizing you to the roles of touch and movement. They develop calligraphic rhythm—the pulse of the living stroke—by coordinating body and breath.

Prototool 1 is covered now, in preparation for using one-point tools. Prototool 2 is presented later, for using two-point tools and the edged pen. (See p. 88) These prototools cultivate the possibility of using an actual tool as an expressive extension of the body.

Stationary: in one place
This exercise establishes the connection between the breath and bodily movement—the first step in using the breath as an aid to directing and staying with the stroke. Use paper or cloth for your surface. (The medieval scribes wrote on prepared animal skins known as vellum and parchment.)
1. Place the prototool in contact with a surface: the index finger is straight but not rigid; the forearm is raised a little above the surface.
2. Without moving the prototool, inhale and note the natural movement of the finger and arm as they rise slightly with the breath.
3. Exhale and let the weight of the arm and shoulder release. Hold the tension of this pressure with a slight stiffening of the finger. Repeat a few times.

Down and up: retracing
Here you take time to experience the stroke as directed bodily motion. Work slowly. Slowing way down helps you tune into the signals from muscular movement.
1. Place the prototool as above. Inhale; pause; exhale and pull the prototool slowly downwards a few inches. (Fig. 1) Let the pressure of contact come from the shoulder. Let the prototool be a purely sensing instrument.
2. Inhale while retracing this line lightly upward; pause briefly; exhale and pull down as above. Note: the diagram in Fig. 1 separates the up-and-down stroke, but in practice each stroke is retraced over the other.
3. Repeat a few times. Keep the prototool upright. Experiment with the weight (pressure) from the shoulder and what effect it has on tactile feedback.

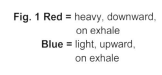

Fig. 1 **Red =** heavy, downward, on exhale
Blue = light, upward, on exhale

"Target practice"
Like archery, calligraphic stroke making implies a target and a strategy for hitting it. At this time, target practice is in quotes because this exercise precedes the use of visible points—such as those found at the beginning (start point) and end of letters (endpoint)—in making strokes. For now, the act of calligraphic aiming will be approached more as an embodied experience than a visual one. Here, the weight of the shoulder, as it pulls strokes down and pushes them up, also connects them to the inhale and exhale of breathing. Let the pause between breaths help you to redirect, re-aim, the stroke.
1. Place the prototool as above.
2. Inhale; pause; exhale and pull the prototool slowly downward a couple of inches.
3. Pause briefly at the bottom of the stroke.
4. Inhale while lightly pushing the prototool diagonally upward and to the right. (Fig. 2)
5. Pause briefly. Repeat the pattern rhythmically, keeping shoulder awareness.

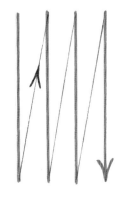

Fig. 2

one-point tools

One-point tools comprise any instrument that has a shaft which ends in a single point. Such a tool may be a pencil, a ballpoint pen, or a roller ball. Although none of these are conventionally regarded as calligraphic tools, they offer a perfect foundation for using them. They allow you to focus on the underlying elements of calligraphic expression—sensitive touch, rhythmical movement and its dynamics; the integral role of the breath; and spacing—before focusing on the demands of the more complex two-point tool and edged pen. Their simplicity allows you an opportunity to become confident with the often neglected basics of holding a tool and directing the stroke. Start with the first tool on the list below, but try the others for comparison. All are available at art stores.

Graphite
Choose soft-lead pencils, from 4B to 6B. (Softness increases with the increase in number.)
1. Artist pencils, such as *Staedtler (Mars Lumograph),* look like a regular pencil, except they are blue and come in a wide range of softness (the "B" series).
2. Large leads, 5.6mm, such as *Cretacolor,* come in a container of five sticks and need to be inserted into a separate holder. I recommend buying a holder of the best quality because the gripping mechanism will withstand pressure without slipping.
3. Graphite crayon, such as a *Lyra Graphitkreide.*

Ink
Pigma Micron roller balls in the larger sizes (05 and 08). These come in both black and a variety of colors.

Other one-point tools will be presented as they are used.

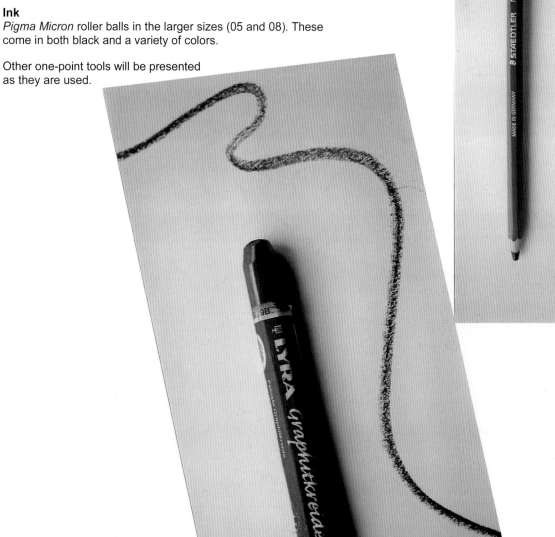

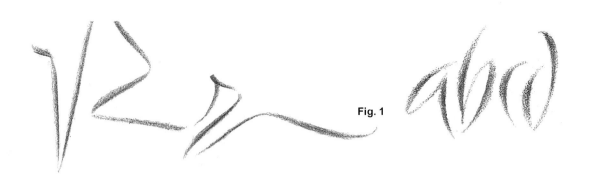

Fig. 1

Visual character

One-point tools make lines of varying width and darkness, depending on size (diameter) and tool hardness. (photos p. 2 and Fig. 1, above) One-point tools also respond to surface texture, to speed and pressure, and to the spirit in which the marks/letters are made.

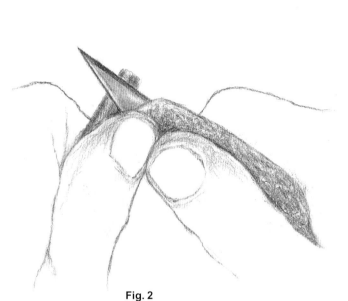

Fig. 2

Fig. 3

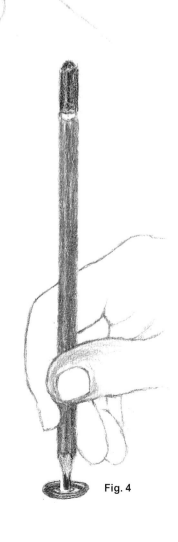

Fig. 4

Preparing the tool

Calligraphers often adapt their tools. Here, preparation focuses on the tip, by which you will create calligraphic marks, lines, and strokes.

The aim of using a one-point tool is to experience the pleasure of consciously moving and directing it. For dry tools, a flat or slightly rounded tip serves this purpose and removes interruption for sharpening. Such a blunt tip also helps you maintain the tool in an upright position— a foundation skill for calligraphic development.

Tools and materials
1. An unsharpened soft pencil (4B or 6B)
2. A knife, such as a mat knife (for whittling the wood casing)
3. A paper surface for further shaping and smoothing. Most papers have enough tooth to provide the needed abrasion.

Shaping the tip
1. Expose the lead. Set the blade about 1/8 inch from the end of the pencil. Place both thumbs behind the knife blade. (Fig. 2) Angle into the wood; shave, curving upward until the blade is parallel to the lead. Continue shaving the wood away, to eventually expose 1/8 inch or more of the lead. (Fig. 3) Be careful, and work slowly.
2. Smooth the tip. Holding the pencil upright, move it about on the paper until it is slightly rounded/flat. (Fig. 4) The amount of lead exposed and breadth of the tip may vary. For most of the exercises ahead, try using the full width of the lead.

Three additional elements: posture, paper and a touch-sensitive surface

Before using the tool, it's time to consider these additional elements integral to the calligraphic process.

Posture

Careful attention to the position of the body helps you to more enjoyably and effectively enact the strokes of letterform. To promote a comfortable range of arm and hand motion, experiment with the following.

Chair height
The correct height is one that permits both feet to be in full contact with the floor. Through the feet, the whole body engages with greater alertness.

Chair in relation to the desk
The height of the chair should raise the body sufficiently above the desk to allow the shoulder a full range of motion, and to easily apply its weight upon the tool.

Desk angle
A slight slope allows the arm—forearm, elbow and upper arm—to move comfortably. It also prevents the need to hunch over the paper. To find this angle, sit at your desk and move the arm, with or without a tool, experimenting with different angles. Treat a portable desk, a board resting on your lap and propped up by a table, in the same way.

Body orientation
Bend forward slightly, from the hips, to enable flexible, easy movement, and encourage alertness. Position the left hand comfortably to balance the body, and, when writing, to help move the paper if needed.

Paper

The interaction of writing tool and surface (usually paper) is of the utmost importance. It can foster or hinder the pleasure of writing as well as the quality of the written product. In this book, papers are selected to serve the aims of different tool categories and writing purposes.

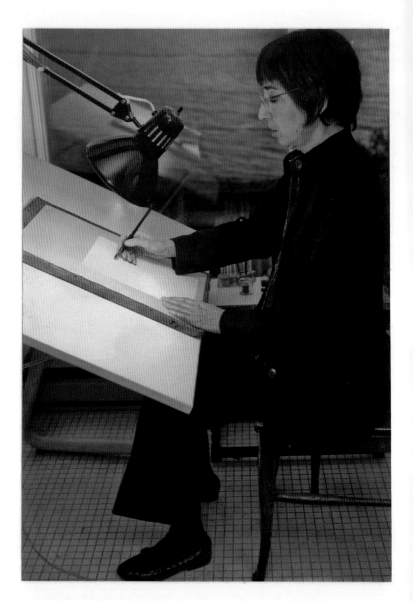

Papers
For the exercises in this section, buy one tablet of each in the sizes specified below. (The drawing and JNB paper will be used throughout the book.) Working in a large area better awakens bodily awareness, particularly the movements of the arm and shoulder. Try all three types of paper. It's a good idea to get in the habit, from the start, of comparing tools and materials.
1. Rough newsprint (12" x 18", or larger) (Art stores)
2. JNB (John Neal Bookseller) Practice Pad (11" x 17") This paper has an excellent surface. (See Suppliers, p. 247)
3. Drawing paper: Strathmore (14" x 17"), 300 series, yellow cover) or JNB's Good Drawing Paper (See Suppliers, p. 247)
4. Tracing vellum (heavier, yet easier to see through than tracing paper): Canson Vidalon Vellum (9" x 12"). (Art stores)

Storing paper
Find a place that is easily accessible and protects the paper. A "flat file," whether of metal or wood is desirable; but under the bed works fine, too!

Touch-sensitive writing surface

To provide for a pleasurable and effective writing experience, it is essential to create conditions that promote useful tactile and kinesthetic feedback. This means enhancing the signals to tool and hand from surface contact. To accomplish this aim, calligraphers place some material between the writing paper and the table/portable desk. It can be as simple as the padding of the tablet itself, or a few sheets from it. For more ideas on this topic, see my website www.ginajonascalligrapher.com for "Nib contact: the case for the touch-sensitive writing board." (Publication section, at bottom)

Holding the tool

The importance of tool hold cannot be overstated. Unlike the prototool, which connects directly with a surface, hand-held tools necessarily mediate between the fingers and a surface. Nonetheless, we can make surface contact with a hand-held tool as though it were a sentient extension of the body. Attuning the hand to tool and surface prepares you to create vital calligraphic letterform.

Positioning the fingers: the 3-finger grip

In this grip, the tips of the thumb and index finger hold the tool and form a loop. The second finger provides support, a sort of brace for the other two.

At the start, this involves placing the fingers at least an inch from the tool point. This placement helps the arm to relax and move more easily and freely. It also breaks any habits formed by handwriting, such as the common clutch. (Known to calligraphers as "the death grip.") Although this grip may seem to offer greater control, it actually cuts off the feedback from contact.

Positioning the shaft

In contrast to the daily hand writer, who usually places the tool's shaft in the bottom of this loop, a calligrapher places it in the top part, against the index finger and near the big knuckle. This supports the tension that results from pulling the tool over the surface. The angle of the shaft to the surface will be nearly upright, which automatically raises your forearm slightly above the writing surface/table. Let this happen!

Since human hands are not alike, slight variations to these directions are not a problem.

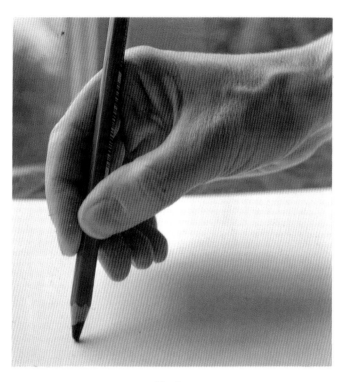

Fig. 1

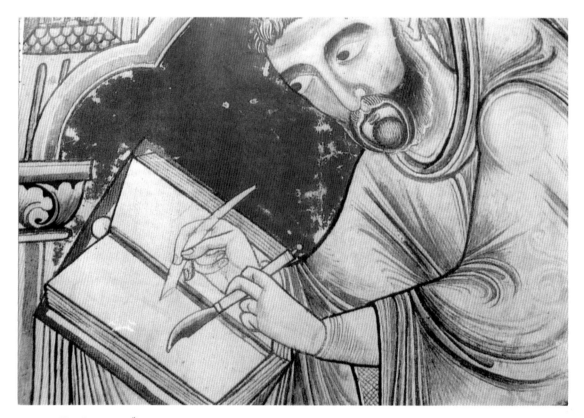

Fig. 2 In this 12th century portrait, the monk Eadwine, "prince of scribes," is shown working with both a pen and knife. The pen knife served to sharpen a dull pen, to scrape the vellum for erasures and to hold the pages in place, and undoubtedly, as a balance to the act of writing.

Coordinating breath, movement, and direction

As you discovered in the prototool exercises, such coordination brings greater awareness to stroke making. As in most physical activities, the interplay of breath and movement develops rhythm.

Work slowly. At this tempo, you're better able to receive the body's signals about its experience directing the tool: its various tactile and muscular sensations from the fingers and arm. These exercises also provide an opportunity to focus on tool hold—firmly supported but not tight—as a response to pulling the tool under pressure from the arm.

> **Tool:** 4b or 6B pencil or other soft, one-point tool
> **Paper:** Try one or all of the papers given on page 4. Use the full pad, or a few sheets from it, to pad the surface.
> **Tool hold:** the three-finger grip
> **Line length:** 5-6 inches
> **Speed:** slow and deliberate

Getting started
1. Sitting comfortably at your desk or drawing board and, working at a slope, test the mobility of your shoulder and arm.
2. Place the tip of the tool on the paper at the bottom of the intended stroke. Make sure the tool is directly in front of you. The left hand replaces the pen knife scribes once used to "anchor" the paper. (image at right and Fig. 2, p. 5)
3. Without moving the tip, inhale and exhale noting the movement of the tool as it rises and lowers with the breath.
4. Also on the exhale, when the arm lowers, note the sense of greater weight, or pressure, in the arm and shoulder. If tension prevents this automatic lowering of the arm, consciously direct the shoulder to drop. Keep the tool shaft upright.
5. After a few breaths, begin the exercises below.

Up and down: retracing (Fig. 1)
Caution! To prevent loss of breath, read the directions before doing the exercises.
1. Place the tip of the tool at the bottom of the intended stroke.
2. On an inhale, push the tip lightly upward from the shoulder.
3. Pause briefly at the top of the stroke.
4. On the exhale, feel the sinking down of the shoulder as you pull the tool point slowly downward, over the upstroke.
5. Pause briefly at the bottom of the stroke.
6. Repeat this pattern—inhale, up; pause briefly; exhale, down.
7. Note: Coordinating the breath with direction and pressure—less on the inhale-upstroke and more on the exhale-downstroke—develops rhythm.

Target practice (Fig. 2)
Here, targets are again implied rather than actual points—using the "endpoints" implicit in gravity and magnetic pull. For downstrokes, let the weight of the shoulder be drawn by gravity and sink directly down (endpoint). For diagonal upstrokes, let a sense of magnetic pull help guide the stroke up and to the right. Let your imagination help you participate in natural forces that can later assist your aim with visible targets.
1. Place the tip of the tool as above.
2. As above, push an inhale-upstroke, pause, and pull an exhale-downstroke.
3. At the bottom of the stroke, pause briefly as you prepare to change direction.
4. On the inhale, push the tool point upward, lightly and diagonally. Inhaling helps "lift" and propel the tool.
5. Pause briefly, preparing to change direction.
6. Exhale and pull the downstroke under shoulder-arm pressure. Don't carve the paper, just exert enough pressure to feel some friction.
7. Breathe at a comfortable rate. Repeat several times to enjoy this rhythm.
8. Pick up the pace: imagine the action as skipping or playing hopscotch—activities with built-in rhythm and spacing.

Note: In this well-balanced posture,
the feet are planted but the hands are not.

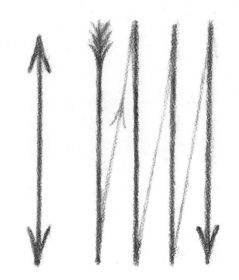

Fig. 1 Above left.
Inhale-upstroke; pause; exhale-downstroke.
Fig. 2 Above right
Inhale-diagonal upstroke; pause; exhale-downstroke.

Warming up: the joy of movement

In any art of movement—dance, sport, or calligraphy—the first step is warming up. To limber and loosen the muscles and joints, the calligrapher works large and at various speeds. The following warm ups introduce you to the pleasure of free, rhythmical gestures through the basic directions of letterform. These exercises are also a natural preparation for the first training alphabet, Playball. Through them, the joy of movement becomes a foundation for your calligraphic experience.

Multiline verticals

Step 1 **Step 2**

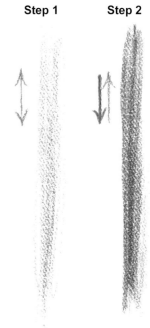

Tools: 4-6B (pencil, large lead or Lyra)
Paper: rough newsprint/drawing/JNB (and padded surface)
Tool hold: the three-finger grip
Body: Focus on the shoulder as the source of arm movement and pressure. Keep the wrist in a fixed position.
Action: "Throwing" a stroke, like throwing a baseball, requires sighting a target and taking aim. For the calligraphic throw, make a directed, energetic sweep with the arm and the tool.
Breath: Experiment to discover comfortable breath patterns for use at different speeds and line lengths. Exercises at a moderate to fast pace need not coordinate the breath with direction.
Line length: At least 4-6 inches—the longer the better!

Step one: Lightly up and down
1. Place the tool on the paper at the top of the intended stroke.
2. Throw the tool down and up quickly and lightly a few times. The hand stays off the paper. For balance, you may wish to let the little finger graze across the surface.

Step two: Rhythmic alteration of pressure
1. Place the tool on the paper at the top of the intended stroke.
2. Working at a slower pace, throw a downstroke applying shoulder pressure. Release the pressure as you retrace with an upstroke. Do this at least three times.
3. To further develop rhythm, try "counting" the directional movements in a 3-count pattern: "one," "two," "three" for the downstrokes, and "and" for their upstrokes. Remember to apply more pressure on the downstrokes.

Step 3

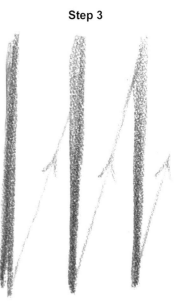

Step three: Diagonal upstroke
1. Repeat step two. After a few throws, pause briefly at the bottom of a downstroke.
2. On an inhale ("and"), release most of the shoulder weight and push the tool diagonally up— to the top of the next multiline downstroke (target).
3. Continue the pattern a few times, remembering to sight your target—the place you wish to begin the next downstroke—and take aim before pushing the connecting, diagonal upstroke.

Multiline diagonals

Unlike verticals, diagonals move downward from left to right or from right to left.
1. Use the same tools, materials, and steps as above.
2. A reminder: this is shoulder-arm work—you need not grip the tool tightly. Use the fingers to hold and support it, but keep them as relaxed as possible. Maintain the shaft in an upright position.
3. Feel free to experiment with the breath, speed, pressure, and number of repetitions—but work large and count.

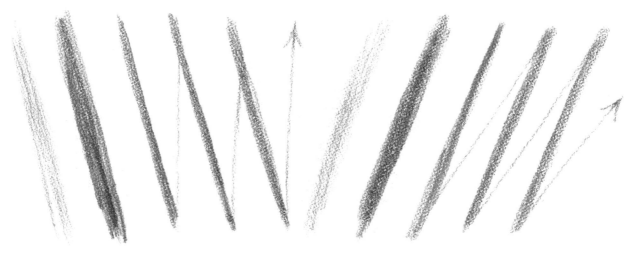

Multiline horizontals

1. Use the same tools, materials, and steps as above. On an inhale, place the pencil; on the exhale, apply shoulder pressure and move the tool from left to right; pause briefly. On the inhale, release pressure and re-trace from right to left. Repeat. After the last exhale:
2. Inhale, release pressure and move diagonally down from left to right. Pause briefly; exhale and repeat the pattern a few times.

Implications for spacing: See how the body's rhythmical movements distribute space evenly between the multiline strokes.

Multiline closed curves

In Western alphabets, the circle and oval undergird the "bowls" of letterform—open as in "c" or closed as in "o." The circle provides a reference for the bowls of more slowly written formal styles. The oval, which results when you speed up the circular motion, is the basis for hand-writing and the less-formal, often-sloped Italic styles. These exercises feature the closed curve, with its free, continuous movement.

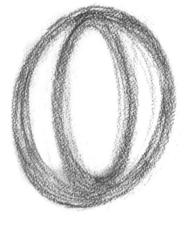

Circle and Oval (Fig. 1)
1. At moderate speed: Throw a few large circles, 8" to 10" in diameter to the left (counter-clockwise).
2. Stop at the top of a circular throw.
3. Now throw a few ovals inside the circle in the same direction. Breathe comfortably. Relax and move from the shoulder. At the top of the oval:
4. Change direction and throw circles and ovals to the right (clockwise).

Fig. 1 Basic closed curves: circle and oval

Coordinating Breath with Direction
1. Place the tip of the tool at the top of an intended circle and inhale.
2. Exhale and throw the left side of a circle, a semicircle. (Not shown.) Inhale as you swing up the right side of the circle to complete it. Repeat a few times.
3. Reverse direction using the same breath pattern, and repeat a few times.
4. Repeat the coordination of breath and direction with an oval inside the circle.

Continuing with the Oval and Pressure
Since the aim of warming up is to experience ease of movement, this exercise continues with the more nimble oval.
1. Working quickly, without focusing on the breath, throw large loose ovals (4" to 6"). Alternate directions. (Fig. 2)
2. At moderate speed, throw ovals applying pressure from the shoulder. First, throw more weight to the left side of the oval, then throw more weight to the right side. (Fig. 3)

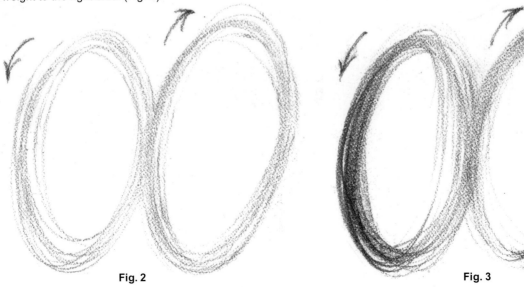

Fig. 2 **Fig. 3**

Oval to Loop
Use tracing vellum (See p. 4) and trace Fig. 4 to acquaint yourself with this pattern of movement and distribution of pressure.
1. Throw a multiline oval.
2. Slow at the bottom of an oval as you prepare to break away from the track. (Fig. 4)
3. Inhale and push up the right side of a loop; pause briefly at the top.
4. Exhale and throw the left side of the loop applying some shoulder pressure. Continue making loops.
5. Repeat freehand at a larger size.
6. Reverse this pattern and commence making loops from the top of the oval.

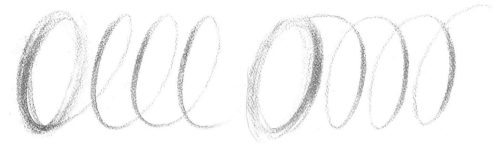

Fig. 4

Note: The soft pencil provides a record of your use of pressure: more pressure, darker; less pressure, lighter. Feedback from applying and releasing pressure develops sensitivity and skill—and rhythm! So, if you don't see a good contrast between light and dark lines, troubleshoot. Are the muscles of the shoulder and upper arm applying enough pressure to get a dark line? Are they releasing enough pressure to get a light line? Experiments—1) to increase darkness, drop or sink your arm as though weighted with a "boulder" and 2) to create lightness, imagine a caress. Reminder: exaggeration and analogy can be helpful learning strategies.

Rhythmical movement as patterned play – give it a try!
(Ballpoint pen, 63% of original)

Training Alphabet 1: Playball

The first training alphabet, Playball, is a "warm-up" alphabet. It provides a foundation in rhythmical, directional movement, which is the basis of calligraphic letterform. By converting the energetic, multiline throws of Warming up into a stroke, Playball continues to develop awareness through bodily motion. (Fig. 1) As awareness of your movements and posture grows, you can more readily experience the

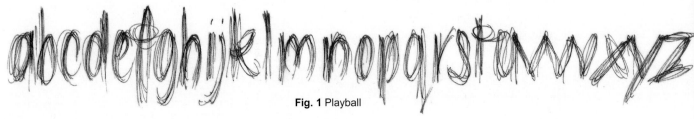

Fig. 1 Playball

pleasure of participating in stroke and lettermaking. Through a body-mind that is relaxed and alert, you can more easily invoke the spirit of play, an essential element of any art.

Design

For the Western calligrapher, an alphabet is first a design: a composition of 26 interrelated letterforms enlivened by variation and unified by repetition. The distinctive character of each letter expresses variety; the traits held in common with other letters create unity. These traits—or visual themes—endow an alphabet with its unique identity; they also allow us to group letters into letter "families" for ease in learning.

Visual themes
- Stroke: the multiline of Warming up. (Figs. 1 and 2) Its weight—lightness or heaviness—depends on the number of throws.
- Shape of curve/bowl: based on the oval.

Fig. 2 The multiline stroke of Playball.

Letter families
There are seven families in the Playball alphabet. Each family takes its name from a letter that displays the family's dominant visual trait.

Word as image
These exercises follow those with letter families. There are two kinds: one develops legibility and spacing, the other graphic expression. The first focuses on creating legible words—on learning to adjust the space between letters as an intrinsic part of learning an alphabet. The second focuses on using graphic elements (e.g., weight and proportion) for creative expression.

Ductus

For Playball, ductus consists of three methods for learning stroke direction:
1. Tracing: familiarizes the eye (and hand) with the direction of letter strokes.
2. Written description: provides the sequence of stroke making, instruction for joining letters, and the use of the breath as an aid to aiming strokes.
3. Repetition: gives you practice, via the multiline stroke, in developing your aim—sighting and re-sighting a target.
Conventional numbered arrows are introduced in the next training alphabet.

Dynamics

The dynamics presented in One-point tools—the natural application and release of pressure—are now used in Playball to help develop calligraphic rhythm. The breath continues as an aid to integrating ductus with dynamics—to developing rhythm, and the pleasure of stroke and lettermaking.

Note: Before using a real tool, I recommend beginning each exercise with the prototool to acquaint yourself with its moves and build confidence.

Lakeside grasses, with their energy and grace, offer inspiration for a multiline design.

Letter Family 1: the "l" (lijt)

Visual theme: the vertical stroke
Vertical strokes, such as those of the "l" family, carry the primary directional stress of most Western writing. In Playball, these are multiline down- and upstrokes. (Fig. 1)

Fig. 1 Repetition of the vertical stroke as a structural theme in alphabet design.

Rhythm and spacing exercise

By using multiline letters you can use the count patterns of warming up. By joining the letters with a diagonal upstroke in this count, the act of spacing becomes a natural part of the rhythm of lettermaking. (Fig. 2)

Tool: 4-6B pencil **Paper:** tracing vellum (See p. 4) **Body:** shoulder-arm **Speed:** at a deliberate pace – slow to moderate

To get the idea of throwing Playball, trace the letters of "lilt" in the following manner:

(l) 1. Place tracing vellum over Fig. 2.
2. Place the tool at the ascender line (top red line) and inhale.
3. Trace the letters using a 2-count stroke pattern:
 a. On the exhale, count "one" while throwing a downstroke with pressure.
 b. On the inhale, release pressure and count "and" while pushing an upstroke.
 c. On the exhale, count "two" while throwing another downstroke.
4. Join to "i" on the second "and": inhale and push a right diagonal upstroke to the waistline (middle red line).

(i) 1 Repeat the count and breath pattern for "l."
2. Join to the next "l" on the second "and": push a diagonal upstroke to the ascender line (top of the letter). Repeat the "l."
3. Join to the "t" on the second "and": push a diagonal upstroke to a little above the waistline.

(t) 1. Repeat the count and breath pattern of "l."
2. On the second "and," inhale and retrace the stroke to the waistline, and move a little to the left.
3. For the crossbar, exhale on "one" moving to the right; retrace on "and," moving to the left; exhale on "two, moving to the right to finish the stroke.
4. Inhale and dot the "i" with a small, multiline oval.

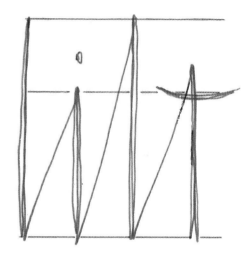

Fig. 2 Practicing rhythm and spacing in a word.

Calligraphic guidelines

These ruled lines establish letter height and depth. They are your first visual targets and help structure your throws. But remember, they are guides—you don't need to follow them precisely. Strokes may better express movement if they fall short of or go a little beyond the guidelines. Precision work comes later.

"Body-height" letters are made between a base- and a waistline. (Fig. 3) The ascenders and descenders of Playball, like those of any alphabet, are related to body height. In this alphabet they are one-and-a-half the body height. (Fig. 3)

Ruling. For the large work of Playball:
1. Mark off measurements along the left and right edges of the paper.
2. Connect them with a long ruler. (Using a T-square comes later.)
3. Fig. 3 shows the letter measurements for the following exercises.

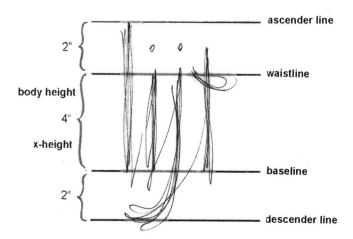

Fig. 3 Guidelines for Playball.

Ductus and Dynamics

When you are familiar with the letters and their joins, focus on getting the feel of making them as a rhythmical, gestural pattern—even leaving the paper.

Tool: 4-6B pencil **Paper:** rough newsprint/drawing/JNB **Body:** shoulder-arm
Breath: exhale, downstroke; inhale, upstroke **Speed:** slow to moderate
Rule guidelines: 2", 4", 2", down the paper.

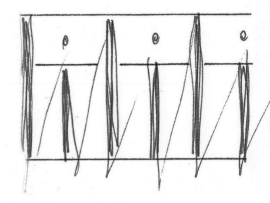

(l and i) Downstroke

1. Place the tool at the ascender line and inhale. (Fig. 4)
2. Throw the letters using a 3-count stroke pattern: "one-and, two-and, three-and."
3. As before, join the letters on the last "and." Repeat the "l-i" a few times.
Dot: a small multiline circle. Dot the "i"s after making the alternating letters.

Fig. 4 A rhythm pattern joining "l" and "i."

(j) Descender

1. Place the tool at the waistline and inhale. (Fig. 5)
2. Throw the letters using a 3-count stroke pattern.
3. As you approach the descender line, release pressure and gently dip down and over in a shallow arc. Push up to retrace the letter.
4. Join to the next "j" on the last "and." Repeat a few times.
5. Dot the "j"s at the end.

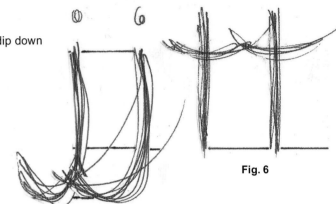

(t) Downstroke

1. Place the tool slightly above the waistline and inhale. (Fig. 6)
2. Use the 3-count stroke pattern for the downstroke.
3. On the last "and" retrace the stroke to the waistline and move a little to the left.
Crossbar: Use the 3-count stroke pattern for this slightly arced horizontal stroke. On the final "and" curve up and join to the next "t." Repeat the "t" a few times.

Fig. 6

Fig. 5

Spacing

Playball provides a foundation in spacing for both beautiful and expressive writing. The initial aim is to create an "even" (similar) distribution of white spaces/shapes between the letters in a word. This is called interletter spacing.

Letter combination 1

Interletter spacing is the product of letter combinations: two adjacent letters. Such a pair of letters creates a shape between them. An alphabet produces a large array of such spatial shapes. It's useful to begin with the most basic one: a rectangle produced by the first letter combination: two parallel verticals, such as any two letters of the "l" family. (Fig. 1) To achieve even spacing, a calligrapher views the spatial shape between two letters both as measurable distance and as spatial volume. Although these ways of viewing are mutually supportive, it's helpful to begin with the first.

Fig. 1 **Fig. 2**

Distance Training

How do you measure the space between letters? To help you with this, I have devised a method called "distance training." It uses a "distance ladder" and "target points"—each described below.

- **The distance ladder:** for measuring
 The "distance ladder" consists of sides—two vertical downstrokes—and rungs—horizontal bars. (Fig. 2) It's used to measure the space between the closest points of any two letters. Distance ladders enable you to find the start point of the next letter. (Fig. 2, red dot)

Fig. 3 Targets

- **Target points:** for sighting and taking aim
 "Targets," such as the start point, are actual or imagined marks. (Fig. 3) I introduce them as another aid for spacing. Joining letters gives you practice aiming at points and directing the tool. (Fig. 4)

Tool: 05 Pigma Micron **Paper:** large-grid, 1/4" (office supply stores) **Guidelines:** 4 squares apart

1. Set targets— start points for the multiline strokes—along the top line 1½ - squares apart. (Fig. 4)
2. Inhale and place the tool on the waistline at the first start point. Use a 3-count pattern; stop on "three."
3. On the "and," push to the second start point at the waistline. The inhale can be especially helpful in reaching this target. Let the target act like a magnet to draw the tool. Repeat.

Fig. 4

Distance Training: words

Tool: Pigma Micron **Paper:** large-grid and drawing/JNB
Guidelines: body height: 4 squares; ascender: 2 squares

1. Set start points 1½ squares apart for the word "lilt: on the ascender line for the "l," on the waistline for the "i," and between the ascender and waistline for the "t."
2. Place the tool at the first start point and write the word "lilt." (Fig. 5) Repeat twice for practice.
3. Now, write "lilt" on drawing paper while imagining the start points. (Fig. 6)

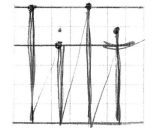 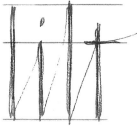

Fig. 5 (slightly reduced) **Fig. 6** (slightly reduced)

"The reference space": This term refers to the amount of space between the first two letters of a word. It establishes interletter spacing for the entire word. As you write a word, it's helpful to glance back to this space from time to time to help you keep it in mind.

Word as image

By varying the design elements in a word, you can create graphically expressive images. Explore spacing, size, stroke direction (e.g., curved), stroke type (e.g., multiline, single line), weight (relative "heaviness"/darkness), slope, and spirit (formal and playful). Begin by tracing the examples below as a way of loosening up and releasing creativity.

a direction: curved multiline strokes, **b** slope: constant,
c stroke weight: "heavy"/dark, **d** spirit: free movement,
e stroke quality: single-line option, **f** slope: variation,
g stroke type: lines adjacent rather than atop one another

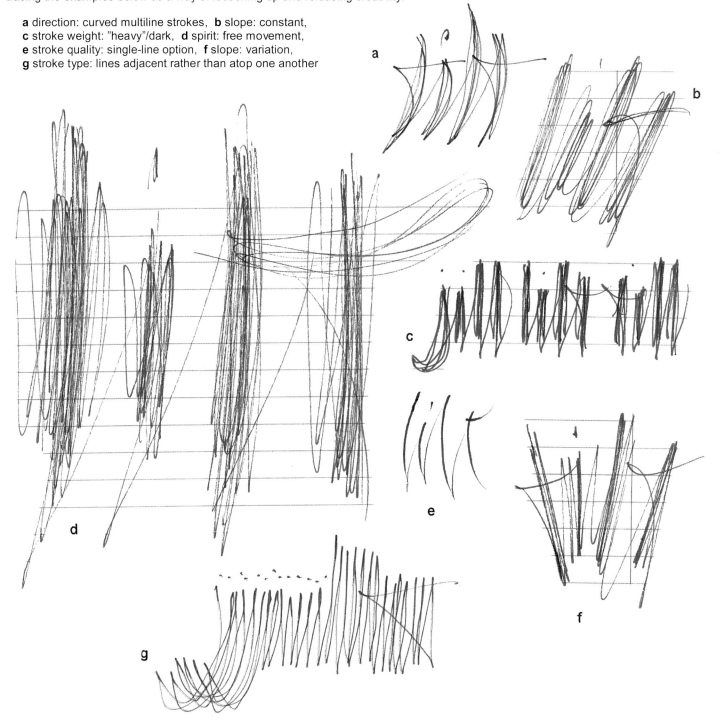

Word spacing

In word spacing as in letter-spacing, the aim is to make the space between words as similar as possible—about two letter spaces in this instance. Try thinking in terms of target points, placing them first as actual marks and then mentally.

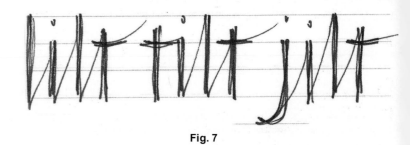

Tool: 05 or 08 Pigma Micron **Paper:** notebook
Guidelines: body height: 2 line spaces;
 ascender/descender: 1 line space

Fig. 7

1. Write the words shown in Fig. 7.
2. Write these words again with narrow and wide spacing. In this way, you begin to explore the plasticity of calligraphic space. (Fig. 8)

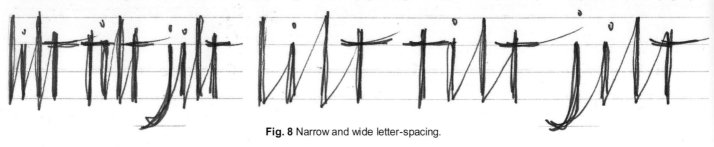

Fig. 8 Narrow and wide letter-spacing.

Note: Feel free to try all exercises at different speeds and sizes, with different one-point tools. Experiment with breathing as you write.

Letter Family 2: the "o" (oce)

Visual theme: the oval

The "o" family, with its open and closed oval bowls, provides the basis for letters with curved strokes. (Fig.1)

Fig. 1 A single-line version of Playball featuring the oval bowl of "o" and its related forms.

Letter Proportion

Letter proportion refers to an intrinsic facet of form: the relationship of width to height, commonly expressed as a ratio. For Playball, letter width is usually one-half letter height, 1:2. This is clearly demonstrated by a rectangular shape (Fig. 2) with the "o" family placed within it. (Fig. 3) The width and height of Fig. 2 are the same as the large red oval of Fig. 1. A rectangle not only provides a structural framework ("proportion frame") for the "o" family, but also for most lower-case letterforms. A change in the expressive quality of an alphabet can be made by changing letter proportion. (Fig. 4)

Counter: the shape/s of the space/s within a letter. (See the red shapes of Figs. 1 and 3.)

External counter: the shapes of the spaces outside a letter but within its proportion frame. (The red triangular shapes of Fig. 4.)

Fig. 2 **Fig. 3**

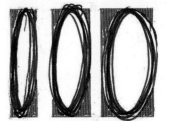

Fig. 4 Variations in the proportion of "o."

Ductus and Dynamics

Warm up with large, free ovals in both directions.

Tool: 05 or 08 Pigma Micron **Paper:** tracing vellum
Body: The shoulder stays active; the wrist holds steady.

First trace the single-line letters for direction, then the larger, multiline letters.

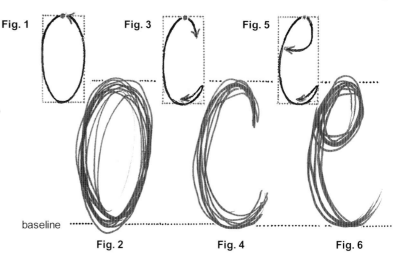

Fig. 1 Fig. 3 Fig. 5

baseline

Fig. 2 Fig. 4 Fig. 6

(o) 1. Place the tool at the red dot (Fig. 1) and inhale.
2. On the exhale, count "one" while throwing a downstroke counter-clockwise to the baseline.
3. On the inhale, count "and" while pushing a curved up-stroke, using less pressure, back to the waistline.
4. Repeat this pattern with a multiline stroke. (Fig. 2)

(c) 1. Place the tool at the red dot (Fig. 3) and inhale.
2. On the exhale, count "one" while throwing a short, curved downstroke to the right.
3. On the inhale, count "and" while retracing this stroke back to the waistline.
4. On the exhale, count "two" while throwing a downstroke to the baseline and into a saucer-like arc.
5. On the inhale, count "and" while retracing back to the waistline. Repeat with a multiline stroke. (Fig. 4)

(e) 1. Place the tool at the red dot (Fig. 5) and inhale.
2. On the exhale, count "one" while throwing an elbow bend for the "eye of e" (the small top bowl). Inhale on "and" to return to the waistline. Exhale and throw the "c" downstroke; inhale and retrace to the waistline on "and."
3. Repeat this pattern with a multiline stroke. (Fig. 6)

Width training: the proportion grid

The consistent proportion of a letter, its width to its height, establishes both individual identity and family member-ship. Horizontal guidelines provide targets for letter height; but, since there are no similar guidelines to assist with letter width, it's useful to draw proportion grids to develop your aim for letter height *and* width. (Fig. 7, red lines)

Tools: red and blue Pigma Microns **Paper:** drawing/JNB

1. Proportion grid (Fig. 7): 1) Rule two vertical lines, 10" in length, 1" apart, and 2) rule horizontal lines 2" apart within the verticals,
2. First oval: place the tool at the red dot on the top line and inhale deeply.
3. On a long exhale, throw three ovals to the count of "one, two, three" (no "ands"). Throw "four," but stop at the baseline. Since you're exhaling while doing the above, this needs to be done quickly.
4. Inhale; exhale and throw the next oval below, repeating the actions for the first oval.
5. As you continue down the grid, enjoy the rhythmical movement of this pattern.

Joining "o," "c", and "e": sighting start points

Joining letters, directing the tool from one to the next, helps develop an awareness of interletter space. The tool is in motion between letters, not just when shaping them.

Fig. 7 A proportion grid (1:2)

Tool: Pigma Micron **Paper:** tracing vellum and drawing/JNB **Guidelines:** 2" apart

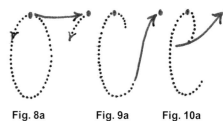

Fig. 8a Fig. 9a Fig. 10a

(o) Single line: Trace Fig. 8a using the breath pattern in "o" above. The join: exhale and pull a shallow arc to the start point of the next "o"; inhale to finish. Repeat.
Multiline (Fig. 8b): Throw a multiline "o"; inhale and sight the start point of the next "o"; exhale and join; inhale; and repeat.

(c) Single line: Trace Fig. 9a using the breath pattern in "c" above. After the shal-low arced base, inhale and push the join up to the start point of the next "c"; exhale.
Multiline (Fig. 9b): Throw a multiline "c"; inhale and sight the start point of the next "c"; exhale. Inhale and join; exhale and repeat.

(e) Single line: Trace Fig. 10a. using the breath pattern in "e" above. After completing an eye, inhale and push up to the start point of the next "e"; exhale.
Multiline (Fig. 10b): Throw a multiline "e"; inhale and sight the target, exhale and join; repeat a few times.

Fig. 8b Fig. 9b Fig. 10b

Spacing

Writing words with both the "I" and "o" families introduces the second basic letter combination: a straight vertical next to a curved stroke. (Fig. 1) This straight-curve combination creates a "half-hourglass" shape in contrast to the rectangle of straight-straight combinations. To distribute space evenly between such a shape, see below.

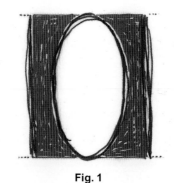

Fig. 1　　　　**Fig. 2a**　　　　**Fig. 2b**

Letter combination 2

- **The distance ladder**
 In the straight-curve letter combination, the distance ladder measures the distance between the straight and the point on the curve nearest to it: the "near" point. This ladder narrows to about half that of the first letter combination's. (Figs. 2a and 2b) This adjustment results from the external counters created by a curve sided letter. (Fig. 2b) Sighting a curved letter's start point is not as straightforward as sighting an adjacent straight. To find it, use the near point as a guide. (Fig. 2b, red dots between base- and waistline)

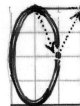

Fig. 3a Straight- curve　　**Fig. 3b**　　**Fig. 4a** Curve-straight　　**Fig. 4b**

- **Target practice 1:** sighting the near point
 In learning to space letters, the distance ladder for a straight-straight combination is the reference space for the distance ladders of the other letter combinations. For straight-curve combinations, the ladder gives the near point. From this point the eye curves up and over to the start point of the curved letter. (Fig. 3b) This exercise develops your ability to find start points via distance ladders and their near points. Figs. 3a and 4a illustrate straight-curve and curve-straight combinations. The dotted lines of Figs. 3b and 4b indicate the sight lines for directing the tool from the end of one letter to the near and start points of the next.

 Tool: 05 Pigma Micron　　**Paper:** tracing vellum

 1. Trace over the dotted lines of Figs. 3b and 4b. As you follow the arrows, note the path your eye takes from the end of one letter to the beginning of the next.
 2. Try to imagine the next letter as you move from one letter to the next.

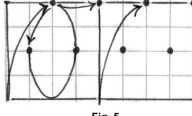

- **Target practice 2:** eye-hand coordination
 Learning to see the near point in your mind's eye is a challenging but important foundation skill. It begins with setting actual targets on grid paper. As your sighting develops, try to visualize them.

 Tool: as above　　**Paper:** large-grid
 Guidelines: 4 squares apart

Fig. 5

 1. Set targets (Fig. 5, red dots)
 a. start points: on the waistline, every two squares.
 b. near points: between the start points, two squares below.
 2. Place the tool at the first start point and pull a single-line downstroke to the baseline.
 3. Keep the tool on the paper and follow the arrow-tipped blue lines. (Fig. 5)
 4. Practice using the sight lines of Figs. 3b and 4b.
 5. Now do the same, but with multiline strokes. (Fig. 6)
 6. When you're ready, use the count and breath patterns to encourage rhythm.

Fig. 6

Word Spacing

In writing words, "the reference space" usually designates the space between the first two letters of a single word. However, we seldom write a single word. In writing a line/lines of words, the reference space also designates the space separating the first two words of a line—which sets the word spacing for the entire line.

 Tool: 05 Pigma Micron　　**Paper:** tracing vellum and notebook

1. Use a copy machine to enlarge Fig. 7 by 100%.
 Trace the words, working slowly and comfortably. Try to visualize target points—near and start points—to help with spacing letters and words.
2. Work freehand on notebook paper. Keep the shoulder engaged. Be aware of your breathing, but no need to have a definite pattern in mind.

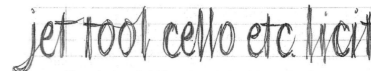

Fig. 7 (reduced). Additional words: "cool, ice, eel, tie."

Letter Family 3: the "a" (adgq)

Visual theme: oval + straight stroke
Combining an oval (the letter "o") with a straight stroke, introduces a new theme. (Fig. 1) Varying the height and direction of the down-and-up strokes creates four distinct letterforms—a, d, g, and q. (Fig. 2)

Juncture: Ovals are thrown to the left; straight strokes overlap the oval's right side. (Fig. 3)

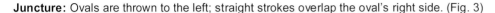

Fig. 1 Oval + straight

Ductus and Dynamics (oval to straight)

Tool: soft pencil **Paper:** tracing vellum **Breath:** Coordinate the down-up with the exhale-inhale.

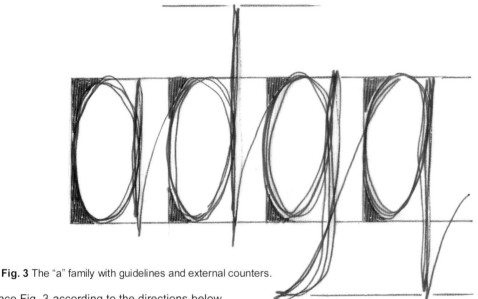

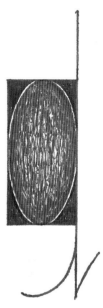

Fig. 2 "o" as the basis for four distinct letterforms.

Fig. 3 The "a" family with guidelines and external counters.

Trace Fig. 3 according to the directions below.

(a) Bowl and downstroke
1. Place the tool at the waistline to begin an "o." Throw an "o" counter-clockwise using the count pattern "one-and, two-and, three..." On the final "and" upstroke, follow the curve of the "o" to about midway and commence straightening as you move to the waistline.
2. At the waistline, throw a downstroke and use the count pattern as above.
3. On the final "and" join to "d."

(d) Bowl and ascender
1. Make the "o" in three counts as above.
2. On the final "and," swing up to the ascender line while straightening the stroke.
3. Throw a multiline "l." On the final "and" join to "g."

(g) Bowl and descender
1. Make the "o" in the counts as above. Break away to the waistline and make the "j" descender.
2. On the "and" following "three," join to "q."

(q) Bowl, descender and uptick
1. Make the "o" in the counts as above. Break away to the waistline and throw a multiline "l" to the descender line.
2. On the "and" following "three," swing upward in a short diagonal stroke.
3. Repeat the "a" family to develop and enjoy its rhythm.

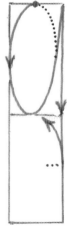

Fig. 4b

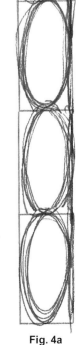

Width training: the proportion grid
All letters of the "a" family—oval plus downstroke—have the same proportion as the "o" family. (Fig. 4a)

Tool: Pigma Micron **Paper:** drawing/JNB.

1. Rule a vertical grid as above for "o" (p. 15). Make a multiline "a" using the count pattern.
2. On "three" of the straight downstroke, continue half a body height below the baseline. (Fig. 4b)
3. Release pressure and, on "and," spring up to the left—to the new waistline—to begin the next "a." Repeat the pattern a few times. Work slowly to start; build speed as you like.

Fig. 4a

Distance training without a grid

Review Letter combination 2, p. 16.

> **Tool:** soft pencil
> **Papers:** tracing vellum and drawing/JNB
> **Guidelines:** 2" apart

1. Trace Fig. 5, noting the near and start points in relation to the distance ladder.
2. Trace Fig. 6, remembering to sight the target points—the start point in joining to a straight, and the start and the near and start points when joining to a curve.
3. Work freehand on drawing paper.

Fig. 5:
Spacing the straight-curve combination: visualizing targets with a distance ladder.

Spacing

This spacing section presents the third basic letter combination: two adjacent curved strokes. (Fig. 1) This combination creates a full hourglass shape in contrast to the rectangle and half-hourglass. To distribute space evenly between these shapes, see below.

Letter combination 3

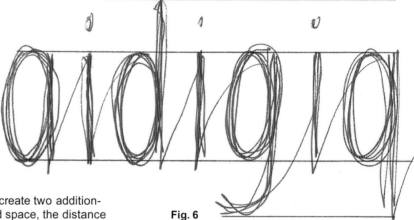

Fig. 6

- **The distance ladder**
 The two adjacent curves of this letter combination create two additional external counters. (Fig. 2) To balance this added space, the distance ladder again narrows by about half. Measure and compare this ladder with those for the two previous letter combinations.

- **Target practice 1:** sighting points
 This exercise uses visible targets—near and start points—to prepare for visualizing them. It is preliminary to using a distance ladder for the actual curve-curve letter combination. Read through the directions before you begin.

 > **Tools:** Pigma Micron (targets); pencil ("o"s)
 > **Paper:** tracing vellum, large-grid
 > **Guidelines:** 4 squares apart
 > **Speed:** deliberate

Trace the single and multiline Figs. 3 and 5. Fig. 4 illustrates the visualization of targets in relation to an anticipated form.

1. Place the tool at the first start point on the waistline and join to the next start point with a shallow arc. (Fig. 3)
2. Sight the near point on the curve—the red dot one square to the left and two down.
3. Aim and throw, completing the form and directing the tool to the next start point. Here, in completing the form, you also move through the near point of the next oval.

Now do this without tracing.

1. Set start points two squares apart on the waistline. (Fig. 3)
2. Set near points two squares below on alternate squares.
3. Throw multiline ovals. (Fig. 5)

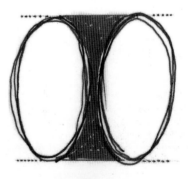

Fig. 1

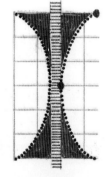

Fig. 2

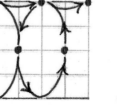

Fig. 3

Fig. 4

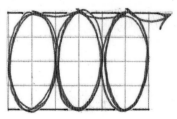

Fig. 5

- **Target practice 2:** visualizing the distance ladder

1. Prepare to make three single-line "o"s:
 a. Set start points on large grid paper two-and-a-half squares apart. (Fig. 6)
 b. Set near points between base- and waistline, one square to the left of each start point. (Fig. 6)
2. Make a single line "o." As you prepare to join to the next "o," try visualizing the letter and a narrow distance ladder to its left. (Fig. 7)

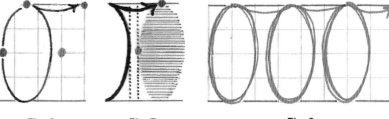

Fig. 6 Fig. 7 Fig. 8

3. In your mind, set a near point on the distance ladder to help guide you to the start point of the next "o."
4. Throw three multiline "o"s while visualizing target points. (Fig. 8)

Note: Remember to use the distance ladder as an aid to finding targets for spacing.

Line as image

First use "scats"— nonsense syllables usually accompanied by music—with your current repertoire of consonants and vowels. Focus on even letter spacing. (Fig. 9) Then write lines of words or divide the scat lines into "words." (Fig. 10)

Tool: Pigma Micron and/or 2B pencil (sharpened) **Paper:** drawing/JNB and/or notebook
Guidelines: drawing paper: ½" apart or notebook paper: two lines spaces apart **Speed:** open to experiment

Fig. 9 "Scatting" with letters

Fig. 10 Three-syllable "word" scats

Word spacing

1. Use the words in Figs. 11 and 12 to develop your spacing skills. First enlarge the examples by 100%. Then trace them as a way to practice sighting targets.
2. Write these or other words on your own. Try setting mental targets—end, start and near points—to help direct your strokes. Work slowly to let mind and body talk to each other.

Fig. 11
Letter combinations 1 and 2:
straight-straight
and straight-curve

Fig. 12 The above line contains the letter combinations 1 (straight-straight), 2 (straight-curve), and 3 (curve-curve).

Word as image

Reread "Word as image" (p.13) to reacquaint yourself with design elements. Try using a combination of them in one word. (Fig. 13) As this word shows, non-conformity need not produce illegibility, but adds a "visual "reading." In this example, the word image suggests the Dadaist protest against traditional artistic values by breaking "the rules" of the Playball alphabet.

Fig. 13 "dada"

Letter Family 4: the "b" (bp)

Visual theme: straight + oval
In this family, the oval follows the downstroke. (Fig. 1)

Ductus: Ovals are thrown clockwise and overlap downstrokes. (Fig. 2)

Ductus and Dynamics

Trace Fig. 2 using the directions below.

(b) Ascender and bowl
1. Throw the multiline downstroke from the ascender line using the 3-count pattern.
2. On the third downstroke ("three"), slightly exaggerate the weight before releasing and curving up toward the waistline on "and," and into the left side of the oval.
3. Slow at the waistline and throw the right side of the oval bowl ("one").
4. Continue to count: "and, two-and, three…" Finish the bowl at the baseline, easing up at the end of the "three…" count.
5. On "and" swing upward to the right to begin "p."

(p) Descender and bowl
1. At the waistline, throw a multiline descender as for the ascender of "b."
2. Retrace the stroke to the baseline and repeat the bowl of "b."

Practice joining ovals

Rhythm practice joining from bowl to bowl. (Fig. 3)
1. Place the tool at the waistline and throw a clockwise three-count multiline oval.
2. On the final "and" swing right and up to the start point of the next oval.
3. Continue throwing and joining clockwise ovals to develop a rhythm.

Word practice

Use the action of the above exercise to join from a bowl to a straight. (Fig. 4)

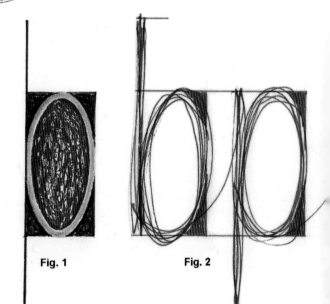

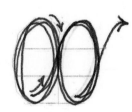

Fig. 3

Fig. 1

Fig. 2

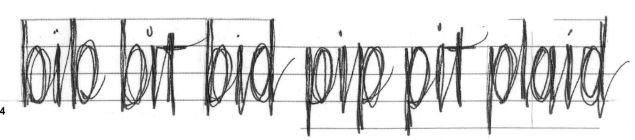

Fig. 4

- 2 adjacent straights,
are farther apart than

- straight and curve,
which are farther apart than

- 2 adjacent curves

Fig. 1 Relative distance creates even spacing.

Spacing review

Fig. 1 recaps the three basic letter combinations with their respective distance ladders. As an aid to spacing, the first purpose of the distance ladder is to help you see the relative distance between the basic letter combinations. The second purpose is to help you position target points as an aid to directing strokes.

"Text block"

In this exercise you practice making similar spaces between the three basic letter combinations without the demanding details of letterform. Here you use the strokes and shapes of letterform as the abstract elements of a visual pattern. (Fig. 2) Combining letter-like lines and shapes into a "text block" trains your viewer's eye apart from your reader's eye. This helps prepare you for making actual text blocks.

> **Tool:** soft pencil
> **Paper:** tracing vellum, drawing/JNB
> **Guidelines:** body height: 1";
> interlinear space: 1/8"
> **Speed:** slow and deliberate

Trace Fig. 2 twice:
1. Focus on arm-shoulder motion while making the strokes.
2. Focus on visualizing the distance between letters with the help of distance ladders and target points.
Freehand patterns: Make a few lines of the basic oval and straight combinations. Whichever combination you begin with becomes the reference space for those that follow.

Letter and word spacing

Now apply the above practice to actual letters and words. (Fig. 3) Use a tool of your choice.

1. Write words, but don't separate them. Focus on interletter space. Use letters from your current repertoire.
2. Rewrite the words as separate words. Focus on making the space between them as similar as possible.

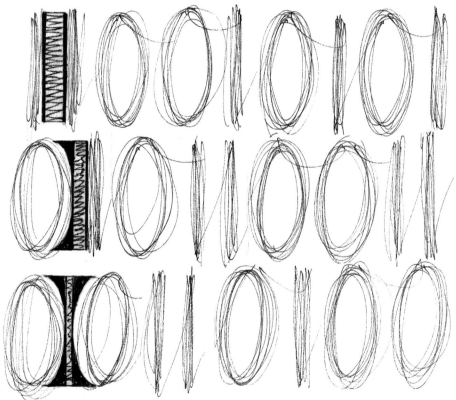

Fig. 2 "Text block."

Fig. 3 More suggested words: bib, babel, pod, pep, beep, bop, pal, blade, dab, lap, tadpole

Alphabet Family 5: the "n" (nmh)

Visual theme: straights and arches

The top of an oval combines with two vertical supports to become the arch for the letters "n, h, and m." (Fig. 1) Set within a proportion frame, this arched counter creates one external counter. (Fig. 2)

Ductus and Dynamics

Trace Fig. 2 according to the directions below. **Tools and paper:** as for the "a" family.

(n) Downstroke and arch
1. Place the tool at the waistline.
2. For the first multiline straight use the "l" pattern counting "one-and, two-and, three..."
3. On "and," inhale and spring up to start the arch, continuing to the waistline.
4. At the waistline, count "one" as you exhale and complete the arch and downstroke. (You are now at the baseline.)
5. On "and," inhale and spring up, retracing the arch counter-clockwise to the waistline.
6. Count "two" and exhale as you complete the arch and vertical.
7. On "and," inhale and retrace the left side of the arch.
8. On "three," exhale and retrace the right side of the arch.
9. On "and," inhale while swinging up to the right to begin "m."

(m) Downstroke and two arches
1. You are now at the waistline, ready to start the "m."
2. Repeat breath and ductus for "n" to create the first arch of "m."
3. On the "and" following "three," make the second arch. Take a deep inhale and join to "h" at the ascender line.

(h) Ascender and arch
1. Place the tool at the ascender line, ready to start the "h."
2. Use the same breath and ductus pattern as in "n," only beginning with an ascender.

Arcade

An "arcade" pattern, with its series of supported arches, is here used for practicing the spring-like action of the "n"-family arch.
1. Rule notebook paper, 3-4 line spaces. Begin the arch at the baseline and follow the count pattern for the arch of "n." (Fig. 3) Focus on moving rhythmically.
2. Large grid, 2 squares by 4 (Fig. 4). Make an arcade as before, this time focusing on proportion.

Letter and word spacing

Write words using the "n, l, a, and o" families. (Fig. 5)

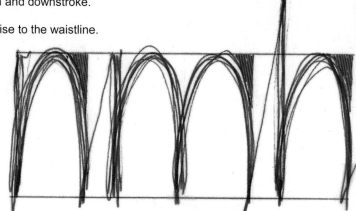
Fig. 1 The arch

Fig. 2 The "n" family with guidelines and external counters.

Fig. 3 **Fig. 4**

Fig. 5 nomad moment hint

Spacing

Here, we back up to consider what determines the reference space. The key is in the width of an alphabet's two-sided letters, such as "h." The importance of this topic is seen in the figures below: Fig. 1a "reads" best with the distance between straight-sided letters a little less than half-letter width; in Fig. 2a, extreme reduction in interletter space diminishes legibility, as does the exaggerated interletter spacing of Fig. 3a. Compare the internal counters (blue shapes) with the interletter space between them. (Figs. 1b, 2b, 3b, red shapes)

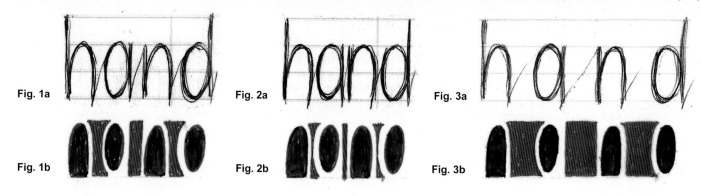
Fig. 1a **Fig. 2a** **Fig. 3a**

Fig. 1b **Fig. 2b** **Fig. 3b**

Investigating space

Use three different "settings" to explore letter width as the determining factor for the reference space. (Figs. 1a, 2a, and 3a, p. 22). Try starting with the extremes—too close and too far—and finishing with "just right."

> **Tool:** Pigma Micron **Paper:** drawing/JNB **Guidelines:** body height, 1" **Speed:** deliberate

1. Write a word that begins with a two-sided letter such as "h" or "a." Use the first counter space as the reference space. Suggested words: animal, banana, piano, time, landing, analog.
2. Write a word that begins with two letters of the "l" family. Suggested words: limelight, jingle. Here, the two vertical straights become the reference space. But finding the distance between them without reference to a two-sided letter, as above, is challenging. It develops in time.

Note: The single external counter of "n" family letters adds a little more space between letters. To balance this additional space, narrow the distance ladder slightly.

Fig. 4

Alphabet Family 6: the "v" (vwxyz)

> **Visual theme:** diagonal straights and triangular counters (Fig. 1)
>
> **Proportion:** The "v" is slightly wider than Playball's 1:2 proportion frame. (Fig. 1)

Ductus and Dynamics

Trace Fig. 2 according to the directions below. Here, the point at which the last upstroke of "v, w, x, and y" ends, also begins the next letter. (Fig. 2) Use the 3-count pattern for rhythm. Make more throws (4-count, 5-count…) if desired, as in Fig. 2.

(v) Diagonal downstroke and upstroke
1. Place the tool at the waistline; throw a multiline stroke counting "one-and, two-and, three…."
2. On the final "and," change direction and make the right diagonal upstroke.
3. Repeat the count pattern "one-and, two-and, three-and" for the upstroke. Pause.

Fig. 1 The triangle as internal and external counter.

(w) At the waistline, begin the "w." Make two overlapping "v"s. Pause.

(x) Crossing diagonals
1. At the waistline, throw the first diagonal of "x" a little farther right than for "v." (Too far to serve as the first diagonal of "v.")
2. Use the same stroke count pattern as above.
3. On the final "and," lift the tool and move directly up to the waistline and a pinch to the left. (Fig. 2, red dotted line)
4. Throw a left diagonal and finish at the waistline. Pause and begin the "y."

Fig. 2 The "v" family with guidelines.

(y) The "y" differs from "v" only in having a descender. On the final "and" of "y," lift and replace the tool a little to the right below the waistline.

(z) Two horizontals and a diagonal
1. Push the top, upward tilted horizontal counting "one-and, two-and, three…"
2. On the final "and," pause in place and prepare for the downward diagonal.
3. On "one," throw the diagonal with the above count pattern.
4. Use the final "and" as a brief pause at the baseline.
5. Push the lower, upward tilted horizontal and finish on "three."

Fig. 3 Larger and smaller zigzag.

Zigzags: Make a line of "v"s. (Fig. 3) Focus on changing direction and making similar counters similar. Change size and speed.

Letter and word spacing (Fig. 4)

Practice moving from diagonals to straights and curves. Note the very short horizontal joins from the final diagonals of "v, w, x, and y."

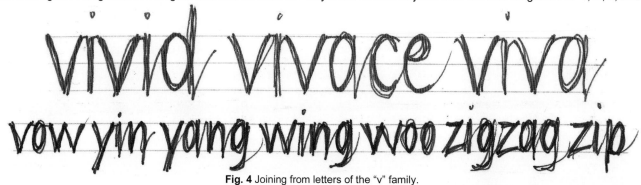

Fig. 4 Joining from letters of the "v" family.

Spacing

We next explore the second approach to spacing: one based on seeing interletter spaces as shapes with volume. (Figs. 1 and 2) This allows the calligrapher to compare the act of interletter spacing to that of filling a container. (Fig. 2) While this method complements and builds on the distance training of ladders and target points, it is more intuitive.

Fig. 1 Interletter space as shape **Fig. 2** Interletter shape as volume

Space as a "glass of water"

In his book *Love and Joy About Letters*, artist Ben Shahn describes his breakthrough with spacing:

> Then [my teacher] shared with me the secret of the glass of water. "Imagine," he said, "that you have a small measuring glass. It holds, of course, just so much water. Now, you have to pour the water out of the glass into the spaces between the letters; and every one has to contain exactly the same amount—whatever its shape. Now try!"
>
> That was it; letters are quantities, and spaces are quantities, and only the eye and the hand can measure them. (p. 13)

The conversion table: interletter shapes—volumes— in relation to distance ladders. (Fig. 3)

Shape 1 (a vertical rectangle): straight + straight
Shape 2 (half an "hourglass"): straight + curve
Shape 3 (an "hourglass"): curve + curve

Triangular spatial shapes 1

For spacing, the "v" family doesn't depend significantly on distance conversions, but goes directly to shape: the triangle and other shapes that are not so easily defined. (Fig. 4) In this exercise, try to imagine these shapes as containers, each holding the same amount of water.

Tools: black and colored Pigma Micron
Paper: drawing/JNB
Guidelines: ½" - 1" (body height)

1. Use words with closed bowls.
2. Omit space between words.
3. Write words and color in the spatial shapes between them. (Fig. 4)

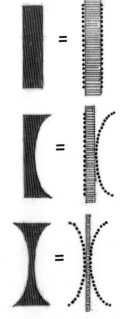

Fig. 3 Conversion table

Fig. 4

Triangular spatial shapes 2

Consider the spatial shapes that form when the "v" family letters combine with verticals and curves. (Fig. 5) Compare them as volumes with those of the "o" and "l" letter combinations. (Fig. 6)

> **Tools:** black and red Pigma Microns
> **Paper:** tracing vellum and notebook
> **Guidelines:** body height for notebook paper,
> 2 line spaces; for drawing paper, 5/8"

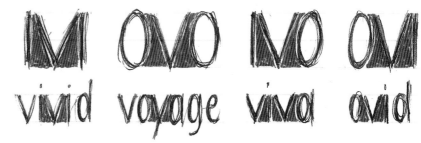

Fig. 5

1. Trace all the combinations, first throwing the multiline strokes in black.
2. Then fill the shapes they create in red. As you color, imagine you are making 3-dimensional shapes that, if they were drinking glasses, would contain the same amount of water.
3. Write words containing such letter combinations as (Fig. 5):
 a. vertical + "v" + vertical:
 playing, dawn, divide, lyre
 b. curve + "v" + curve:
 glove, shovel, oval
 c. vertical + "v" + curve:
 divan, travel, awe, axel, weave
 d. curve + "v + vertical:
 bovine, town

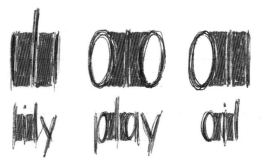

Fig. 6

Alphabet Family 7: the "**hybrids**" (skufr)

Visual theme: diversity

In Playball, the letters of this family share a kindred spirit rather than a specific trait. Each letter displays shapes from one or more of the previous families. (Fig. 1) Alphabet styles usually contain such a letter group.

Fig. 1 "s": juxtaposed ovals + diagonal
 "k": vertical + eye of "e" + diagonal
 "u": baseline arch
 "f": entrance to "c" + vertical + crossbar of "t"
 "r": vertical + partial arch of "n"

Proportion

"s, f, and r" are slightly narrower than the basic 1:2 ratio of Playball.

Fig. 1

Ductus and **D**ynamics

Trace Fig. 1 according to the directions below. Note the slight difference in the count pattern for "w" and "f."

 Tools and paper: as for the "a" family

(s) 1. Begin the "s" as a "c," at the waistline. (p. 15)
2. Throw the body of "s" on "two"; pause and retrace on "and."
3. Count to "six" using this pattern. On the final "and," after "six," join to the ascender of "k."

(k) **Ascender, loop and diagonal downstroke**
1. At the ascender line, throw an "l" with the count pattern "one-and, two-and, three…."
2. On the final "and," spring into the arch of "n" to the waistline.
3. Use the 3-count pattern to complete the eye of "e": On "one," continue over and around to make the eye, finishing at the ascender. On "and" retrace the entire loop counter-clockwise. On "two," retrace the eye again. Repeat this loop action through "three-and"
4. Throw the diagonal with a count pattern of "one-and, two-and, three…."
5. On the final "and" join to "u."

Fig. 1

(u) **Underhand arch and downstroke**
1. From the waistline, throw an arch in a "u"—down to the right and up to the waistline—on "one"; retrace on "and." Count up to "three." (You are at the waistline.)
2. On the "and" following "three," pause briefly. (Apply a little more weight on the downward action than the upward.)
3. Throw the "i" stroke with the 3-count pattern. On the final "and," join to the top of "f" at the ascender line.

(f) **Downstroke, top, and crossbar**
1. From the ascender line, make the short, downward curve to the right on "one," and retrace on "and" (as for "c").
2, On "two," throw the vertical downstroke; on the "and," retrace to the ascender line.
3. Using this pattern, count to "six…"
4. On the "and," follow the directions for the crossbar of "t" (p. 12). On the last horizontal sweep, join to the "r." At the start of "r," pause briefly while counting "and."

(r) **Downstroke and ear**
1. From the waistline, throw the multiline stroke to the count of "three…"
2. On the final "and," spring up and make a partial arch, short and shallow, ending a little below the waistline.
3. Retrace and finish on "three-and."

"She sells seashells… by the south side of the seashore." Practice the "s" with this tongue twister. (Fig. 2)

 Tool: pencil and/or Pigma Micron
 Paper: notebook paper
 Speed: deliberate

Joining from "r"

In joining, the ear of "r" shortens a little before dipping slightly and continuing into the next letter. (Fig. 3) Practice the "r" followed by vertical and diagonal straights, and curves.

 Tool: Pigma Micron **Paper:** tracing vellum **Speed:** deliberate

First trace Fig. 3; then write the following freehand:
1. Words beginning with "r"—ride, roof, red, rose, rare, rake
2. Words containing an "r"—bridge, crow, crepe, crawl, stars

Fig. 2

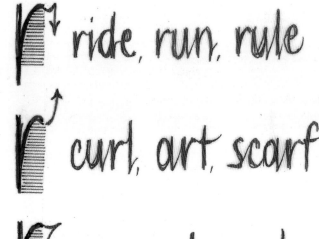

Fig. 3

An alternative "k" join
Try this join: the diagonal continues into the letter bowl. (Fig. 4)

Joining from "k" and "r"
To keep interletter spacing similar in words with "k" and "r," curb the tendency to swing too far to the right. (Fig. 5) The letters "k" and "r" only require a slight amount of additional space in letter combinations. (Fig. 6)

1. Write a few of the words below, letting the hand move as it will. (Fig. 5)
2. Rewrite these words, exercising restraint and following the methods of even spacing. (Fig. 6)

koala kangaroo

Fig. 4.

Fig. 5 *kaleidoscope skirt kinetics ocean*

Fig. 6 *kaleidoscope skirt kinetics ocean*

Spacing and Legibility
Letter spacing governs legibility; words break down when their interletter spaces aren't even (similar). To produce even, legible spacing, remember to use target points to help direct strokes. Read the lines in Fig. 1 aloud to better appreciate the difference between uneven and even spacing.

the movie was mo no to nous.
the movie was mon oto nous.
the movie was mono ton ous.
the movie was monotonous.

Fig. 1

- **Fine tuning:** spacing open letters and bowls
As a general rule, any letter following an open letter ("s," "x," and "z") or open bowl ("o" and "c") is placed more closely to it to compensate for the openness. (The letter may also be slightly narrowed, see "plasticity" below.) Nonetheless, the interletter space usually appears slightly greater than the reference space. This additional space helps preserve letter identity and enhance legibility, but it's not enough to break a word's visual coherence. Spacing these letters takes practice. Start by tracing Fig. 2 to get the idea.

Fig. 2 Open and closed bowls

- **"Plasticity"**
Here, plasticity refers to the inherent nature of the calligraphic stroke: a responsive, living line, one capable of stretching or contracting to accommodate artistic needs as well as those of legibility. This hallmark of calligraphy distinguishes it from type, which can adjust interletter space (kerning) but not the letters themselves.

To use plasticity in the act of writing requires alertness— completing one letter while being aware of the one that will follow. Trace the examples in Fig. 3 to learn what parts of these letters can be adjusted without damage to their identity. Working with these subtle adjustments helps develop both your eye and your hand.

Fig. 3 "tides"— the bases of "e" and "s" contract, as does the top of "s"
"keys"— the base of "s" stretches and the top contracts
"lacy"—the base of "c" stretches and the top contracts

Plasticity and spacing

Tool: 05 Pigma Micron **Paper:** drawing/JNB and/or notebook
Guidelines (body height)**:** drawing paper, 5/8";
 notebook, one or two line spaces

1. Write words with the open letters "e, c, s, x, and z." Suggestions: ocean, boxing, hazy, knock, cheese.
2. Write words with "t and f." Make the crossbars long enough to maintain letter identity but short enough to create interletter spaces similar to the reference space. (Fig. 4, top words, too much space) When one of these letters begins a word, and there is no visible reference space, similar to spacing "l" family letters, it's more challenging. To practice, rewrite until the letters are evenly spaced.
3. More plasticity with "r." As already seen, the ear of "r" can be shortened; it can also be raised slightly to help reduce space, particularly between "r" and "y." (Fig. 5)

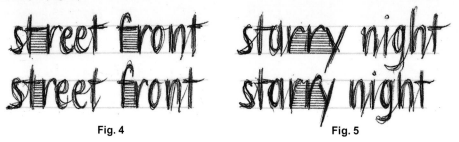

Fig. 4 Fig. 5

More spacing

Tool: 05 Pigma Micron
Paper: tracing vellum, drawing/JNB and notebook
Guidelines (body height)**:** drawing paper, 5/8";
 notebook, one or two line spaces

1. Place tracing vellum over "kaleidoscope" and trace the word. (Fig. 6)
2. Now write the word independently on drawing or notebook paper.
3. Compare your traced and freely written versions of kaleidoscope. Check to see whether the interletter spaces are similar or whether any show too much/too little space. If so, write again and make adjustments.

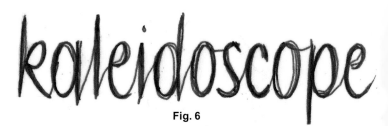

Fig. 6

More practice
Write more words from the "skufr" family below. Make any adjustments needed to produce even spacing.

s kirt, shrink, skunk, skiers, shuckers

k isser, kinesthesia, kohlrabi, kale, karma

u seful, universal, union usury, upstart

f ruit, fructose, floss, first, flutes, funk, flask

r ucksack, rickshaw, rosebushes, rusty, rye

Fig. 7

Single line Playball
Write a few of the above words using a single line version of Playball. Try to visualize the spatial shapes as you write. Color the interletter shapes to contrast with the writing. (Fig. 7)

Fig. 8

Joining "k" and "s"
A suggestion for this spacing challenge: continue the diagonal of "k" into "s" (Fig. 8). Trace and freehand the "k-s" letter combination.

Congratulations!
You have now completed the lower-case Playball alphabet.
(Since it was not intended for writing texts, an alphabet of capital letters does not follow.)
I hope Playball has helped you find pleasure in moving a tool and to develop skill in directing it.
Try the bonus exercise on the next page.

Fig. 1 Playball proportion frame, 1:2

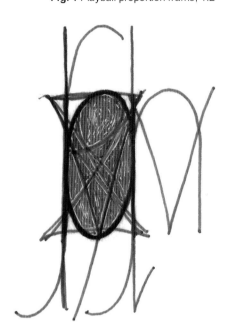

Playball: An alphabetic workout

In this exercise, throwing the letters of Playball on top of each other ("layering") becomes a warm up. It can be practiced as a physical workout to loosen up and/or as a meditation in motion. The calligrapher's "diamond" is a rectangular proportion frame. Legibility is clearly not the purpose; rather, the letters are patterns for directed bodily movement and attention. Another baseball analogy also applies: a ballplayer loosening his shoulder with large over- and underhand rotations.

> **Tool:** Use the prototool, or a hand-held tool of your choice.
> **Paper:** Your choice of paper, or other surface.
> **Size:** Let this be a reflection of your particular state of mind, mood, intention, and/or time constraints. Use it as a time for exploration, renewal, or energizing.

1. **Set up:** Make a rectangular proportion frame. (Fig. 1) If your aim is to get the kinks out, make it large (body height, 8-10 inches). You might try placing your paper vertically and work standing up or seated to face it squarely.
2. **Stroke:** Whether you choose a multi- or single-line version also depends on mood, intention, and/or time constraints. (Figs. 2 and 3)
3. **Pattern:** Spatially, one letter lies over another using the proportion frame as a framework; in time, one letter follows another in a continuous flow, interrupted only by pauses for changes in stroke direction.
4. **Alternate metaphor:** Rather than baseball, consider water ballet. Here you imagine the tool, and by connection, the whole arm, pushing through water as it makes contact with the paper. Let imagined resistance help sensitize you to the actual.

Fig. 2 Single-line version of Playball

Elements to consider in your workout

Suggestion: Try focusing on one of the elements below for a few letters, and then take up another for a few letters; or, focus on one for the entire alphabet.

- Breathing: The three phases of the breath—inhale, pause, and exhale—again coordinate with stroke direction and focus the mind.
- Action: Calligraphic movement is not only the vigorous thrusting of downstrokes. The upstroke, for example, may be driven upward in a swan-like glide.
- Rhythm: This develops with sensitivity to the breath and alternations in weight.
- Speed: The pace is deliberate to begin—slow enough to explore timing and orient the action to the proportion frame. As the alphabet continues, feel free to pick up the pace, to use speed as an expression of your mood.

Fig. 3 Multiline Playball

Introduction to
stroke тechnique: calligraphic "dynamics" .

Writing results from contact: the interplay of body and tool upon a surface. It has calligraphic potential when you take the *quality* of contact seriously. This develops through the basic unit of calligraphic letterform, the stroke. Through stroke exercises you engage all facets of contact by bringing awareness to the body's role in perceiving and channeling pressure, pulling, and pushing. Through these dynamics, you begin to distinguish between the complementary roles played by the shoulder and fingers. Sensitization to their muscular, tactile and kinesthetic feedback promotes the discovery of calligraphic rhythm and gesture. This creates the living stroke—the foundation of calligraphic letterform—and prepares you to express your own vitality.

But what is a "living" stroke? To a calligrapher it's one that expresses energy, movement, and feeling. In particular, it's represented by the tensile elasticity of a taut stroke. How does a calligrapher create such a stroke?

Elasticity and calligraphy
The elasticity of a taut, living stroke develops from the pressure of contact: from consciously applying physical pressure upon a tool and creating resistance as you direct it. The trick is to engage the resistance; the first step, to physically experience tensile elasticity. Try the experiment below.

Rubber band "stretch" experiment
1. Place a sturdy rubber band between the index fingers of each hand.
2. Hold one end of the band to the edge of a table to anchor it.
3. With the free hand, stretch the band slowly away from the anchor point. Close your eyes and focus on the sensation of pulling and stretching.

The second step in developing a living, elastic stroke is experiencing tool contact as applied bodily pressure. The following "getting the feel" exercises provide an introduction. They feature a relaxed body-mind, the spirit of exploration, and the pleasure of play. They also prepare you for the second training alphabet, Jumprope.

When we use a tool, like a shovel, we can perceive tactile events at the working end of the tool almost as if our fingers were present there…even though your hands are far away from the contact point. Furthermore, with practice, our ability to interpret this kind of long-range touch information improves. In this way, the violinist's bow, the surgeon's scalpel…become sensory extensions of the body.

Touch: The Science of Hand, Heart and Mind
by David J. Linden

Pressure and Release

The hallmark of calligraphic art is its energetic, expressive stroke. This develops through the skillful application and release of pressure. We focus first on even pressure: exerting a steady, consistent amount throughout the stroke. (Fig. 1) Next, on uneven pressure, which distributes the pressure and its release within the stroke. (Fig. 2) These pressure-release patterns help you energize the stroke, enhance your control, and promote your enjoyment of stroke and letter making. The following exercises help sensitize you to the all-important feedback of contact—tactile and kinesthetic—from the shoulder, arm and fingers.

Introducing the Conte crayon: This tool is particularly well-suited to sensitization training. Like the pencil, this soft, one-point tool visually reflects differences in physical pressure. (Fig. 3) In addition, however, its composition of graphite and wax or clay gives this tool a more abrasive action than graphite-only pencils. This heightens the resistance of contact. The tool seems to "bite," or grip, the paper as it moves. The intensified feedback it sends to muscles and fingers also heightens the calligrapher's moment-by-moment experience of the stroke—the better to maintain concentration. Of the variety of colors it comes in, I recommend the "Sanguine" and "Sepia" because they seem to have more bite.

Weight: The relative "heaviness" (darkness/lightness) of a stroke/letter. With the Conte crayon visual weight corresponds directly to physical weight (pressure): the greater the pressure, the heavier stroke.

Tool prep: Prepare the tip as for graphite pencils, with this caution. Since its marking material breaks a little more easily than pure graphite, shave the wood away slowly and expose a bit less of the crayon.

History: Conte crayons were invented in 1795 by Nicolas-Jacques Conte in response to the shortage of graphite caused by the Napoleonic Wars.

Fig. 1 Fig. 2

Pressure: getting the feel

Begin by getting acquainted with your body exerting itself: with sensing the weight of the shoulder and arm on the tool. At the start, exaggerate: How forceful can you make the mark without "carving" the paper or breaking the crayon? How delicate can you make it and still feel some resistance? The pleasure of "just right" ultimately depends upon your purpose and comes with experience.

Fig. 3

> **Tool:** Conte crayon—"Sanguine" **Paper:** drawing/JNB **Body:** shoulder, arm, and hand
> **Speed:** slow and deliberate
> **Padded surface:** This is essential to receiving the signals from pressure. Use the tablet of paper or a number of sheets from it. (You may wish to tape these to a board.)

- Make a heavy and a light stroke: the first with as much pressure as possible, the second with as little as possible.
- Now try to create strokes showing a spectrum of gradations in weight. (Fig. 3) Start with three lines and increase up to six—the greater the number the greater the challenge.
 1. Stroke one
 a. Place the tool on an inhale. On an exhale, apply pressure: sink the weight of the shoulder and arm onto the tool; pull it downward, slowly, 1-2 inches in length.
 b. On the inhale, release pressure, lift the tool and move to the next stroke. Keep the strokes close together. Keep the pressure steady and even. To help direct the stroke, sight an end point and pull the tool, as through a viscous medium such as water, to reach it.
 2. Make subsequent strokes with less pressure. Note: Experimenting with varying degrees of pressure helps you develop a feel for the sensation of moving a tool with resistance—pulling a stroke.

Even pressure: getting the feel

Practice with pulling begins with a steady, even pressure: applying a similar amount to the entire length of the stroke. In a calligraphic context, you pull a tool when you move it downward, toward a target point. Here, pulling is synonymous with stretching and elasticity. It's helpful to begin by using the prototool. Note: Even pressure produces even weight (darkness/lightness).

> **Tools:** Pigma Micron for targets; Conte crayon for strokes **Paper:** large-grid
> **Padded surface Speed:** slow and deliberate **Body:** shoulder-arm focus

- **Step one:** Along a vertical, set 6-7 target points every fourth square. (Fig. 4)
- **Step two:** pulling vertical strokes with even pressure
 1. Place the prototool/Conte crayon at the start point and inhale.
 2. On the exhale, sink into a comfortable amount of pressure and pull the stroke to the second target—keeping the pressure steady and even.
 3. Inhale and release pressure.
 4. Repeat the stroke: exhale-sink-pull. With each stroke, experiment with the amount of pressure needed to feel a pull. Find the rhythm of combining the breath with movement.
- **Step three:** pulling diagonal strokes with even pressure
 1. Add targets one square to the right of the line, midway between start-end points. (Fig. 5)
 2. Pull diagonal straights, pausing at each target to take aim at the next.

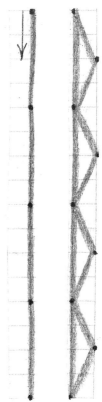

Fig. 4 Fig. 5

This sand drawing is a variation of start pressure: maximum intensity is reached a little after contact.

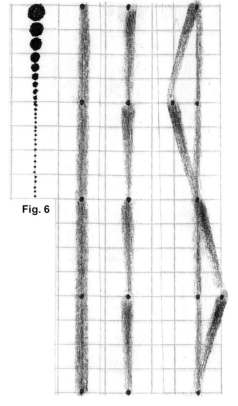

Fig. 6

Fig. 7 Fig. 8 Fig. 9

Uneven pressure: start pressure

Using start pressure, you exert the greatest amount of pressure early in the stroke. (Fig. 6) It's helpful to think of it in two phases—leaning in and pushing off. For the leaning in you push down (lean) forcefully from the shoulder. For the pushing off you use the energy of releasing pressure to propel the rest of the stroke. It's like the release of a spring after compression.

Getting the feel: strokes
Use your shoulder as the source of exertion and direction. Use the pressure of contact as a ground for pulling strokes.

> **Tools:** Pigma Micron, Conte crayon
> **Paper:** large-grid
> **Padded surface**
> **Speed:** slow and deliberate

1. Warm up: throw the tool down and up a few times to activate the shoulder and relax.
2. Make three rows of targets set 1" apart along vertical lines. (Figs. 7 and 8)
3. First line: Pull strokes with even pressure (inhale; exhale-sink-pull). (Fig. 7)
4. Second line: Pull strokes with start pressure (Fig. 8):
 a. Inhale and place the tool at the start point.
 b. The exhale includes leaning in and pushing off. First, move quickly into pressure (leaning in); then, release it as you pull the stroke with decreasing pressure (pushing off). Repeat, working rhythmically.
5. Third line: Pull strokes with even and start pressure (Fig. 9):
 a. Set targets 1" apart along a vertical and pull strokes with light, even pressure.
 b. Set targets one square to the left of the first stroke's end point and one square to the right of the third stroke's end point.
 c. Pull diagonals using start pressure. Note the visual expression of this pressure pattern: the stroke changes from heavy to light, becoming narrower and lighter as pressure decreases, producing a change of weight within a stroke.

Getting the feel: starbursts (Fig. 10)

> **Paper:** drawing/JNB (approximately 8" x 10" in size)

1. Place the tool in the approximate center of the paper.
2. Pull strokes with start pressure radiating a short distance from the center. Note: Pulled strokes are rooted in throwing: in its energy and directed aim.
3. Try stretching strokes of different lengths in the release phase of start pressure.

Fig. 10

Uneven pressure: center pressure

Using center pressure, you exert greater pressure in the middle of the stroke. (Fig. 11) The action of leaning in and pushing off also applies to center pressure. It differs in the distribution of pressure: here, the distance toward and away from maximum pressure is similar. Visually, the stroke changes in weight: becoming darker and thicker as it moves toward stroke center; lighter and narrower as it moves away from it.

Getting the feel: vertical and diagonal strokes

Tools, paper, padded surface, and speed, as above

1. Warm up: as on the previous page.
2. Make three rows of targets set 1" apart along vertical lines. (Figs, 12, 13, and 14)
3. First line: Pull strokes with even pressure (inhale; exhale-sink-pull). (Fig. 12)
4. Second line: Pull strokes with center pressure (Fig. 13):
 a. Inhale and place the tool at the start point.
 b. Exhale and pull the stroke with increasing pressure to the first target.
 c. Push off with a steady decrease in pressure to the next point. Repeat.
5. Third line: Pull diagonals with center pressure (Fig. 14):
 a. Set targets 1" apart along a vertical and pull strokes with light, even pressure.
 b. Set targets one square to the left of the first stroke's end point and one square to the right of the third stroke's end point. (Fig. 14)
 c. First diagonal: Pull with increasing pressure to the left target; second diagonal: push off with decreasing pressure to the right target. Repeat.

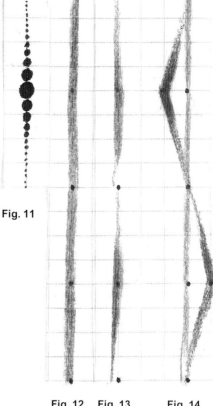

Fig. 11

Fig. 12 Fig. 13 Fig. 14

Uneven pressure: end pressure

Using end pressure, you gradually exert pressure from the start of a stroke to its end. (Fig. 15) You have already begun to practice it as the leaning-in action of center pressure. Visually, the stroke increases in weight (darkness/heaviness).

Getting the feel: vertical and diagonal strokes

Tools, paper, padded surface, and speed, as above

1. Warm up: as above.
2. Make three rows of targets set 1" apart along vertical lines. (Figs. 16, 17, and 18)
3. First line: Pull strokes with even pressure (inhale; exhale-sink-pull). (Fig. 16)
4. Second line: Pull strokes with end pressure (Fig. 17):
 a. Inhale and place the tool at the start point.
 b. Exhale and pull the stroke with increasing pressure (shoulder) to the first target. Release and inhale in place. Repeat the pattern.
5. Third line: Pull diagonals with end pressure (Fig. 18):
 a. Set targets 1" apart along a vertical and pull strokes with light, even pressure.
 b. Set targets one square to the left of the first stroke's end point and one square to the right of the third stroke's end point. (Fig. 18)
 c. First diagonal: Inhale and place the tool. Exhale and pull to the left target with increasing pressure; inhale and release pressure.
 d. Second diagonal: Exhale and pull to the next target with increasing pressure. Inhale and release. Repeat the pattern.

Fig. 15

Fig. 16 Fig. 17 Fig. 18

Getting the feel: Sparklers (Fig. 19) **Paper:** drawing/JNB (at least 8" x 10")
1. Place the tool in the approximate center of the paper. Throw large arcs clockwise and use end pressure. (Fig. 19) Make this a vigorous gesture.
2. Play with the number of strokes in the sparkler.
3. Make smaller sparklers.

"Press-release": pressure points

For stroke entry or exit—making or breaking contact—pressure is applied and released as a single concentrated point. The tool pushes down and springs up in place. (The image of a pogo stick, though exaggerated, gives the idea.) As a start or end point, press-release, whether energetic or subtle, allows you the time to sight a target and take aim in preparation for making a stroke. (See "Pulsing," page 62, for another use of press-release technique.)

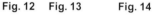

Fig. 19

Training Alphabet 2: Jumprope

Jumprope takes Playball's raw material, bodily movement, and transforms it into calligraphic movement. Playball's lively, energetic "throw" featured a natural combination of pressure, pulling and pushing. Jumprope's exercises help you harness these forces through a stroke technique based in pressure and release. (See pages 30-33) Through these dynamics, the calligrapher engages the body, tool and writing surface with energy and alertness. Like Playball, Jumprope also invites the spirit of play.

Fig. 1 Jumprope: a single-line (monoline) alphabet

Design

Visual themes
- Stroke: a conventional single line, with both symmetrical and asymmetrical arcs. (All Figs. this page)
- Bowl: a pointed oval or almond (mandorla). (Fig. 2)

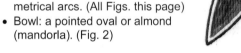

Fig. 2

Letter families
Like Playball, Jumprope is made up of seven families. Their composition, however, reflects the different visual themes of the two alphabets.

Guidelines for Jumprope
Jumprope expresses movement, in part, by the relationship of its strokes to the guidelines. Letter strokes may dip below, rest shy and rise above the guidelines. Ascenders and descenders may also vary in length to further promote liveliness. (Fig. 3)

Fig. 3

In addition to horizontal guidelines, Jumprope uses the verticals which grid paper supplies, as a reference for directing its curved strokes.

Ductus

A conventional style of ductus is appropriate for Jumprope. Numbered arrows accompany each model letter to show stroke order and direction. (Fig. 4)

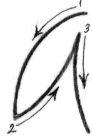

Fig. 4 Ductus for "a"

Lakeside grasses: tensile strength, delicacy and grace.

Dynamics: focusing on stroke technique

Stroke technique is built upon "making contact"—the patterned application and release of tool pressure to the writing surface. (Fig. 5, start, center and end pressure) Stroke-making exercises build technique by developing tactile and muscular sensitivity. This enables you to participate with feeling and awareness in the rhythmical gestures of letter making.

Fig. 5

Fig. 1 The "l" stroke is a prominent motif in Jumprope, whether facing left or right.

Letter Family 1: the "l" (lij)

To begin, try warm ups and exercises with the prototool to become familiar with their features and gain confidence. Then explore the feel of the Conte crayon.

Visual theme: shallow, asymmetrical arcs
This theme is also repeated in letters with more than one stroke. (Fig. 1)

Structure: A letterform, like a building, depends on a framework. Here, grid paper, with its straight verticals and horizontals, helps to organize and support letter strokes and spaces.

Warming up

Uniquely, in Playball, warming up is built into the letters. In Jumprope, and the other training alphabets, warm up exercises are separate and precede the study of a letter family. For the open curves of the "l" family downstrokes, prepare by throwing loose clockwise ovals and long arcs.

Tool: Conte crayon
Paper: large-grid
Padded surface
Speed: slow and deliberate

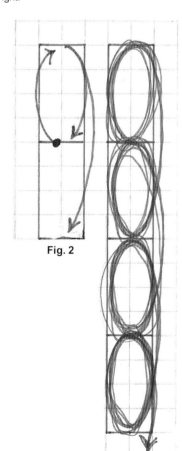

Fig. 2

1. On grid paper, make a 1:2 proportion framework of five stacked rectangles. Rule vertical lines two squares apart and horizontals four squares apart.
2. Place the tool at the baseline of the top rectangle. (Fig. 2, large dot)
3. Inhale on "one" and push the left arc of the oval up to its top and pause.
4. On the exhale, count "and" and throw the right arc.
5. Continue this elliptical motion and breath pattern through "two, and."
6. On "three," at the top of the oval, exhale and throw a long arc to the base of the second rectangle. (Fig. 2)
7. Make the ovals and long arcs of Fig. 3.
8. Focus on coordinating the breath with directing the stroke—experiencing this interplay as a sequence of rhythmical and relaxing movements.

Fig. 3

Ductus and Dynamics

Note that the ascenders and descenders of Jumprope generally reach just shy of two body heights. (Fig. 4)

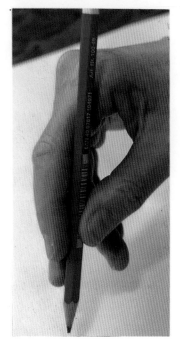

Tool: Conte crayon
Tool hold: as for the pencil, at left
Paper: "marker"
This paper provides greater tooth than tracing vellum or drawing paper. Since it is translucent, though, it can be used for tracing. Suggested brands:
1) Bienfang: Graphics 360, 100% rag translucent marker paper and
2) Borden and Riley: #37 Boris Brightwhite layout translucent visual bond

Padded surface
Speed: slow and deliberate

Trace Fig. 4 using even pressure (p. 31):

(l) Place the tool point at the ascender line and inhale. On the exhale, pull the stroke to the baseline with shoulder awareness.

(i) Place the tool point at the waistline and inhale. On the exhale, pull the stroke to the baseline. Place the dot.

(j) Place the tool point at the waistline and inhale. On the exhale, pull the stroke to the descender line. Dot the "j."

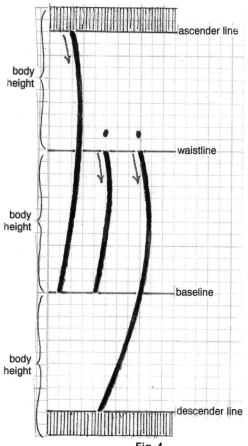

Fig. 4

Introducing "stretch" points

The "l" family arced downstrokes develop into taut, living strokes with the aid of "stretch" points. These targets are positioned on the arc at its maximum swell: the point farthest from a vertical straight. (Fig. 5, brown dots) I choose the term "stretch" to help you imagine a stroke as an elastic band, or bowstring. The experience of stretching a stroke develops as you practice pulling it under pressure.

Using grid paper to set stretch, start and end points helps structure the arc: dividing the stroke into two pulls—the first to the stretch point and the second to the end point. A two-part stroke also helps coordinate stroke dynamics and the breath. In Jumprope, stretch points are positioned asymmetrically between start and end points.

Tools: pencil, Conte crayon **Speed:** slow and deliberate
Paper: marker, small-grid (8 squares per inch) I recommend JNB's small-grid pad.
 (See Suppliers, p. 247.)

1. Trace Fig. 5 with the prototool.
 a. Place the prototool at the start point; take aim and pull to the stretch point, and then to the end point.
 b. Now use the breath and dynamics: Place the prototool as above.
 First pull: inhale; exhale-sink-pull with even pressure to the stretch point.
 Second pull: repeat this breath and dynamics pattern to the end point.
2. Rule horizontal guidelines on small-grid paper: body height (twelve squares apart) and ascenders/descenders (ten squares). Rule vertical guides four squares apart. (Fig. 5, heavy brown lines)
3. Set stretch points one square to the right of each vertical; for
 "l": two squares above the waistline; for
 "i": four squares below the waistline; and for
 "j": seven squares below the waistline
4. Pull the strokes of the "l" family using the above pressure and breath patterns. Feel the bite of tool contact to help you stretch the strokes. (Think bowstring, image at right.) Focus on awakening sensation in the bicep.
5. Repeat to get the feel of pulling strokes as you coordinate direction, breath and pressure.
6. On marker paper, pull freehand letters visualizing the stretch and end points.

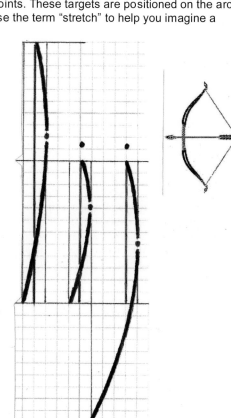

Fig. 5 Stretch points for "l" family letters

Stroke technique: even pressure

To get better acquainted with the arc—one of Jumprope's primary visual themes—the following exercises offer practice with symmetrical and asymmetrical arcs. Although the strokes here use even pressure, feel free to practice the strokes with uneven pressure patterns as well.

Pulling arcs

After constructing triangles with start, stretch and end points, use these frameworks for seeing and stretching the arcs of Jumprope.

> **Tools:** Pigma Micron and Conte crayon
> **Paper:** large-grid

Pulling arcs: symmetrical

Although the arc of Jumprope is asymmetrical, it's helpful to begin with the more familiar symmetrical one.

1. Set points for a triangular framework. (Fig. 5, p. 31) The midpoint is now a stretch point. Pull a long, segmented vertical. (Fig. 6)
2. Pull the first half of the arc to the stretch point with even pressure (inhale; exhale-sink-pull); release pressure on a quick inhale; exhale and pull the second half of the arc to the end point with even pressure. (Fig. 6) Finishing this arc also completes the symmetrical arc. Repeat.
3. Repeat step 1. above. Now, make the two half arcs into a single one on a single breath. Inhale to start, exhale, and in one stroke, pull through the stretch point to the end point. (Fig. 7) Keep stretching to the end. Think of pulling a bowstring as you make the arc.
4. Make internal arcs (Fig. 7): Set stretch points between the vertical lines and stretch points one square away. Pull slightly more shallow arcs.

Fig. 6 Fig. 7

Pulling arcs: asymmetrical

1. Set start points six squares apart and pull a long, segmented line using the breath and even pressure. (Fig. 8)
2. Set stretch points one square from the line and two squares below the top line and each subsequent start point. (Fig. 8)
3. Make asymmetrical triangular frames by pulling straights to the stretch and end points. (Fig. 9)
4. Pull asymmetrical arcs over the frames; first in two pulls, then in one, as above. (Fig. 10)
5. Make internal arcs as in step 4 above.

Fig. 8 Fig. 9 Fig. 10

Pulling letters

Pull the "I" family letters with even pressure. Remember: with even pressure, quickly sink the weight of your shoulder before you pull. Let the shoulder direct the stroke.

> **Tools:** Conte crayon and ruling pencil
> **Paper:** marker/drawing/JNB

1. Trace the large letters of Fig. 5, previous page.
2. Make letters freehand using guidelines (Fig. 11):
 a. body height, 2" (large and slow)
 b. body height, ½" (small, more quickly)

Fig. 11

Stretch points—
and aesthetic judgment

Tool: Conte crayon
Paper: tracing vellum and drawing/JNB

This additional practice with stretch points gives you a chance to develop your eye by comparing a symmetrical downstroke with the asymmetrical one of Jumprope.
1. Trace Fig. 12. (left arc, asymmetrical; right arc, symmetrical)
2. Trace Fig. 13 to help you compare further: the name "jill" with symmetrical and asymmetrical downstrokes. (Fig. 13)

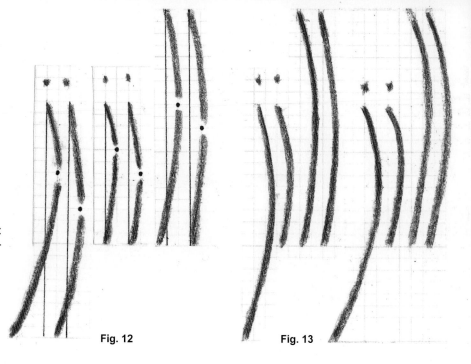

Fig. 12 Fig. 13

Letter Family 2: the "o" (ocexs)

Visual themes: asymmetrical and symmetrical arcs
These arcs form open and closed letters with curved tops ("o, c and s") and pointed junctures (the bottom of "o" and the eye of "e"). (Figs. 1 and 2)

Letter proportion (Fig. 2)
The primary proportion for Jumprope is 1:2, like Playball, but there is also variation in Jumprope. E.g., "c, e and s" have a ratio of about 1:4

Letter structure (Fig. 3)
Straight lines help you understand letter structure; they include proportion frames and vertical and horizontal axes. For the "o," the horizontal axis spans the width of the letter and provides stretch points for the arced downstrokes.

Letter slope: "posture"
The axis of a letter controls its slope, or posture—another facet of an alphabet's character. The vertical axis of Jumprope's "o" family letters gives them an upright formal stance.

Warming up

First loosen up throwing ovals in a framework with a Pigma Micron. Then, pull single-line arcs with the greater friction of the Conte crayon. Try to let the more relaxed action of throwing become part of your awareness in pulling the single-line arcs. The grid and target points are guides, not dictators.

Fig. 1: "o, c, e" **Fig. 2** Proportion: 1:4 **Fig. 3** Axes

Tools: Pigma Micron, Conte crayon
Paper: large-grid

1. Draw a framework of three rectangles, each one 3 x 6 squares. (Fig. 4)
2. Pigma Micron (multiline). In each rectangle, throw counter-clockwise and clockwise ovals at moderate speed. Use enough pressure to feel a slight pull as you throw.
3. Set start, stretch, and end points on the multiline, oval frames. (Fig. 4)
4. Conte crayon (single line). Inhale and place the tool at the top/start point; exhale and pull an arc to the left, through the stretch point, to the end point. Sink gently on the exhale to prevent resistance to starting the stroke. (If necessary, release a little pressure.) Follow the left and right sides of the ovals using even pressure.
5. Repeat on the right side of the oval.
6. Breathe between strokes of the oval and between ovals: inhale, lift; exhale, place.
7. Now, shift focus: as you pull the stroke, think of it as throwing.

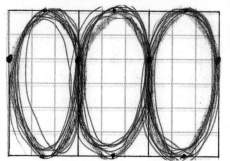

Fig. 4

Ductus and **D**ynamics

For ductus, trace the letters of Fig. 5 according to the numbered arrows. Focus on pulling to stretch and end points. Use even pressure—enough to feel the resistance when you pull a stroke. For dynamics, trace again as described below. The "o" family features start, center and press-release (pages 32-3). Retrace each letter a few times. (Fig. 6)

Tool: Conte crayon **Paper:** tracing, ductus; marker, dynamics

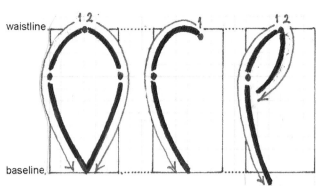

(o)
1. **Left downstroke:** Place the tool on the waistline (start point). Inhale, press-release; exhale and pull to the left stretch point using center pressure: leaning in and pushing off (p. 32), exhaling to the end of the stroke.
2. **Right downstroke:** Place the tool at the start point. Inhale, press-release; exhale and pull to the right stretch and end points. Use the same pressure and breath patterns as those of the left stroke.
3. Repeat a few times, retracing the above strokes, concentrating on the feel.

(c)
1. **Top:** Place at the start point, just below the waistline. Inhale, press-release and, continuing the inhale, push up and left to the waistline in a short curved stroke.
2. **Downstroke:** Exhale, pull the downstroke arc of "c" with center pressure—leaning in to the stretch point and pushing off as you round it and continue to the end point.

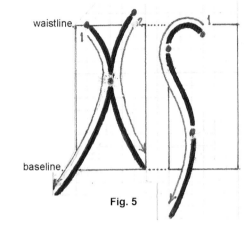

(e)
1. **Left downstroke**: Inhale, press-release as you place the tool at the start point. Exhale and pull to the left stretch point with the first phase of center pressure, leaning in; continue the exhale while pushing off to slightly below the baseline. Place the tool at the start point.
2. **Eye of "e":** Inhale, press-release, exhale and pull the short downward arc with a condensed version of center pressure.

(x) "x" and "s" contain the open arcs characterizing this family.
1. **Left downstroke:** Inhale, press-release as you place the tool. Exhale and pull to the middle stretch point (leaning in) and continue the exhale while pushing off to below the baseline. Place the tool at the start point of the next stroke.
2. **Right downstroke:** Inhale, press-release; exhale and pull to the stretch and end points. Use the pressure and breath as above.

Fig. 5

(s)
1. **Top:** At the start point, repeat the top of "c."
2. **Downstroke:** Exhale and pull the top, right-facing arc, with condensed center pressure. Continue and pull the bottom, left-facing arc, with center pressure, to well below the baseline.

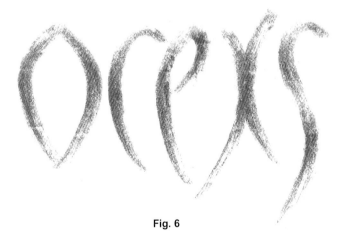

Fig. 6

Spacing

This exercise sequence is a transition from Playball, where all your movements leave visible traces, to Jumprope, where the joins are usually not visible. Even though unseen, these movements contribute to legible and expressive spacing. The next two exercises are designed to maintain awareness of space and rhythmical movement as you proceed from the visible to the non-visible.

Tools: Pigma Micron, Conte crayon **Paper:** large- and small-grid **Body:** shoulder

Visible movements (leaf pattern):
1. Framework (Fig. 1): Rule base- and waistlines eight squares apart across the paper. Rule verticals for proportion frames four-squares wide and one square apart. Make 4.
2. Set start, stretch, and end points as in Fig. 1. (These arcs will be asymmetrical.)
3. Inhale and place the Pigma Micron; exhale and pull the left arc with end pressure.
4. Use the energy of release to propel a vertical upstroke (inhale; light, even pressure).
5. Exhale and pull the right arc with end pressure.
6. Use the energy of release to propel a diagonal join (inhale; light, even pressure) to the next start point. Repeat.
7. Use the Conte crayon to trace the pattern according to the dynamics above.

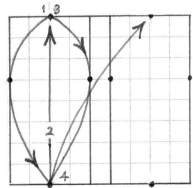

Fig. 1

40

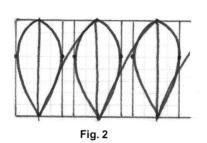

Fig. 2

top op paper

Fig. 3

Fig. 4 Fig. 5

7. Repeat the previous exercise on small-grid paper, using both tools. (Fig. 2) Work a bit more quickly and focus on rhythm.

Visible and non-visible movements

Tool: Conte crayon **Paper:** marker/drawing **Guidelines:** waistline, ¼" below the top of the paper and 1" above the baseline

1. Place the ruled paper just below your work on the small grid. (Fig. 3) Repeat the pattern, getting your bearings (letter width and stretch points) from the work above; darting your eyes upward and back for orientation. (Fig. 4)
2. Now work below Fig. 2 again, lifting the tool between strokes and letters. (Fig. 5)

Word/phrase as image
For now, just enjoy the rhythm of pulling strokes into letters. Spacing details follow this exercise.

Tool: Conte crayon and Pigma Micron
Paper: tracing vellum, notebook, and marker/drawing/JNB

1. Trace the figures: Fig. 6 with a Conte crayon and Fig. 7 with the Pigma Micron. Use the end pressure pattern with both (p. 33). Note how it feels to apply pressure with the Pigma Micron, which does not visually reflect it.
2. Write words freehand—Fig. 8, next page, shows an experiment.

Fig. 6

Fig. 7

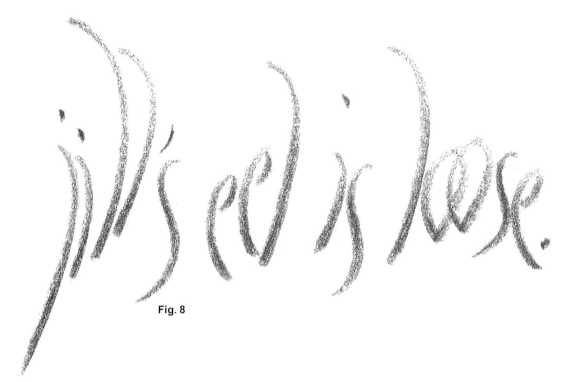

Fig. 8

Spacing

In Jumprope, as in Playball, the aim is distribute space evenly among different letter combinations. The spatial combinations of Playball, with its mixture of straights and curves, provide a working template. Here, in Jumprope, the "I" family downstrokes, though arced, are analogous to the straight downstrokes of Playball. (Figs. 9, 10, and 11) In spacing, the stretch points are also the near points. (See "near points," p. 16, Target practice 1.)

Tool: Conte crayon **Paper:** tracing vellum, notebook, drawing/JNB **Speed:** deliberate **Guidelines:** 4 line spaces (notebook)

Two vertical arcs
1. Using the Conte crayon, trace Fig. 9 using even pressure.
2. Freehand, on notebook paper, pull a few vertical arcs, visualizing their stretch points and spacing the arcs as evenly as possible.
3. Breath: Inhale and place the tool; exhale and pull the stroke. Inhale as you lift from one stroke to the next. Repeat a few times. Relax and let the lifts between strokes become part of your rhythm.

Vertical arc + curve
1. Trace Fig. 10 using even pressure.
2. On notebook paper, repeat this combination a few times. Breathe.
3. Note the different spatial shapes/volumes the curved verticals produce on either side of "o."

Fig. 9 **Fig. 10** **Fig. 11**

Two curves: These back-to-back asymmetrical arcs create asymmetrical hourglasses. (Fig. 11)
1. Trace Fig. 11 using even pressure.
2. Repeat this combination on notebook paper. Pay particular attention to reaching each new letter via its left stretch (near) point.

To practice the three basic letters combinations discussed above, copy Fig.12 on notebook paper. Make the strokes four lines spaces high. Place or visualize stretch (near) points.

$$|||\ 0|\ 0|\ 0|\ 0\ 0\ 0|||\ 0|\ 0|\ 0|\ 0|\ 0\ 0\ 0|||\ 0\ 0\ 0|||\ 0|\ 0|\ 0|$$

Fig. 12

Play: write words

Tool, paper and size: of your choice

1. Choose a word using "o" and "I" family letters.
2. Experiment with the uneven pressure patterns: start, center and end. Compare forceful and subtle applications.
3. Focus first on precision in stroke making and then on the the stroke as a rhythmical gesture.

At right: an experiment. I first pulled the "I" family letters in subtle arcs with either a mauve colored pencil or a Sanguine Conte crayon using end pressure. Then, with the other tool, I pulled arcs with more distant stretch points also with end pressure.

Letter Family 3: the "a" (adgq)

Visual themes: tilted, pointed oval bowls and open-arc strokes. (Fig. 1) The bowls of this family are left slightly open to give a sense of movement. (Figs. 8 and 9, next page)

Letter proportion: 1:2

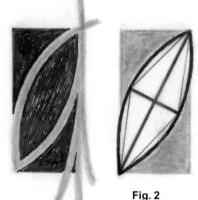

Fig. 1 "a, d, g, and q"

Bowl: The bowl tilts to the right along a diagonal axis, drawn from the top right corner of the proportion frame to the bottom left. (Fig. 2)

Letter structure: The third stroke overlaps the second at the top. (Fig. 3)

Fig. 2 **Fig. 3**

Warming up

In addition to loosening up, this exercise also aims to develop agility with changes of stroke direction/axis.

> **Tools:** Pigma Micron (for framework),
> Conte crayon (for strokes); ruler
> **Paper:** large-grid
> **Speed:** slow and deliberate
> **Body:** shoulder and arm

1. Make a framework on large-grid paper: a series of four horizontal proportion frames, one square apart, with diagonal axes. (Fig. 4)
2. Throw multiline strokes from the apex over the two diagonal axes (Fig. 5):
 a. Axis 1—Count "one-and, two-and, three-and"; pause to change direction.
 b. Axis 2—Count "one-and, two-and, three"; on "and," following "three," push up to the next apex.
3. Throw ovals (Fig. 6): wider ovals over the left diagonal axis and narrower ovals over the right axis.
4. Now, use Fig. 6 as a framework.
 a. First downstroke: Place the tool at the first apex on an inhale. On the exhale, pull a single-line stroke along the left side of the wider oval with end pressure (p. 33).
 b. Upstroke: Release pressure while inhaling and pushing up along the right side of the oval, with even pressure, to the start point. Exhale.
 c. Second downstroke: Inhale in place; on the exhale, pull a stroke along the left side of the narrow oval, with end pressure, to the baseline.
 d. Inhale and lift the tool to the next apex. Repeat with attention to the breath and pressure patterns.

Fig. 4

Fig. 5

Fig. 6

Preparation for the "a" family

Tool: Conte crayon **Paper:** marker/drawing/JNB

1. Rule guidelines ¾" apart.
2. Make a saw tooth pattern (Fig. 7):
 a. Make the first stroke as in 4a. (above directions).
 b. Lift the tool and move up as though making the upstroke of 4b.
 c. At the top of this arc, replace the tool and pull the second downstroke as in 4c.
3. Repeat as a rhythmical gesture.

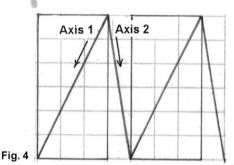

Fig. 7

Ductus and Dynamics

For ductus, trace the letters of Fig. 8 with even pressure, enough to feel resistance, according to the numbered arrows. For dynamics, trace again as described below. The "a" family dynamics feature end pressure (p. 33). Retrace each letter a few times. (Fig. 9)

> **Tool:** Conte crayon
> **Paper:** tracing vellum, ductus; marker, dynamics
> **Speed:** slow and deliberate
> **Body:** pressure from the shoulder and arm

Hold the paper steady and visualize or set stretch points before pulling the arced strokes. Since these are symmetrical, these targets are about midway between start and end points.

Fig. 8

(a)
1. **First downstroke:** Place the tool at the start point, slightly above the waistline, while inhaling. (Fig. 9) Exhale, "grabbing" the tool shaft and pulling the stroke around the stretch point as you move toward the end point (end pressure).
2. **Upstroke:** Inhale and release pressure. Let the energy of release help propel the push upward to a little below the waistline (even pressure).
3. **Second downstroke:** Exhale and pull the stroke just below the baseline (end pressure).

(q)
Descender: After the upstroke of "a," exhale and pull a long, subtle arc to the right, to the descender line (end pressure).

(d)
Ascender: After the first downstroke of "a," release pressure. Let the energy of release help propel the upward push of the long arced ascender. Inhale, pushing up with even pressure to the waistline, continuing to the ascender line with or without end pressure.

(g)
Descender: After the upstroke of "a," exhale and pull a long arc to the descender line (end pressure), to the left of the proportion frame.

Fig. 9

Compare the arced descenders of "q" and "g." Rule a line from the start point to the end point of each to reveal their symmetry/asymmetry.

Stroke technique: center pressure

The three arcs of "a" provide practice with the dynamics of center and even pressure. By drawing frameworks you can repeat these strokes as a musician practices a particular passage.

The bowstring

Begin with the symmetrical arc of the second downstroke of "a."

> **Tools:** Pigma Micron, Conte crayon **Paper:** large-grid

1. Rule waist- and baselines six squares apart across the paper. (Fig. 1)
2. Set start points along the waistline, two squares apart.
3. Set end points along the baseline one square to the right of the start points.
4. Rule diagonals.
5. Place the Conte crayon at the first start point while inhaling.
6. Exhale and pull an arc with center pressure (lean in-push off) to the stretch and end points.
7. Lift the tool and move upward in a shallow arc to the next start point. (Fig. 1, dotted line)

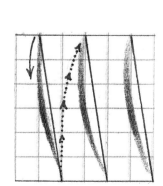

Fig. 1

Next, the two strokes that form the pointed, mandorla-like shapes of "a" family bowls.

1. Make a framework on a full sheet of paper (Fig. 2): Begin at the top right hand corner and set a point. Count three squares to the left and six down and set another point. Rule the right diagonal through the two points to the bottom of the paper. Rule two additional parallel diagonals one square left and right of the first diagonal.
2. Set start, stretch, and end points down the page for each bowl. (Fig. 2, large blue dots)
3. Using center pressure, pull left arcs from the start points, through the stretch points, to the end points along the middle diagonal.
4. At the bottom of the page, push upward arcs using even pressure.
5. Sense the different rhythms of the two pressure patterns and the different gestures of moving down/up.

"Air stroking"

It can be helpful to rehearse a stroke In the air before committing tool to paper. Hold the tool just above the paper: at a start point (for making a stroke) or at an end point (for continuing to the next letter). Move the tool back and forth, at least once, to discover a path and a gesture for hand and eye to reach its target. Air stroking assists with letter spacing and construction. In the exercise below, you use this technique for stroke making and spacing.

1. Make a framework on small-grid paper (Fig. 3): Rule four proportion frames 6 x 12 squares each and two squares apart. Rule diagonal axis lines.
2. Left downstroke: Inhale and place the tool on the paper one square above and to the right of the left proportion frame. Exhale and pull with center pressure to the bottom left corner of the frame.
3. Upstroke: Inhale and push the upward arc with even pressure to the right side of the frame, two squares below the waistline.
4. Right downstroke: Pull the arc with center pressure overlapping the upstroke, to the right of the frame and a little below it.
5. Now, air stroke to the next start point. (Fig. 3, dotted, arrow-tipped lines) Repeat.

"a" family strings

1. On marker paper, rule waist- and baselines ¾" apart. (Fig. 4)
2. Pull and push the "a" family letters with center and even pressure.

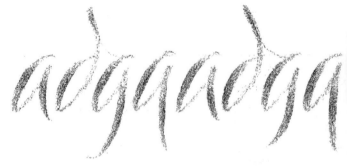

Fig. 2 **Fig. 3**

Fig. 4

Spacing: basic letter combinations

The "a" family spacing exercises introduce terms for the nuanced interletter shapes of Jumprope. Its letter combinations create three spatial shapes/volumes—concave (Fig. 1a, facing arcs), convex (Fig. 2a, back-to-back arcs) and "nested" (Fig. 3a, arcs that face the same direction). To make these shapes similar in volume: 1) identify the interletter shape that two letters will form, 2) locate target points (start, stretch, and end), and 3) air stroke from the end point of a letter to the start point of the next.

Jumprope's three basic interletter shapes and connecting paths

Fig. 1a Concave, "a-i" **Fig. 1b** **Fig. 2a** Convex, "i-a" **Fig. 2b** **Fig. 3a** Nested, "a-g" **Fig. 3b**

Tool: Pigma Micron **Paper:** tracing vellum

1. Note the three spatial shapes shown by heavy solid lines and filled with light horizontals. (Figs. 1a, 2a and 3a)
2. Trace the stroke paths following the solid blue lines on the paper, and the dotted brown ones in the air. (Figs. 1b, 2b, and 3b)

Interletter shapes: spacing practice

In the first tracing-coloring exercise, you practice seeing Jumprope's three basic letter combinations.

Tools: Pigma Micron, colored pencils **Paper:** tracing vellum

1. Trace the letter pairs of each combination. (Fig. 4) Remember to move from the shoulder, even when writing small characters.
3. Remove the paper from the tracing position and color in the three basic shapes—as stand-alone abstract shapes and with letters.

Concave: Convex: Nested:

Fig. 4

In this tracing-coloring exercise, the emphasis is on identifying the spatial shapes/volumes as you write words.

Tools: Pigma Micron, colored pencils, Conte crayon
Paper: tracing vellum, notebook, drawing/JNB

1. (Pigma Micron) Trace the words of Fig. 5. Each letter combination is colored to correspond with a letter combination from above.
2. (Pigma Micron; notebook paper, *two* line spaces high) Write words and color the shapes between the letters according to the above color code or one of your own. (Fig. 6)

Fig. 5

Fig. 6

3. (Conte crayon; drawing paper, rule lines ¾" apart) Write words using end pressure. (Fig. 7) Try releasing from it as from a spring. More words that contain your current repertoire of letters: dale, saddle, sledge, eagle, algae, aloe, aegis, axial.

Fig. 7

Words at play

Try a new tool—Peel and Sketch Charcoal by General—or use a Conte crayon, and trace or freehand the words of Fig. 8. Reminder: Hold this unpointed tool upright. Experiment with pressure patterns as you awaken a sense of swoop to better enjoy the acts of stroke-making and letter spacing.

Fig. 8

Interlude 1: line as play

Rather than a warm up, a preparation for something else, this section focuses on line in itself. It offers a chance to experience line for no other purpose than enjoyment—as play. Instructions are provided— even the playground has some rules—but feel free to use them as a jumping off for your own explorations.

Getting comfortable

> **Tool:** Conte crayon and/or large, soft lead (e.g., Cretacolor)
> **Paper:** drawing/JNB
> **Body:** feel the arm at work
> **Breath:** not necessarily coordinated with direction

1. Fast: throw some large ovals. (Not shown.)
2. Slow down; pull ovals from small to large and then from large to small. (Not shown.)

Note: Awareness is part of play. It develops with your attention and helps you participate in the action: the energy of throwing and sensations of contact (pulling and pushing).

Featuring center and even pressures (Figs. 1-4)

> **Tools, Paper, Body and Breath:** as above
> **Speed:** deliberate (slow to moderate)

1. Fig. 1: Pull single loops with an upright axis. Begin at the top of the first loop and use center pressure, or at the bottom using even pressure.
2. Fig. 2: Pull loops moving the axis from left to right in a fan-like pattern.
3. Fig. 3: Pull three ovals in three axis positions, left to right, and connect the cluster with a horizontal arc at the top.
4. Fig. 4: Pull single arcs in clusters.
5. Using center pressure, create a flower of facing single arcs with pointed petals radiating around a center point. (Not shown.)

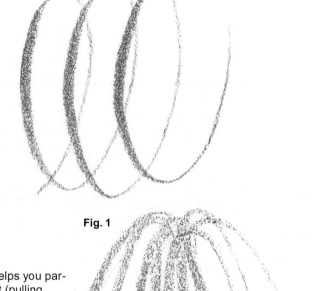

Fig. 1

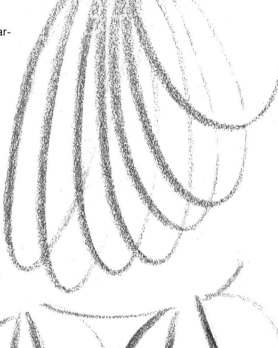

Fig. 2

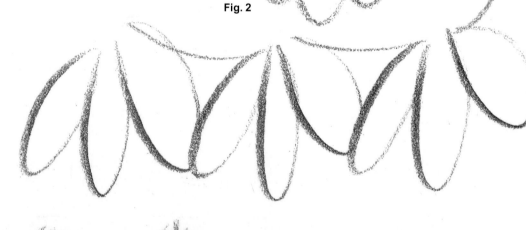

Fig. 3

Fig. 4

Remember:

The source of pressure is the shoulder-arm.
The role of the fingers
is to keep hold of the tool—
hold the tension—
and sense the variations in friction
as you pull the stroke.

Interlude 2: art and nature

Letters are made of lines. This exercise continues to explore this basic calligraphic ingredient with inspiration from nature.

Tool: pressed charcoal
Paper: drawing/JNB
Speed: as you wish
Size: work large

1. Draw nested arcs (parallel and non-parallel) and experiment with pressure patterns.
2. Take or find pictures of "lines" in nature such as tree trunks and flower stems. Imitate their directions as gestures—first, with your body and then on paper. This helps you to awaken a sense of felt movement and develop an empathy with line.

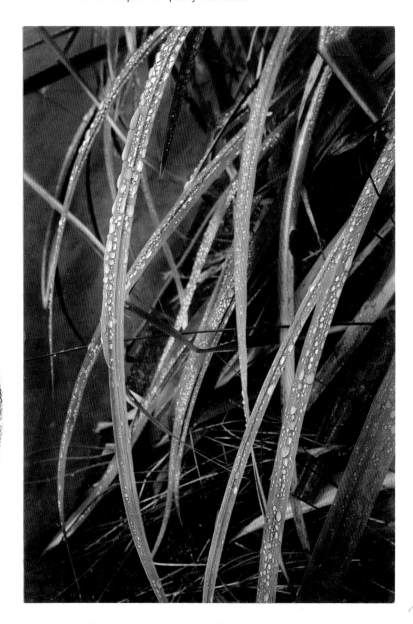

Lakeside grasses support the dew in nature's version of nested arcs.

Letter Family 4:
the "n" (nhm)

Visual themes: pointed arch
The "n" family combines an "l" family arced downstroke with an asymmetrical, pointed arch: two symmetrical arcs joined at the waistline. Strokes begin or end just above or below the guidelines. (Fig. 1)

Letter proportion: 1:2 for "n and h," nearly 2:1 for "m." (Fig. 1)

Bowl axis: The axis of the "n" family arch, shown by the diagonal line, is a little less tilted than that of the "a" family. (Compare Fig. 2 here with Fig. 2 on p. 42.)

Letter structure: "branching"
Like a branch from a tree, the arch diverges from the downstroke. The place of divergence, or "branch point," is structural; in Jumprope, it's about midway between the waist- and baselines. (Fig. 3, middle) The branch point can also be an expressive choice: compare mid-branching with lower and higher branch points in Fig. 3.

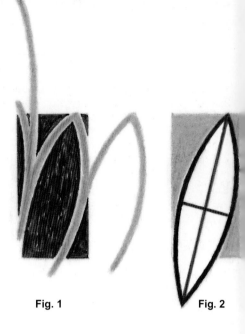

Fig. 1

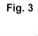

Fig. 2

Warming up
Loosen up and get the feel of branching and combining start and end pressure. (If you like, review pages 32-3.)

Tools: soft pencil / Conte crayon **Paper:** large-grid, drawing/JNB
Size: large enough to engage the shoulder (2-3 inches) **Speed:** moderate

Multiline ovals: Throw slightly sloped, clockwise ovals in place; on the last one, stop at the baseline and begin a new multiline oval. (Fig. 4) Repeat a few times.
Single-line arches
1. Rule diagonal axis lines from the top right to the bottom left of each oval.
2. Mark the top point of each axis line.
3. To the left of the first oval, at the baseline, press-release and push into an upward arc to the first mark. (See Press-release, p. 33)
4. Pause; begin the right side of the arc with start pressure and, straightening it, pull it as a downstroke to the baseline (end pressure).
5. In the release of pressure, push off into the next arch. Repeat

Fig. 3

Ductus and Dynamics
For ductus, trace Fig. 5 with even pressure, enough to feel resistance, according to the numbered arrows. For dynamics, trace again combining start and end pressure in one stroke. Set or visualize stretch points.

Fig. 4

Tool: Conte crayon **Papers:** tracing vellum for ductus; marker for dynamics
Speed: slow and deliberate

(n) 1. **First downstroke:** Place the tool just above the waistline. Apply start pressure to begin the "i" stroke; use end pressure to finish it just above the baseline.
2. **Branch upstroke:** Inhale and release pressure as you push up with even pressure to the waistline.
3. **Second downstroke:** Use start pressure; pull a downward arc, finishing the stroke with end pressure just below the baseline.

(h) Place the tool at the ascender line and pull an "l" two squares short of the baseline. Repeat the branch and downstroke of "n."

(m) 1. **First downstroke and branch upstrokes:** As for "n."
2. **Second downstroke:** As for "n," but finishing higher above the baseline.
3. **Third downstroke:** As for "n."

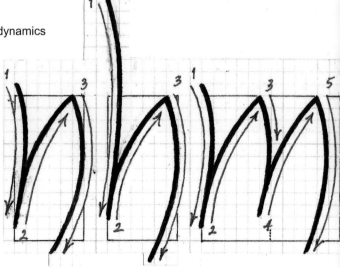

Fig. 5

Spacing: equidistant nesting

The "i, n and m" each contain arced downstrokes that face the same direction; unlike those in the "a" family, these arcs are nearly equidistant. (at right)

Tools: Pigma Micron, Conte crayon **Paper:** tracing vellum

1. Trace Fig. 1, staying aware of your movements in the air as well as on paper.
2. Make a row of nested "i" strokes with your choice of paper, tool, and size using the current pressure palette: even, end, center and start.
3. At the same size, write the word "mini" a few times, using a pressure pattern. As you move from one letter to the next, glance back to the interletter space between the previous two letters. Use air stroking to find start points.

Words

The word list below includes all three spatial combinations—concave, convex and nested—and all the letter families presented so far.

Tools: Pigma Micron and/or Conte crayon **Paper:** drawing, notebook

Suggested words: animal, mammal, handsome, mend, camel, gnome, nomadic, shine, hone, dance, onions, mince, cinnamon, loan, minimalism
1. On drawing paper, rule guidelines: 1" body height.
2. Write the words with a Pigma Micron using even pressure.
3. On notebook paper, write the words at a one-line body height.
4. On your choice of paper, write the words with a Conte crayon working at the 1" size. Experiment with the pressure patterns and their combinations.

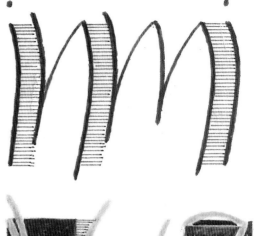
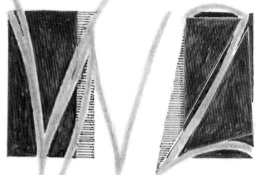

Fig. 1

Letter Family 5: the "v" (vwyz)

Visual themes
- Triangles: Each letter contains one, two or three. (Fig. 1)
- Diagonals—arcs or reverse curves (presented in this family). The two central diagonals of "w" use the reverse curve to form an ogee arch. (Fig. 2)
- Overlapping junctures (at the bases of the letters)

Fig. 2 Ogee arch

Letter proportion: Most letters are a little wider than 1:2, "w" is nearly 2:1.

Letter structure: Fig. 4 places straight lines next to the arc strokes of "v" to show their symmetry and help you set stretch points for pulling their subtle arcs.

Letter slope: The axes of "v" and "w" lean a little to the right of a vertical and give these letters a slight slope. (Fig. 5) Slope need not be exactly the same for all letters or letter parts. Review Jumprope's "a" and "n" families. See the active tension they display in contrasting the axes of downstrokes with those of bowls or arches.

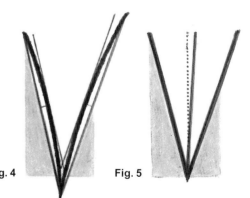

Fig. 4 **Fig. 5**

Warming up

Tools: soft pencil/Conte crayon **Paper:** drawing/marker/JNB **Size:** 2"-3"
Speed: slow and deliberate **Body:** shoulder and arm

1. Throw clockwise multiline ovals – large and loose. The first oval tilts to the right; on the last lap of this oval, throw the line up and over to begin the left-tilting second oval. (Fig. 6) Repeat. Use these ovals as a framework for tracing out diagonal arcs. (Fig. 7)
2. Downstroke-upstroke: Place the tool at the top of a rounded arch; apply subtle start pressure and pull the remainder of the stroke using end pressure. Release pressure and push the arced upstroke with even pressure. (Breath: inhale, up; exhale, down)

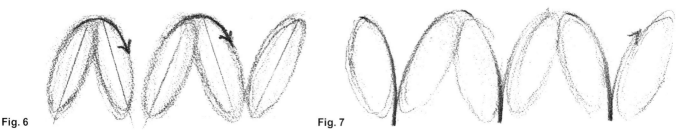

Fig. 6 **Fig. 7**

50

Ductus and Dynamics

For ductus, trace Fig. 1 (heavy blue letters) with even pressure, enough to feel resistance, according to the numbered arrows. The reverse curves of the "w" are fully described on p. 52-3. For now, just observe the arch's alternate facing arcs (strokes 2 and 3). For dynamics, trace Fig. 2 combining start, end and even pressure as below. Set or visualize stretch points. Repeat each letter a few times.

Using the pressure patterns:
- Downstrokes: start and end pressure
- Upstrokes: even pressure
- Horizontals of "z": even pressure, or experiment

Tool: Conte crayon **Paper:** tracing vellum **Speed:** slow and deliberate

(v)
1. **Downstroke:** Place the tool at the waistline, at the top left corner of the proportion frame; pull a shallow arc a little below the baseline. Pause.
2. **Upstroke:** Push up and to the right, above the waistline and outside the frame.

(w)
1. **First downstroke:** Place the tool above the waistline and to the left of the proportion frame; pull an arc a little below the baseline. Pause.
2. **First upstroke:** Push up a reverse curve to a little below the waistline. Pause.
3. **Second downstroke:** Pull a reverse curve to just below the baseline. Pause.
4. **Second upstroke:** Push an arc up and to the right, to the waistline.

(y)
1. **First downstroke:** Pull the initial "v" stroke.
2. **Upstroke:** Push an arc a little right of the proportion frame and just below the waistline. Pause.
3. **Descender:** Pull a long arc to the descender line, a little left of the proportion frame.

(z)
1. **Top horizontal arc:** Place the tool just below the waistline; set or visualize a stretch point toward the left side of the arc. Push the stroke via the stretch point. Pause.
2. **Downstroke:** Pull a diagonal arc to the left of the proportion frame and below the baseline. Pause.
3. **Bottom horizontal arc:** Set or visualize a stretch point for this stroke toward the right side of the arc. Push the stroke, moving through the stretch point.
Note: Feel free to experiment with the breath. The aim is to use it to enhance the flow of your stroke and to stay focused. You may want to take an extra inhale-exhale as you pause between strokes.

Stroke technique: pushing and pulling

In conventional calligraphic instruction, the fingers both apply the pressure for contact and direct the stroke. This tends to tighten the grip on the tool, which cuts off sensation in the fingers. Shutting down tactile feedback prevents you from developing the sensitivity essential to refining strokes. It also greatly reduces the pleasure of calligraphy.

In my approach, the pressure of contact is shared by the shoulder, arm and fingers—but it arises from the shoulder and arm. Distributing pressure among the three develops awareness, increases pleasure, and opens the calligrapher to a connection between physical sensation and the meaning of her chosen words. This is a path to the visual expression of language.

Pushing (Figs. 1a-e, next page)
The following exercises further cultivate tactile sensitivity. They focus on the thumb, which, situated behind the tool, is the major player in pushing.

Tools: Pigma Micron, Conte crayon **Papers:** large-grid and drawing

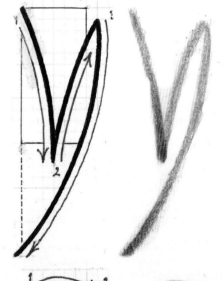
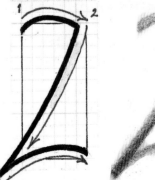

Fig. 1 Ductus **Fig. 2** Dynamics

These exercises use even pressure. Experiment to see how much is needed to awaken the thumb and engage resistance. Using the Pigma Micron, rule a base- and waistline four squares apart.

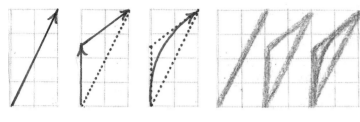

Fig. 1a **Fig. 1b** **Fig. 1c** **Fig. 1d** Conte crayon

Stroke one: 1. On an inhale, place the tool on the baseline at the left corner of a square; exhale. (Fig. 1a)
2. On the inhale, use your thumb to push up a diagonal two squares over; exhale. Play with the position of the hand and wrist, as needed ased, to support the tool. The force of contact comes mostly from the shoulder and arm. Let them move the hand.

Stroke two: 1. Inhale and return to the start point of stroke one; exhale. (Fig. 1b)
2. On a deep inhale, push a stroke up two and a half squares; continuing to inhale, connect with the end point of stroke one. Exhale.

Stroke three: 1. Inhale and return to the start point of stroke one; exhale. (Fig. 1c)
2. Inhale and push an arc. Use the triangular framework to guide it.
3. Next, push the above strokes with a Conte crayon. (Fig. 1d)
4. Repeat Fig. 1d to get the pattern and find the rhythm of these movements.

Repeat the above pattern with drawing paper, working freehand. Try stretch points, as In Fig. 1e, for pushed upstrokes.

Shut your eyes and see. Seems to see with his fingers. Touch. Fingers. Asking. Answer. Yes.
Ulysses, James Joyce

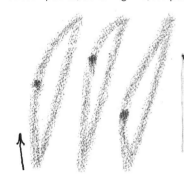

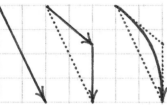

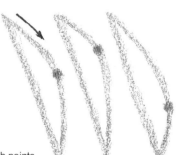

Fig. 2a **Fig. 2b** **Fig. 2c** **Fig. 2d** Conte crayon

Fig. 1e Pushed arcs with stretch points.

Fig. 2e Pulled arcs with stretch points.

Pulling:
Repeat the above exercise with pulling. (Figs. 2a-e) Remember: exhale, down; inhale, up.
The index finger guides the pull. First let the arm sink down; when you begin pulling the stroke, pay attention to the index finger. Keep the hand off the table. Use your pinky for balance if desired. Try closing your eyes: this is more about how it feels than how it looks.

Pushing and pulling
This exercise integrates the fingers with directional movement: thumb—pushes the upstroke; index finger—pulls the downstroke. Set or visualize stretch points as needed. Note: the process of sensitizing the fingers takes time!

1. **The framework:** Rule horizontal guidelines four squares apart. (Fig. 3)
2. Draw diagonals in a zigzag pattern.
3. **Upstroke arcs:** At the base of the left side of the first triangle, place the tool and inhale; exhale. Inhale and push to the top of the arc, paying attention to the thumb; exhale.
4. **Downstroke arcs:** At the apex of the triangle, inhale in place; exhale and pull an arc down paying attention to the index finger.
5. Repeat the alternation of pushed and pulled arcs.

Fig. 3 Pulled arcs with stretch points.

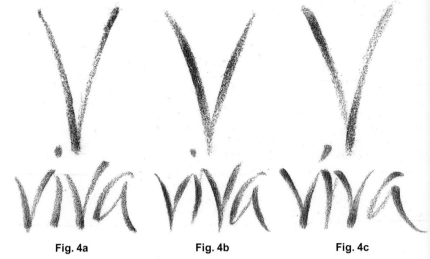

Word as image: pressure

Practice keeping the tool as upright as possible.
Hold the tension of *additional* pressure by remembering to brace the tool against the big knuckle.
Breathing and staying with the flow of energy from
the shoulder will keep you relaxed.

Tool: Conte crayon **Paper:** drawing/marker
Guidelines: letters, 2" apart; words, 1"

Make the "v" with each uneven pressure pattern
and write "viva" after it. (Figs. 4a, b, and c)

Fig. 4a **Fig. 4b** **Fig. 4c**

End pressure (Fig. 4a)
1. Downstrokes: Place the tool on an inhale and
 apply end pressure on the exhale. Let pressure
 from the shoulder-arm activate awareness in
 the index finger.
2. Upstrokes: Shift awareness to the thumb. Inhale
 and push the stroke up with end pressure.

Center and start pressure (Figs. 4b and c)
Repeat the letter and word using center pressure
and then start pressure.

Mixed pressure. It is common to mix pressure patterns in a stroke
to find its particular rhythm in a letter or word. Note: Each pressure
pattern may be extended or reduced in duration/length.
1. Trace "vivace." (Fig. 5) Identify the pressure pattern/s in each stroke.
2. Work freehand. Try: vivid, voyage, avid, lavish, love, vision.

Fig. 5

The "reverse curve"

This stroke is composed of two arcs
facing in opposite directions. It features
most prominently in the "s," but more
subtle versions give character and refinement to other letters/strokes. (In
Jumprope, the central strokes of "w,"
Fig. 6) Enjoy its rhythms as you prepare to use it with intention.

Fig. 6

Fig. 7

Tool: as noted **Paper:** drawing/JNB
Speed: moderate
Size: large

Warming up: Make a framework (Pigma Micron).
1. Throw a multiline oval 6" to 8" in height. (Fig. 7)
2. Within the oval, throw multiline straights as follows: vertical; horizontal, left to right; right diagonal, right to left; left diagonal, left to right.

Ductus and dynamics: (Conte crayon) Read the instructions below and then
Trace Fig. 8; first, with the prototool, then with the Conte crayon.

1. Place the tool at the large blue dot on the right side of the oval, below the top.
2. Follow the arrows. Breath: inhale, up; exhale, down/across.
3. The downward three strokes and the one horizontal use center pressure. As
 you release pressure, inhale and push into the upward loops.
4. Reminder on center pressure: Lean into the downstroke as you approach the
 mid-point; then, push off to the edge of the oval. Both actions use shoulder
 and arm pressure, but now also involve the fingers in the directional pulling
 and pushing of strokes.
5. The upward connecting loops use even pressure.
6. Freehand on drawing paper. Try leaving the paper as well as staying on it for
 the connecting loops. (Fig. 9, top next page)
7. As soon as you are comfortable with the pattern, try making the strokes and
 connections a rhythmical, dance-like sequence.

Fig. 8

Stroke technique: "hugging"

The aim of this technique is to develop subtle curves. It involves pulling/pushing a curved stroke as closely as possible to a straight one, as in the exercises below.

Hugging diagonals (Fig.10): Preparation for making the second and third strokes of "w."
1. Rule long diagonals and set target points 1¼" apart.
2. From the base of the left diagonal, use start pressure to push a reverse curve up—the first arc to the left of the line, the second, to the right. Try to feel the flow from the first arc into the second.
3. From the top of the right diagonal, use start pressure to pull a reverse curve down—the first arc to the left of the line and the second right.
4. Play with different speeds and sizes to find a rhythmical, slalom-like action.

Ogee arches/wishbones
1. Make a triangular framework three squares wide and six squares high. (Fig. 11)
2. At the baseline, from start pressure, push a reverse curve up, right and left of the framework, to the waistline; move to the right diagonal. Pull a reverse curve down with start pressure in the same way. Repeat. Try to find the rhythm and gesture of these strokes.
3. Imagine yourself bowing a stringed instrument. This is not precision work.
4. Work without a framework, just enjoying the flow of your gesture.

"w" arcades (Use "w" ductus.)
The strokes in this exercise combine center and start pressures. Note that the ogee and lancet arches alternate. (Fig. 12)
1. Rule guidelines six squares apart; set start, end and apex points as in Fig. 12.
 a. First, work with ruled diagonal frameworks, starting at the waistline.
 b. Second, freehand with only target points.
2. Use start pressure for the reverse curves and center pressure for the single arcs.

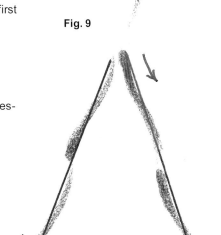

Fig. 9

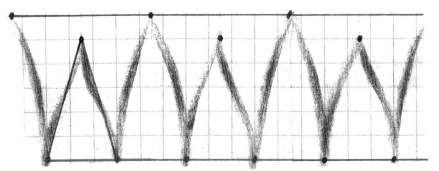

Fig. 10

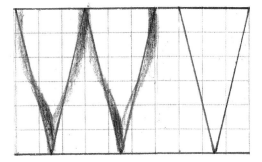

Fig. 11 Ogee arches with framework.

Fig. 12 Three "w"s. Note the arches: three ogee and two lancet.

Spacing

"v" family arcs create concave, convex and nested shapes (p. 44) when combined with other letter families. (Fig. 1, below, and 3, p. 54)

Spacing "v" and "w"

For spacing purposes, the design of "v" and "w" is the same: concave arcs facing left and right.

Tools: Pigma Micron, Conte crayon
Paper: tracing vellum

1. Trace the letters of Fig. 1, first with even pressure (Pigma Micron) and then with pressure patterns (Conte crayon). Notice the spatial shapes that form as you direct the letter strokes. Use the breath.

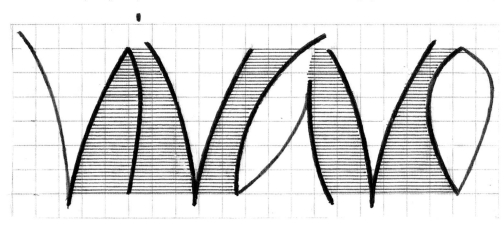

Fig. 1 **"v-i"** concave; **"i-v"** left nested; **"v-a"** right nested; **"a-v"** concave; **"v-o"** right nested

2. Trace and/or freehand the words of Fig. 2, noting the concave and nested spatial volumes.

vivid save van voice move give convivial

Fig. 2

Spacing "y"

1. Trace the letters of Fig. 3, first with even pressure (Pigma Micron) and then with pressure patterns (Conte crayon). Note the subtle variation in hour-glass shapes that the convex combinations of "y-o" and "y-a" create.
2. Trace and/or freehand the words of Fig. 4, naming the interletter shapes—concave, convex, and nested—before you begin. Color in the shapes/volumes according to a color code (p. 45).
3. On your own, write other "y" words: why, coy, eye, yonder, yodel, lily, yellow.

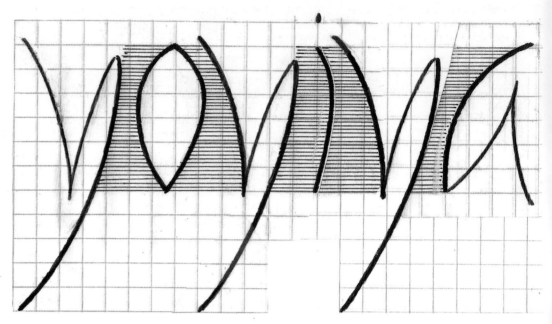

Fig. 3 **"y-o,"** convex; **"o-y,"** left nested; **"y-a,"** left nested; **"i-y,"** left nested; **"y-a,"** convex

yield evelyn voyage yogi yay wavy sexy

Fig. 4

Spacing "z" (Fig. 5)

The spacing for this open letter is similar to that for "c," "e," "x" and "s." Combinations with these letters apportion some of their open (white) space to the letter's identity and some to interletter space (blue line). Eventually, a calligrapher chooses the ratio between them, weighing concerns for legibility with those of graphic expression. For now, note that following the model results in a slight spatial *unevenness*—which is not a problem.

Note the "z"s of Fig. 5 also demonstrate plasticity. (Next page)

Tools: Pigma Micron and Conte crayon
Paper: tracing vellum and drawing/JNB

Fig. 5 **"z-i,"** right nested; **"i-z,"** left nested; **"z-a,"** convex; **"a-z,"** concave; **"z-o,"** convex

1. Trace Fig. 5 with attention to the above comments and noting the variations in the horizontal strokes of "z."
2. Trace the words with their nested, convex and concave "z" combinations. (Fig. 6)
3. On your own, write other words that include "z": zigzag, zillion, zingy, zilch, maze, wiz. (For the "z-z" combination, see next page.)
4. Experiment with combining pressure patterns.

zig oz hazy azalea zodiac zany

Fig. 6

Letter plasticity

Plasticity is a defining trait of calligraphy. As noted in Playball (p. 27), it involves customizing letter strokes—their length and direction—to the meet demands of legibility and desires of self-expression. In each case, the calligrapher is as much interested in the configuration of the word as that of the letter. That is, in the process of constructing letters, you also distribute space within a word. Like a conductor, the calligrapher coordinates parts into a larger whole. In visual art, this aspect is often referred to as design. It is integral to calligraphic art.

The following exercises with "v" family letters aim at developing your calligraphic design skills: they introduce you to a repertoire of possible variations both to build confidence and prepare you to try out your own ideas. Again, attentive tracing is the first step.

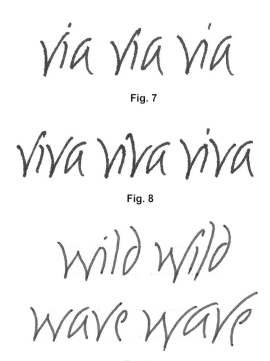

Fig. 7

Fig. 8

Fig. 9

> **Tools:** Pigma Micron (for tracing), Conte crayon, regular pencil
> **Paper:** tracing vellum, drawing/marker/JNB

1. **"v":** Trace, with even pressure, the three different "v-i" combinations in "via." (Fig. 7) Here, plasticity allows three different means of presenting the word.
2. Trace the word "viva" and note the three "viv" combinations. (Fig. 8) (Legibility alert: the "v-i" join may be mistaken for an "n." The calligrapher decides whether the context of the word suffices to resolve potential confusion.)
3. **"v" and "w":** Trace Fig. 9. The first version of each word uses the model alphabet; the second applies plasticity to create an expressive word image. Suggested words: vivid, wind, lavish, willow, woven, meow, swallow, howl, avid, wonder, view, wow.
4. **"z" and "zz":** Both invite your experiments with plasticity—contracting the top and bottom horizontals and/or dipping the bottom one below the baseline. (Fig. 5, previous page) Words: jazz, pizazz, pizzicato. Try experimenting first in pencil then in ink.
5. Further explorations: Use the Conte crayon: be bold; work larger.

Letter variants

To address particular spacing or expressive needs and delight the eye, calligraphers vary the design of letterforms. Although these changes stay within the bounds of an alphabet's style, they can be significant. For example, the model three-stroke "y" may become a two-stroke letter with a single-arc or reverse-curve descender. (Fig. 10) The exercises below explore this facet of calligraphic creativity.

> **Tools and papers:** as above.

1. Trace the model "y" and two variants. (Fig. 10, large letters)
2. Next, trace the words. Consider your response to the words using the various forms of "y." Note the use of plasticity as well.
3. If you feel ready, write these words or your own and experiment with designing variants. Use letters from your current repertoire. To stimulate ideas for creating letter variants:

- After writing a word, check it for legibility and spacing.
- If you see room for improvement, place tracing vellum over the word and sketch possible alternative strokes with a pencil.
- If this produces an idea for a variant, explore it on marker paper.
- Rewrite the word with your experiment/s.

Fig. 10 The model "y" and two variants

Note: As you gradually broaden your experience with alphabets, you also seed your imagination for creating new letter designs.

Letter Family 6: the "b" (bpkr)

Visual themes: tilted, pointed bowl
Although this bowl has the same shape as that of the "a" family bowl, it branches out of the downstroke. (Figs. 1 and 2)

Letter proportion: basically 1:2

Letter structure: Branching as in the "n" family.

Warming up

Tools: Pigma Micron, Conte crayon **Paper:** drawing/JNB
Guidelines: 2" downstrokes; 1" wide bowls
Speed: deliberate **Body:** shoulder and arm

Armature: Pigma Micron
1. Throw narrow, upright, clockwise ovals 2" high. (Fig. 3a)
2. Throw wider, sloped, clockwise ovals 1" high. Note the axis of the bowl. (Fig. 2)
3. Use the familiar breath pattern: inhale, upstroke; exhale, downstroke. Pressure can be the natural weighting and release of throwing.

Strokes: Conte crayon
1. Downstroke: Pull an "l" along the right side of the oval (combined start and end pressure, Fig. 3b)
2. Bowl: From the end of the downstroke, push an upstroke arc (even pressure); at the top; pull a downstroke arc (center pressure) to complete the bowl.
3. Repeat with a focus on rhythm and enjoyment.

Ductus and Dynamics

For ductus, trace the letters of Fig. 4 with even pressure, enough to feel resistance, according to the numbered arrows. For dynamics, use marker paper and trace again as shown in Fig. 5 (and described below). Hold the paper steady and visualize or set stretch points on the paper before beginning.

Tool: Conte crayon **Paper:** tracing, marker

(b, k, r)
1. **Downstroke:** For all three, begin with start pressure and conclude with end pressure. Pull the stroke in a smooth, rhythmical gesture.
2. **Branch-stroke dynamics:** Use the release of end pressure to push the upstroke branch. Give primary attention to the thumb.
3. **Finishing "b":** Pull an arced downstroke with center pressure to just below the baseline.
4. **Finishing "k":** For the loop, pull a short arced downstroke with center pressure just shy of the ascender. For the diagonal, pull an arced diagonal (center pressure) to a little below the baseline.

(p)
1. **Descender:** Begin just below the waistline and pull to the descender line. Lift the tool and replace it at the baseline.
2. **Bowl:** Make the bowl as in "b" but finishing a little shy of the descender, and of the baseline.

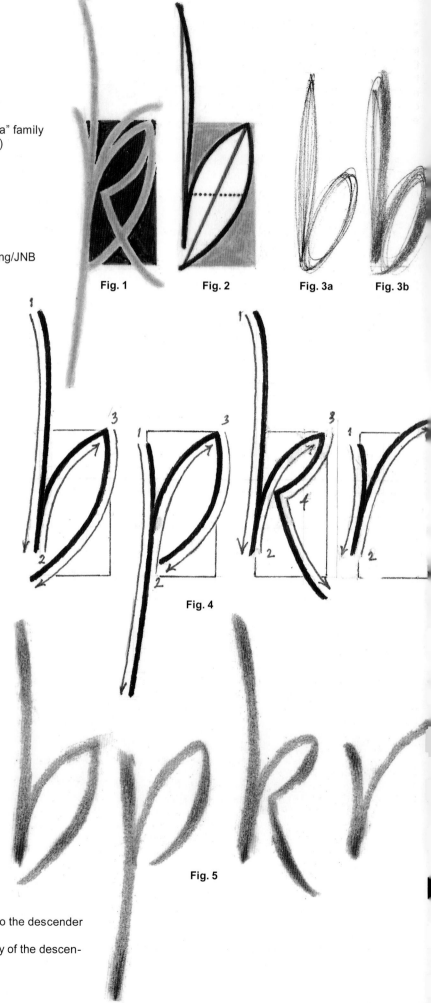

Fig. 1 Fig. 2 Fig. 3a Fig. 3b

Fig. 4

Fig. 5

Stroke technique: exiting a letter

In writing the calligraphic word, the exit from a letter continues the flow of energy and feeling. (Fig. 1) The exit activates the space between letters as it anticipates the next one. You engage in the dynamics of a stroke's exit through its pressure pattern. The exercises below develop your fluency in exiting from start, center, and end pressure patterns.

Exiting from end pressure

Here, the release of pressure at stroke finish energizes movement to the next stroke.

Tool: Conte crayon **Paper:** drawing **Guidelines:** 1½" apart

Connected strokes (Fig. 2)
1. Place the tool; inhale and press-release, softly.
2. Exhale and pull the downstroke using end pressure.
3. Release and move up on the inhale to exit. Use even pressure. The release of pressure is also the time to visualize the start point of the next stroke and take aim. Repeat to get a rhythmical action.

Separate strokes (Fig. 3)
1. Make a downstroke as above.
2. With the release of pressure, lift the hand off the paper and move directly (or air stroke) to the next start. Press-release and repeat rhythmically.

Word as image (Fig. 4)
1. Write words with "b" family letters using end pressure. Suggested words: spark, ribbon, kipper, surprise, peruke.
2. Write with restraint, as in "biblio," then try more expressive intent, as in "pillow," if you wish.

Start and end pressure combined (Fig. 5)
1. Make strokes combining start pressure with end pressure: first connected, and then separate.
2. Try this stroke pattern in words; then, a variation of it: alternating pressure patterns between strokes as in "rickrack."

Exiting from start/center pressure

This exit is a "rebound" action, where the energy of movement in one direction also contains enough fuel to reverse. (Fig. 6) It results naturally from the thrust released by start or center pressure. Remember: pressure patterns can be delivered with any degree of strength from soft to forceful. They can also be compressed or extended.

Tool, paper and guidelines: as above

Connected strokes (Fig. 7)
1. Place the tool; inhale and press-release, softly.
2. Exhale and pull the stroke with center pressure.
3. At stroke end, off the paper, continue the movement a short distance beyond the baseline. Immediately reverse direction and push a diagonal upstroke with even pressure. Repeat.

Separate strokes (Fig. 8)
1. Make a downstroke, curved or straight, with center pressure.
2. With the release of pressure, the hand lifts off the paper and, still using the energy of release, rebounds to the next stroke.

Word as image (Fig. 9)
1. Write words with "b" family letters using the rebound exit.
2. Try writing words with expressive potential, such as "silk."

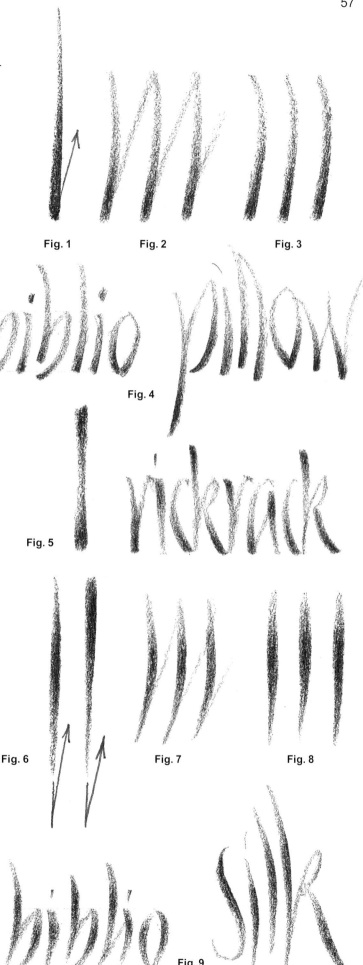

Fig. 1 Fig. 2 Fig. 3

Fig. 4

Fig. 5

Fig. 6 Fig. 7 Fig. 8

Fig. 9

Bowing (as with a stringed instrument)

Calligraphic "bowing" begins by imagining the physical gesture of a musician drawing a bow. Calligraphic bowing connects you, through the bicep, to the physical, somatic experience of the stroke as a felt, emotional one. It takes time to fully engage this muscle but, by involving it, you develop a more dynamic, engaged connection to the stroke. Note: The rebound exit is a natural part of the bowed gesture.

Tool: Conte crayon
Paper: drawing/JNB, marker
Padded surface

Awakening the bicep

1. Place the tool on the paper; inhale; on the exhale, sink down sending your attention first to the shoulder as the source of the weight, and then to the bicep. Touch the bicep with your other hand. Allow yourself time to awaken to this muscular sensation and perceive the bicep.
2. Release; then make a stroke with start pressure, trying to engage the bicep.
3. Make a segmented, long-line slalom of diagonals; first with start and then with center pressure, focusing on the bicep as the source of pressure. (Figs. 1 and 2)

Bowing

Translated to calligraphy: the tool is the "bow," the paper is the "string," and the stroke is the "note." In the exercise below, explore the sensation of contact as you apply bowing to stroke making. Consider it as a way of attuning to your own "music," or mood.

1. Place the tool on an inhale. (Fig. 3)
2. On the exhale, bow a downstroke with start pressure, 2 to 3 inches in length, focusing on the bicep. (Fig. 3)
3. Rebound on the inhale as you push up to the next stroke.
4. Continue the pattern; then repeat it with center pressure. (Fig. 4)

Experiment: make the downstroke with a forceful thrust, leaving the paper. Does this change the feel of the rebound exit and upstroke?

Alternating patterns and back-to-back patterns

1. Alternate strokes using start- and center-pressure patterns. (Fig. 5) Note that the start-pressure arcs are subtly asymmetrical and the center-pressure arc more symmetrical.
2. Make two start-pressure strokes back-to-back, then two center-pressure strokes back-to-back, and next alternate these couplets. (Fig. 6)
3. Write words, such as "combining." (Fig. 7)

Playing with arcs and words

1. Identify the pressure patterns in Fig. 8.
2. Trace these playful, gestural arcs, bowing the patterns you identified.
3. On your own, work according to your mood, spontaneously, or from a preliminary sketch.
4. Rewrite "biblio," or another word (Fig. 9): focus first on bowing the strokes, then on the exits. Connect the letters of the word first on the paper, and then lifting the tool between letters but continuing the flow of energy.

Note: Bowing enriches stroke making with greater pleasure as it deepens the expressive potential of this act.

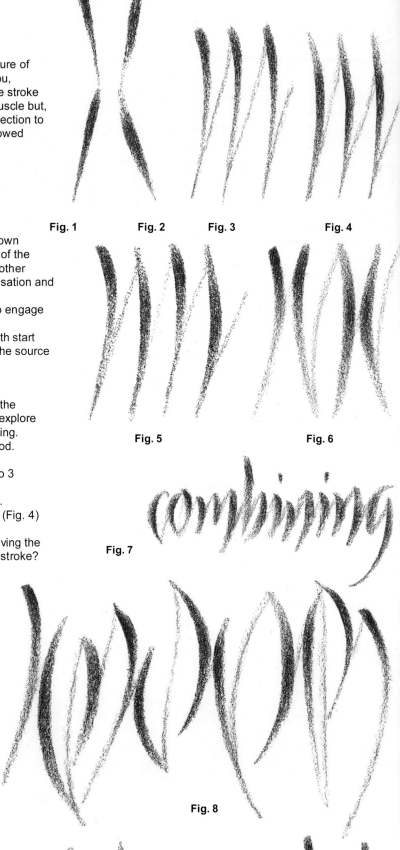

Fig. 1 Fig. 2 Fig. 3 Fig. 4

Fig. 5 Fig. 6

Fig. 7

Fig. 8

Fig. 9

Spacing: the "b" family

This family contains both closed letters, "b" and "p," and open, "r" and "k." Like the "o" family's "c" and "e," the "r" and "k" give some of their open space to letter identity and some to interletter space. (Figs. 1 and 2) Once again the standard of evenness serves as a frame of reference rather than as an absolute measure. In making spacing adjustments, remember the calligraphic stroke's plastic nature as an aid to distributing space.

Tools: Pigma Micron
Paper: tracing vellum, drawing, notebook

1. Identify each spacing combination and trace it. (Fig. 1)
2. On drawing paper, rule guidelines ½" apart.
3. Write words with your current repertoire of letters, visualizing stretch points. (Fig. 3, suggested words) Then, identify the spatial combinations they contain; next rewrite them to make any desired adjustments. Refer often to the reference space. (p. 13)
4. Color the interletter spaces using the code on page 45 or your own.

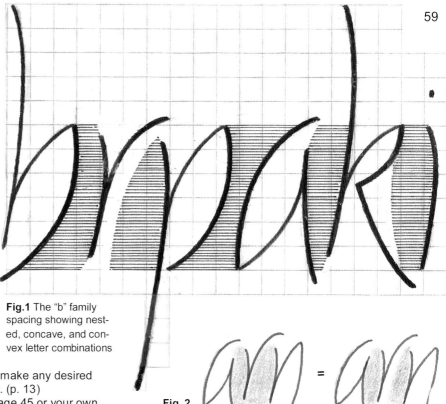

Fig.1 The "b" family spacing showing nested, concave, and convex letter combinations

Fig. 2

Fig. 3 baroque poem dab gap big pier nibs globe hop

Word as image: dynamics

Now, turn your attention from analysis to dynamics—to bowing and feedback from the bicep. This exercise contrasts words written with guidelines (Figs. 4 and 5) with those written without (Figs. 6 and 7). The latter is intended to invite a freer, possibly more interpretive exploration, one arising out of the freely bowed gesture. Do you detect signs of plasticity or hints for letter variants? The baseline, drawn after writing (Figs. 6 and 7), is added to help you reflect upon the results.

Tool: Conte crayon **Paper:** marker, drawing/JNB **Guidelines:** ¾" - 1" apart **Speed:** slow and deliberate, or experiment

1. Use bowing as you trace Figs. 4-7—to get the feel and become comfortable with your breathing and gestures. Use marker paper.
2. Write your own word couplets with and without guidelines. Suggested words: monkey, jump-rope, lullaby, parade, sarabande, experience, bounce.

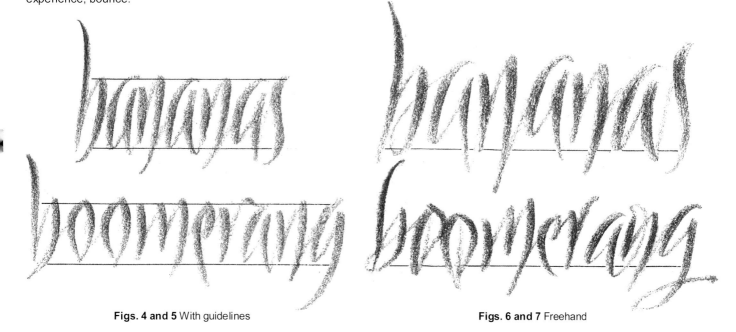

Figs. 4 and 5 With guidelines **Figs. 6 and 7** Freehand

Word as image: plasticity and letter variants

Returning to analysis, this exercise presents different approaches to the challenge of spacing "r" and "k."

Plasticity

1. Two "r"s side by side. On the second one, try stretching the arc and dropping its stem below the baseline. (Fig. 8)
2. Write words with the double "r" (marriage, barrel, irregular), and with the single "r" (road, organ, branch, word, roar).
3. The "k." The diagonal of this letter has a tendency to swing and, in doing so, create too much interletter space.(Fig. 9, top line. Note: Other open letters, such "e," are also vulnerable to over spacing.) Stretching the diagonal of "k" may be suitable at the end of a word, but it should be restrained at the beginning of or within a word. If its swing is not curbed, especially if the space between words is insufficient, legibility is impaired. (Fig. 9. Compare the top and bottom lines).
4. Write words with "k" in the initial, mid- and end positions of a word (kind, bike, pick).

Variants

In the word "ride," an "i" that faces right instead of left reduces an otherwise unwieldy amount of space. (Fig. 10)

The "r-y" combination is particularly challenging. Using the model creates too much space between letters; it goes beyond an acceptable unevenness. (Fig. 11a) Here, a variant of "y" offers a solution. (Fig. 11b)

Legibility alert: tangles below the baseline

When "b" follows "a" or "e," the likely result is an unwanted tangle or joining of downstrokes. (Fig. 12) To avoid these, use plasticity to adjust the length of one or both of the strokes.

Fig. 8

Fig. 9

Fig. 10

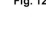

Fig. 12

Fig. 11a Fig. 11b

Letter Family 7: the "f" (ftu)

The "f" family completes the training alphabet of Jumprope.

Visual themes: vertical and horizontal arcs

In this family, vertical arcs open to the right, and the horizontal arcs face down for the top of "f," or up, for the crossbars of "f" and "t." The "u" combines an initial right-facing arc with the second and third strokes of the "a." (Fig. 1)

Letter proportion: basically 1:2

Letter structure: In Fig. 2, two straight brown lines, a short horizontal and a long vertical, meet at an angle to reveal the double-arc structure of the "f" downstroke. Thinking of this unfamiliar stroke as a horizontal arc meeting a vertical arc helps the calligrapher pattern its flow and find its rhythm.

Reminder: Although the three "d"s—design, ductus and dynamics—are taken up separately, in calligraphic practice they interact. The "f" offers an example. Structural analysis (design) reveals two arcs, rather than one. With this understanding, a letter which appears to be a single stroke (ductus) becomes two contiguous arcs to provide a framework for rhythmical action (dynamics).

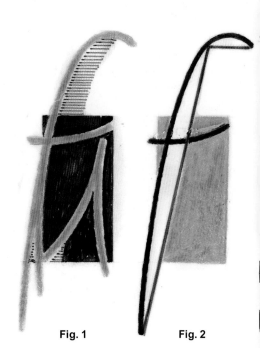

Fig. 1 Fig. 2

Warming up: wrist pivoting

I have emphasized that calligraphic action takes place primarily from shoulder to fingertip, but the wrist is also a player. The following pivoting exercises help you become more aware of the wrist to better maintain it in a fixed position. You'll use this skill as we continue with two-point tools and the edged pen.

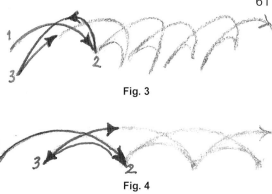

Fig. 3

Tool: soft pencil **Paper:** drawing/JNB

Wrist pivot, vertical: From the wrist, throw quick, loose, and continuous vertical arcs about 6"-8" high. (Not shown here.)

Wrist pivot, horizontal:
1. From the wrist, quickly throw arcs sideways 2"-3", pivoting back and forth. Imagine a pendulum swinging overhand. (Fig. 3)
2. Throw arcs slowly and rhythmically, beginning and ending each with soft pressure. (Fig. 4)

Fig. 4

Ductus and **D**ynamics

For ductus, trace the letters of Fig. 5 with even pressure, enough to feel resistance, according to the numbered arrows. Note that the "f" does not reach the ascender line. For dynamics, use marker paper and trace Fig. 7 as described below. Hold the paper steady, and visualize or set stretch points before beginning.

Tool: Conte crayon
Paper: tracing vellum, marker
Body: fixed wrist

(f)

1. **Top stroke:** Place the tool at number 1. Inhale, press-release and push up to the top of the horizontal arc—the first stretch point. (Fig. 6, arrow) Pause briefly while visualizing the place where the downstroke arc begins—the second stretch point. (Fig. 6, the intersection of the solid brown lines)
2. **Downstroke:** Exhale, sink a little and pull around the stretch point; apply center pressure to the long-arc downstroke. Keep the wrist fixed as you pull this stroke. Let the arm move, try not to plant it on the table/board. It you like, use the pinky for support/balance.
3. Make a rebound exit (p. 57) on the inhale and place the tool at the beginning of the crossbar—a little to the left and below the waistline.
4. **Crossbar:** Exhale and use start pressure to push a shallow arc slightly upward.

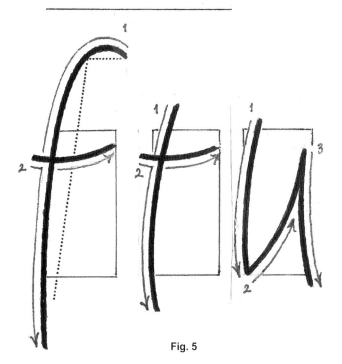

Fig. 5

Note: To help accomplish the "f" downstroke, imagine its two-part action as a waterfall: as movement which leads to a promontory and then falls over and down in a rush of energy. Visualizing this, try the stroke a few times.

(t)

1. **Downstroke:** On an inhale, place the tool slightly above the waist-line. On the exhale, pull the downstroke arc with center pressure. Rebound to the left of the downstroke to begin the crossbar.
2. **Crossbar:** As in "f."

(u)

1. **First downstroke:** On an inhale, place the tool a little above the waistline. On the exhale, pull the stroke with center pressure to the baseline. Pause briefly.
2. **Upstroke:** Inhale, apply a little pressure and push the arced up-stroke with this pressure (even), ending just below the waistline.
3. **Second downstroke:** Exhale and pull the stroke with center pressure to just below the baseline.

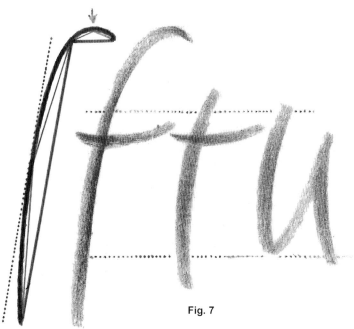

Fig. 7

Note: There is room for play in the height of "f" and "t." An increase or decrease depends on the letter's position relative to other letters.

Fig. 6

The visually distinct dots on the cactus represent the physically discrete applications of pressure in pulsing.

Note: The technique below requires/develops a more advanced skill. Try it, but don't be frustrated if you're not ready for it now. You may want to return to it later.

Stroke technique: "pulsing"

So far you have learned to apply and release pressure at various places within a stroke (center, start, and end). With pulsing, you apply and release pressure as discrete points repeated continuously along a stroke. As with applying start, center, and end pressure, the tool does not leave the paper. Consequently, the continuous line of pressure points creates a pulsing pressure pattern that is felt but not visible.

Here, one point immediately following another brings you firmly into the moment-by-moment act of stroke making. This offers a vivid engagement with the stroke's flow and energy. The continuous application of pressure/pulse points orients the calligrapher's body-mind rather than leaving a record of pressure variation.

The bodily sensitivity needed for pulsing develops gradually, perhaps because it starts with slowing down—an unfamiliar tempo in modern life. As a moving meditation, it's a path to relaxation and alertness. Remember to breathe, not necessarily in the structured way of previous exercises, but comfortably, as an integral part of the action.

Getting the feel
The physical exercises below prepare you for an enhanced mental engagement with the stroke.

Fig. 1
Conte crayon
and compressed charcoal

Tools: Conte crayon and/or compressed charcoal **Paper:** drawing/JNB
Speed: slow and exploratory

Physical (Fig. 1)
1. Greater pressure: Make a line 2" to 4" in length. Forcefully apply discrete points of pressure from the shoulder. This activates the fingers, which now join the shoulder in your attention. In the brief releases of pressure, stay in paper contact, letting the weight of the shoulder also pull the tool. Finger and arm-shoulder muscles relax momentarily in the releases of pressure—a strobe-like effect for the muscles.
2. Less pressure: Apply just enough pressure to feel the pressure points as discrete but subtle events as you pull the stroke.

Note
Pulsing gradually enhances your ability to refine strokes and use them expressively.

Figures
Using the above experiences with pulsing, try the designs of Fig. 2 or create your own.

Fig. 2

Words (Fig. 3)
Write words with pulsing. Pulsing technique can be part of any other pressure pattern. When you're ready, try imbuing the other pressure patterns with pulsing awareness.

Other uses of pulsing/pulse points:
- To refresh your attention.
- To start or end a stroke. (See "Press-release," Stroke technique, p. 33.)
- To enhance concentration for highly precise work.

Fig. 3

Spacing:
the "f" family

The "f," like all open letters, apportions some of its open (white) space to its identity and some to the interletter (blue lines) space. (Fig. 1)

Tool: Conte crayon
Paper: tracing vellum

1. Identify the spacing combinations of Fig.1: e.g. "concave." Note that the nested "ff" and "fu" combinations are equidistant.
2. Trace Fig. 1. Work slowly. Try pulsing if you're ready.

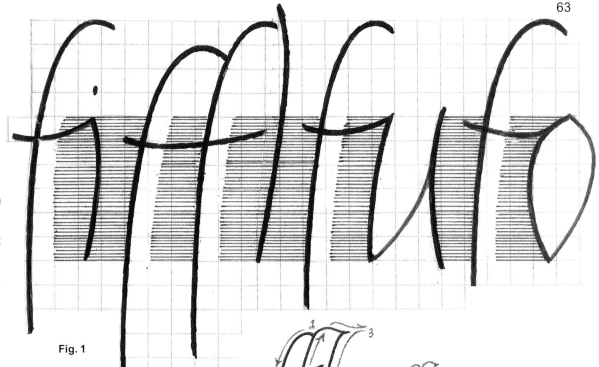

Fig. 1

"f" and "t" ligatures

The crossbars of "f" and "t" often connect to letters in a *ligature:* Two letters joined together by a stroke of the first letter. Ligatures, a tradition since the Middle Ages, add to the sense of movement and flow.

Tool: Pigma Micron
Paper: tracing vellum, drawing/JNB
Guidelines: 3/8" apart (body height)

1. Trace all the figures noting the ductus arrows. (Fig. 2)
2. On drawing paper, rule guidelines and write words, first without ligatures and then with them. Suggestions: baffle, muffler, transformation, first, statistic.

Fig. 2

Word as image

Here, you practice analysis of interletter spacing with the words written above.

Tool: Pigma Micron **Paper:** drawing/JNB

Uneven spacing

Fig. 3

Fig. 4

Analysis
1. Look at each word as a whole, lightly squint your eyes to help spot deviations from evenness. Remember to allow for the unevenness of open letters, which now include "f, t, and r."
2. Identify the shapes of the spaces each letter combination creates: concave, convex and nested. (Fig. 3)

Rewriting
1. Adjust interletter spacing: in Fig. 4, it increases ("i - n") and decreases ("e - r"). Compare the first version with the rewrite.
2. Experiment with plasticity, letter variants and ligatures. (Fig. 5)
3. Trace the rewritten words with attention to the dynamics of stroke and exit making.

Fig. 5

Word spacing: Line as image

Word spacing is to the line as interletter spacing is to the word; in both, you distribute space to create a calligraphic image. For the line, the first aim is to separate words clearly and distinctly while keeping a sense of connection between them. How much space is enough for this dual purpose? Explore this in the exercise below.

Note: Although the space between words is naturally larger than that between letters, it, too, is bounded by letters and exhibits the same concave, convex, and nested shapes found within words. (Figs. 1-4)

Tools: Pigma Micron, Conte crayon **Paper**: ruled notebook and drawing/JNB

Step one: Spacing two words
1. Choose two words that are meaningfully connected to each other, e.g., a name or place, and write them as one word. (Fig. 1)
2. Add a little more space between them, but not enough to make them clearly distinct. (Fig. 2)
3. Write the words with enough space for certainty. (Fig. 3) It may take more than one try. Squint your eyes to help you see the words and the space between them as units.
4. Disconnect the words by adding too much space. (Fig. 4)

Step two: Spacing more than two words
In a line of words, the first space between two words becomes the reference space for word spacing. (See p. 16.) Making these spaces as similar as possible enhances legibility in the same way it does in spacing letters evenly in a word. (Fig. 5)
1. Choose a few words that are meaningfully connected, e.g., a title or phrase.
2. Write the first word and look back at the spaces between the letters.
3. Allow two to three times this amount for the space between the first two words.
4. Write the second word and look back at the space between it and the first word.
5. Approximate this space as you place the first stroke of the next word.
6. Squint to analyze the phrase for evenness between letters and words. Rewrite with any adjustments, placing a new sheet of paper below the words.

Step three: Fine tuning
The space between words depends on the space between letters. Generally, the greater the interletter space, the greater the space between words. (Fig. 6) Rewrite the above words with the letters a little closer together and a little further apart; adjust the word spacing as needed.

From "The Marriage of Heaven and Hell" by William Blake

Fig. 1 mickread
Fig. 2 mick read
Fig. 3 mick read
Fig. 4 mick read

Fig. 5 beginning my studies

Fig. 6 mick read / mick read

energy is eternal delight

Interlinear space:
Text as image and experience

Interlinear space—the distance between lines—is the last spatial element needed to design a text. (Fig. 7) In choosing the amount of this space, calligraphers engage two expressive facets of text design: "texture" and weight, or "color." Here, "texture" refers to the interweaving of letter strokes between written lines. In Fig. 8, next page, the greater distance between the chorus lines allows the ascenders and descenders to sweep boldly into the interlinear space. Next weight/color, which here refers to the mixture of light and dark—to the lines of writing and the interlinear space between them. The eye reads this as a gray tone when using black and white. In Fig. 8, compare the verses with the chorus.

letter spacing word spacing

lower-case
alphabet

beginning my studies the first step pleased me so much,
the mere fact consciousness, these forms, the power of motion,
the least insect or animal, the senses, eyesight, love, interlinear space
the first step i say awed me and pleased me so much,

Fig. 7 From "Beginning My Studies" by Walt Whitman

The exercises below feature two essential aspects of writing a text—its design as noted above, and the experience of writing as a rhythmical act. A text, with its repetition of letters, words and lines, helps provide this experience.

Although capital letters are still needed for many purposes, despite e. e. cummings, e-mail and text messaging, studying them at this point would stall your momentum. Focus here on gathering the written and spatial elements you know and knitting them together into a text.

> **Tools:** Pigma Micron, Conte crayon
> **Paper:** notebook and drawing/JNB
> **Text:** Choose a text for its personal meaningfulness and/or a felt connection to the spirit of Jumprope.

Note: Although we usually practice with the precisely ruled lines of scribal tradition, the unruled lines of letters and documents are also part of our heritage. Explore both below.

Ruled lines
1. Use the ruled lines of notebook paper as the base- and waistlines for body height.
2. Experiment with interlinear space
 a. One line space between lines of writing: keep ascenders and descenders short.
 b. Two line spaces: slightly extend ascenders and descenders.
 c. Three line spaces: stretch ascenders to the baseline of the line above and descenders to the waistline below. "Ride" these long lines, staying with the stroke in a sweeping gesture.
3. Focus on rhythm using what you know about the forms. Remember to pause briefly before changes in stroke direction.
4. Move the paper as needed to keep the writing in front of you.
5. Remember to let the breath help you maintain shoulder awareness and to stay with the stroke.

Troubadour by Mick Read Calligraphy by Gina Jonas

Fig. 8 In this piece I sought to calligraphically interpret the lyrics of a song by my singer-songwriter husband. Through variations in interlinear spacing, nib size, proportion, and letter style, I explored visual possibilities for expressing the mood of loss and caution.

Unruled lines
1. Work small with the Pigma Micron (Fig. 9) and/or large with a Conte crayon on a large sheet of drawing paper.
2. Warm up before starting. Don't worry about the absence of ruled lines. This enables you to work more spontaneously and with greater freedom. Focus on the spirit of writing: on engaging written forms as gestural compositions.
3. Experiment with different speeds. An alphabet model like Jumprope supports learning and grows confidence, but it can constrain expression and creativity. For those wishing to go beyond the model, speed can help break its constraints and release spontaneity. Also, note the tendency of letters to slant when you speed up.

Fig. 9 Unruled lines; adding speed but keeping the focus on rhythmical movement. Lines from Walt Whitman's "Beginning My Studies"

Character potpourri

Common symbols used in writing, such as the ampersand, invite the imagination. (Fig. 1)

The ampersand

This character stands for *and*. It is a ligature of the letters "et," Latin for "and." The symbol takes two basic forms: the "&," from classical antiquity, and the "et" ligature from the Renaissance. (Fig. 2) There are many possible designs and stroke orders for these figures. Here are a few suggestions.

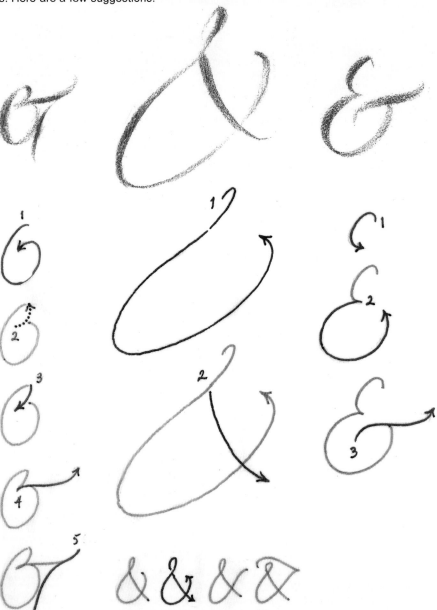

Fig. 1 The two ampersand examples above and below are from wedding invitations. They were designed to connect the names of bride and groom and have the same stylistic flavor as the writing.

Fig. 2 Ampersand designs with ductus

Exercise

 Tools: Pigma Micron, Conte crayon **Paper:** marker

1. Trace Fig. 2 with a Pigma Micron for ductus and a Conte crayon for pressure patterns.
2. Write two words three times, each time using a different ampersand design between them. Consider the variation in their look and feel.

Renaissance handwriting manuals often included the ampersand at the end of the alphabet.

Et cetera

Et cetera is a Latin expression that means "and other things" or "and so forth." (*et,* "and;" *cetera,* "the rest") This symbol builds on the "et" and can be written etc. or &c. (Fig. 3) Use the ampersand's ductus and add the "c." Try this sign at the end of a list. (Fig. 4)

Fig. 3

The treble clef

The present form of this sign, also known as the G-clef, may be the result of a 17th century notational technique. Its current design likely evolved in the course of copying musical manuscripts by hand. (Fig. 5)

The @: Try an email address (Fig. 6).

Fig. 6

Numbers

Numbers, when used in a text with a particular alphabet, take on its style characteristics. The numbers in Fig. 7 were designed to accompany Jumprope. As in the address of Fig. 8, numbers are usually a little larger than lower-case letters.

Fig. 7 The numbers above, called "lining," or modern, are written between two lines.

Fig. 8

"Dingbats"

are ornaments used within or to conclude a text. Trace; then invent your own.

Fig. 4

Fig. 5 As in "fingering" music, there's more than one way.

"Making": word as image—a label

The next two exercises produce calligraphic pieces with a single word. They introduce step-by-step methods for making a finished piece. I encourage you to undertake them in the spirit expressed by the poet Robert Bridges: "I too will something make/And joy in the making!"

The first piece, a label, is practical; the second, a "reminder," is of a more personal nature. In the process of making, you are guided by the interaction of objective and subjective factors. Objective factors are such practical elements as size and appropriateness. Subjective factors include such personal elements as expression and meaning. Enjoy their interplay as you enter into the process of design set out below.

These pieces introduce two ways of working with size and proportion:
1) "fixed format," in the label, where these are predetermined and
2) "fluid format," in the reminder, where intention plays a greater role.

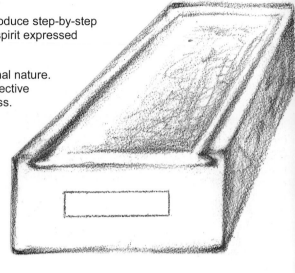

Fig. 1

Preparation: asking questions
The questions below guide a creative process.

> 1. What is the purpose of the label? To identify a tool drawer. (Fig. 1)
> 2. What size is the label? It is pre-cut to ¾" x 3".
> 3. What style is the writing? Jumprope.

Testing: "roughs"
In making roughs you experiment with tools, materials, and calligraphic elements such as letter height and proportion. (Fig. 2) They serve to help you develop a range of graphic ideas.

> **Tools:** HB or #2 pencil for ruling, Pigma Micron for writing
> **Paper:** marker paper or layout bond. As noted earlier, these papers offer an excellent writing surface, and their translucence is highly desirable for testing roughs in the design process. (See p. 36 for brands)

1. Place the label on a work surface.
2. Test the size of the writing on one of the above papers.
 a. Write the word at a size you think will fit the label. Work with/without guidelines.
 b. Cut out the word and place it on the label.
 c. Assess: Too big, too small; does it serve your purpose—clearly identifying the drawer? Adjust as necessary.
3. Style: You can try changes in proportion, a narrower or wider form; slant, more sloped or upright; the ratio of the ascender/descender height to body height, e.g., a shorter ascender changes the feel and may help to fit the space. (Fig. 2)

Fig. 2
Left: Jumprope model
Right: wider proportion and shorter extenders

Composition: positioning
Composition is an interactive process, bringing essential parts into a vital whole. You begin by experimenting with the position of your word image within the "visual field": the space encompassed by the top, bottom and side edges of a writing surface. The photographer positions an object within the camera's viewfinder; the calligrapher creates an adjustable "view" with strips of black paper or matboard. (See photos this page and next) Calligraphers refer to such strips as "frames" or "finders."

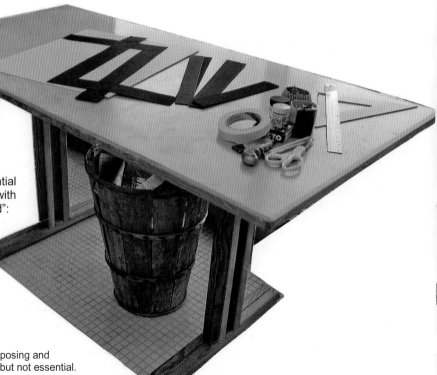

A layout table provides a flat surface for composing and holding supplies. It's useful but not essential.

Materials: for frames
- Heavy black paper
- Pencil for ruling on black, e.g., Pentel Metallic, 1.3
- Ruler with a cork backing
- Scissors (or knife, See Cutting, p. 124)

Cut four strips, one inch wide, and long enough to frame your label; or make L finders: two right-angled corners (photo). For larger work, make more sturdy frames of black mat board (with a black core, if available).

Materials: for experimenting with position
- Tracing paper or vellum
- Frames (above)

Fig. 3

Positioning: get acquainted with some possibilities

1. Top to bottom
 a. Place the word nearer the bottom edge of the label. (Fig. 3, top)
 b. Place the word in the center. (Fig. 3, center)
 c. Place the word nearer the top edge. (Fig. 3, bottom)
 d. Repeat each position covered with tracing vellum. (Figs. 4a and b) This lessens the need to squint and helps you to see the position of the image more clearly.
 e. At each position, place the frame strips over the vellum at the top and bottom edges of the label. (Fig. 4c)
 f. Decide which position gives you the most pleasure.

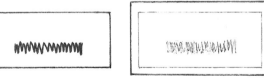

Fig. 4a
Rough on label.

Fig. 4b
Vellum (bold line) covers rough.

Fig. 4c
Frames placed over vellum.

2. Side to side
 a. Place the word nearer the left edge of the label. (Fig. 5a)
 b. Place the word in the center of the label. (Fig. 5b)
 Symmetrical compositions create equal spaces on either side of the image. They connote formality, authority, convention, elegance; they produce a static balance.
 c. Place the word nearer the right edge. (Fig. 5c)
 Asymmetrical compositions distribute the space unequally to either side. (Figs. 5a and c) They express less formality and a dynamic balance.
 d. Use the frames and vellum to view and test the three positions of your word as in Figs. 5a, b and c.

Fig. 5a Left

Fig. 5b Centered

Fig. 5c Right

Transferring: measuring

This prepares you for the next step, ruling. It involves measuring all aspects of the composition, or final rough, with either a conventional metal ruler or customized "paper rulers." (As pieces become more complex, a metal ruler cannot easily record or retain all the details.) Because this piece is not complex, it's a good time to get acquainted with the paper ruler.

Materials: all of the above, and
- Plain paper
- Kneaded eraser
- Pencil: #2/HB, sharpened to a fine point. I recommend the Staedtler sharpener. Or, whittle the lead with a knife and "point" it on a paper surface.
- Drafting tape

Fig. 6 **Fig. 7**

Fig. 8 **Fig. 9**

Setup
Place your word on the label in the position you have chosen and
1) carefully place a piece of tracing vellum over it;
2) place framing strips over this at the edges of the label (Fig. 6), and
3) rule lines on the tracing vellum for the waist- and baselines of your word. (Fig. 7)

Measure: making "paper rulers"
Cut two strips of paper both ½" wide: the first, the height of the finished piece (here, the label, Fig. 8) and the second, the width of the piece. (Fig. 9)
1. Vertical positioning: Write "T" at the top of the first ruler. Place it over the tracing vellum, its top aligned with the top of the label. Mark the base- and waistlines. (Fig. 8)
2. Horizontal positioning: Write "L" at the left edge of the second ruler. Place it horizontally just above the word, with its left edge aligned with the label's left edge and mark the beginning of the word. (Fig. 9) If centering the word, see below.

Fig. 10

Transferring
1. Now, lightly pencil the marks from the paper ruler onto the label at both the left and right edges. (Fig. 10)
2. Mark the beginning of the word. (Fig. 10)

Centering
Pencil a mark in the center of both the visual field (here, the label) and the rough. (Fig. 11) Align these marks, one above the other. Optically, an image appears centered, top to bottom, when it is actually just above it, with slightly more space at the bottom. The challenge of spacing a word horizontally arises naturally: the letters at either end of a word are not straight verticals (note the "p" and "s" of "pencils"). To meet it, balance the open curves and bowls visually, offsetting the open space at one end of the word with that at the other. This skill develops with practice.

Fig. 11

Ruling
Here, with only two to four lines to rule, you can limit ruling equipment to a pencil and cork-backed ruler. Rule carefully: stay as light as possible, but dark enough to see.

Finished work: relax and focus
1. Use the finish tool and warm up with a breath and movement exercise, for example, the reverse curve "compass." (See p. 52.)
2. Write your word on the same kind of paper as the finished piece—here, a spare label—a few times.
3. Tape the rough just above where you'll write on the label. (Fig. 11)
4. Write the label and erase the ruled lines.
5. Stick it in place. (Congratulations!)

Making: word as image —a reminder

The power of the word goes beyond identifying objects; a word can "re-mind" us of actions we want to practice in daily life. This piece introduces composing in a fluid format, one in which the finished size is not pre-set.

Fig. 1

Preparation

- Purpose? To create a card that carries a word to be kept in view and easily moved about. A table tent should suit this purpose. (Fig. 1)
- Size? Approximately 2"x 4". Precise measurement depends on the size of the writing and the space surrounding it.
- Writing tool? Conte crayon.
- Additional tools? A bone folder.
- Finish paper? Sturdy white or off-white stock such as Strathmore 2- or 3-ply.
- Style? Jumprope, with its quiet liveliness, is suitable for my reminder to "breathe."

Testing

Tools: pencil for ruling, Conte crayon
Paper: marker/JNB **Ruler** (cork backed)

1. On the marker/JNB paper, draw a rectangle the approximate size of the visual field.
2. On another piece of this paper, test writing sizes.
 a. Cut out the roughs and place them in the proposed visual field.
 b. Make any desired changes in body height, and the ratio of body height to extender (ascender/descender).
3. Style: Experiment with Jumprope as in the first project. Take your time; play. This kind of relaxed concentration tends to invite creativity.

Composition

Paper: tracing vellum **Frames Paper ruler**

1. Cover your working rough with tracing vellum. (Fig. 2) Position the frames at different vertical and horizontal distances from the word.
2. Make desired adjustments (size, style, margins).
3. Finally, use a paper ruler to mark the position of the word in the visual field.

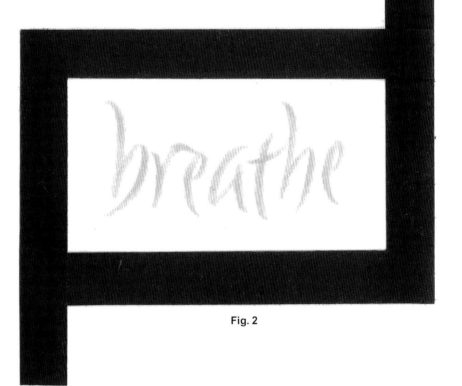

Fig. 2

Transferring, Ruling and Cutting

Tools: pencil for ruling, Conte crayon **Paper:** finish
Scissors/cutting equipment (See "Cutting," p. 124.)
Bone folder

1. Transfer the information in light pencil from the paper ruler to the paper for the finished card. Remember to double the height to allow for folding. With a smearable tool such as the Conte crayon, rule the lines so they are barely visible.
2. Cut out the card.
3. On the reverse side of the card, rule a line midway etween the top and bottom. "Score" the line with the point of a bone folder for later folding.

Finished work

1. Repeat steps one through three for the label.
2. Erase lines, if applicable.
3. Use a spray fixative to prevent smearing. Fold.

"Graphopoeia"— word as expressive image

The calligrapher's expressive potential expands through the use of plasticity and letter variants. The next step for investigation (hinted at previously) is a word's visual expression of its meaning—graphopoeia. Poets use "onomatopoeia," where a word's meaning is in its sound—"buzz," "splash," "whisper." In a similar way, graphopoeia, a term my husband coined, conveys a word's meaning (or some aspect of it) in its appearance. Exercises in graphopoeia help you develop calligraphic empathy—the ability to identify with feelings implied by the direction of strokes and the posture of letterforms.

The process

As in literary translation, the calligrapher transcribes one set of symbols into another: here, verbal to visual. Take the word "machine" as an example (next page). First, consider its meaning—denotative, includes precision and repetition, and connotative, includes conformity and rigidity. (Graphopoeia, like metaphor, does not aim to represent the entire range of a word's meanings.) Second, look for graphic "equivalents" in the realms of line, space, and shape. For example, "machine": compression (rigidity); staying within the guidelines (conformity); and emphasizing vertical downstrokes (mechanical repetition).

Warming up

Graphopoeia integrates mind and body in the process of creating a "word picture"—an evocation of verbal meaning. Relaxed alertness supports this undertaking. Take a little time to tune up by stretching, and opening and closing your fists. Can you exert the forces of push and pull using the body as its own source of resistance? Think of an actor wishing to let go of familiar tensions before performing. (You might try yoga's Lion pose, or just sticking out your tongue.) Look at such preliminaries as an invitation to the imagination.

Tracing

The following exercises offer a method for developing your connection between a verbal meaning and its calligraphic expression.

> **Tool:** Conte crayon or other relatively soft tool
> **Paper:** tracing vellum, drawing/JNB

1. Trace "dandelion," a graphopoeiac rendition using Jumprope (this page). I suggest enlarging the word by 100% before you begin.
2. Now write "dandelion" on drawing paper, using the model alphabet Jumprope. Rule guidelines using the first "n" of the enlarged copy for your body height.
3. Compare the two. Place the traced "dandelion" over the model alphabet "dandelion." How do they vary? How does the use of plasticity and/or letter variants help you create a graphic interpretation? How does the Conte crayon influence the visual meaning?

Choosing a word

Choose a word that would lend itself to graphic expression. Test its potential by considering the following:
 a. **spirit:** e.g., dynamic/static; extrovert/introvert; serene/disturbed
 b. **gesture/posture:** e.g., stiff/soft; relaxed/tense; upright/slouched
 c. **movement:** e.g., skipping, marching, wandering; light and free/heavy and lugubrious; coordinated/chaotic
 d. **orientation:** e.g., level, straight ahead; ascending/descending; undulating curves, serpentine
 e. **characteristic traits:** e.g., a monkey's tail, a giraffe's neck

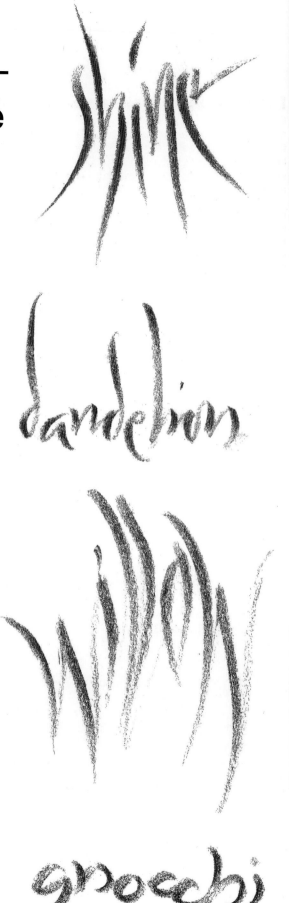

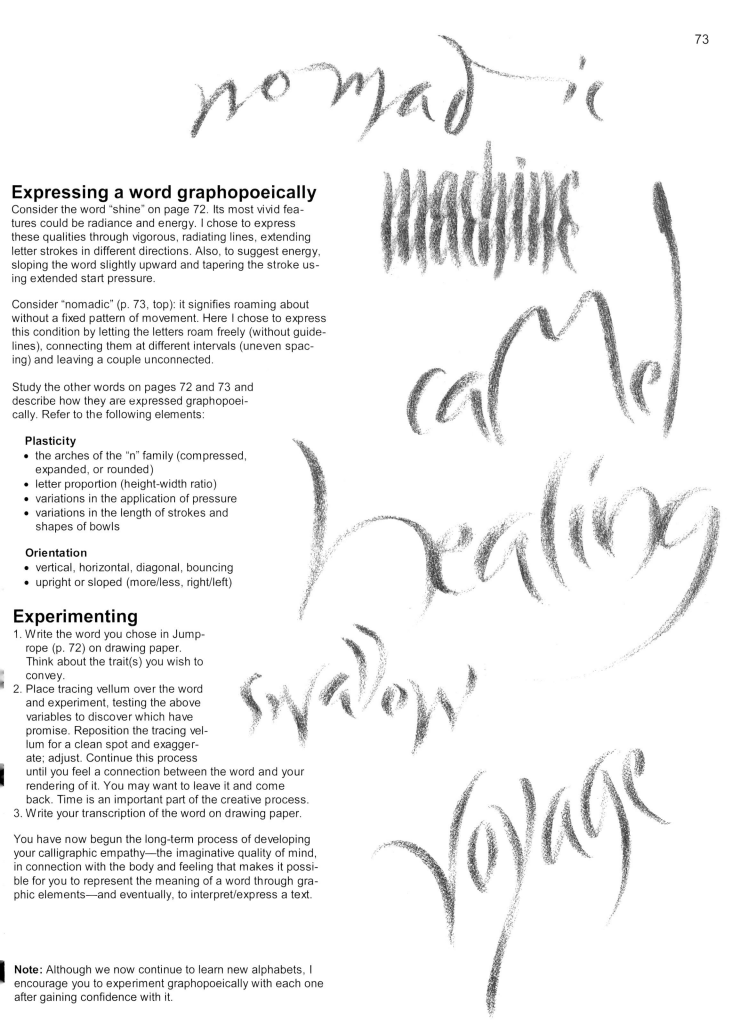

Expressing a word graphopoeically

Consider the word "shine" on page 72. Its most vivid features could be radiance and energy. I chose to express these qualities through vigorous, radiating lines, extending letter strokes in different directions. Also, to suggest energy, sloping the word slightly upward and tapering the stroke using extended start pressure.

Consider "nomadic" (p. 73, top): it signifies roaming about without a fixed pattern of movement. Here I chose to express this condition by letting the letters roam freely (without guidelines), connecting them at different intervals (uneven spacing) and leaving a couple unconnected.

Study the other words on pages 72 and 73 and describe how they are expressed graphopoeically. Refer to the following elements:

Plasticity
- the arches of the "n" family (compressed, expanded, or rounded)
- letter proportion (height-width ratio)
- variations in the application of pressure
- variations in the length of strokes and shapes of bowls

Orientation
- vertical, horizontal, diagonal, bouncing
- upright or sloped (more/less, right/left)

Experimenting

1. Write the word you chose in Jumprope (p. 72) on drawing paper. Think about the trait(s) you wish to convey.
2. Place tracing vellum over the word and experiment, testing the above variables to discover which have promise. Reposition the tracing vellum for a clean spot and exaggerate; adjust. Continue this process until you feel a connection between the word and your rendering of it. You may want to leave it and come back. Time is an important part of the creative process.
3. Write your transcription of the word on drawing paper.

You have now begun the long-term process of developing your calligraphic empathy—the imaginative quality of mind, in connection with the body and feeling that makes it possible for you to represent the meaning of a word through graphic elements—and eventually, to interpret/express a text.

Note: Although we now continue to learn new alphabets, I encourage you to experiment graphopoeically with each one after gaining confidence with it.

Training Alphabet 3: Jumprope caps

In conventional approaches to the study of capitals, those based on Roman monuments generally lead the way. Their focus on form and structure ignores the principles of flow and movement, which are central to this book's approach. I recommend studying Roman capitals after you have an appreciation of vital letterform, which integrates form, flow, and feeling.

Fig. 1 Jumprope caps with dots over enlarged lower-case forms.

Design

Visual theme: Jumprope caps, like Jumprope's lower-case letters, use only curved strokes, often extending beyond or resting short of the guidelines and proportion frames. (Figs. 1 and 2)

Structure: Straight lines and geometric shapes—oval, rectangle and triangle— again provide reference points for stroke direction and letter structure. (Fig. 3) Caps are generally more complex than lower-case letterforms.

Proportion: Although many letters extend beyond a1:2 proportion frame, the strokes needed to identity them stay within it. (Fig. 2)

Fig. 2　　**Fig. 3**

Ductus: Most strokes pull left to right and top to bottom. The first stroke of letters such as "A" and "N," however, can also push up from just above or below the baseline.

Dynamics: Use pressure patterns, singly or in combination, to help you find a stroke's rhythm.

Figs. 4a and b Two "Thurbers"

Guidelines: The previous framework now adds a cap line, which is adjustable because cap height becomes an expressive feature in relation to the lower-case. In the example above, a variation creates two "Thurbers": in Fig. 4a, at a ratio of just over 1:1, "Thurber" appears modest and friendly. In Fig. 4b, with a ratio of over 2:1, his name cuts a figure of stature and, perhaps, elegance. A calligrapher sensitive to context, sets the cap line where it will support an artistic intention.

The cartoon by James Thurber appeared in *The New Yorker* in 1934. The leg-to-body ratio of the large creature tells the viewer this is a humorous, friendly situation, despite contrary evidence. In a similar way, Figs. 4a and b use a lower-case-to-cap ratio for an expressive purpose.

Fig. 5 "What have you done with Dr. Millmoss?"

The "L" Family

Visual themes: Arcs and reverse curves.

Proportion: This varies from the 1:3 ratio of "J" to the 3:4 of "T."

Structure: Overlapping strokes and embedding strokes within others.

cap line

waistline

baseline

Warming up

Tool: soft pencil (6B) or Conte crayon **Paper:** drawing/JNB
Body: shoulder-arm **Speed:** slow and deliberate

Narrow ovals: Prepare you for the downstrokes of this alphabet.
1. Throw a framework of adjacent narrow ovals. Work large, 4"-6" high, and loose. (Fig. a)
2. Pull "I" downstrokes along the right side of the ovals with start pressure and rebound exits. (Fig. b)
3. Breath and count pattern: inhale (up) on "and," exhale (down) on "one."

Fig. a **Fig. b**

The "interlace": This figure of interlocking loops prepares you for reverse-curves—two connected arcs facing in opposite directions.
1. Work large, 8" wide, and loose.
2. From the start point (Fig. c, brown dot), inhale and push to the top of the left horizontal arc; pause.
3. Exhale and throw a shallow, downward diagonal.
4. Toward the bottom arc, inhale and loop up and around to the left, pausing briefly at the top of the arc.
5. Exhale and continue, throwing a shallow diagonal to the left. Repeat this pattern of movement as a felt gesture.

Fig. c

Reverse-curve single strokes: Use the above interlace as a framework.
1. Lower arc (Fig. d): From the brown dot of Fig. c, move down and to the right, applying start pressure to make the arc. Release pressure as you continue up and into the diagonal.
2. Upper arc (Fig. d): Continue from the diagonal, pulling into the upper arc using end pressure.
3. Release, lifting the tool and following back in the path of the framework to begin another single stroke.

Fig. d

Bowing an interlace
1. From the brown dot (Fig. c), inhale and push up to the top of the upper arc. On the diagonal, exhale and apply and release pressure to bow the stroke. (p. 58) Use the energy of release to come around the loop and reach the top of the right upper arc.
2. Reverse number 1 and repeat.

Reverse curves at play: a variation on the above interlace.

Ductus and Dynamics

In general, caps are more complex than lower-case letterforms. Work slowly; remember your repertoire. For ductus: The prototool, tracing vellum and grid paper help you see the direction of and relationship between strokes. For dynamics: The Conte crayon and pressure patterns help you experience the letter physically and stay with the stroke. The descriptions below provide guidance; mindful repetition gives confidence.

Fig. 1

Tools: Pigma Micron, Conte crayon
Paper: tracing vellum, large-grid

(I) Downstroke: Pull Jumprope's lower case "I."

To practice the reverse curves of "L," "E," and "F":
Draw a shallow, diagonal line (Fig. 1); make reverse curves: (1) the curves are exaggerated and (2) the curves hug the line. Repeat to get the feel.

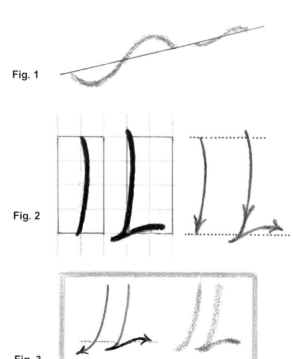

Fig. 2

(L) 1. **Downstroke:** Begin just above the cap line; pull the downstroke of "I," dipping slightly below the baseline and continuing left in a short, shallow arc. (Fig. 2)
2. **Horizontal:** Retrace this arc with start pressure and continue the stroke in a slightly upward reverse-curve. (Figs. 2 and 3)

Fig. 3

(E) 1. **Downstroke and lower horizontal:** Begin just below the cap line with a short stroke to the right (even pressure) and complete the "L." (Fig. 4, strokes 1 and 2))
2. **Top-horizontal bar:** Overlap the downstroke's short entry with a shallow reverse curve. (Fig. 5)
3. **Mid-bar:** "Embed" this stroke by placing it within the down-stroke, just above center. Apply start pressure, softly, and arc the midbar slightly upward. (Figs. 4 and 6)

(F) 1. **Downstroke:** Begin as "E" above and continue through the baseline. (Fig. 7)
2. **Horizontal bars:** Overlap and embed as in "E."

(H) 1. **First downstroke:** Begin at the cap line and pull the lower-case "I" with soft end pressure, finishing just above the baseline. (Fig. 8) Release and lightly retrace the down-stroke, or leave the paper as in Fig. 8, to reach the next stroke, midway between waist- and baseline. (Fig. 8)
2. **Mid-bar:** As in "E" above. Set or imagine a target for the start of the second downstroke, slightly above the cap line.
3. **Second downstroke:** Pull the stroke in a slightly sloped, symmetrical arc to just below the baseline.

(J) 1. **Top, entry-bar:** Tilt the first stroke of Jumprope's lower-case "z" (p. 53) slightly upward. (Fig. 10)
2. **Downstroke:** Pull a long arc below the baseline and a little to the left of the pro-portion frame. Note its asymmetry: find this by placing a straight edge from start to end point.

(T) 1. **Top stroke:** Begin slightly above the cap line and swing into a shallow, downward arc. (Fig. 11) Pause.
2. **Downstroke:** On an inhale, pull to the left, overlapping the end of the top stroke a short distance, slowing as you bend the stroke; exhale and pull the arc down-ward to the baseline.

Word as image: caps & lower case

This exercise focuses on the distance between the cap and first lower-case letter. (Fig. 12) It depends, to a large extent, on the cap: the open "L" and "T" naturally create more space in combination with a lower-case letter than the "I" and "J." These latter can exhibit the same interletter space as lower-case combinations or slightly more. The aim is to create a legible image.

Tools: Pigma Micron, Conte crayon **Paper:** tracing vellum, drawing/marker

1. Trace Fig. 12 noting the:
 - proportion of the cap
 - cap-to-lower-case ratio
 - distance between cap and lower-case
 - letter variants and how they contrast with the model
2. Write words freehand on plain paper using proper names or geographical places.

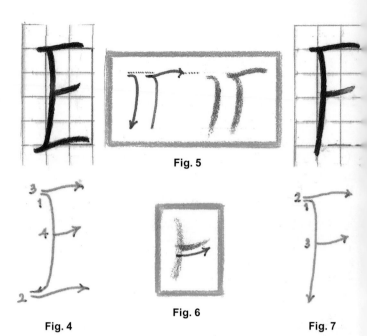

Fig. 5

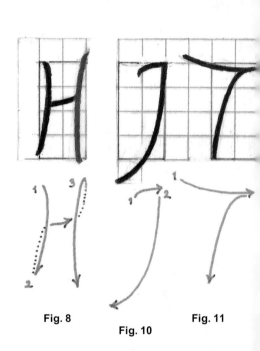

Fig. 4 Fig. 6 Fig. 7

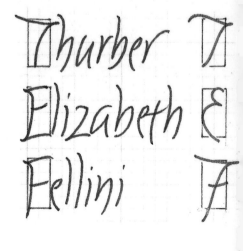

Fig. 8 Fig. 11
Fig. 10

Fig. 12

The "O" Family

Visual themes: deep arcs and bowls as in the lower-case "o" family. (Fig. 1)

Proportion: 1:2 (O, Q, D, X), slightly less (C, G), about 1:4 (S). (Figs. 3; 6 and 7 next page)

Fig. 1

Warming up

Tools: Pigma Micron, Conte crayon **Paper:** large-grid **Speed:** deliberate **Body:** shoulder-arm

1. Draw six frameworks three squares by six. (Fig. 2)
2. Throw counter-clockwise ovals—the first two in place and the third connecting to a new set.
3. Use a count pattern: "one" (down); "and" (up); "two" (down); "and" (up) "three" (down); "and" (swing over and up to the top of the next oval). Coordinate the breath: inhale, up; exhale, down.

Ductus and Dynamics

Fig. 2

Trace ductus first. Dynamics are suggested below; feel free to experiment.

Tools: Pigma Micron, Conte crayon
Paper: tracing vellum, large-grid

(O) Jumprope's lower-case "o." (Fig. 3) Place the tool at the cap line on an inhale. Exhale and pull the downward arc toward an imagined stretch point. Use center pressure, pushing off after the stretch point to finish the stroke—just piercing the baseline.

(C) Jumprope's lower-case "c." (Fig. 3) Place the tool just below the cap line; inhale and arc left and up to the cap line. Exhale and pull into the downward diagonal arc (center pressure).

(G) Notice the verticality of the downward arc. (Fig. 3) Use the dynamics for "C," but stop short of the baseline. Use the momentum of pushing off from center pressure to carry the stroke into the upward bend and to its end. Inhale and pause. Exhale and pull a shallow arc a little to the left. This stroke slightly overlaps the previous one.

(Q) The first stroke of "O," but significantly shorter. (Fig. 3) For the second stroke, pull slightly below the baseline and left of the proportion frame. For the tail, retrace the second stroke a short way as you move into a shallow, slightly upward arc.

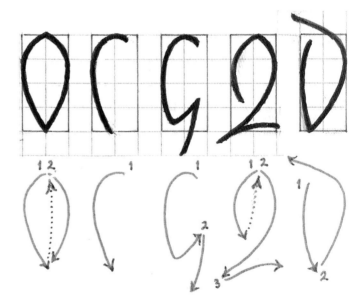

Fig. 3

(D) Conventionally, the second stroke of "D" is pulled from the top; in this alphabet, however, it's pushed up from the baseline. This reversal of ductus broadens your range of calligraphic skill and kinesthetic pleasure.

To grasp the movement of this long, continuously changing upstroke, note the two arcs revealed by its triangular structure—a symmetrical (red) arc and an asymmetrical (green) arc. (Fig. 4): The right point of the triangle places the swell of the bowl (central stretch point), where the arcs meet.

Name and trace the pressure patterns of Fig. 5. (Remember to start at the baseline.) If you desire more weight for the stroke, try retracing it.

Try making the second stroke of "D" with conventional ductus, pulling to the right, around and down to meet the downstroke.

Note: Try to relax and use the directions as guides to your own experience, rather than as directives.

Fig. 4 **Fig. 5**

(X) Jumprope's lower-case "x." (Fig. 6)

(S) Jumprope's lower-case "s." (Fig. 7)

Fig. 6 Fig. 7

Word as image: caps & lower case

Tools: Pigma Micron, Conte crayon **Paper:** tracing vellum, drawing/JNB

1. Trace Fig. 8, noticing the cap-to-lower-case ratio; then write the words freehand.
2. Trace and freehand the cap variations. (Fig. 9) Note the subtle reverse curves: "Q," tail; "D," second stroke; and "X," both strokes.

Oregon Chopin Groucho Quebec Douglas

Xanadu Scarlatti

Fig. 8

Fig. 9

The "B" Family

Visual themes: Arced downstroke and upward-tilted bowl. (Figs. 1, 2, and 3)

Proportion: Slightly less than 1:2 for the bowls, with "R" kicking outside the proportion frame. (Figs. 2 and 3)

Structure: Branching, as in lower-case "n" and "b"; contrasting axes: vertical downstroke and tilted bowl. (Figs. 2 and 4)

Warming up: Get the feel of branching with pressure.

Tools: Pigma Micron, Conte crayon **Paper:** large-grid
Size: as in Fig. 4 **Speed:** slow and deliberate
Breath-count pattern: on "and," inhale-up; on the number, exhale-down

Vertical-oval framework
Throw alternating multiline ovals: narrow and upright with wider and tilted. (Fig. 4)

Single strokes
Tracing over the oval frameworks add: end pressure for the downstroke, start pressure for the bowl's upstroke; and center pressure for the bowl's downstroke. (Fig. 5) Note: the downstroke and upstroke are separated here to better show their pressure patterns.

Ductus and Dynamics

The triangle again reveals an underlying structure in the bottom bowl of "B." (Fig. 2)

Tools: Pigma Micron, Conte crayon **Paper:** tracing vellum, large-grid

1. With the prototool, trace the large "B," experimenting with pressure patterns—start, center, etc., alone or in combination—to see what helps you stay with its strokes.
2. Note: Both arcs of the bottom bowl are symmetrical.

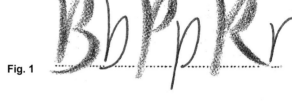

Fig. 1

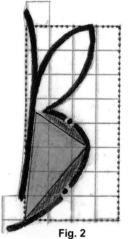

Fig. 2

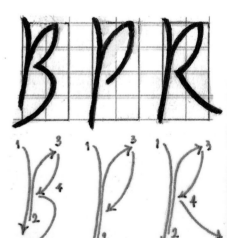

Fig. 3

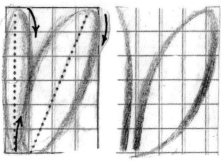

Fig. 4 Fig. 5

Word as image: caps & lower case
Trace Fig. 6 and then freehand your own choice of words.

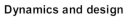

Fig. 6

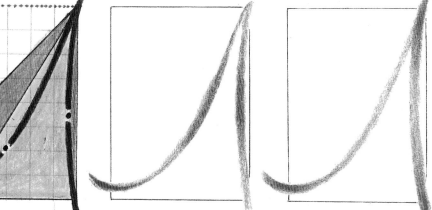

The "A" Family

Although the "A" family letters share a prominent trait with the the "V" family's triangular structure, the dramatic "swash" entry justifies giving it separate status. The "A, M and N" diverge significantly from their lower-case namesakes. (Fig. 1)

Visual theme: A long entry swash.

Proportion: Entry swashes increase proportion to at least 3:4. (Fig. 2)

Structure: Triangles provide a structural frame for the letter and its entry swash. (Fig. 2)

Fig. 1

Dynamics and design
Variation in pressure patterns can produce slight differences in stroke direction: in Fig. 3, pressure is applied twice to the swash and promotes a subtle reverse curve; in Fig. 4, pressure is applied at the start only and creates a continuous arc.

Warming up
Here, get the feel of pushing up from pressure.

Tool: Conte crayon
Paper: large-grid
Speed: slow and deliberate **Body:** shoulder-arm

Fig. 2 Fig. 3 Fig. 4

Entry swash pressure pattern
1. Trace Fig. 5 with the prototool, beginning at the dot. Place the index finger on an inhale and, continuing to inhale, lightly push up to the top of the oval. Round the top and exhale as you pull the arc down, applying end pressure toward the base of the oval.
2. As you come around the curve, inhale and release pressure slightly, and then apply start pressure, propelling the hand up to complete the right side of the oval. (Note: Pressure patterns may merge.) Throw two full ovals. At the bottom of the third, apply start pressure and swoop up to the right corner of the next frame.
3. Exhale and throw the next oval as above. Repeat a few times to get a rhythmical flow.
4. Now, on large-grid, draw a framework of four rectangular frames 3 x 6 squares. (Fig. 5)
5. With a Conte crayon, repeat the above instructions for directional movement and dynamics.

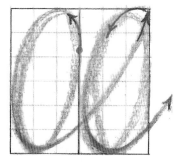

Fig. 5

Ductus and Dynamics

Ductus is described and depicted; dynamics are suggested—feel free to experiment.

Tool and paper: as above

(A) 1. **Left diagonal**: Push an entry swash; begin just above the baseline and finish just above the cap line. Pause. (Fig. 6)
2. **Right diagonal:** Pull the downstroke using pressure as in Fig. 3 or 4 above.
3. **Crossbar:** Pull a shallow, slightly downward arc, beginning to the left of the first downstroke, above the center.

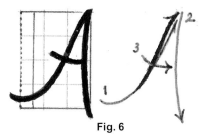

Fig. 6

Fig. 7

Experiment: Use the various pressure patterns in a wave design (Fig. 7) to help you discover rhythmical flow and build confidence.

(M) 1. **Stroke one:** Push the swash entry stroke to just below the cap line. (Fig. 8a) Use start pressure. Pause briefly.
2. **Stroke two:** From inside the previous stroke, on the exhale, pull the diagonal downstroke with an asymmetrical reverse curve—a short arc followed by a longer one. (Fig. 8b) Apply start and end pressures to this stroke.
3. **Stroke three:** Inhale and release from pressure, pushing a shallow arc upward to a little above the cap line. Use even pressure.
4. **Stroke four:** Pause; on the exhale, pull the fourth stroke (as for the downstroke of "A").

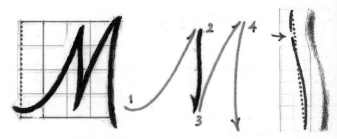

Fig. 8a Fig. 8b

(N) 1. **Stroke one:** Push the first stroke as above. (Fig. 9a) Pause.
2. **Stroke two:** From inside the previous stroke, on the exhale, pull the diagonal down—a little farther to the right than the "M"—in a symmetrical reverse curve. (Fig. 9b)
3. **Stroke three:** Inhale and release from pressure, pushing upward to a little above the cap line. Experiment with pressure.

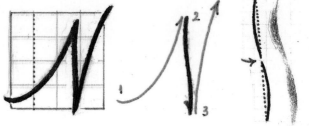

Fig. 9a Fig. 9b

Variation and repetition

While most calligraphic instruction focuses on repetition aimed at conforming to a model, this approach begins with repetition but, to nurture creativity, moves quickly to variation.

Tools: Conte crayons—"Sanguine" and "Sepia" **Paper:** drawing/JNB

Fig. 1

1. Start with a structural pattern, such as the wave design on p. 79. (Sanguine Conte crayon) (Fig. 1)
2. Relax your body and repeat this pattern as a rhythmical movement. Breathe.
3. With a Sepia Conte crayon work on top of the "base." Follow your hand and mood, and engage an "I don't know, what the heck," attitude. Possibilities: changes in direction, length of stroke, distance between strokes, pressure, bowing.
4. Write a word, drawing on the energy and rhythm of this exercise. (Fig. 2)

Fig. 2

Word as image: caps & lower case

See p. 76, "Word as image." Note plasticity and letter variants. (Fig. 3)

Fig. 3

The "V" Family

The "V" family is almost the same as the "v" family. (Fig. 1) It differs by including a variant of "W," which can also be a lower case letterform.

Warming up
Use the warm ups for the lower-case "v" family on p. 49. (Feel free to invent your own.)

Ductus and **D**ynamics

 Tools: Pigma Micron, Conte crayon
 Papers: tracing vellum, large- and small-grid, drawing/JNB

Notes
1. The variant "W" is wider than the model, and its axes converge more dramatically. Compare the "W"s in Figs. 2 and 3.
2. Although it's common for the first and last strokes of caps to begin and end at the cap line, in Jumprope's "V" family they usually differ in height. This variation infuses greater energy and increases expressive potential. Compare the "V" and "W" in Fig. 4. You can choose whether the first stroke begins above or at the cap line.

Word as image:
caps & lower case
Use small-grid and drawing papers. (Fig. 4) See "Word as image," p. 78.

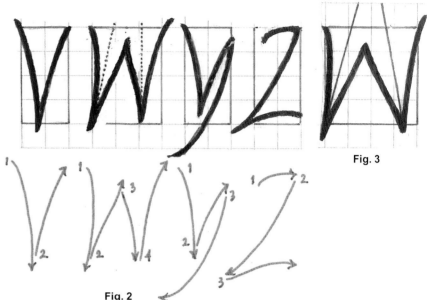
Fig. 1

Fig. 3

Fig. 2

Fig. 4

The "**UK**" Family (Not just for Brits!)

These two letters don't fit comfortably into the above families; so, despite their differences, they're coupled together. (Fig. 1)

Ductus and **D**ynamics
Use the tools and materials in the "V" family. Warm up as you wish.

(U): As for the lower-case "u." (Fig. 2)

(K) 1. **Stroke one:** Begin a little above the cap line and end a little below the baseline. (Fig. 2)
2. **Stroke two:** Begin slightly below the cap line; place the tool on an inhale; exhale and pull a subtle reverse curve to just above the center of stroke one, barely touching it. Pause.
3. **Stroke three:** Inhale while gauging an approximate right angle; exhale and pull the lower diagonal to, or just above, the baseline.

Note: The right angle in "K" is not arbitrary; it's an integral part of the structure of the letter. (Fig. 2) To change it weakens the form. Be aware of this aspect when you create variants.

Word as image: caps & lower case
Use small-grid and drawing papers. (Fig. 3)

Fig. 1

Fig. 2

Fig. 3

Making: text as image—a small sign

This exercise explores Jumprope caps as an independent alphabet before combining them with lower-case forms. Here, with the addition of interlinear space, you progress from a single to a multiline piece. The same methods and principles for this small sign also apply for album inscriptions, dedications, and lists (of donors, etc).

Generally, "all caps" expresses authority or importance, and commands attention; hence their use for such public purposes as monuments, signs, headings and titles. In personal, everyday email correspondence, using the all caps setting for more than a few words, for emphasis, may communicate as a rant or "shout" at the reader.

Preparation: What's the sign's purpose? Size? Writing style?

Fig. 1

Fig. 2

Testing

Tool: any one-point tool **Paper:** marker/drawing/JNB/mat board

1. Working template: Use either paper or matboard. Choose a format:
 1) fixed, working on pre-cut paper, e.g., standard 8½" x 11" or
 2) fluid, staying open to what develops, but having an approximate size in mind.
2. Use either marker or drawing paper. Choose a tool and test the size of the writing.
 a. Write a word or phrase in a size you think will fit within the width of your template.
 b. Cut out the word/s and place it/them on the template.
 c. Assess size: large enough? Too large? Adjust as desired.
3. Style: You can try changes in proportion (a narrower or wider form), letter plasticity, or variants (Figs. 1 and 2, note the "Y"s and "T"s)
4. Decoration: Is it appropriate? Figs. 1 and 2 include small ornaments in keeping with the topic of the sign.

Composition

Materials
- Tracing vellum/paper
- Black frames larger than the anticipated size of the finished piece (See p. 69)
- HB/#2 pencil for marking and ruling

Positioning
In the visual field of the working template, consider the arrangement of the words/lines, the space around and between them (interlinear space).
1. Arrange the cut-out words/lines in each of the formats of Fig. 3. Then choose one. (Continue, top of next page)

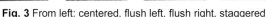

Fig. 3 From left: centered, flush left, flush right, staggered

a. Top to bottom
- Use tracing paper/vellum and frame strips.
- Place the text in your chosen format near the top, in the center and near the bottom.

b. Side to side
- Symmetrical: centered (or staggered)
- Asymmetrical: flush left or right (or staggered)

Note on margins: According to convention, margins—the space around the writing—frame the text and aid the reader. This surrounding space, or lack of it, can also be used expressively. Fig. 1 uses a minimal amount of margin space, suggesting a bold, assertive text. In contrast, a generous amount of space "reads" differently. Fig. 4 quietly invites the viewer to investigate the words. You're not, however, limited to these extremes. (Fig. 5) Try various amounts of space using the frames. Which margins best "speak" the message you wish to convey?

2. Consider interlinear space—the amount of space between lines: Too much? Not enough? Adjust as desired. The final decision depends on the degree of legibility desired, and design considerations about texture and color.
3. When you have a multiline text organized within a visual field, place tracing vellum/paper over it if you have not already done so. Rule lines in pencil to clearly show where to mark letter height and interlinear space. (Review, p. 70)
4. Make and use paper rulers as described below.
 a. Top to bottom (letter height and interlinear space)
 - Cut two strips of paper ½" wide and the length of the visual field. Write "T" at the top of each.
 - Take the first ruler and place it at the top of the visual field. (Fig. 6)
 - Mark the cap, baseline and the next cap line on it. Cut off the ruler about an inch below the last mark (dotted brown line).
 - Place the shortened paper ruler adjacent to and in alignment with the top of the full-length ruler. (Fig. 7)
 - Move the shorter ruler down the edge of the longer one, marking the additional lines of your text on it.
 b. Side to side (starting points/s for the text)
 - Cut a strip of paper ½" wide and the width of the visual field.
 - Place the left edge of the strip at the left edge of the visual field and mark the start point/s of the lines/words.

Transferring

1. Using a pencil, transfer the marks from the paper rulers to the finish paper or matboard. (Review, p. 70)
2. Make these marks just dark enough to see. (If you're using a Conte crayon for final work, it's not easy to erase without smearing.)
3. Ruling
 a. For a few lines of text, use the method of marking the side edges of the paper and ruling across.
 b. For a text with more lines, or because you're ready, learn to work with a T-square and right angle. (See Ruling, p. 125)

Finished work

Erase guidelines; use a spray fixative if your work might smear.

Note on stroke width: This is not confined to the diameter of a tool. (Fig. 8)
1. To make a wider/heavier stroke, begin by writing a letter.
2. Draw a line on either side of it. Experiment to get the weight you want.
3. Fill in the space between the lines.
Such "built up" forms were commonly drawn in the manuscript tradition and are known as Versals. Today, as well as in the past, Versals are painted, gilded or decorated. The extent of their elaborateness depends on their use or the customers wallet.

"Making": text as image and experience

With knowledge of both an upper- and lower-case alphabet, you are now prepared to write a conventional text. (See pages 64-5.) I encourage you to give this a try!

Fig. 4

Fig. 5

Fig. 6 **Fig. 7**

Fig. 8

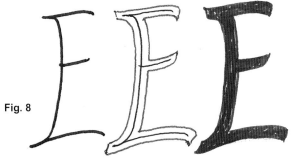

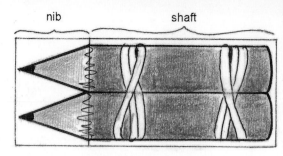

Fig. 1 The nib and shaft of a two-point tool

Two-point tools

Banding together two one-point tools creates the nib and shaft of a two-point tool. (Figs. 1 and 2) The twin points of the nib produce calligraphic strokes, commonly called "thicks and thins," whose width may vary significantly. (Fig. 3) In this section and in the training alphabets that follow, you will learn to create a full repertoire of these strokes. (See Visual character, below)

Variation in stroke width features prominently in Western calligraphy. An edged pen, loaded with ink, is commonly used to make such strokes. The two-point tool employs the same fundamentals without the challenges of loading ink. (Fig. 4) Preparatory training with the simpler two-point tool develops the understanding, skill, and sensitivity needed for success with an edged pen.

Two-point tools

 Graphite
Artist pencils, 4B to 6B. The hardness of the paired pencils should be the same.

 Ink
Pigma Microns in the larger sizes (05 and 08).

Visual character

Two-point tools create thick ("double-walled") and thin (single-line) strokes that, in combination, form most calligraphic letterforms. (Figs. 3, 5 and 6)

Thicks consist of two one-point strokes (the walls) and the space between them. These strokes may be open or closed. (Fig. 3 and p. 93, Fig. 3) There are two ways to vary the maximum width of a thick stroke. The first is by changing the distance between nib points. (Fig. 2) The second, by changing nib angle. (See Nib angle, p. 86) When the nib is set at a particular angle, a change in stroke direction also varies stroke width. We then speak of the stroke as "graduated." Since letter strokes change direction frequently, most thicks are graduated to a greater or lesser degree. For example, in Fig. 3, the stroke forming the bowl of each "b" begins narrow, expands to full nib width, and returns to the narrow width of its beginning.

Thins: There are two types. Although they look alike, they are not identical. The first, a single-line thin, results from rocking the tool to one point. (Fig. 6) Like any one-point stroke, it moves freely, without constraint. The second, a "hairline" thin, is made with both points on the surface and aligned in the direction of the stroke. (See the bottom of p. 87) With both points on the surface, one necessarily plays tag with the other, and constrains the stroke.

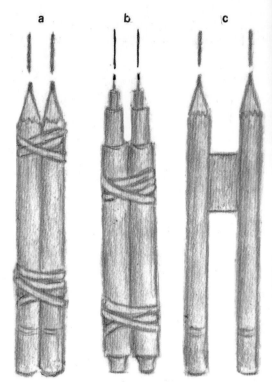

Fig. 2 Two-point tools showing a full-width stroke
(the distance between points):
a pencils, **b** Pigma Microns, **c** pencils with a spacer

Fig. 3 A "b" with open and closed strokes.

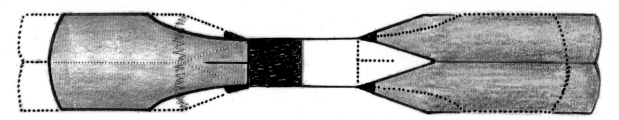

Fig. 4 Two-point tools are analogous to the edged pen.

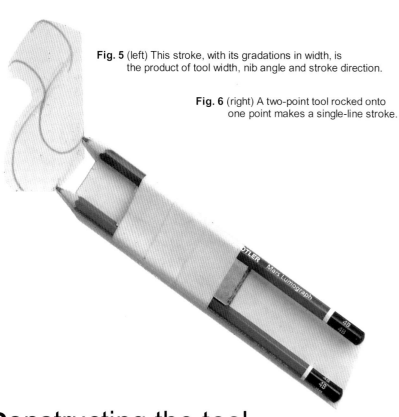

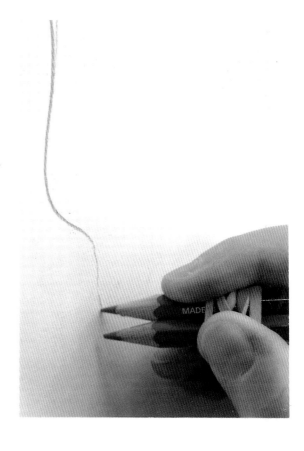

Fig. 5 (left) This stroke, with its gradations in width, is the product of tool width, nib angle and stroke direction.

Fig. 6 (right) A two-point tool rocked onto one point makes a single-line stroke.

Constructing the tool

Make a two-point tool by banding two one-point tools together near the top and bottom of the tool. (Fig. 2, previous page)

For broader strokes, those greater than the distance between the points, add a spacer. Here, corrugated cardboard taped between the two pencils. (Fig. 5)

For narrower strokes, those less than the distance between the points, shave the shafts, especially at the top.

Working with a banded tool

* As you band the shafts together, keep the points even. Test this by holding the new tool upright on a surface and making sure that both points are in contact. Move the tool up-and-down, side-to-side, diagonally (Fig. 7), or in any other directions that the hand wishes. First, review tool hold below.
* If the points become uneven, readjust them.
* Disassemble the tool for sharpening.

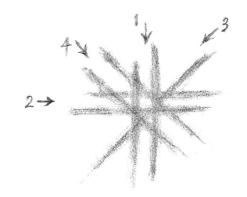

Fig. 7

Holding the tool

Although a two-point tool is wider than a one-point, its hold is essentially the same: place the fingers about an inch from the nib points and hold the shaft nearly upright. Remember that your energy comes from the shoulder, that moving the tool with your arm and hand off the table gives you greater freedom. Let the pressure of contact determine the tightness of your grip. As with one-point tools, hold the tension by placing the right shaft of the tool against the index finger and near the big knuckle.

Relax, breathe. Get comfortable with balancing your weight over the points to keep them both in contact as you move them about on the paper. Try to keep your hand position steady.

Experiment: As you balance weight (shoulder-arm) over the points, try to find the minimum amount needed to produce the same darkness from both points.

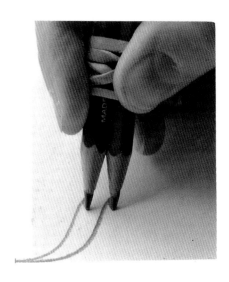

Nib angle

Focus is now on the nib, the distinguishing feature of a two-point tool. You create the varied strokes of this tool by placing its nib at an angle to a horizontal line. (Fig. 1)

Nib angle: getting the feel
On notebook paper, place both points of the nib on a horizontal line. With the left point as an "anchor," pivot the right point counter-clockwise—away from the horizontal and toward the vertical. Try the three angle settings of Fig. 1.

Nib angle operates in two basic ways as you direct strokes: 1) the points of the nib keep a steady ("constant") angle or 2) the nib changes angle within a stroke ("nib turning"). The tracing exercises below help acquaint you with the influence of nib angle on stroke thickness/width.

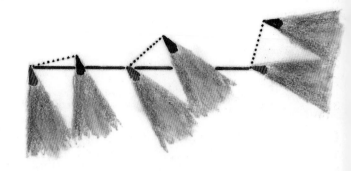

Fig. 1 Three nib angles using a horizontal frame of reference

Single strokes (same direction, different angle)
Trace Figs. 2, 3, and 4 according to the directions below.

Tool: a red (left) and a black Pigma Micron banded together **Paper:** tracing vellum

Fig. 2 Horizontal strokes, three nib angles

Fig. 4 Curved strokes, three angles

1. After getting the feel of the tool, making the strokes described on p. 85, Fig. 7, trace as below:
2. Fig. 2: Use the left point as an anchor as you move the tool horizontally at three different angles.
3. Fig. 3: Place the left point on the horizontal line for each different angle and pull vertical strokes.
4. Fig. 4: The curved strokes take a bit more attention as both points are continuously changing direction. The inner curve of the counter anchors the outer curve.

Fig. 3 Vertical strokes, three angles

Stroke patterns (same angle, different direction)
Trace the stroke patterns of Fig. 5. Here, using a constant nib an-gle, changes in stroke direction produce changes in stroke width. Similar to a letterform, each stroke pattern shows that nib angle both distributes stroke weight and influences the figure's proportion.

Note: Nib angles are said to be "flatter" or "steeper" according to the position of the nib: flatter, as the nib's right point approaches the baseline, and steeper, as it approaches a vertical line.

"Characteristic" nib angle
Fig. 6 shows nib angle's formative influence on alphabet/letter design. Since an alphabet's character is largely derived from a single angle, the one used to make most of its strokes, it can be called an alphabet's "characteristic" angle. Note the variation in stroke width of the two words in Fig. 6.

Fig. 5 Nib angle, stroke weight, and proportion

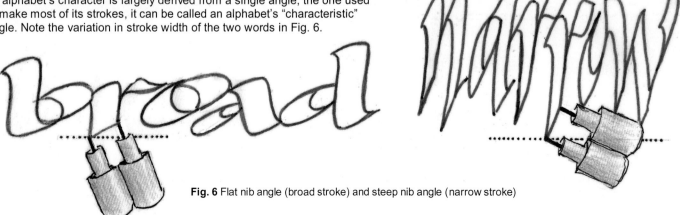

Fig. 6 Flat nib angle (broad stroke) and steep nib angle (narrow stroke)

Nib angle and the square

The square customarily provides the frame of reference for nib angle. (Fig. 7) Its right-angle brackets, lower left and upper right, allow you to visualize angles more clearly than does a single horizontal line.

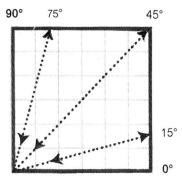

Fig. 7

Tool: two-point, pencils **Paper:** marker **Speed:** moderate **Padded surface**

1. Place marker paper over Fig. 7.
2. Place the left point of the nib atop the lower left corner of the square. Place the right point of the nib atop the black dotted line (75°). Move the tool up and down, making contact from the shoulder. Feel free to exceed the bounds of the square.
3. Repeat at 45° and 15°. Note the positions of your hand, arm and elbow at each angle.

Characteristic angle: preparing for "Trapeze"

The next training alphabet, Trapeze, is designed to develop the foundation skill of holding nib angle steady (for this alphabet, at 45°) while moving in the various directions of letterform ductus.

Fig. 8

Tool: Band two Pigma Microns so their points measure the distance between the right-angle brackets of a large-grid square. (Fig. 8) If you need to reduce distance between the points, try placing the top band nearer to the points.
Paper: Large-grid (Its squares help you get familiar with setting and maintaining a 45° angle.)

1. Start near the top left corner of the paper. On an inhale, place the nib at 45°. Exhale and pull a long, double-walled vertical stroke the length of the paper, or nearly. (Fig. 9) Let your arm move freely but keep your wrist fixed. Let the pressure of contact come from the shoulder and be equally placed over the points. Work slowly enough to feel this. Return to the start.
2. On an inhale, place the nib at 45°. Exhale and pull a long, double-walled horizontal stroke the width of the paper, or nearly.
3. Repeat, shutting your eyes to better feel the muscular pull (kinesthetics).
4. Use alert relaxation to help you keep a steady nib angle.
5. Try segmenting the long strokes into a series of shorter ones, one or two squares at a time. Try using one or more pressure patterns. Freelance.

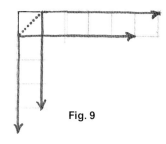

Fig. 9

"Stairs"

The next two exercises alternate their focus between arm and eye. **Keep your wrist fixed.** Trace, then freehand on large-grid. Work slowly.
Arm: Distributes pressure evenly to the nib points as it pulls/pushes the strokes.
1. Place the nib at 45° on an inhale. (Fig. 10a)
2. Exhale and pull a one-square-long vertical with end pressure. Inhale as you release pressure and prepare to make a one-square-long horizontal. Exhale and pull the stroke.
3. Stay relaxed, use the grid as guides. (This is not precision work.)
4. Find a rhythm and gesture for this angular action: jerky, smooth, stately…
Eye: Focuses attention on the left tool point and its target. For this training, the above body-work comes second in your awareness.
Place the nib at 45° on an inhale. Exhale and pull strokes, focusing the eye on the left tool point while pulling to a target point. (Fig. 10b, black dots). Inhale and release pressure before changing direction. (This *is* precision work and takes practice; it's a foundation skill.)

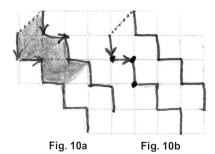

Fig. 10a **Fig. 10b**

Diagonals, thick

An alphabet makes its thickest and thinnest strokes in relation to its characteristic angle: the thinnest aligns with this angle (a hairline), the thickest at a right angle to it. (Fig. 11a)
Arm: For a thick stroke, place the nib at 45° on an inhale. Exhale and pull a double-walled diagonal with a series of short, jerky strokes, each one square in length. (Fig. 11b) Apply end pressure for each segment; inhale between segments.
Eye: Place the nib at 45° on an inhale. Exhale and pull short strokes to the black target points with light even pressure. Focus on the left point. (Fig. 11b)

Fig. 11a **Fig. 11b**

Diagonals, thin (the "hairline" stroke)

Aligned with nib angle, the hairline stroke looks like a single line but is composed of three parts:
- First: a single-line segment the width of the nib starts the stroke. (Fig. 12a)
- Second: an overlap segment—the trailing point traces over the path of the leading point. (Fig. 12b)
- Third: a single-line segment the width of the nib ends the stroke. (Fig. 12b)

Now trace: Place the nib at 45° on an inhale. Exhale, sink; inhale, release a little pressure and push the nib up, slowly, one square. Exhale; inhale and repeat. Focus on the left tool point while pushing to the target point—the upper right corner of each square. Keep the points aligned with stroke direction.

Note: By developing your ability to align the nib's points with nib angle, you will be better prepared to use the edged pen with skill and confidence.

Fig. 12a Fig. 12b

Hairlines and thicks

1. Lattices: alternate thins (hairlines) and thicks (double-walled strokes). (Fig. 13) Use the same tools and materials as above.
 a. Rule two horizontal lines four squares apart.
 b. Place nib at 45° on the baseline at 1, with the left point touching the line. Inhale and push a hairline up through the top right corners of four squares exhale. Inhale as you lift the tool and place the right point of the nib three squares to the left.
 c. Exhale and pull a thick stroke diagonally down to the bottom horizontal. Repeat the pattern.
2. Zigzags: without lifting the tool, alternate thin and thick in vertical and horizontal zigzags. (Fig. 14) For the vertical: inhale, up; exhale, down. For the horizontal: on the inhale, push the horizontal; on the exhale, pull the diagonal.

Note on nib angle and stroke width
At the same nib angle, diagonal strokes appear wider than horizontals and verticals.

Fig. 13 Lattices

Fig. 14 Zigzags: top, vertical; bottom, horizontal

Stroke technique

Partnering

Partnering develops command of the tool through a mental connection between fingers and nib points. (Fig. 1) We imagine the thumb (T) and index finger (IF) paired with the tool's left and right points. The use of such partnered points gradually translates into skillful and expressive letterforms.

Prototool 2 (See p. 1)

This prototool features the index finger (IF) and thumb (T). It sensitizes you to a productive partnership between them and the points of a two-point tool. (Later, the corners of the edged pen.) "Rocking" is a technique that helps awaken partnering between the fingers and the nib points.

Rocking

Here we move from one fingertip (tool point) to the other by rotating the wrist.

1. Place Prototool 2 (T and IF) on the table, but not the hand. The finger tips tend to line up naturally at a 45° angle.
2. Rock onto the index finger while lifting the thumb and rotating the wrist to the right.
3. Rock onto the thumb while lifting the index finger and rotating the wrist to the left.
4. Repeat in place a few times.
5. Add an accent for a rhythmical beat:
 a. Accent on the IF:
 Place both T and IF on the table; rock to the T. Rock back to the IF with emphasis. Use the count pattern one-**and**, two-**and**, three-**and**… with the IF emphasizing the "and."
 b. Accent on the T: Place both T and IF on the table; rock to the IF. Rock back to the T with emphasis. Use the above count pattern.

Partnering with tool points

Tool: red and blue Pigma Microns banded together **Paper:** drawing/JNB

1. Repeat the above rocking exercise using the two-point tool. Start with the points at approximately 45°. Mentally partner the fingers and nib points. (Fig. 1)
2. Exaggerate the rocking action; play with it.

Fig. 1 Mental partnership between the fingers (T and IF) and nib points

By learning to partner with the simpler two-point tool, with its open strokes, you prepare for making the solid, ink-filled strokes of the edged pen. The partnerships with its two corners are also activated through rocking.

At right, a photo sequence illustrates rocking with an edged pen. Its two corners—each a meeting of edge and one side of the nib—are analogous to the points of the two-point tool you have constructed. (Fig. 2)

Fig. 2

Point/corner walk

This partnering exercise uses rocking and pivoting to further develop wrist awareness and rhythmical movement. The two-point movement pattern of Fig. 3 is based on a cornered edged-pen pattern. (Fig. 4 and photo)

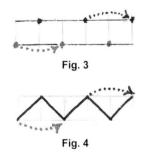

Fig. 3

Fig. 4

Tool: red and blue Pigma Microns banded together

Papers
- large-grid (for focusing on precision and target practice)
- drawing (for focusing on tactile and muscular sensation)

1. On large-grid: Place the nib at 45° with attention to the right nib point (IF). (Fig. 3)
2. Rock onto it—now, a "grounded point." The left point is in the air.
3. Bring attention to the left point (T) and, in the air, pivot under and to the right of the grounded point. Land on the left point (T), now the new grounded point. (IF lifts)
4. Bring attention to the right point (IF) and, in the air, pivot over and to the right of the grounded point, and touch down. (T lifts)
5. Repeat in a dance-like motion as you rock and pivot the tool.
6. Repeat freely on drawing paper.

The following exercises develop skills that apply to both two-point tools and edged pens.

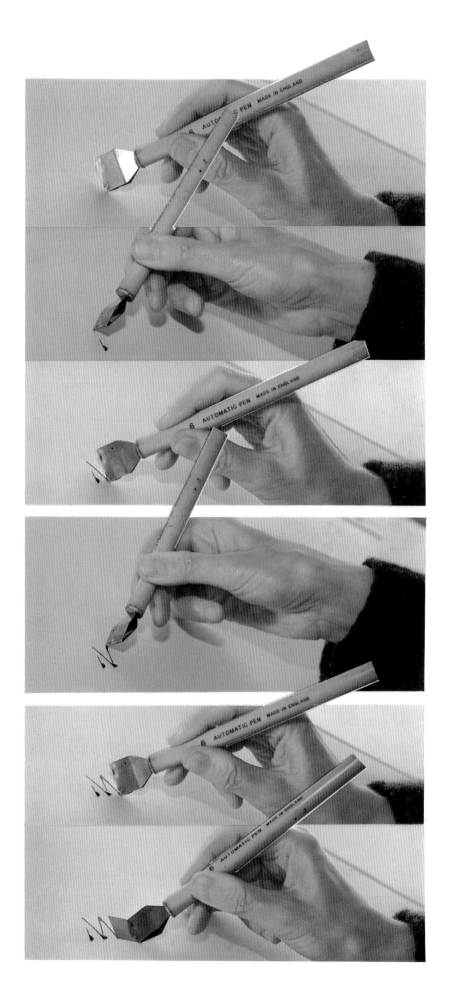

One-point, single-line verticals

In this partnering exercise you consciously move one point with one finger. The aim is to further establish an "identity" between a point and the finger that guides it. (Here you also develop facility with the two-point tool's single-line thin stroke, a distinctive feature of the next training alphabet, Trapeze.)

Tool: banded red and blue Pigma Microns **Paper:** large-grid, drawing/JNB **Speed:** deliberate, slow to moderate
Body: The arm-shoulder for pulling combines with the fingers for partnering and guiding.

1. Set target points on large-grid paper as in Fig. 5.
2. Place the nib atop the upper left start points at 45° on an inhale.
3. On the exhale, pull a diagonal thick one square in length.
4. Inhale and rock to the right point (IF). Exhale and pull the right point six squares down through the mid-point to the end point. Use even pressure from the shoulder; focus on guiding the tool point with the IF, supporting the tool shaft against the big knuckle, or nearby.
5. Inhale and replace the left point (T).
6. Exhale and pull the two points diagonally down one square. Inhale and rock to the left point (T). Exhale and pull the point through the mid-point to the endpoint. Note: The left-point partnership may be more challenging. Rocking onto the thumb helps place it above the shaft, making it easier to pull down.
7. Relax and repeat. Look for a rhythmical play of action.

One-point, single-line arcs ("bowstrings")

In this exercise you add arcs to what you have just completed above.
1. Add one stretch point to the right of the blue vertical's midpoint, and one to the left of the red vertical's midpoint. (Fig. 6)
2. Use the same breath pattern as above.
3. Place the nib at 45° atop the start points of Fig. 6. Pull a one-square diagonal.
4. Rock to the right point (IF).
5. Pull the right nib point through the stretch point to the endpoint.
6. Do the same for the red left arc (left point, T).
7. Repeat as a flowing sequence of point shifts and pulled strokes. (Congratulations! You've just earned the Arc de Triumph prize!)

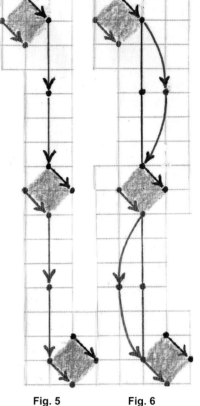

Fig. 5 **Fig. 6**

Freehand: The focus here is on the play of movement and timing.
On drawing paper, make variations of Fig. 6 using multiple arcs, e.g., slim, asymmetrical. (Fig. 7)
Reminder: work slowly. As your attention expands, focus on holding the tool as a response to pulling it.

Partnering and pressure: With the awakening of partnerships, you're ready to make double-walled strokes with partnered pressure. Be sure to work on a sloped, padded surface.

Tool: banded soft pencils 6B) **Paper:** drawing/JNB **Speed:** deliberate, slow to moderate

Fig. 7

Even pressure: equal pressure to each point. (Fig. 8a)
1. Place the points at 45° on an inhale.
2. Exhale and sink the weight of the shoulder-arm on both points, as evenly as possible, and pull a downstroke 2-3 inches in length.

Partnered pressure: both points stay in surface contact with slightly more pressure applied to one of the partnered points. Pressure comes primarily from the shoulder, allowing the partnered finger to focus on guiding the stroke.
1. Place the points at 45° on an inhale.
2. On the exhale, without moving, place a little more pressure on the right point (IF)—a subtle form of rocking. Still exhaling, pull a downstroke keeping greater pressure on the right point (IF). Start by exaggerating. (Fig. 8b)
3. Repeat 1. and 2. but with greater pressure on the left point (T). (Fig. 8c)
4. Alternate partnered points while pulling a downstroke. Pause to shift pressure to the new partnered point. (Fig. 8d)
5. Pull short diagonals (Fig. 8e): apply more pressure to the right point (IF) as you pull the stroke to the right; release and pull diagonally to the left—the first segment of a hairline (See p. 87)—to close the stroke. Repeat.
6. Use the same pattern and partner with the left point (T). (Fig. 8e)

X = pressure

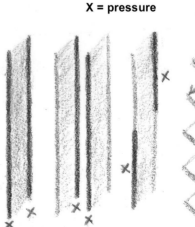

Figs. 8a **8b** **8c** **8d** **8e**

Partnered play

Play is not only enjoyable, it's productive. Because the word itself encourages relaxation, it opens you to discoveries that might not be readily available otherwise. Play generates a mood of spontaneity that releases creativity. It is not an indulgence, but an important part of the calligraphic process—for seasoned practitioners as well as for beginners. In fact, in the Persian tradition, the warm-up sheet of a talented calligrapher may itself be regarded as a work of art.

Tools: two-point with banded pencils (6B) and Pigma Microns
Paper: tracing vellum and drawing/JNB/marker

Both points in contact
1. Trace Figs. 9, 10 and 11. First, use even pressure to get the pattern, pausing as you change from one direction to another; second, with partnered pressure.
2. Notice the play of the stroke—its springiness, how it gives—especially as you change directions.
3. Experiment.

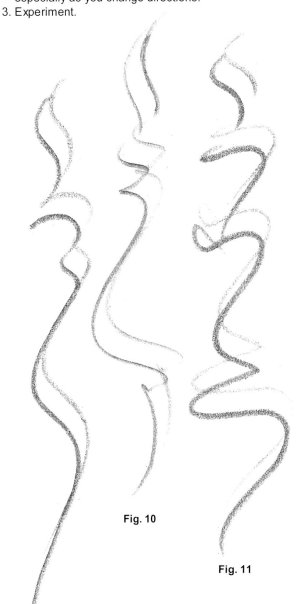

Fig. 10

Fig. 11

Fig. 13

Fig. 12

Fig. 14

Fig. 9

One or both points in contact
1. Trace Figs. 12 and 13 to get the idea. You are using the two-point tool to make both single, one-point lines and double-walled, two-point lines. (Remember to rock!)
2. Freehand: experiment with zigzags, arcs, angles, straights and curves in a set sequence or just as you feel. This play/work depends on your imagination and mood.
3. Trace Fig. 14 noting the single-line and double-walled strokes, as well as the open and closed ones.
4. Experiment.

Training Alphabet 4: Trapeze

This alphabet trains you to use nib angle for creating the calligraphic thicks and thins of letterform. Its bold, spirited strokes develop your sensitivity to the subtleties of calligraphic letterform. The previous lessons in touch and movement with the one-point tool prepare you to enjoy the more sophisticated strokes created with the two-point tool.

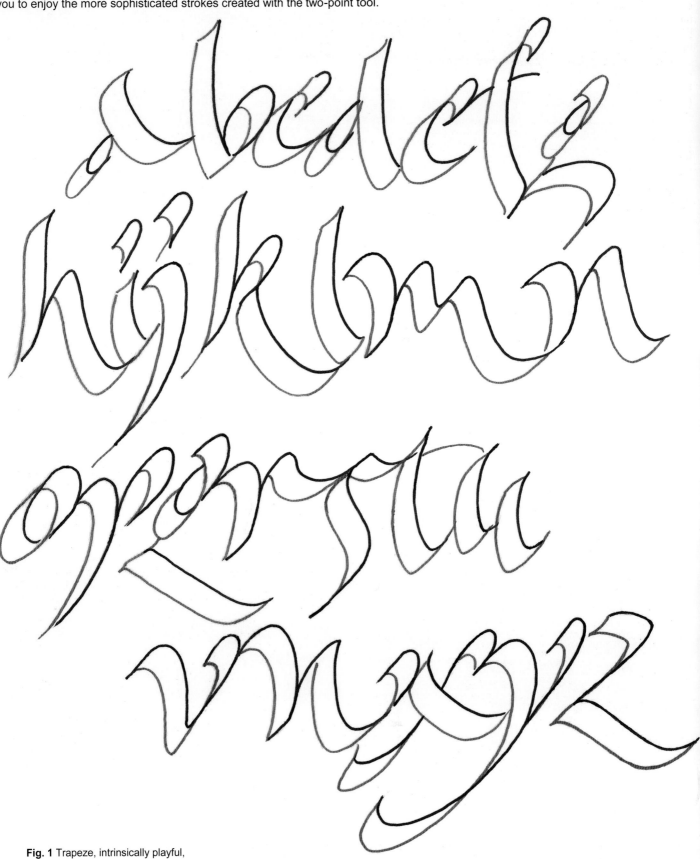

Fig. 1 Trapeze, intrinsically playful, welcomes your experiments with plasticity and letter variants.

Design

Characteristic angle: 45°

Visual themes
Thicks: curved double-walled strokes that close at each end end and graduate in thickness. (Figs. 2 and 4) Stylistically, these double-walled strokes are seen as shapes from which lines may project, but not enter. (Note the crossbars of the "t"s in Fig. 4.)
Thins: single-line and hairline strokes. Single-line thins are used to close thicks that don't close as a natural result of the tool. (Fig. 3) These strokes also draw the crossbars of "t" (noted above) and "f."

Structure: The verticals and horizontals of grid paper allow you to clearly and precisely map the structure of Trapeze's letterforms: their height and width (proportion), and directional strokes.

Letter families
Trapeze is made up of seven families, their members varying in response to the distinctive traits of this alphabet.

Ductus

Trapeze creates thick and thin strokes strictly by the direction of their movement (and a steady nib angle). Partnering technique is presented as part of "Ductus and Dynamics" to help you direct and stay with the strokes of a two-point tool.

The spirit of the alphabet.

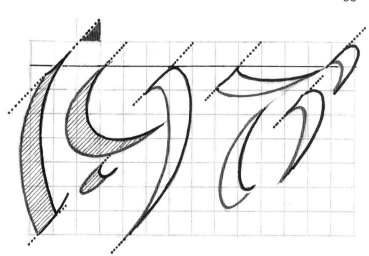

Fig. 2 Closed, double-walled stroke shapes

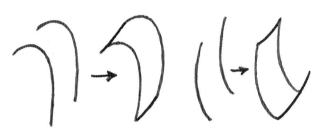

Fig. 3 Single-line strokes (black) enclose double-walled strokes.

Dynamics

This alphabet integrates Jumprope's pressure patterns to help you create Trapeze's strokes in a rhythmic, coordinated flow. Using a two-point tool as a trapeze, you'll sweep over the paper, alternating between one- and two-point strokes as you push and pull them into letters. Such "gymnastic" training develops agility with the tool. The skill it engenders leads to the discovery of letterform's potential to convey power, grace, and personal expression.

Guidelines for Trapeze
Like Jumprope, Trapeze expresses movement, in part, by the relationship of its strokes to guidelines. Here, too, guidelines support and channel, rather than confine, the course of letterform. (Fig. 4)

Fig. 4 Latin saying: "Nothing terrifies me." Encouraged by these words, I wrote them without the safety net of guidelines. (The dotted line was added later.)

94

Letter Family 1: the "i" (iltuf)

Characteristic angle: thicks at 45°, and single-point thins that are independent of nib angle.

Visual themes: curved, slightly graduated downstrokes with single-line entries, exits and crossbars. (Fig. 1)

Proportion
Discussions of proportion refer only to letters that are wider than the width of a single (double-walled) stroke such as "i" and "l." In Fig. 1, note the red background shapes and compare the "i" and the "u."

Warming up
These exercises focus first on establishing a 45° nib angle, and then keeping the tool steady as you move it. This prepares you for the demands of lettermaking with both a two-point and an edged tool.

Tool: two 05 Pigma Microns banded together
Paper: large-grid
Body: shoulder-arm for large double-walled strokes and hairlines

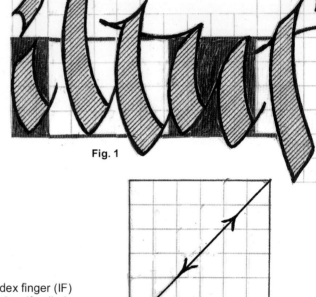

Fig. 1

Fig. 2

Characteristic angle
1. Draw a square figure, six squares by six. (Fig. 2)
2. Place the nib at 45° in the lower left square.
3. Inhale and push the nib up to the top right corner of the square. The index finger (IF) guides the right point, aiming it at each square's top right corner, moved as if pulled magnetically. The left point (T) follows, overlapping it, and makes a hairline stroke.
4. At the top right corner of the full square, exhale and pull the nib down, retracing, aiming the left point (T) at the lower-left corner of the each square.
5. Repeat using different speeds and pressure patterns.
6. After you get the angle-direction in mind, close/blur your eyes to focus on the muscular sensations and experience the kinesthetics.

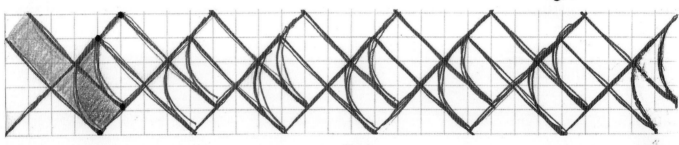

Fig. 3

Lattice framework with arcs
1. Make a lattice five squares in height using the stroke pattern in Fig. 13, page 88. (Fig. 3)
2. Add target points for pulling arcs. (Fig. 3, black dots)
3. Place the nib over the top two dots. Make a quick inhale; exhale and pull the stroke one nib width (first segment of the hairline). Use even pressure.
4. Inhale and partner with the right (IF) point.
5. Exhale and pull an arc to the bottom target points, as your eye follows the partnered point. Repeat, partnering with the left point (T). Compare the experiences.
6. At the bottom of the arc, inhale and push a hairline, tracing upward over the lattice frame to begin the next arc. Repeat the pattern.
7. From the last arc, pull single arcs freehand in a vertical row. (Fig. 4)
8. Apply end pressure to both points.

Fig. 4 (shows end pressure)

Ductus and Dynamics

In Trapeze, the two-point tool techniques of partnering and rocking play important roles. Below, the "i" demonstrates stroke moves used in most letters of Trapeze. After the detailed construction of each stroke of "i," you'll find an exercise to further sensitize you to its features. First trace with prototool 2.

Fig. 1

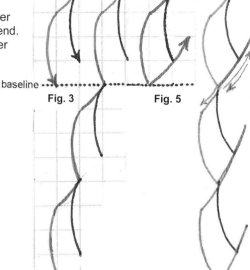

Fig. 2

Tool: a red and black Pigma Micron banded together **Papers:** tracing vellum, large-grid, marker

(i) Single-line entry (Fig. 1)

1. On large grid, draw a waist- and baseline four squares apart.
2. On an inhale, place the left point (T) in the top right corner of a square at the waistline.
3. Exhale and pull the single-line entry stroke down, in a shallow arc, to the lower left corner of the square. Make three more of these at the waistline. First use even pressure then end.
4. As you finish the last entry, prepare to make the downstroke: as part of the exhale, lower the right point to the paper onto the upper right corner of the square. Repeat this action with the previous three entries.

> **Slalom exercise:** sensitizes the thumb and develops its partnership with the left point.
> a. On large-grid paper, place the left point as above. (Fig. 2)
> b. Take a quick inhale. Exhale and pull a single-line stroke as above.
> c. Inhale, releasing pressure, and push a horizontal arc; exhale and pull another diagonal arc. Repeat in a slalom pattern.

Fig. 3 **Fig. 5**

Double-walled downstroke (Fig. 3)

This stroke follows the single-line entry above.

1. Make the above single-line entry. As you finish the stroke, still on the exhale, lower the right point. Inhale and position the weight of the arm over both points.
2. Exhale and pull a shallow, double-walled arc—applying even pressure to both points and holding nib angle steady. End the stroke with the left point touching the baseline. (Fig. 3)
3. Try the rhythm exercise below to get comfortable with this one-to-two point action.

> **Rhythm exercise:** continues from the end of the above downstroke. (Fig. 4)
> a. Inhale and rock to the left point: exhale and pull the single-line entry stroke. At the end of it, lower the right point. Inhale, balance weight; exhale and pull the double-walled arc.
> b. Repeat this pattern a few times. Use end pressure for both the single-line entry and the double-walled downstroke. Let the pressure act as an elastic pull to help you keep nib angle steady.

Fig. 4 **Fig. 6**

Single-line exit (Fig. 5)

1. Make an "i" stroke (entry plus downstroke).
2. Inhale and rock to the left point (T). Push a single-line exit (start pressure), one square above the downstroke's right wall.
3. To get the feel of this point shift (moving from two points to one), try the exercise below.

> **Rocking exercise 1**
> a. Trace Fig. 6 as follows: At the completion of each downstroke push the single-line exit (T).
> b. Then, on the same point (T), retrace this stroke downward to the baseline. Pause and pull the single-line entry to begin the next downstroke. Repeat and coordinate with the breath.

Fig. 7

The dot of "i" (Fig. 7)

1. Begin two squares above the waistline. Make the single-line entry stroke (left point, T) two squares above the entry to "i." Lower the right point (IF).
2. With both points in contact, pull a short diagonal arc to the right. (Fig. 8a)
3. Rock to the right point (IF) and draw a curved, single-line thin. End with a short up-tick to close the dot.

Fig. 8a **Fig. 8b**

> **Rocking exercise 2:** Make a row of dots. (Fig. 8b) Practice making the point shifts smoothly, remembering to pause between them.

"I-i" sequence: To practice "I," a longer version of "i," alternate the two letters as described below. (Fig. 9)

1. Add an ascender line three squares above the waistline. On an inhale, place the left point in the top right corner of a square on the ascender line.
2. Follow the stroke directions for "i."
3. Swing the single-line exit (left point, T) up to the waistline. On the same point make the entry stroke and then the double-walled downstroke. Inhale and push a single-line exit (T) up to the ascender line. Repeat. Here, single-line strokes intrude into double-walled strokes. (Fig. 9)

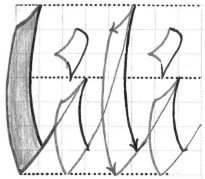

Fig. 9

Note: Unlike the double-walled strokes of the "l-i" exercise, those of "u, t, and "f" hold true to one of Trapeze's basic features: open strokes free of intrusion. The moves to accomplish such strokes are provided in the following instructions. Although they include all aspects of letter formation, the letters are best approached in an incremental way. I recommend focusing first on stroke direction (ductus) and point shifts. Then, integrate the breath to more enjoyably participate in the rhythmical flow of stroke making. Lastly, as you gain confidence with these elements, add the suggested pressure patterns. Work slowly. And, in the spirit of Trapeze, try making "u, t, and f" into acrobatic performances!

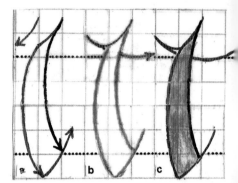

Fig. 8

(u)
1. **Entry:** Inhale and place the left point (T) a half square above the waistline. (Fig. 8) Exhale; pull the single-line entry down one-half square below the waistline and lower the right point.
2. **First downstroke:** Inhale and balance arm-shoulder weight over the two points. Exhale, pulling both points to the baseline and rocking to the left point (T).
3. **Upstroke:** Inhale and push a single-line exit to one square below the waistline. As part of the inhale, lift the left point from the paper and replace it in the square's top right corner.
4. **Entry to second downstroke:** Exhale; pull the single-line entry and lower the right point. Inhale.
5. **Second downstroke:** Exhale and pull the double-walled downstroke of "i," dipping a little below the baseline, then rocking to the left point (T).
6. **Single-line exit:** Inhale and push the stroke using start pressure.

(t)
1. **Entry:** Inhale and place the left point (T) one-and-a-half squares above the waistline. (Fig. 9a) Exhale; pull a single-line entry stroke to one-half square above the waistline and lower the right point (IF).
2. **Downstroke:** Inhale and balance the points. Exhale and pull to one square below the baseline; then rock to the left point (T).
3. **Single-line exit:** Inhale and push this stroke up through the baseline. At the end, lift off the paper, continuing the upward motion to the top of the letter, replacing the left point as if to begin the letter again.
4. **Crossbar:** an interrupted, single-line stroke
 a. At the top of the entry stroke, on the left point, exhale and retrace the entry stroke with even pressure; inhale and apply start pressure as you swoop up and to the left about a square. (Fig. 9b) Pause.
 b. Exhale and swing down with end pressure to the left wall of the downstroke.
 c. Inhale, release the pressure, hop over the width of the stroke, exhale and touch down on the right wall, inhale. Exhale and, using start pressure, finish the arced crossbar. (Fig. 9c) Trace Figs. 9a, b, c a few times to get the flow of the point shifts, breath, and pressure patterns.

Fig. 9a, b and c

(f) The height of "f": two squares above the waistline, a square shy of other ascenders.
1. **Downstroke:** Make a single-line entry and downstroke, finishing two squares below the baseline. (Fig. 10a)
 a. Inhale and rock to the right point (IF); exhale and pull a shallow, single-line curve down to meet the left wall of the downstroke (end pressure). (Fig. 10a)
 b. Inhale and use the release of pressure to energize the return leap to the top of the letter—exhaling and touching down on the *right* point (IF) (Fig. 10b)
2. **Top stroke:** Inhale and push up into a single-line *convex* arc. (Fig. 10b)
 a. Exhale, lower the left point (T) and balance the points.
 b. Inhale and push up a short way; exhale and pull around in a short, narrow curve. Inhale and rock to the right point (IF).
 c. Exhale and close the stroke (as in the dot of the "i"). Inhale.
3. **Crossbar:** Use the "t" crossbar, or make a variation (Fig. 10c):
 a. Exhale and retrace the single-line entry; pause and inhale (left point, T). Exhale and pull down along the left wall to the waistline. Inhale. Exhale and swoop to the left, below the waistline, in a shallow arc.
 b. Inhale and complete a shallow loop finishing with end pressure at the stroke wall. Exhale.
 c. On an inhale, release pressure and hop over the stroke. Exhale and touch down on the right stroke wall (waistline); inhale. Exhale and use start pressure to complete the arced crossbar. Trace Fig. 10c a few times to get the flow of changes in breath, point shifts and pressure.

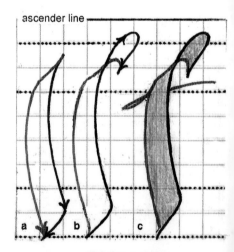

Fig. 10a, b and c

Note: In setting the crossbar, neighboring letters and/or the spirit of the text may influence the direction of this stroke. (Fig. 11)

Fig. 11

Weight

When I introduced "weight" while working with the one-point Conte crayon (p. 31), I defined it as the relative darkness/lightness of a stroke produced by tool pressure. In contrast, a two-point tool uses the width of the nib to "see" stroke/letter weight. (Figs. 1) By stacking nib widths in a "stair" pattern, you have a way to "measure" the relative darkness/lightness you see. (Fig. 5) With a two-point tool, letter weight is relative to the width of the nib and to letter height. Compare the three "i"s in Fig. 1: the shorter the "i" (fewer nib widths), the heavier it appears; the taller the "i (more nib widths) the lighter it appears.

Nib width as a unit of measure is analogous to the human head used by artists. (Fig. 2) Such units of measure develop visual acuity: to see and set the weight of a subject.

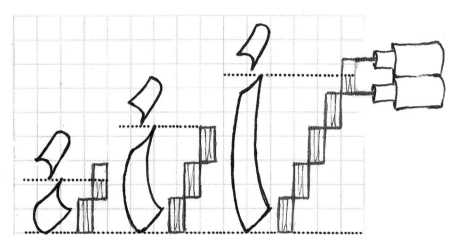

Fig. 1
Three different scales based on the number of nib widths create three letter weights: far left (1½) features letter shape; center (3) shows Trapeze's characteristic scale; far right (4½) features the linear quality of the letter.

Fig. 2
In figure drawing, the head often acts as the unit of measure for scale/weight.

Nib scale: A method of measuring and describing the weight of letter stroke/form in terms of the number of its nib widths.

Scale as measuring method: For this, nib widths are stacked in a stair pattern. (Figs. 1, 3, and 5) The number it takes to reach the waist- or cap line gives the height of a letter. (Figs. 1 and 3) With experience, however, the use of measurement via nib width becomes less necessary. Gradually it becomes possible to convert weight directly from your mind's eye to a writing surface.

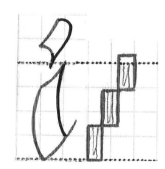

Fig. 3 Guidelines for Trapeze

"Characteristic" scale
In addition to characteristic nib angle, an alphabet style also displays a characteristic scale. This usually encompasses a range, which for Trapeze is approximately 2½ to 3 nib widths. A scale that is less or greater than an alphabet's characteristic creates letterforms with a different "personality." (Fig. 1 and Fig. 8, p. 102)

Guidelines
Guidelines reflect scale. For Trapeze, large-grid paper offers a convenient source of ruled lines (as well as providing a frame of reference for nib angle). Lines at four squares apart fall within Trapeze's characteristic scale, as they are just under three nib widths. (Fig. 3)

Fig. 4

Making a scale

Tools: two-point; one-point for ruling **Paper:** large-grid **Ruler**

1. Rule a baseline. (Figs. 5a, b and c)
2. Place the left point of the nib on the line and the right point directly above it. The nib is now at a right angle to the line. (Fig. 4)
3. Pull the two points one square to the right (Fig. 5a); pause; then push the points directly up one nib width. (Fig. 5b) This is the first segment of the hairline stroke. (See p. 87)
4. Keep stacking to get the feel and the idea. (Fig. 5c) To begin, this need not be rigid, a little play—such as overshooting the mark and returning to it—is fine. Then, stay relaxed while trying for greater precision, through mental concentration rather than physical tension.

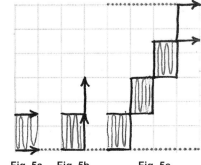

Fig. 5a Fig. 5b Fig. 5c

Word as image: exploring weight

In this exercise you make two nib scales to explore the relationship between weight (scale) and height.

Tools: two soft pencils banded together; pencil for ruling
Paper: large-grid or drawing/marker **Ruler**

1. Choose words using "i" family letters, such as tiff, tilt, if, full, tuft.
2. Write each word at a different scale and compare them. (Fig. 6)
3. Write each word at the same scale with tools having different nib widths. (Fig. 7)
4. Use partnered pressure, applying more pressure to one point than the other. (Fig. 6)

Note
Scale is one of four primary calligraphic factors—in addition to nib width, nib angle and stroke direction—that influence the shape of the stroke. A change in any one of these creates a change in stroke shape.

Toward eyeballing weight

Focusing on height, this exercise aims to further develop your confidence in seeing and articulating variations in weight.

Tool: two-point, your choice **Paper:** drawing/marker/JNB

1. Write a word at three different heights.
2. Analyze them in terms of weight (scale). For example, "lift," at two nib widths is heavier than "lift" at five. (Fig. 6) If your aim is graphopoeiac (see p. 72), the first "lift," with its wide, short stroke, appears heavy for the word it embodies. The second, lighter version, a trimmer, somewhat elongated stroke, seems closer in feel to the word it represents.

Note
Scale is an elegant and efficient method of teaching the eye to see weight in terms of the tool. (Fig. 8) As you learn these lessons, this training device, like any other, becomes unnecessary.

Alphabet design process:

solving problems through experimentation

The calligrapher of today is not the scribe of old. Changes in alphabet design used to occur over centuries. Now, graphic designers and artists may create an alphabet "on demand" for a practical or expressive purpose. The present-day calligrapher also modifies and interprets historic styles for today's eyes and usage.

In the creative process, it is common to encounter design "problems" (as described below). Part of this process is prioritizing the sometimes conflicting demands of design and legibility, of resolving them through experimentation.

Two problems arose in designing Trapeze: the crossbars of "t," "f," and the join into the second downstroke of "u." By definition, "crossbars" cross through downstrokes. Since "t" and "f" require them, Trapeze's characteristic unfilled, double-walled stroke would not be preserved. (Fig. 1a) This feature also precludes the usual method of constructing "u." (Fig. 2) These problems and their solutions derive from the nature of the two-point tool. In the case of the crossbars, if both points are grounded, two strokes must trespass the downstroke. (Fig. 1b) For "u," if two points remain in contact there will also be an unwanted intrusion. (Fig. 2) However, using the single-line capability of the two-point tool resolves this design issue. (Figs. 1c and 2)

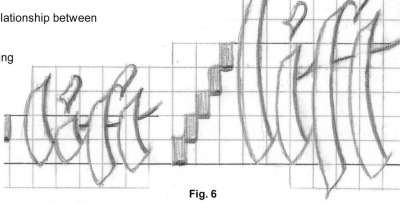

Fig. 6
Two different scales with their corresponding letter weights/heights.

Fig. 7

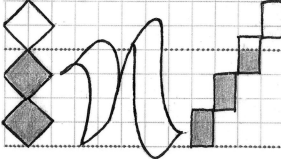

Fig. 8 Persian calligraphers use a diamond lozenge to measure scale.

Fig. 1a: A single-line crosses the downstroke; **1b**: both points cross the downstroke; **1c:** a single-line that doesn't cross it

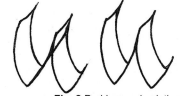

Fig. 2 Problem and solution

Letter family 2: the "o" (oce)

Characteristic angle: 45°

Visual themes
- Open and closed bowls (Fig. 1)
- Graduated arcs

Fig. 1

Proportion: An approximate square (Fig. 2)

Structure: The internal frameworks for "o" and "c" take the shape of unusual quadrilaterals: lower-left right angles and upper-right obtuse angles. (Figs. 3 and 4). Here, stretch points are either embedded in the strokes, as previously, or placed inside the counter. (Fig. 6, next page)

Letter variants
Variants add liveliness to an alphabet; in addition, they offer flexibility in the spacing of different letter combinations. (E.g., Fig. 1, "c" dips below the baseline which would allow "e" to move closer to it).

Fig. 2

Warming up
This loosening up exercise aims to help you get comfortable keeping both nib points on the paper. It focuses on distributing the weight of contact evenly between the points.

Tool: 05 red and black Pigma Microns banded together
Paper: drawing/JNB
Body: shoulder-arm

Two-point throws – fast and slow
Start with ovals three to five inches high; then throw shorter ones of one to one-and-a-half inches.
1. Fast: Place nib points at 45° on an inhale.
2. Exhale and throw counter-clockwise ovals quickly and loosely across the paper. (Fig. 5)
3. Slow: Place nib points at 45° on an inhale.
4. Exhale and pull the left side of the oval.
5. Inhale and push the right side. (Fig. 6)
6. Repeat 4. and 5 above.
7. Try this pressure pattern: Use end pressure as you swing into the bottom of the arc. Use the energy of releasing pressure to propel the arc up, over and to the right.

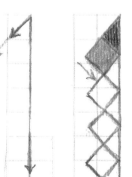 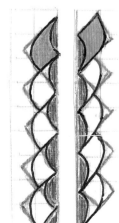

Fig. 3 **Fig. 4**

Preliminary: making graduated strokes
This sequence explores partnering as an aid to shaping the graduated arc. It brings awareness to the spatial shapes/counters (red) that result as you make strokes (green).

Fig. 5 **Fig. 6**

Tool: two-point (soft pencils)
Paper: large-grid **Body:** shoulder-arm

Framework: even pressure
1. Place the nib points at 90° atop one of the vertical grid lines and pull a long hairline. (Fig. 7)
2. Return to the top of the line. Place nib points at 45° (the right point touches the vertical).
3. Pull a hairline (first segment). (Fig. 7)
4. Partner with the right point (IF); pull a double-walled diagonal back to the vertical until the right point touches it. (Fig. 8)
5. Repeat to form a row of diamonds and triangles (framework for arcs below).

Graduated arcs: even pressure
1. Atop Fig. 8, place the nib at 45° (the right point touches the top of the vertical).
2. Pull an arc over the top diamond of the framework. (Fig. 9, green shape)
3. Repeat to form a row of right-facing graduated arcs. Keep nib angle steady.
4. Alternate your focus from stroke (green) to counter (red).
5. Pull a hairline (Fig. 7) and make a diamond framework to the right of it.
6. Make a row of left-facing graduated arcs. (Fig. 10)

Fig. 7 **Fig. 8** **Fig. 9** **Fig. 10**

Ductus and **D**ynamics

Trace the figures according to the instructions and then make them freehand. The "o" family also introduces the "counter" stretch point. These targets are placed inside the counter or embedded in the stroke. (Figs. 4, 6 and 8) Whether inside the counter or embedded, these stretch points are aids to producing a taut, living stroke. (See Stroke dynamics, p. 101)

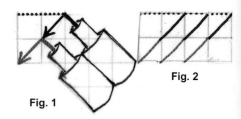

Fig. 1　　**Fig. 2**

Tool: 05 red and black Pigma Microns banded together
Paper: tracing vellum and large-grid
Guidelines: 4 squares apart　**Speed:** slow and deliberate

Breathing: Inhale as you place the tool to begin a stroke; exhale as you pull the stroke.

The hairline: a little target practice
1. Inhale and place nib points at 45° on large-grid paper. (Fig. 1)
2. Keep both points on the paper as you exhale and pull a hairline (first segment) aiming the left, leading point (T) at the lower left corner of the square. (Fig. 1) A tight grip does not guarantee precision. Relax and enjoy the movement as you integrate it with breathing.
3. Repeat a few times. (Fig. 2)

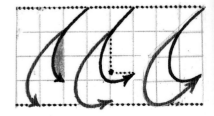

(o) Entry hairline
1. Inhale and place the nib at 45° with the right point touching the waistline. (Fig. 3)
2. Balance shoulder-arm weight over the points; then partner with the left point (T).
3. Exhale and pull the first segment of a hairline as above.
4. Note: this stroke tends to curve slightly as it anticipates the next stroke.

Fig. 3　　**Fig. 4**　　**Fig. 5**

Left side: vertical and horizontal arcs
1. In place, inhale and mentally partner with the right point (IF).
2. Exhale and pull the arced double-walled downstroke. (Fig. 3) Use even pressure or pulsing (p. 62) to stay with the stroke. Slow slightly toward the baseline.
3. Inhale and pull around the counter stretch point; exhale and push the horizontal arc. (Fig. 4) Close the stroke, rocking to the left point (T) and pushing a single-line stroke diagonally up. (Fig. 5)
4. As these arcs become more fluid, try making them on a continuous exhale.

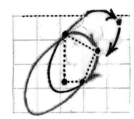

Right side: diagonal arcs
1. Inhale and place the nib points atop the entry hairline. Exhale and balance your weight on the points, mentally partnering with the left point (T).
2. Inhale and push the first part of the horizontal arc up to just above the waistline. (Fig. 6)
3. Exhale and pull the double-walled arc to the stretch point. Use even pressure or pulsing.
4. Slow slightly and inhale as you pull around the embedded stretch point.
5. Exhale and continue pulling the arc to meet the finish of the first stroke.
6. Inhale and rock to the right point (IF); exhale and pull a single line arc to close the "o." (Fig. 7) Repeat the letter a few times.
7. With practice, letter making with point shifts becomes a smooth and continuous action.

Fig. 6

(c) Entry hairline: As in "o."

Left side: vertical and horizontal arcs.
1. Repeat the left side of the "o" pulling the vertical arc a little farther to the left. The horizontal arc then becomes a little broader. (Fig. 8)

Top stroke
1. Inhale while placing the nib points atop the entry hairline; exhale.
2. Inhale and push the first part of the horizontal arc up to just above the waistline.
3. Exhale and pull a short horizontal arc, following the course of "o," but shorter in length and more rounded. End by pulling it around and closing the stroke, as in the top of "f." (p. 96)

Fig. 7

(e) Entry hairline and left side: As in "c." (Fig. 9)

The eye of "e": an unclosed loop (breathing as above)
1. Top stroke: Place the nib points atop the entry hairline. Pull a rounded stroke as in "c."
2. The eye: Rock to the right point (IF); pull down and to the left, closing the stroke, and ending just short of the downstroke.

Fig. 8

Note: The bottom horizontal arcs of "c" and "e" may broaden or contract depending on the letter that follows. At the end of a word, bottom horizontals can observe the model or swing slightly to the right.

Fig. 9

Fig. 1 The "o" of Trapeze, left, and Jumprope, right.

At the beach,
pulling curves around counter stretch points

Stroke technique:
pulling curves
The bowl of the Trapeze "o" features a curved rather than a pointed base. (Fig. 1) Each of its sides is composed of a horizontal and vertical arc. A comparison of the two "o"s reveals the formative influence of their different internal frameworks. (Fig. 1)

Negotiating the curve
In Trapeze, as in Jumprope, an internal framework structures the dynamics of "o." Here, the lower left and upper right corners of a quadrilateral act as counter stretch points for the surrounding arcs. (Fig. 1) Now, consider an analogy between these corners and those of a street. To turn a corner, a driver steps on the gas at just the right place in time to negotiate the curve; calligraphic drivers pull around a stretch point while applying a pattern of tool pressure. In Figs. 2 and 3, variations in shading and dot size represent such variations in pressure. (The heavier the shading or the larger the dots, the greater the pressure.)

 Tool: a two-point tool **Paper:** tracing vellum, drawing/JNB

1. Trace the left side of the bowl using center pressure. (Fig. 2)
 a. Inhale and place the nib points.
 b. Exhale and pull the hairline (first segment) of the "o." Inhale.
 c. Exhale and pull around the counter stretch point—red dot, lower left—applying pressure as you finish the vertical arc and releasing it as you pull into the horizontal arc. (Analogous to start pressure's leaning in and pushing off, p. 32). Close the stroke with a single-line exit.
2. Trace the right side of the bowl. Pull around the counter stretch point (red dot), with center pressure, from a horizontal to a vertical arc. Close the stroke.
3. Focus on the feel, with most of the pressure coming from the shoulder and arm. When you have established the pattern, turn your attention to the speed of your actions, making any small adjustments in acceleration or deceleration. This quality of engagement with the stroke helps you cultivate its rhythmic potential.

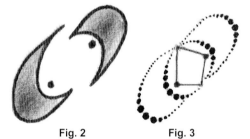

Fig. 2 **Fig. 3**

Learner's permit
A sensitizing exercise to help you negotiate letter curves. This helps you develop greater awareness of muscular and tactile sensations as it cultivates them. When you are ready, apply partnered pressure to the point closer to the bowl's counter.

 Tool: two-point with pencils **Paper:** large grid **Speed:** slow and deliberate

Fig. 4

Left side of the oval: focusing on the right point (IF) partnership
1. Warmup: throw loose, large ovals to the left (counter-clockwise). (Fig. 5, p. 99)
2. Draw frameworks 3 squares by 5 with stretch points (Fig. 4, red dots). With both points touching the paper, pull an oval arc while applying center pressure as you pull around the dots.
3. Retrace.

Right side of the oval: focusing on the left point (T) partnership
1. Warmup: throw loose, large ovals to the right (clockwise).
2. Draw frameworks as above. Place stretch points as in Fig. 5. With both points touching the paper, pull an oval arc while applying center pressure as you pull around the dots.
3. Retrace.

Fig. 5

Practice writing

1. Use the letters in your repertoire and focus on:
 - giving the bowls a rhythmical swing.
 - spacing the letters, making any adjustments to improve evenness.
 Note that the open bowls of "c" and "e" are plastic and the lower hori-
 zontal arc may dip and stretch (Fig. 1, p. 99), or contract, to reduce
 space between letters. (Fig. 6)
2. Combine the "l" and "o" families in scats, as in Fig. 7.

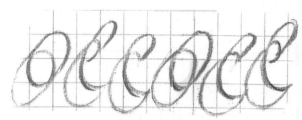

Fig. 6

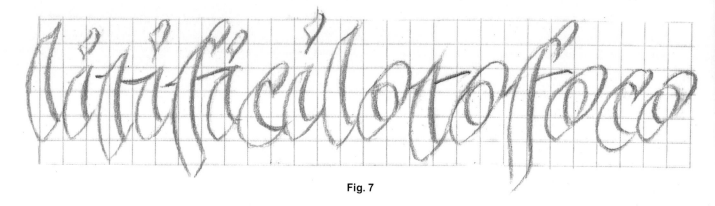

Fig. 7

Letter design:

scale and proportion

Notice the influence of scale on stroke weight
and proportion. As scale decreases, letters
become heavier and wider, and strokes grad-
uate more rapidly; as scale increases, letters
become lighter and narrower, and strokes
graduate more slowly. (Figs. 8 and 9) The
first example, at two nib widths, like the bal-
lerinas at the bottom, is a caricature of the
parent form—both used here in the spirit of
fun.

Fig. 8

Word as image

Tool: two-point
(pencils/Pigma Microns)
Paper: large-grid and/or drawing/JNB

1. Write words from letters of the "o" and
 "l" families at two different scales.
2. Mark the scale with the tool, e.g., two-
 and four-nib widths. (Fig. 9)

Fig. 9

Scale and the human body
In drawing the human figure, artists usually use the head as the unit of measure for scale. The typical
fashion model on page 97, ten heads in height, exceeds the seven-and-one-half average. The figures
at right, at about seventeen heads, move into altogether different territory—that of playful caricature.

Letter Family 3:

the "a" (adgq)

Visual themes

- The teardrop counter. The "a" family displays this shape in each letter: in a smaller version for "a" and "g" and a larger one for "d" and "q." (Fig. 1)
- Stroke refinement for Trapeze. Using both points of the two-point tool creates excess bulk in the top right strokes of the bowls of "g" and "q." (Fig. 1, solid red areas to the left and right of these strokes.) Slimming them, described below, better suits the dynamic spirit of Trapeze.

Proportion and scale

An increase in scale (number of nib widths) changes the proportion of the two teardrops: the smaller ones of "a" and "g" yield a narrow square and the larger ones of "d" and "q" a squat rectangle. (Fig. 2)

Warming up

Tool: a soft pencil and a Pigma Micron banded together
Paper drawing, tracing vellum/marker/JNB
Body: primarily shoulder and arm **Size:** bold

"Flying" trapeze

1. Place the nib at 45° and make a quick inhale.
2. Exhale and pull down the hairline entry stroke (first segment) of the "o" family letters. Follow this with shallow, diagonal arcs. (Fig. 3) Repeat.
3. Experiment with both even pressure (the same amount of pressure to each point) and partnered (uneven) pressure.
5. Try varying stroke length and direction. (Figs. 4, 5, and 6)

The teardrop: getting the idea

Trace first according to the instruction below.

1. Place the nib at a 45°; apply a little pressure to both points and hop/spring to the right—leaving the paper a few times (Fig. 7, far left).
3. From the last set of points, pull the hairline entry of the "o" family letters, which also begins the teardrop.
4. Continue as though making the left side of "o," only narrow the width of the bottom arc. Rock to the left point (T), close the stroke and, to form the teardrop, continue pushing the single line up to the start point.
5. Replace the right point (IF) and pull into a short, diagonally downward arc.
6. Repeat the sequence, making teardrops of the same/varying size. Try partnered and unpartnered pressure, rhythm, breath, and speed.

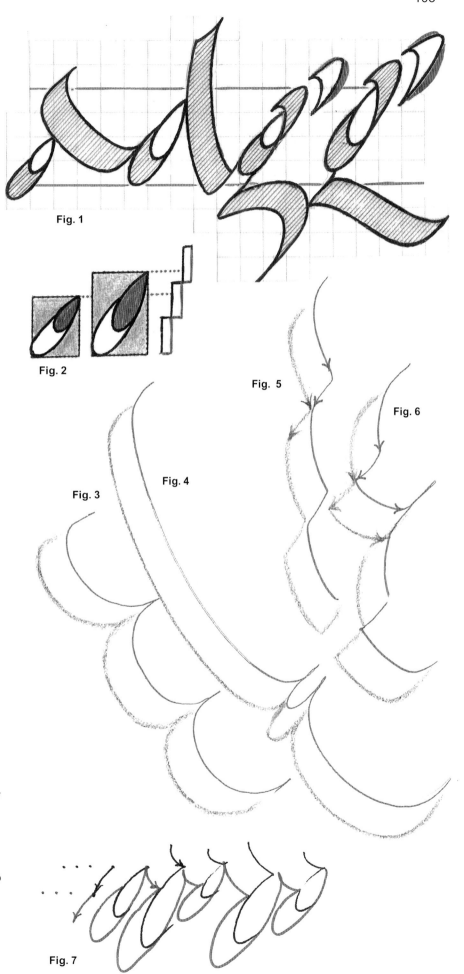

Fig. 1

Fig. 2

Fig. 3

Fig. 4

Fig. 5

Fig. 6

Fig. 7

Ductus and Dynamics

Trace and then use grid paper. The "a" family letters all begin with a teardrop-shaped bowl. Get familiar with the ductus, then add the breath: inhale, press-release; exhale, pull.

Tool: 05 red and black Pigma Microns banded together **Paper:** tracing vellum and large grid

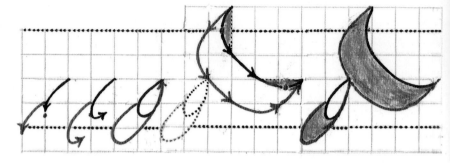

(a) 1. **The teardrop bowl:** greater precision
Rule guidelines with a four-square x-height.
Set a stretch point (Fig. 1a, red dot) and use
the following three steps to make the teardrop:
- a. **Initial thin** (Step 1, Fig. 1a): Place points
at 45° two squares below the waistline.
Partner with the right point (IF) and pull
the entry hairline in a shallow arc to the
stretch point (end pressure). The left point
echoes the right.
- b. **Graduated bowl** (Step 2, Fig. 1b): Re-
lease pressure as you bend into the loop.
- c. **Finish thin** (Step 3, Fig. 1c): Rock to the
left point (T) and, pushing up, close the stroke and then the bowl.

Fig. 1a Fig. 1b Fig. 1c Fig. 2 Fig. 3

2. **The diagonal**
- a. Place the left point (T) one square above the waistline and one square to the right of the start of the "a" counter. (Fig. 2) Pull a single-line *convex* entry.
- b. Place the right point (IF) and pull a vertical arc down two squares. Here, the left point connects to the top of the teardrop.
- c. Pause; pull the stroke diagonally one square to the right—a straight section. Pause and continue in a shallow horizontal arc. (Note: The pauses are brief, just long enough to allow you to orient to a change in stroke direction.
- d. Rock to the left point (T) and close the stroke.
- e. Repeat this letter a few times. (Fig. 3, finished letter)

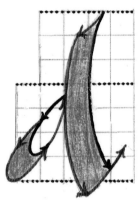

(d) 1. **The teardrop bowl:** Place points at 45°, one-half square below the waistline. Repeat the teardrop bowl in a 3½ -square-high version of the "a" teardrop. (Fig. 4)
2. **Downstroke:** Attach the "l" stroke. Place the left point (T) at the ascender line, 1½ squares to the right of the completed teardrop. Pull a single-line entry. Place the right point and pull both points, partnering with the left (T), first to meet the bowl (the top of the teardrop) and then just through the baseline.
3. **Exit:** Rock to the left point (T) and push the single-line exit stroke.

Fig. 4

(g) 1. **Left side of teardrop:** Place both points of the nib one square below the waistline and make the first two steps of the "a" teardrop. (Fig. 5) Rock to the left point (T) and close the loop. Push this point to the left in a short horizontal arc.
2. **Right side of teardrop:**
- a. At the end of the arc, push up to the waistline on the left point.
- b. Switch points: place the right point (IF) where the left finished. On the right point, push up slightly into a narrow arc and pull around into a shallow, downward arc to close the stroke.
3. **Single-line connector:** Place target points ½ and 1½ squares below the baseline. (Fig. 5, center) and draw a reverse curve with the left point (T).
4. **Tail of "g":** Replace the right point (IF) and push an asymmetrical horizontal arc through the baseline. Negotiate the curve and pull the stroke around into a diagonal arc.
5. **Exit:** Finish with the last segment of the hairline, with the left point (T) drawing below the descender line.

Fig. 5

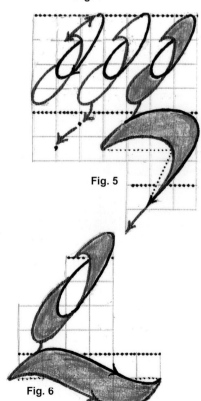

(q) 1. **Left side of the teardrop:** With both points down, make the 3½ -square teardrop of "d" above. (The right point is on the waistline.) (Fig. 6)
2. **Right side of the teardrop:** As the "g," only longer.
3. **Single-line connector:** As in "g
4. **The tail of "q":** Replace the right point (IF) and draw a reverse curve in a shallow, diagonal direction. Note that a straight midsection is bounded by horizontal arcs.
5. **Exit:** Rock to the left point and close the stroke.

Fig. 6

Stroke technique: "follow through"

This technique features the single-line exit as a smooth continuous motion— that is, one that does not make a full stop to rock to one point, but releases contact in motion: as you release pressure while pushing up to exit. (Fig. 1) Let momentum create a sense of follow through. Use this technique to finish the teardrop as well as any other double-walled downstroke.

Tools: Prototool 2 (index finger and thumb), a two-point tool **Paper:** tracing vellum **Fig. 1**

1. Trace Fig. 1, first the Prototool 2 and then a two-point tool. Increase pressure as the dots grow larger; as they diminish in size, release onto the left point and follow through. Imagine giving a massage as you lean into and away from the stroke.
2. Retrace the "o" and "a" family letters using this technique. Write words or scats freehand.

Word as image: spacing

Trapeze expands your awareness of the space above and below letters. This extends the possibilities for plasticity and variants.

Tools: two-point (Pigma Microns), Pigma
 Micron for ruling
Paper: tracing vellum, drawing/JNB
Materials: ruler, removable tape

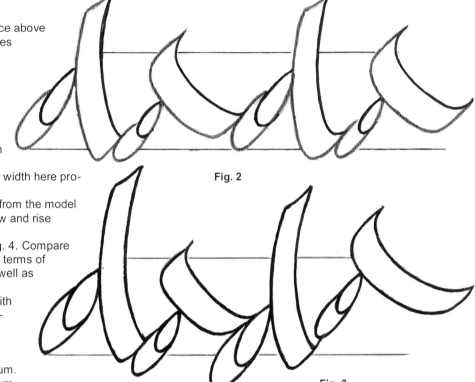

Fig. 2

1. Trace Figs. 2 and 4. These letters are from the model alphabet and touch each other. Don't be concerned that variations in letter width here produce uneven spacing.
2. Trace Figs. 3 and 5. The letters are again from the model alphabet and touch; but they also dip below and rise above the guidelines.
3. Place Fig. 3 over Fig. 2 and Fig. 5 over Fig. 4. Compare the versions, articulating the differences in terms of letter width, height, and distance apart as well as above and below the guidelines.
4. Follow a.-e. below to guide experiments with your own word design. (See word suggestions at the bottom of the page):
 a. Select a word using letters from your repertoire.
 b. Rule guidelines 1" apart on tracing vellum.
 c. Write the word on the ruled tracing vellum, tracing letters from the model alphabet (letters touching).

Fig. 3

 d. Analyze the spacing. Experiment with letter width (interletter space) and letter position in relation to the guidelines. Letters may touch, nest, or be separate. For more dramatic spacing, exaggerate these variables. Feel free to trace and retrace, to cut letters out and try them in different positions. Although you begin working one letter at a time, you gradually develop the skill of seeing these single forms as parts of a whole, as a word composition.
 e. On drawing paper, write and rewrite the word freehand.

Note: By treating ruled lines as *guide*lines, Trapeze offers varied rhythmic possibilities, providing a frame of reference for the play of form rather than the constraints of "a floor and a ceiling." (Johnston) Take an attitude and, in a mood of play, make numerous variations. See what happens. Look at each version to see how you feel about it, to see if it "works." This isn't about "right or wrong."

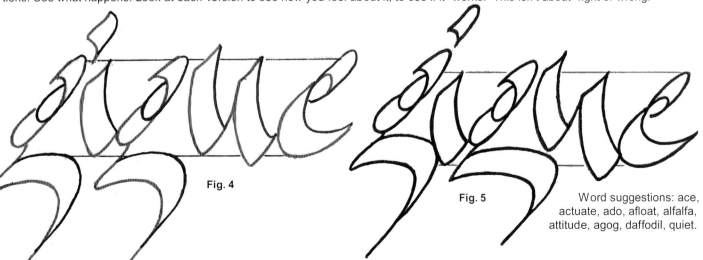

Fig. 4

Fig. 5

Word suggestions: ace, actuate, ado, afloat, alfalfa, attitude, agog, daffodil, quiet.

Letter Family 4: the "n" (nhkm)

Visual themes
- Diagonal and arced downstrokes (Fig. 1)
- Reverse-curve ascenders
- Rounded stroke entries (mn)
- Branching: A single-line upstroke branches up and out from the first downstroke into an arch (nhm) or a loop (k). (Fig. 1)
- Tapering: The initial downstrokes taper at the baseline as a result of a change in direction; nib angle remains steady.

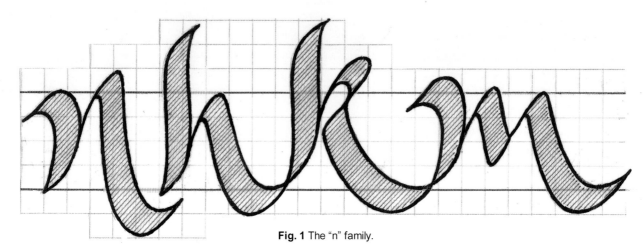

Fig. 1 The "n" family.

Proportion: varies with the diagonal's directional "kick." (Fig. 2) Diagonal downstrokes are not fixed and may dip below the baseline or swing further to the right, depending on the following letter.

Structure

Again, large-grid paper provides a framework for constructing the unfamiliar, swooping strokes of this letter family.

Warming up

These warm-ups prepare you for the rounded stroke entries of "m" and "n," and the narrow curved arch which emerges from a single-line branch.

Tool: red and black Pigma Microns banded together **Paper:** tracing vellum, drawing/JNB

Partnering

 One-point (circular frame):
1. Breath pattern: inhale, up; exhale, down.
2. Place tracing vellum over Fig. 3.
3. Place the right point (IF) atop the black dot. Throw 3 counter-clockwise circles.
 At the top of the last, replace the left point (T) at 45°.
 Two-point (double-walled rounded entry and downstroke):
1. On both points, push up and into a rounded arc; pull the arc over, around and down to the baseline with end pressure.
2. Release pressure as you rock to the right point (IF). Pull down and around in counter-clockwise circles.
3. Repeat the pattern—a one-point circular frame and a two-point, double-walled stroke—a few times.
4. Work freehand on drawing paper.

Rounded zigzag (with breath)
1. Place tracing vellum over Fig. 4.
2. Place the right point (IF) atop the black dot as you inhale and push up nearly two nib widths. Exhale and replace the left point (T).
3. Inhale and continue pushing up into a narrow arc.
4. After making the arc, exhale while applying start pressure to help pull the downward, double-walled diagonal. Enjoy the ride as your left point joins the right to create the narrow bend, and whoosh downward as in riding down a slide. With a relaxed arm-shoulder, a reverse curve is likely to emerge naturally.
5. Rock to the right (IF) and repeat in a rounded zigzag pattern.
6. Practice smoothly, coordinating the breath with point shifts and directional movement.

Fig. 2

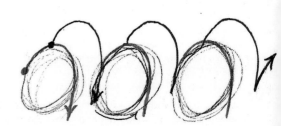

Fig. 3

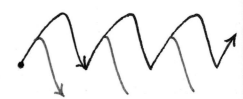

Fig. 4

Ductus and Dynamics

Trace; then work freehand on large-grid paper. Rhythmical flow grows naturally as the body becomes accustomed to the patterned movements of lettermaking. To better get the feel of each movement, begin by working mechanically. Transitions smooth with practice.

Tool: 05 red and black Pigma Microns
Paper: tracing vellum and large grid

(n) **Entry, downstroke, and exit**
Fig. 1a Fig. 1b

1. Rule guidelines with a four-square x-height.
2. Place the right point (IF) in the bottom left corner of a square one line below the waistline. (Fig. 1a)
3. Inhale and push up to the right corner of the square.
4. Exhale and place the left point (T). Inhale and push an arc one square to the right (both points are touching). (Fig. 1a) Pause briefly to mentally reset for the stroke's vertical arc.
5. Exhale and pull an arc a little to the right of the vertical grid line—to the arc's imaginary stretch point. Complete it at the baseline.
6. Inhale and rock to the right point (IF); exhale and pull a single line to complete the downstroke. (Fig. 1a)

Fig. 1c Fig. 2

Branching and arch
1. Inhale and lightly push the right point (IF) up to midway between the base- and waistlines. Exhale and place the left point (T).
2. Inhale and push the points into a hairpin arch. The top of the arch is one square above the waistline. (Fig. 1b) Note: Negotiate the hairpin arch, slowly, exhaling as you come around. This gives you time to aim for the target points of the diagonal downstroke.

Diagonal downstroke
1. Exhale and pull the diagonal downstroke to the baseline (right point) and one square below it (left point). (Fig. 1c)
Note: To help hold the line as you pull—to give it a good stretch—use pulsing, start or center pressure. What works best for you?
2. You may wish to use the rounded zigzag exercise to help get comfortable with this stroke.

Fig. 3

Exit arc
1. As you move into the horizontal arc, apply a little pressure; release it as you complete the stroke with rocking or follow through. (Fig. 1c)
2. Trace the letter until you can make the above movements smoothly. (Fig. 2) Note the relative widths of the arch and the rounded exit arc. (Fig. 3)

(m) **Entry, downstroke and arch:** as in "n." (For variation, the entry of "m" can be a little broader and higher than that of "n.")

Diagonal downstrokes
1. The first diagonal stops one square above the baseline. (Fig. 4) Rock to the right point (IF) and close the stroke.
2. The second diagonal is parallel to the first. It swoops below the baseline. (Fig. 5) The lengths of the final diagonal and its swoop below the baseline depend on letter position and the spirit of the text.

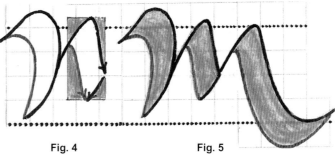

Fig. 4 Fig. 5

(h) **Reverse-curve ascender**
1. Trace over the framework of Fig. 6 following the instruction below.
2. Inhale and place the left point (T) on the start point at the ascender line.
3. Exhale and pull a single-line entry in a shallow arc to the bottom left corner of the square.
4. Inhale and place the right point atop the start point; exhale and pull a subtle arc to the first set of target dots, glancing at Fig. 7 to see how the arced letter stroke wraps the frame.
5. Make a quick inhale to help you prepare for the change of direction. Exhale and pull the stroke to the second set of dots, finishing with soft end pressure.
6. Inhale and release as you begin pulling to the left.
7. Exhale and finish the stroke in a subtle arc with the left point on the baseline. Rock to the right point or use directed momentum to close the stroke.
8. Follow the steps for "branching and arch" above. Trace Fig. 8 a few times, then set target points on large-grid and make the letter freehand.

start point

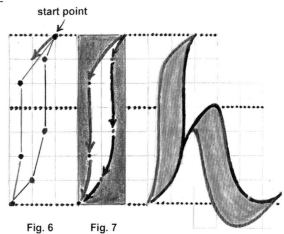

Fig. 6 Fig. 7 Fig. 8

(k) The loop

1. Begin with the ascender stroke of "h."
2. Push the branch stroke, on the right point, to one square above the waistline and place the left point (T).
3. Pull a short horizontal arc. (Fig. 9a)
4. Continue pulling around and down into an open loop. (Fig. 9b)
5. Pause; pull into a shallow-arced diagonal downstroke, finishing in the exit arc. Close the stroke. (Fig. 9c)
6. Trace Fig. 9d. Focus on making the various shifts and directional moves into a smooth rhythmical action.

Fig. 9a Fig. 9b

Fig. 9c Fig. 9d

Sweeps

Focus on the pleasure of movement as you make these strokes, sweeping and swooping down the paper. Begin with tracing, then play with them freehand.

Tools: 05 Pigma Microns/soft pencils **Paper:** tracing vellum, drawing/JNB

1. From narrow entry arches (Fig. 10a) pull diagonals of similar length down the paper. (Fig. 10b)
2. The main power source for these strokes comes from the shoulder and arm.
3. Breath: Inhale up into the arch, and exhale as you sweep down and across the paper.

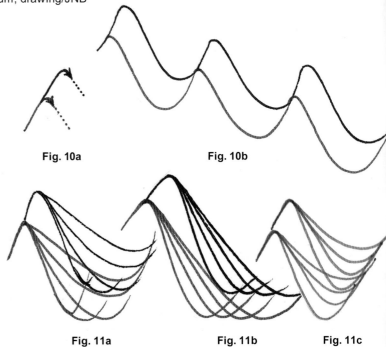

Fig. 10a Fig. 10b

Diagonal dives

Practice your aim with diagonals by creating three different base patterns. (Figs. 11a, b and c) Trace; then freehand. Use the same tool and papers as above.

1. **Scalloped (**Fig. 11a): From an arch ("n") pull a diagonal down steeply. For successive diagonals, retrace the arch and pull strokes down and away, at different lengths, to create a scallop-shaped base.
2. **Horizontal** (Fig. 11b): Aim strokes to form a horizontal base.
3. **Diagonal** (Fig. 11c): Aim strokes to form a diagonal base.

Word as image

This exercise focuses on the word as a composition of directional strokes. (Fig. 12)

Tool: two-point **Paper:** drawing/JNB, tracing vellum

Fig. 11a Fig. 11b Fig. 11c

1. Begin by tracing "imagine." (Fig. 12)
2. Think of a word and trace the letters from the model alphabet. (p. 92) The letters may touch or be separate.
3. Place another piece of tracing vellum over the word and draw straight lines over the prominent directional strokes. Consider them as an abstract pattern.
4. Rewrite and experiment with a new pattern. Create this by making variations in stroke direction, length, height, and distance between other strokes. Analyze and rewrite. Look for possibilities for creating contrast (diverging strokes) and unity (parallel or nested strokes). (See p. 45)
5. How far can you take it and still preserve legibility? Make at least one version of your word on drawing paper.

Fig. 12

Fig. 1

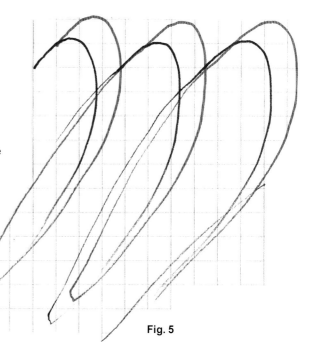

Fig. 2

Letter Family 5: the "j" (jp)

Visual themes
- Long-arc descenders (Fig. 1)
- Tapering: Downstrokes graduate from the full-width of the nib to a hairline (last segment). (Fig. 2)

Warming up

The "flying" descenders of "j" and "p" swoop to the left. This warm-up sequence helps develop their dynamic thrust—and with it your confidence.

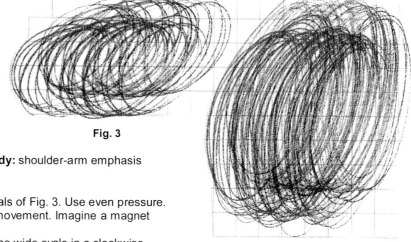

Fig. 3

Tool: two-point
Paper: tracing vellum, drawing/JNB, large-grid **Body:** shoulder-arm emphasis

Wide, fast ovals
1. Quickly trace and/or freehand the wide, clockwise ovals of Fig. 3. Use even pressure.
2. Focus on the shoulder as the source of contact and movement. Imagine a magnet pulling the tool, in its gyrations, to the right.
3. At moderate speed, add a little weight as you throw the wide ovals in a clockwise direction.

Fig. 4

Narrow, fast ovals
1. Trace and/or freehand narrow clockwise ovals. (Fig. 4) Use even pressure.
2. Partner with the left point (T). Now, imagine gravity pulling the long arcs down, especially the right one.
3. At moderate speed, add weight to the overhand throw.

Long-loop arcs
1. Trace and/or freehand Fig. 5. Work slowly and deliberately.
2. On large-grid paper place the points at 45°.
3. Inhale and push up the first segment of the hairline.
4. Continue the inhale as you pull over in a rounded arch, slowing as you come around and prepare to pull-throw the long, shallow arc.
5. Exhale and pull the long arc: try leaning in—to an actual or imagined stretch point—and pushing off to the end of the arc. This encourages an elastic, living stroke, one that combines the power of a thrust with the sense of pulling around a point. Think of stretching a bowstring just before re-releasing the arrow.
6. Alternate your focus from imparting thrust and elasticity to maintaining nib angle.
7. Repeat using drawing paper.
8. Focus on developing these long-looped arcs as a felt, even rhythm in the body. Then note the effect of the physical on the visual.

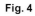

Fig. 5

Ductus and Dynamics

In making these descenders, the focus is on "timing": slowing down with pressure and speeding up in the release—Jumprope's leaning in and pushing off. Performing this with a two-point tool, however, adds nib angle to the gesture. The lower-case "j" and "p" train the body-mind for the challenge of holding a steady nib angle while pulling a long stroke.

Tool: 05 red and black Pigma Microns banded together
Paper: tracing vellum, large-grid and drawing/JNB

Note the target points in Fig. 1 which provide a framework for the following exercises.

(j) Descender

1. Trace over the framework of Fig. 1 following the instructions below.
2. Inhale and place the right point (IF) atop the start point, one square below the waistline in the lower left corner. Exhale.
3. Inhale and push up to the black dot in a slightly curved arc.
4. Exhale and place the left point. Inhale and push both points up and over into a narrow arch. (See Fig. 2)
5. Pause, exhale and then pull to the second set of target points with soft end pressure. (Glance at Fig. 2 to see how the arced letter stroke wraps the frame.)
6. Release the pressure and use the energy to push off to the third set of target points. End the stroke in a hairline (last segment) at the final set of target points. Repeat the descender of "j" many times to coordinate the directional movement with the dynamics. Note the shape of the arc. (Fig. 2, colored in red)
7. **The dot:** as in "i." (p. 95)
 Repeat the letter a few times focusing especially on the dynamics. (Fig. 3)

Freehand (on large-grid paper):
1. Rule three guidelines four squares apart (waistline, baseline and descender).
2. Place target points using the two-point tool. The points are enlarged in the diagram but will be much smaller using the two-point tool. Pull straight lines to connect the dots. (Fig. 1)
3. Working atop your frame, repeat the above directions for "j."
4. On drawing paper, write the letter without the frame.

(p) Descender

1. Trace over the framework of Fig. 5. Note: The downstroke starts below the waistline and finishes below the descender line. (Figs. 5 and 6a)
2. Place the right point (IF) one and one-half squares below the waistline. Breathe as above.
3. Make the entry and descending downstroke as for "j."
4. **Branch stroke:** Place the right point (IF) at the baseline on the right wall of the downstroke.
 a. Inhale and push up and over to the first red target point. Exhale.
 b. Inhale and continue pushing up through the next two target points. You are now one square above the waistline.
 c. Exhale. Note: Segmenting this stroke, as above, helps you learn the arc's trajectory. After retracing it a few times with stop-and-go action, launch a smooth, continuous stroke. Let the inhale carry the nib one square above the waistline in one continuous draw.
5. **Bowl:** After the branch, place the left point (T) Inhale and push up and into the double-walled bowl. (Fig. 6b) Exhale and pull the stroke into an upside-down teardrop. Repeat. (Fig. 7)

Freehand (on large-grid with a frame and on drawing paper without a frame) as above for "j."

Bowl practice: Trace and then freehand Fig. 8.

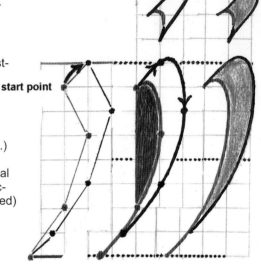

start point

Fig. 1 Fig. 2 Fig. 3

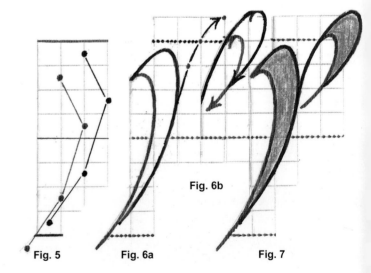

Fig. 6b

Fig. 5 Fig. 6a Fig. 7

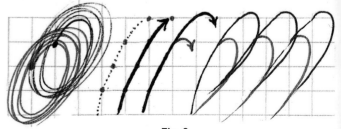

Fig. 8

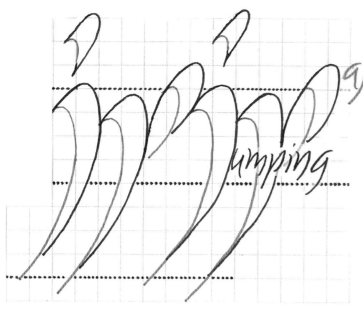

Fig. 1

Letters as decoration: bands

By repeating "j" and "p," or other letter combinations, you can create decorative patterns as you practice any letter duo or trio to find its rhythm.

 Tools: two- and one point
 Paper: large-grid and marker/JNB

1. Rule guidelines as in Fig. 1.
2. Write the letters "j" and "p" as a band, touching each other on the right and left sides. (Fig. 1)
3. On marker paper write words in small letters from the Jumprope alphabet using the large "j" and "p" as initial letters. Cut out the smaller word and tape (clear) or paste it in place. (Fig. 1)

Word as image: "calligraffiti"

Take this opportunity to play with the letters in your repertoire.

 Tool: two-point
 Paper: tracing vellum/marker, drawing/JNB

1. Trace Fig. 2 and note the use of plasticity and letter variants.
2. Using these words or ones of your own choosing, write words freely on a piece of drawing paper, scattering them about to fill the paper. Relax and enjoy just playing on the "wall."
3. Place tracing paper over a word and experiment with spacing the letters horizontally and vertically.
4. Try changes in speed and gesture; imagine swinging your body from a trapeze.

Fig. 2

Letter Family 6:
the "v" (vwy)

As this family with its slight slope shows, all the letters of an alphabet need not have the same slope to create a harmonious whole.

Visual themes
- Slight slope (Fig. 1—The black dotted lines show the slope of the letters in this family.)
- Triangularity (Fig. 2)
- "Weighted" thins: These combine one-point single-line strokes with two-point double-walled strokes.

Structure: A variety of junctures
- "v" A gently pivoted join (pivot hinge).
- "w" Branching, as in the "n" family, launches the second stroke from the first.
- "y" "The second stroke detaches from the first.

Warming up

This exercise sequence combines loose, relaxed work with more precise relaxed work. (Figs. 4 and 5) They prepare you to make a reversal of direction with ease and assurance.

Tools: three two-point tools: 1) red Pigma Microns, 2) black Pigma Microns and 3) one red and one black
Paper: drawing/JNB, tracing vellum **Body:** shoulder and arm emphasis **Size:** about 2"

Framework (on drawing paper)
1. Using a two-point red tool: Throw a wide, multiline oval, in place, with both points in contact. Use a clockwise action. (Fig. 3a)
2. After this oval, lift the tool off the paper and, in the air, rehearse the starting place for an adjacent counter-clockwise oval. (Fig. 3b) Throw a few alternating ovals.

Double-walled strokes
1. Using a two-point black tool: Slow down, make the single-line entry of "n" at the top left of the clockwise oval; place the left point at 45°and pull a double-walled stroke over the framework: a rounded entry arch and slightly curved downstroke. (Fig. 3a)
2. Lift the tool and place it at the top left of the counter-clockwise oval. (Fig. 3b) Pull a shallow arced vertical down and around into a rounded saucer.
3. To help reveal the two-part structure of what appears to be a continuous stroke, draw straight horizontal and diagonal lines as in Figs. 3a and 3b.
4. Repeat the frameworks and double-walled strokes.

Freehand (on tracing paper)
1. Use a red-and-black tool to enhance your awareness of partnering.
2. Pull the arcs focusing first on the red left point (T) and then the black right point (IF). (Fig. 4) Tracing is a good way to begin. It allows you to pay greater attention to muscular-tactile feedback from the points and their partnerships, and on positioning new strokes.

Connecting the arcs: "w"
1. Make the clockwise-rounded entry and downstroke. (Fig. 5)
2. Rock to the right point (IF) and pull a single line down to close the stroke.
3. Push up, as in the branch of "n."
4. Place the left point (T) and pull the shallow vertical arc and the rounded saucer counterclockwise. .
5. Continue up and around to the left to finish the stroke. Retrace to begin the next clockwise stroke. Repeat, focusing first on the direction of the strokes and then making them as a rhythmical gesture.

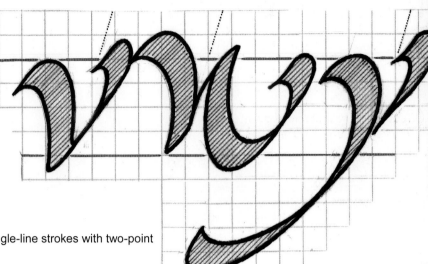

Fig. 1

Fig. 2

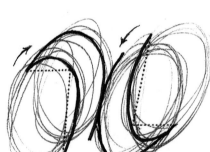

Fig. 3a **Fig. 3b**

Fig. 4

Fig. 5

Ductus and Dynamics

This family introduces the technique of "nib turning"—changing the angle of the nib without lifting it from the paper. Rather than holding the angle steady, you rotate it to thin or thicken a stroke. Calligraphers develop this skill to refine strokes and use them expressively.

Tool: 05 red and black Pigma Microns banded together
Paper: tracing vellum and large-grid **Body:** appropriate use of shoulder, arm and fingers in relation to each other

(V) Entry and left diagonal downstroke

1. Trace Fig. 1. Begin with a single-line entry (right point, IF); place the left point (T); partner with it to make the double-walled entry and downstroke to the tips of the arrows: to the baseline with the left point (T) and one square above with the right point (IF). Note the external framework of the right angle.
2. On grid paper, rule guidelines four squares apart.
3. Repeat freehand. Use the breath: Inhale before the bend (shoulder rises slightly) and exhale taking the diagonal plunge (shoulder lowers, pulls). Close or blur your eyes to get the feel of coordinating breath and action.

Fig. 1 **Fig. 2** **Fig. 3**

"Pivot hinge." This move helps you connect left and right diagonals in a gently pointed juncture. It introduces you to nib turning where nib angle steepens within a stroke. From the baseline, pull the points downward a short distance to the right. As you move, use the right point as a pivot—bringing the left further down and around to the right. (Fig. 2) The right point moves less that the left. Next, join the right diagonal, pulled or pushed according to your preference.

Pushed diagonal (right upstroke and ending): From the pivot, inhale and push the nib up (first segment of the hairline). Due to the pivot, this is steeper than 45°. Keep this nib angle steady as you continue pushing up and around to the left in a narrow, arched curve. (Fig. 3) Or "catch" the right diagonal as below.

Fig. 4 **Fig. 5**

Pulled diagonal (entry and right downstroke, fig. 4)

1. From the hairline after the pivot (first segment), lift the tool off the paper. Land on the right point (IF) directly above the finish of the hairline, half a square below the waistline. (Figs. 3 and 4)
2. Push the single-line entry (IF) and place the left point (T). Push up and around in a narrow, arched curve (T). (Fig. 4)
3. Rock to the right point (IF); use start pressure and pull down to meet to the hairline. Where not given, use the breath and pressure patterns you have learned to aid in making the letters.
4. Trace Fig. 5 a few times alternating the two right diagonals above.

Exercise: Developing point shifts and pressure changes takes time. To practice, use these strokes to make a border. Set evenly spaced target points. (Fig. 6)

Fig. 6

(W) Entry and downstroke arcs

1. Trace Fig. 7a. Place the right point (IF) on the waistline and push a single-line entry; place the left point (T). (This entry arc is broader than that of "n.")
2. Close the stroke with the right point (IF) as before.

Exercise: Use the framework of Fig. 7b and wrap it with the connecting arcs of the entry and downstroke.

Upstroke branch: Continue the letter. (Fig. 8a) Push about midway up the downstroke on the right point; push the branch two squares over and one-half square above the waistline.

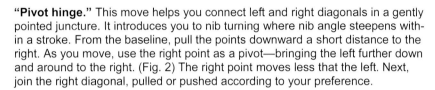

Figs. 7a and 7b

Figs. 8a and 8b

Second downstroke

1. Place the left point at 45°. (Fig. 8b)
2. Exhale and pull a shallow vertical arc. As you approach the baseline, negotiate the curve—leaning in and pushing off, dipping slightly below the baseline, into the saucer-like exit arc.
3. Close the stroke.

End stroke

1. Lift the nib and place the right point one-and-a half squares below the waistline and a half square left of the end of the exit arc. Repeat the ending described in "Pulled diagonal" above.
2. Trace Fig. 9 and then write the letter a few times freehand.

Note: The gap in Fig. 8b, between the second and third strokes, may also be closed as in Fig. 9. To do so, push the left point up to meet the second stroke.

Fig. 9

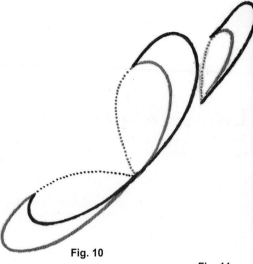

Note: The "y" contains three implied teardrop shapes of varying sizes. (Fig. 10, dotted lines)

(y) Entry and downstroke arcs

1. Trace Fig. 11a. Begin with a single-line entry made on the right point (IF). Place the left point (T) and apply partnered pressure as you pull the double-walled entry and downstroke arcs to one-and-a-half squares below the baseline.
2. Rock to the right point (IF) and close the stroke. Or, release pressure from the right point and follow through. (See p. 109)
3. Repeat, tracing over the framework of Fig. 12. Work with awareness of the horizontal and vertical grid lines.

The tail of "y": This stroke is especially plastic, lengthened of shortened to harmonize with the letters surrounding it. Whether pulled as an extension of the first stroke, or pushed up as a separate stroke, each has its particular challenges—try them both.

1. As an extension
 a. Pull the downstroke into a long shallow arc. (Fig. 11a) In this method, the beginning of the stroke closes naturally.
 b. As it does, the right point's black line "crosses" the left point's red line (Fig. 13) and activates a change in partnered pressure. This shift, from the left (T) to the right point (IF), allows you to focus on shaping the counter space—an implied teardrop. (Fig. 10, black dotted line)
 c. Try pulsing to help you stay with the continuously changing direction of this stroke as its arc pulls down and then pushes up. Use the follow through of directed momentum, or rocking, to close the stroke.

2. As a separate stroke
 a. Close the entry downstroke using a single-line exit.
 b. Lift the nib off the paper and move five-and-a-half squares to the left and one-and-a-half squares down. Place the left point (T) and pull a single-line entry. Place the right point and pull the short vertical arc that begins the stroke.
 c. Lean in as you apply pressure into the bend; push off as you release the energy into a long asymmetrical arc. (Fig. 11b) Close the stroke and connect it with the first downstroke.

Right diagonal (a "flier"): The last stroke of "y" might be called a "flier" as it does not land at the baseline to meet the left diagonal. (Fig. 11c)
1. Repeat the second stroke of "v." (See previous page.)
2. Try the target point pattern of an angular framework if you find it helpful. (Fig. 12) Remember, you are pulling shallow arcs as you hug the lines connecting the target points.

Trace the "y" a few times. (Fig. 13) On each tracing choose an aspect for your focus. For example, stroke direction, partnering, or partnered pressure. Combine them when you feel ready. Then make the form freehand on drawing or marker paper.

Note on alphabet design

Using both convex and concave single-line entry strokes within a word or line of text enhances liveliness. Note, too, a concave line reduces the weight of the stroke and is a little more dynamic than the thicker convex line. Experiment.

Fig. 10

Fig. 11c

Fig. 11a

Fig. 11b

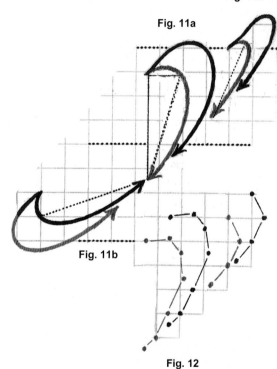

Fig. 12

Fig. 13

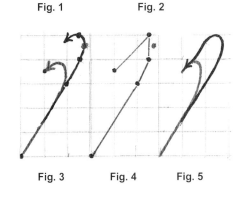

Letter design: thicks and thins

To impart its graphic rhythm, the two-point tool alternates thick, double-walled strokes with thin, single or hairline strokes. Usually, however, the thin is visible for only a short distance—leading quickly to a graduated stroke, as in the right diagonal of "v" in Trapeze. However, a hairline can be used as the stroke itself. (Fig. 1) And, although this thin extended stroke differs from the characteristic pattern of Trapeze (Fig. 2), and may produce a less legible letter, it expands your potential for creating expressive variants.

Fig. 1 Fig. 2

Stroke technique: walled push strokes

The weighted, double-walled ends of the "v" family's right diagonals can be either pushed or pulled, as noted in Dynamics and Ductus above. To help you gain skill in pushing, this exercise focuses on developing mental alertness as well as tactile sensitivity. The seductive nature of the hairline, with its undeviating direction and perfectly aligned points, requires mind-body acuity. Aiming at target points is a mental aid—helping you to push the tool's points along a directional path. (Figs. 3, 4 and 5)

> **Tool:** 05 red and black Pigma Microns banded together
> **Paper:** tracing vellum and large-grid

Fig. 3 Fig. 4 Fig. 5

1. Trace Fig. 3, focusing on directional movement.
2. On large-grid paper, set black target points and an embedded red stretch point to help direct the curve.
3. Place the tool at the baseline. Note: The angle of this stroke is greater (steeper) than 45°. Push the hairline diagonal until the tool points reach the first two black targets.
4. Pause briefly, partner with the left point (T), and then push up and to the left into the narrow arch. Work at a speed, usually a slow one, which allows you to experience the friction.
5. Pause; rock to the right point (IF) and close the stroke or release with directed momentum. (Fig. 5)
6. Try the variants of Fig. 6. Here, stroke shape changes as a result of a steady nib angle moved in different directions.

Fig. 6

Word as image

A letter's position in a word also influences its design. Begin by tracing the word pairs of Figs. 7 and 8, and 9 and 10 (next page). As you do so, compare their differences in letterform and letter position. In the words of Figs. 8 and 10, letter variants are also attempts to symbolize meaning through graphic means. (See "Graphopoeia," Jumprope, p. 72) Here, the variations include the spacing methods of touching and overlapping. The notes below describe some design choices. When you are ready, choose a word; trace its letters from the model, and then experiment with your own design.

> **Tool:** 05 red and black Pigma Microns banded together
> **Paper:** tracing vellum and drawing/JNB

"vim"—using letter variants and plasticity (Fig. 8)

"v" The downstroke starts above the waistline. The letter narrows and stands more upright. A single-line second stroke joins into the "i."

"i" This letter begins by extending the join from "v." The left point (T) is replaced at 45°. The gap between the single-line entry and walled downstroke is left open.

"m" This version emphasizes the stroke exit while making the stroke entry lower and narrower. The tops of the arches go up rather than down.

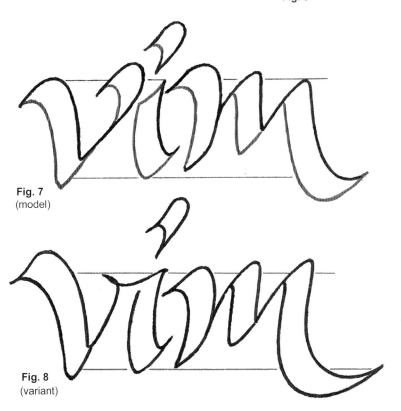

Fig. 7
(model)

Fig. 8
(variant)

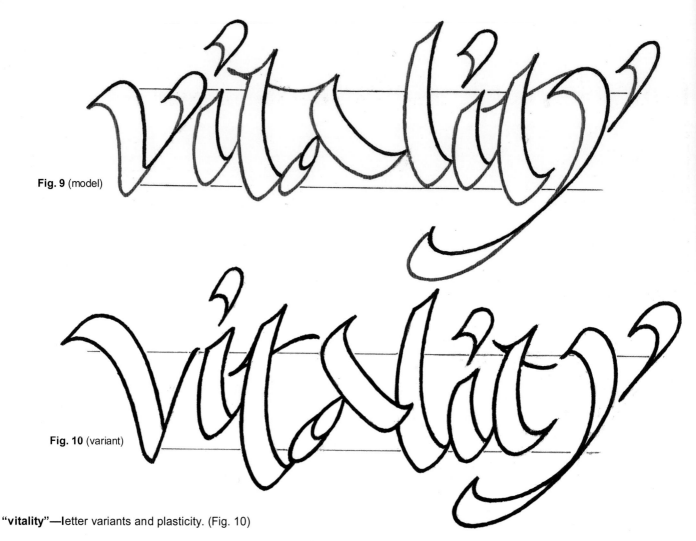

Fig. 9 (model)

Fig. 10 (variant)

"**vitality**"—letter variants and plasticity. (Fig. 10)

"v" The visual emphasis is on the downstroke, which starts well above the waistline. The letter is upright. The single-line second stroke, though a hairline, uses the dot of "i" to anchor it visually.

"i" The letter is slightly higher than the model to add liveliness.

"t" The crossbar does not physically touch the "a" but, coming near, creates a visual, or elastic, tension.

"a" The diagonal of "a" overlaps the "l."

"l" In making the "l" downstroke the left point (T) lifts when it encounters the diagonal of "a." The letter is slightly lower than the model to add variety.

"i" The lowered and slightly enlarged dot compensates for the letter's short stature.

"t" A downward dipping crossbar also adds variety; the broader base adds stability.

"y" This letter slightly exceeds the height of the model "y" and switches the order of concave and convex entry strokes to suit the design.

Reminder
The design of the word includes the shapes of space between the letters as well as those within the double-walled strokes.

Letter family 7: the "hybrids" (brxsz)

As in Playball, the hybrids share a kindred spirit rather than a specific trait. Each letter is a combination of strokes from one or more of the previous families; each sports the characteristic nib angle—one of the strongest unifying elements of alphabets designed with a two-point tool or an edged pen.

Uniqueness and unity
In alphabet design, concerns of legibility sometimes vie with principles of design. Alphabetic symbols enact their unique identities in solo performances, while an alphabet design achieves unity through a combination of contrast and repetition. Although each is necessary, the ratio of one to the other is flexible, changing with the context and aim, allowing many possibilities for creative expression.

Fig. 1

From this perspective, letter families serve calligraphers as a conceptual tool. They develop an appreciation of visual motifs which sensitize the eye. This enhances your ability to express the mood or meaning of a text.

Warming up
These exercises encourage energy, rhythm and fluidity in stroke and letter making.

 Tool: two-point
 Paper: drawing/marker/JNB
 Body: shoulder and arm emphasis, finger guidance
 Size: as in the figures, or larger

Fig. 2

The "z" slalom
1. Preliminary: Use prototool 1 and ductus of Fig. 2. Large, in the air, "conduct" these lines as directional strokes; then smaller, on a surface.
2. Next, conduct the slalom with a two-point tool. (Fig. 3) Using a light, pendular action, enjoy the sway of this gestural pattern. Develop some gusto!
3. Slow down; use start pressure for a firmer bite on both directional strokes. (Fig. 4) Hold the tool with enough tension to maintain nib angle for both the double-walled horizontal swoops and the hairline diagonal glides.

Follow through and release
1. Throw two-point traveling ovals, fast and light. (Fig. 5)
2. Place the left point (T) on the paper and pull a single-line entry to the left. Place the right point (IF) and pull a rounded arc, swooping up with the left point. Lift the right point as you do this. (Fig. 6) Follow through to close the stroke.
3. "Scallops" (Fig. 7): Repeat a slightly more shallow arc than in Fig. 6. (You can connect these by lifting the right point and keeping the thumb in contact with the surface as you travel forward.

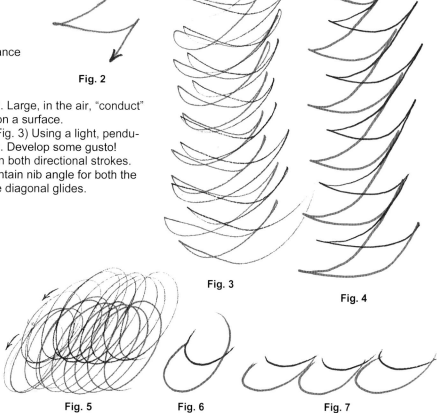

Fig. 3

Fig. 4

Fig. 5

Fig. 6

Fig. 7

Ductus and Dynamics

These letters combine traits from the six previous families. First, trace; then use large-grid and work independently.

Tool: 05 red and black Pigma Microns **Paper:** tracing vellum and large-grid **Body:** appropriate use of shoulder, arm and fingers

(b) **The downstroke of "l," branching, and the reverse teardrop ("a" family).**

Downstroke: As in "l" but unclosed.

Bowl

1. Rock to the right point (IF); push up the right wall one square. (Fig. 1) Reminder: check tool hold.
2. Continue on the right point (IF) and branch: first push up one square to the red target point below the waistline. (Fig. 2) Second, push to the black dot one square up and to the right. (Fig. 2)
3. The remaining dots and connecting lines provide the structure for the bowl stroke of Fig. 3.
4. Place the left point (T); push a shallow horizontal arc one square to the right. (Fig. 3)
5. Pull the nib around, partnering with the left point (T) to complete the bowl and close the stroke—the last phase of the hairline stroke.

Trace the "b." (Fig. 4) Repeat, focusing on smooth point shifts and coordinating with the breath.

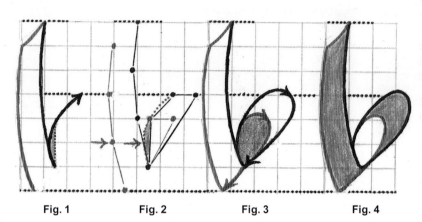

Fig. 1 Fig. 2 Fig. 3 Fig. 4

(r) **The downstroke, branching, and arch of "n."**
Follow "Ductus and Dynamics" for "n," through "Branching and arch." (See p. 107) The downstroke of "r" is slightly longer than that of "n." (Fig. 5)

The ear of "r"

1. Stop about one square down the diagonal double-walled downstroke. (Fig. 6)
2. Apply some pressure as you bend into the upward arc. Use the energy of release to push the arc up and through the waistline. (Fig. 6)
3. Close the stroke.

Trace Fig. 7, focusing on rhythmical point shifts and hand position.

Fig. 5 Fig. 6 Fig. 7

(x) **The diagonal of "a" (lowered), the tail of "y" (shortened), and the top of "f"**

Right diagonal
Begin the double-walled diagonal at the waistline and arc into and up from the baseline. (Fig. 8)

Fig. 8 Fig. 9 Fig. 10

Left (crossing) diagonal
This two-part stroke preserves the openness of the first stroke. The dotted red line shows its continuity. (Fig. 9)
1. Details of the lower portion:
 a. Place the right point (IF) on the left wall of the downstroke about one-and-a-half squares above the baseline.
 b. Place the left point so that the nib is in contact at a 45° angle.
 c. Pull down diagonally one nib width (first segment of hairline); pause and take aim. Pull down and around to a little below the baseline, though this stroke may be lengthened as desired.
 d. To close the stroke, release the right point (IF) while pushing up with the left (T). Note the teardrop (Fig. 9, black dotted line and colored shape.
2. Details of the upper portion:
 a. Place the nib at a 45°angle and run it in the air, diagonally up and down. This helps you land accurately to continue the top portion of the diagonal.
 b. Land the nib with the left point (T) touching the right wall of the downstroke; place the right point to make a 45° angle.
 c. Push up one nib width (the first segment of the hairline stroke). Pull the weighted ending as in the top stroke of "f."
3. Trace Fig. 10 as a "gymnastic" calligraphic routine.

(s) A reverse curve: single-line entry and double-walled downstroke (more pronounced than that of "h" and "k")

Fig. 1 gives a framework for the curved strokes of "s." The red and black dotted lines show the stroke curves in relation to the straight lines of the framework. The large red dot is the start point; the medium-sized dots are target points. The dotted lines show the walls of the stroke. Trace each letter stroke over the framework according to the instructions below. Then work on large-grid.

Single-line entry: a reverse curve on one point
1. (Fig. 2) Set three target points, the first, a half square above the waistline; the second, one square to the left and one square down; the third, same as the second.
2. Place the left point (T) atop the first black dot.
3. Connect the dots: pull a concave arc to the second black dot and a convex arc to the third.
4. At first set the targets by hand. When you're ready, try to place them by eye.

Reverse curve downstroke: on two points
1. (Fig. 3) Place the right point (IF) and pull the reverse curve in three sections:
 1) a short vertical arc;
 2) a reverse curve that hugs a straight;
 3) a diagonal arc longer than the first one.
2. To finish, pull the last segment of the hairline.
3. Note the narrow width of the reverse curve (Fig. 3, the green, shaded rectangle).
4. Repeat a number of times to find the flow of this stroke, carefully observing pauses and variations in pressure as you negotiate changes in direction.

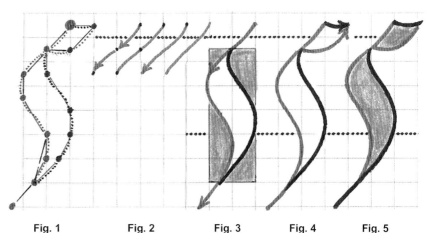

Fig. 1 **Fig. 2** **Fig. 3** **Fig. 4** **Fig. 5**

Top stroke: a short "scallop"
1. (Fig. 4) Place both points over the top two dots and pull a shallow, horizontal arc.
2. Close the stroke.
3. Trace Fig. 5; then make the letter freehand. On drawing paper, try loosening up a bit.

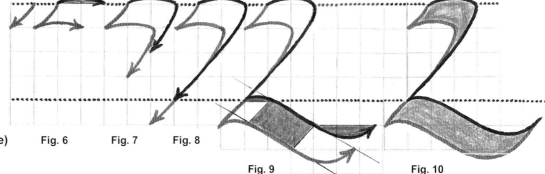

Fig. 6 **Fig. 7** **Fig. 8** **Fig. 9** **Fig. 10**

(z) A horizontal arc (top stroke) and reverse curves (middle and lower diagonals)

Top stroke: a shallow horizontal arc
1. (Fig. 6) Place the left point on the waistline in the top left corner of a square. Pull a single-line convex entry.
2. Place the right point and pull a shallow horizontal arc two squares to the right with start pressure. Pause and, with a little pressure, pull down in a tight bend. (Fig. 7) A tight, short vertical bend leads into the graduated part of the diagonal.

Diagonal
1. (Fig. 8) Release pressure after negotiating the bend and pause briefly. Then pull into a diagonal hairline at 45°.
2. Continue to one square below the baseline; pause.

Bottom stroke: a reverse curve—but not too wavy
1. (Fig. 9) Push slightly up the hairline diagonal and pull into the reverse curve.
2. Pressure pattern: up: even pressure; down: start pressure.
3. Close the stroke.

Trace Fig. 10; then make the letter freehand on large-grid and drawing paper. (Not too curvy!)

Try various breath and pressure patterns to see what suits you best.

Spacing and plasticity: notes on "r," "z," and "s"

Letter strokes that are primarily horizontal—such as the tops of "r," "s," and "z"—may stretch outside their proportion frames. Since this can have dramatic consequences for a word's legibility, calligraphers use horizontal extension judiciously, with an eye to overall design and the feeling you wish to communicate.

Tool: two-point (6B pencils) **Paper:** tracing vellum **Body:** appropriate use of shoulder, arm and fingers

Fig. 1

Trace the figures. Notes:
- The "r" and "s" may form ligatures with letters that follow them.
- When the ear of "r" stretches significantly beyond that of the model letter, as in the "r-o" combination of Fig. 1, the characteristic 45° angle may flatten to slim the stroke. (Fig. 2) At the top of the branch stroke, with both points on the paper, pull down and to the right while pivoting the two points clockwise. The left point moves with the right, but more slowly. Let the wrist play a significant role in this rotating motion. This method of nib turning can also thin the horizontals of "z." (Fig. 3)

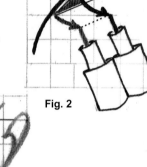

Fig. 2

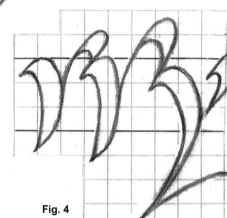

Fig. 3

- When "r" is stretched horizontally, the entry of the next letter is usually reduced in size. (Fig. 3) One letter may nest above or below another: see "z-o," "r-r" and "r-v," (Fig. 3)
- The ear of "r" invites variants, such as one that echoes the top of "f." (Fig. 4)
- The "r" and "s" take on the graphic spirit of their neighbors. (Figs. 5 and 6)

Note: Trapeze has a particular character but, like any alphabet, it is plastic and may be changed to suit a variety of expressive intents. In other words, it can start a design process.

Fig. 4

Fig. 5

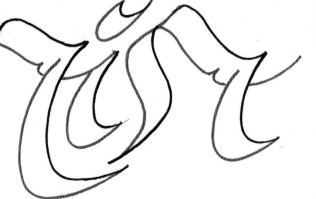

Fig. 6

Text design: the calligraphic line in space

While Jumprope introduces interlinear spacing (see p. 64), Trapeze investigates "vertical letter spacing", the up-and-down positioning of letters on the calligraphic line. Guidelines are useful for producing readable lines of writing. However, for a more expressive text design, they can also be used as a frame of reference for experimentation—or abandoned entirely. The exercises below cultivate both vertical and horizontal spatial awareness. (Note: The exercises below are made with the same tool and nib angle as used for letters.)

Spatial rhythm series

These rhythm patterns, composed of narrow arced strokes, engage both the horizontal and vertical spaces of writing.

> **Tool:** two 05 Pigma Microns banded together
> **Paper:** tracing vellum, large-grid and drawing/JNB
> **Nib angle:** 45°

Reminder
- The breath: Inhale as you move up; exhale as you move down
- Dynamics: Push up with even pressure; pull around and down to negotiate the curve. (See p. 101)

Vertical spacing (interlinear)
Trace first, then freehand on large-grid paper.
1. (Fig. 1) The basic arch: Push up one square to the first black dot (the first segment of the hairline). Continue, pushing up and into the arc—pulling the stroke around and down to the stretch point (second dot) and back to the baseline. Repeat a few times to find the rhythm of these arches.
2. (Fig. 2) First, make the basic arch. Then, pull the second arch a square below the baseline and into the last hairline segment. Alternate the "body-height" arch with the "descender" and find a rhythm that incorporates this small variation in pattern.
3. (Fig. 3) First, make the basic arch. Then, push the second arch one square above the waistline. Alternate the "body-height" arch with the "ascender" and find the new rhythm.
4. (Fig. 4) Combine 1, 2 and 3 above. These simple extensions in the visual field also enliven it.

Horizontal and vertical letter spacing
Trace first, then freehand on large-grid paper.
1. (Fig. 5) First, make the basic arch. Then, pull the second arch two squares over. Repeat in alternation.
2. (Fig. 6) First, make the basic arch. Then, make the ascending and right-extending arches of Figs, 3 and 5. Repeat.
3. (Fig. 7) Vertical and horizontal variations.
4. Fig. 8) Narrowing the basic arch.

Play
Freehand on drawing paper. Make your own experiments. Design a pattern in advance or just see what happens.

A Meditation exercise
1. Begin by turning to awareness of your body.
2. Place prototool 2 in contact with a surface.
3. Slowly, take a few breaths: the body and hand rise on the inhale and lower on the exhale.
4. Take up a two-point tool on an inhale and place it on the grid paper on the exhale.
5. Coordinate breath and movement: inhale and push up into and around the arch; exhale and complete it.
6. With relaxed alertness, see what pressure patterns emerge.
7. Enjoy, there's no hurry.

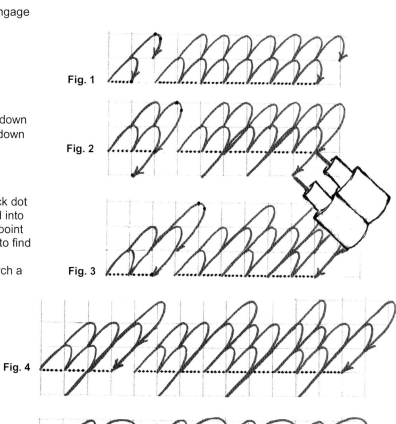

Fig. 1

Fig. 2

Fig. 3

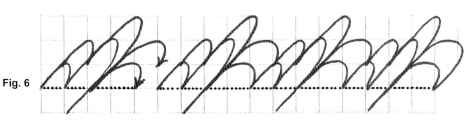

Fig. 4

Fig. 5

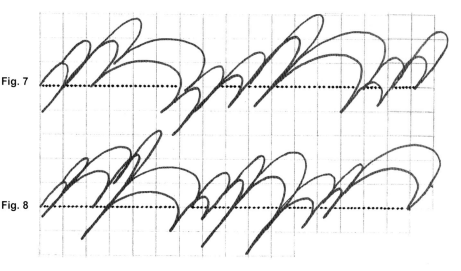

Fig. 6

Fig. 7

Fig. 8

Fig. 1

Fig. 2

Vertical rhythm: letters

This exercise focuses on relating letters to each other in ver-
itical space. To get acquainted with its calligraphic potential,
you combine the hybrid-family letters with vowels to form
scat sequences. (Figs. 1 and 2)

Tool: two-point with pencils
Paper: tracing vellum and drawing/JNB **Nib angle:** 45°

Scat one. Trace Fig. 1: Alternate the "b" with the "i" of the
model alphabet. In this scat "i" takes three positions in rela-
tion to "b": 1) that of the model, 2) dipping below the guide-
lines, and 3) rising above them. To get the feel of this, begin
as in the figures, with only a slight variation in depth and
height, or exaggerate the depth and height.
 Scat two. Trace Fig. 2: Alternate the "i" and "b" working
as above but with the "b" changing position.
 Freehand. On tracing vellum, rule guidelines ¾" apart.
Use the scat patterns above with other hybrid letterforms.

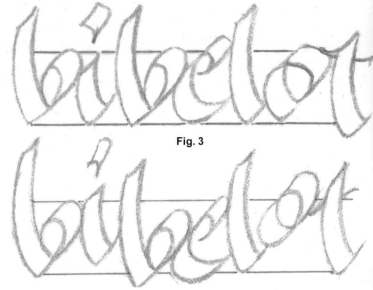

Fig. 3

Word as image

Play with the vertical spacing of a word.

Tools: two point with pencils, Pigma Micron for ruling
Paper: tracing vellum and drawing/JNB
Body: appropriate use of shoulder, arm and fingers

1. Choose a word with hybrid-family letters and trace its
 letters from the model. (Fig. 3) Words: stargazer, bron-
 cos, sidereal, bananas, saxophone, exotic, box springs.
2. Experiment with the vertical positioning of the letters.
 (Fig. 4) Vertical spacing is one vehicle for expressing/
 symbolizing the meaning of a word. "Bibelot," for ex-
 ample, signifies a small decorative object for the home.
 Bouncing the letters helps to convey the friendly, relax-
 ed aspect of this word.

Fig. 4

Making: a scroll (line as image)

Although ancient in origin, the scroll continues to reson-
ate with human experience and purpose. A self-suffici-
ent object, it can be rolled up or left open. In the medie-
val miniature at right, it's used to proclaim a message.
In antiquity, it served as a vehicle for literature, philoso-
phy and other important texts. Today, the Torah, read
aloud in public worship, must still be written as a scroll.

 This format also accords with a sense of ceremony:
to honor, recognize, or show appreciation to a group or
individual. You can display it on a table, shelf or mantel,
or stretch it across a freeway overpass. The soft, flexi-
ble nature of the scroll, with its ability to enclose, also
makes it a desirable choice for communicating personal
sentiment, endearment and poetry.

An Annunciation from a Dutch Book of Hours, c. 1440

Preparation

Start with questions about purpose, size and style. Using Trapeze, a style written with a large, two-point tool, helps answer the question of size. It may also stimulate ideas for your choice of word(s).

Testing: making roughs

Tool: two-point
Paper: tracing vellum and marker paper
 Marker paper, like tracing vellum, allows you to see through it (if a little less easily), and offers a writing surface with some tooth. (See p. 36 for information about brands.)

1. Choose a word or phrase.
2. Rule a base- and waistline ¾" apart on tracing vellum; trace the letters of you word(s) from the model alphabet. (E.g., Fig. 1) Omit caps for this exercise unless the cap, as here, is an enlarge-ed lower-case letter. (See pages 126-7)
3. Rewrite the word/phrase on marker paper without guidelines, focusing on the gesture of the strokes. (Fig. 2) This may stimulate graphic ideas. Look for the relationship between the meaning of the text and the graphic spirit of Trapeze. The aim is to make a piece that communicates symbolically through letterform as well as through the graphic elements of line, form and space.
4. Return to using guidelines, or continue freehand; rewrite your word/phrase paying attention to letter and word spacing.
5. Make more roughs if you wish, trying out ideas that emerge; then, on marker paper, trace over the forms and spacing you prefer.

Fig. 1

Fig. 2

At this point, you may proceed to "Composition" (See p. 124), or experiment further with letter design and spacing. To help find a greater accord between form and feeling, consider the following:

Weight

1. Rule guidelines at scales slightly less and slightly greater than those of the model guidelines. (See Ruling, p. 125)
2. Write your word/phrase at each of these scales.

Fig. 3

Form and space

An alphabet model presents each of its characters as a unique individual. However, brought together in words, they enter into society. Imagined as guests at a dinner party, these characters would adjust to the spirit of the occasion, formal or casual, and to their neighbors—those seated on either side as well as those down and across the table. Graphic characters adapt to their context by using the graphic possibilities given below. (E.g., Fig. 4)

1. Experiment with each:
 • Plasticity: Stretch/shorten a stroke/s.
 • Letter variant: Create a variation in the model.
 • Horizontal spacing: Move the letter closer or farther away from its neighbor/s.
 • Vertical spacing: Move the letter up or down in relation to its neighbor/s.
2. To begin, write the chosen word/phrase according to the model. (Fig. 1) Use tracing or marker paper to continue your exploration of weight, form and space. It may be helpful to cut out letters, even parts of a letter, so you can physically move them around and test their form and position.
3. When you see something you like, trace over it with one of the two papers. Adjust. Use white-out to remove unwanted lines.
 Note: This is a process; creativity, like any form of growth, takes its own time. It's ok to "stall."

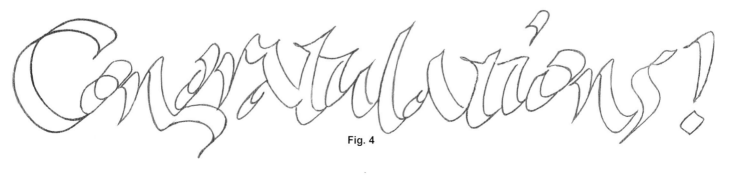

Fig. 4

Composition

The scroll also denotes a long strip of paper. If your text makes a wide rectangle rather than displaying linearly, try stretching strokes horizontally and/or adding ornaments to the sides of the text. (E.g., Fig. 5) If necessary, extend the paper by taping or gluing another strip to it.

Fluid format: In this exercise, finished size is not pre-set but arises from the piece itself, as an expressive element.
1. Place your rough on a larger sheet of paper.
2. Place a piece of tracing paper over the rough.
3. Place framing strips around it to determine:
 * The total amount of space around the image, which gives you the size of the finished piece.
 * Side margins (symmetrical/asymmetrical). Consider the spirit of the scroll to help you decide these margins.
 * Top, bottom margins. Consider the ascenders and descenders: making them short allows you to preserve linearity.
4. When you are satisfied with the margins, measure the size of the paper, and, on a paper ruler, mark the baseline, waistline (if appropriate) and the left and right margins.

Note on illusion: As you bring framing strips closer to an image, the image appears to increase in size and weight; as you move them away, it appears to decrease in these variables.

Note on margins: The word margin ties the calligraphic image to its traditional role in the design of the book. When text leaves this format, as it does in most contemporary work, the space can act as more than a field in which to float a text. Consider: What kind of tension is possible between image and paper edge? Can the amount of space between image and edge "activate" the image?

Cutting

Skill in cutting paper or matboard gives you greater freedom to set the size of your piece. To start, obtain the following equipment:

> **Tools:** mat knife, sharp pencil for ruling **Drafting tape**
> **Cutting surface** (a piece of matboard or a self-healing mat)
> **Metal T-square,** or other metal cutting edge
> **Right angle:** for cutting down large sheets or irregular papers
> **Finish paper:** drawing **Kneaded eraser**

1. Mark the height and width of the finished piece on the finish paper (a larger sheet).
2. Place the paper on the cutting surface.
 a. With a T-square: see p. 125.
 b. Without a T-square: position the straight, cutting edge in alignment with the marks transferred from the paper ruler.

Tips
1. Position the knife with one hand next to the metal edge (photo) just above the mark for the top or bottom edges of the paper. Place the other hand so that it will hold both the metal edge and the paper steady.
2. Press the knife into the paper until you feel the "bite," making sure the other hand is engaged and holding firm. Pull the blade against the metal, down and toward your body as you exhale. It's likely you'll need more than one pass of the blade. It's not advisable to exert maximum force with the knife, trying to make the cut in one pass. Keep the blade in a fixed relation to the metal.
3. For irregular papers:
 Make a couple of marks along the edges of the right angle. From these, measure the width and height of the finished paper.

Fig. 5

Metal to metal

Ruling (Tools and materials for "Cutting," above)

In preparation for ruling a multiple-line text, you can practice the method with a single line of text.

1. Mark a paper ruler with your chosen measurements for body height, ascenders and descenders. (Review p. 70)
2. Tape the paper squarely—at right angles—to a table with a straight edge:
 a. Cut or tear a couple of short pieces of drafting tape and tape them to a nearby surface.
 b. Place the lip of a T-square over the straight edge. (I use the top edge of my drawing table.)
 c. Align the top edge of the paper with the stem of the T-square and tape. (You may wish to place a couple of pieces of tape at the bottom of the paper before aligning it.) Keep the left edge of the paper about an inch from the straight edge. (See p. 172)
3. Tape the paper ruler to the table in the space just left of the finish paper.
4. Rule the three guidelines with the T-square. Keep the pencil upright as you draw each line.

Finished work: copying / graphite transfer

Drafting tape Kneaded eraser

Copying
1. Tape the final rough above the writing area of the ruled, finish paper. Write the text just beneath the rough.
2. Erase lines. Test for smearing on a separate sheet of paper.

Tools: two-point (black Pigma Microns), #2/HB pencil
Paper: tracing, finish paper

Graphite transfer
1. Preparing to transfer the design:
 a. Make your final rough on tracing vellum with the two-point tool.
 b. Position it over the ruled guidelines on the finish paper.
 c. Make light pencil "registration" marks on the rough and finish paper: draw short lines from near the edge of the rough, across the edge, and a short way onto the finish paper.
 d. Turn the rough over and blacken the lines of the word image with the pencil.
 e. Flip the blackened paper over; place it over the guidelines, according to the registration marks, and tape.
2. Making the transfer:
 a. Trace a short line on the blackened image to check the darkness of the transfer line: adjust pressure on the tool if the line is not dark enough to see it clearly, or too dark, which will make it more difficult to erase.
 b. Remove the transfer pattern and trace over the transferred image with the finish tool. Note: Peel the drafting tape from the finish paper with care.
3. Erase lines.

Two-point play
1. Stretching and Multiples (letters, a; lines, b)
2. Two- and one-point letter strokes (c)

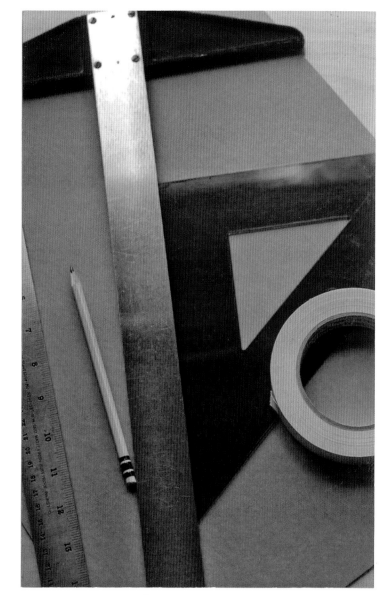

Ruling equipment

a

b

c

Training Alphabet 5:
Trapeze caps

Trapeze Caps, a contemporary version of Roman Capitals, feature lively gesture, varied postures and non-conformity. (Figs. 1, 3, and next page.)

Design

Nib angle
- 45°, characteristic angle (Fig. 2, solid line) and
- 70°, "adjusted" angle. This is a nib angle that differs from characteristic angle, one chosen to adjust imbalances in stroke weight or to help create a unique alphabet design. (Fig. 2, dotted line)

Visual themes
- Stroke: Curved thick and thin strokes. (Fig. 3)
- Weight: Relatively thin downstrokes contrast with relatively thick horizontals and diagonals.

Structure: Large-grid paper orients you and provides a frame of reference.

Proportion: Variable, but non-classical.

Letter families: Shared family traits are shown by "overlays"—letters superimposed on each other to highlight the identifying trait.

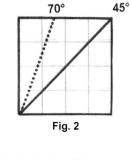

Fig. 1 A black dot over a character indicates an enlarged lower-case letter.

Fig. 2

Fig. 3

Fig. 3, cont.

Guidelines

For Trapeze caps, you draw a cap line six squares above the baseline—two above body height. (Fig. 4, "Mi") The placement of this line, as noted in Jumprope Caps, is an expressive graphic element. Generally, the shorter the cap, the wider and heavier it becomes. Note: The model offers letters whose strokes and relationships can be stretched or shortened, expanded or narrowed. After you are familiar with this alphabet, choose a letter and write it at different heights/scales.

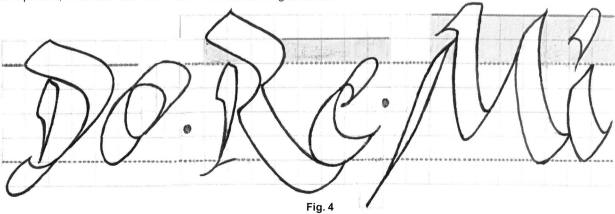

Fig. 4

Alphabet/letter design: adjusted nib angle

In most alphabets, using characteristic nib angle for all strokes results in making some too thick/heavy or thin/light. To redress such an imbalance in stroke weight, calligraphers adjust nib angle to thin/thicken the stroke. (For Trapeze: 70° to thin the downstroke.) Fig. 1 demonstrates the downstroke of "E" at characteristic angle, and Fig. 2 shows it at an adjusted angle. To further adjust thickness, you can turn or rotate nib angle within a stroke. (Fig. 3, Index, "Nib turning") Such changes of angle also expand your expressive potential.

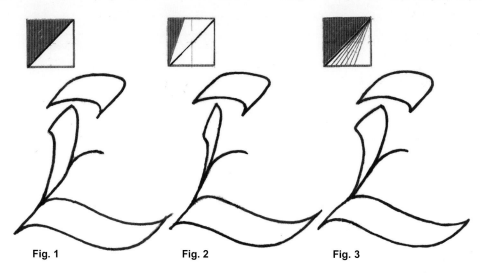

Fig. 1 Fig. 2 Fig. 3

Adjusted angle is described *relative to* characteristic angle. For example, with a characteristic angle of 45°, an adjusted angle greater than 45 degrees is "steeper"; one less than 45° is "flatter." (Fig. 4) "Steeper" and "flatter" can also refer to the relationship of nib angle to the absolutes of 90° and 0°: an angle is flatter when closer to 0° and steeper when closer to 90°. (Fig. 4)

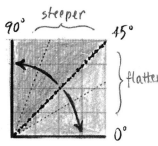

Fig. 4

Note
The thickness of a stroke depends on nib width, nib angle and stroke direction. (Figs. 5a and b: same angle, different direction) Nib angle can be steady, as in Figs. 5a and b, or turned as in Fig. 5c (a change of angle within the stroke).

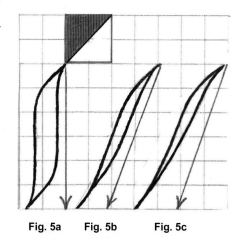

Fig. 5a Fig. 5b Fig. 5c

Same direction, two nib angles
This exercise and the one below help you develop a command of angle and direction with the two-point tool.

 Tool: two-point **Paper:** large-grid

Fig. 6

1. Trace Fig. 6 with its alternating angles: 45° and 70°.
2. Remember to make the single-line entry on the left nib point (T).
3. Note: strokes at 70° should be decidedly thinner than those at 45°. For now, the adjusted nib angle need not be precise. Later, using the edged pen, we will use a protractor to obtain a more precise nib angle.

Same nib angle, two directions
Make a border of downstrokes, changing stroke direction, but keeping nib angle steady. (Fig. 7)

Fig. 7

Ductus and **D**ynamics

Trapeze caps is a contemporary, invented alphabet that offers an opportunity to develop your sense of exploration. For ductus, follow the general rule: move strokes from left to right and top to bottom. Notes are given to help orient you further. For dynamics, apply those used for lower-case letters.

Tool: two-point, 05/08 Pigma Microns **Paper:** tracing vellum

General directions
1. First, trace the individual caps of each family, using the alphabet model on the previous two pages.
2. Second, trace the overlays which, on this and the next page, feature the shared family trait.

The "I" family: I, J

These letters share the traits of characteristic angle, entry stroke, and dominant stroke direction. (Fig. 1)

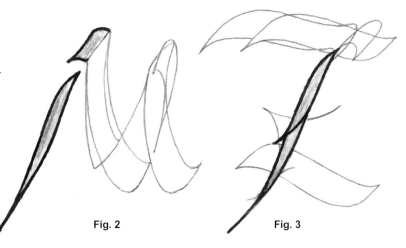

Fig. 1

> **Visual themes**
> - Nib angle: characteristic (45°).
> - Entry: a short horizontal arc (may be slightly wider for "J").

Notes
> **I:** To thin the connection between the entry and the downstroke, pull diagonally down to create a "neck" between entry and downstroke. The downstroke is a long, subtle reverse curve. The base is a one-point, single-line reverse curve.
> **J:** The base stroke is an abbreviation of the tail of "y."

The "L" family: M, N, L, F, T

> **Visual themes**
> - Nib angle: characteristic (45°) and adjusted (70°).
> - Entry: a short horizontal arc for M and N (Fig. 2).
> - First downstroke: a sloped diagonal (Figs. 2 and 3).
> - Horizontals: slight downward slope; reverse curves in L, F and T (Fig. 3).
> - Diagonals: scooped diagonal arcs for M and N (Fig. 2 and alphabet model).

Fig. 2 Fig. 3

Notes
> **F:** The crossbar, a single-line stroke, starts at the left wall of the downstroke and pushes up before coming across.
> **T:** A single-line stroke finishes the downstroke as in "I."
> **M:** A single-line upstroke connects the second and third strokes.
> **N:** Stroke three uses complementary angle (70°).

Fig. 4

The "C" family: C, G

The "C" is an enlarged lower-case form.

> **Visual themes**
> - An open bowl.
> - Top horizontals are broadened versions of that of the lower-case "c."

Compare the open and closed bowls of the "C" (Fig. 4) and "O" families (Fig. 5): the C-family bowl pulls to the left, away from a vertical, to gain bottom width; the O-family bowl stays close to the vertical to narrow the base. (Figs. 6a and b)

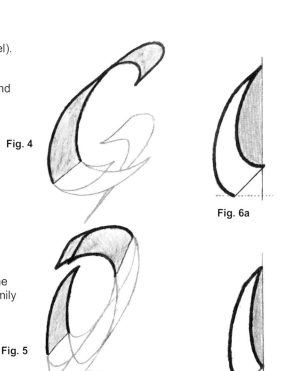

Fig. 6a

The "O" family: O, Q

Fig. 5

Visual themes:
- Closed bowls and shallow arced downstrokes. (Fig. 5)
- Horizontal arcs: broad at the top and narrow at the bottom.

Fig. 6b

The "H" family: H, K, E

Although the "H" and "B" families share the same narrow downstroke, in the "H" family "straight" directional strokes, rather than bowls, attach to the stems. (Fig. 7) Review the alphabet model to see the letters as individual characters.

Visual theme
- Downstroke: adjusted angle (70°). The lengths of these strokes vary.

Notes
H: Crossbar: a single-line arc is interrupted by the first downstroke and continues in a single-line upward arc to meet the second downstroke. (See lower-case "t," p. 96); the second downstroke, at the characteristic angle (45°) is slightly sloped. The graduation in width is a result of changes in stroke direction.

K: Top diagonal: This stroke begins as a hairline slightly to the right of the downstroke, midway between the base- and cap lines. It then pushes up and into the top of the lower-case "f." The lower diagonal swings down in a slight arc, reaching below the baseline or sitting above it. This stroke closes with the familiar single-line exit.

Fig. 7

The "B" family: B, D, P, R

In this family, bowls attach to the narrowed downstrokes. (Fig. 8)

Visual themes
- Downstroke: adjusted angle (70°) The length of this stroke also varies.
- Bowl: the entry, a subtle diagonal reverse curve, leads into the bowl. Neither the entry nor the bowl touches the downstroke.
- Exit strokes of "B" and "D" are the same as the one used for "J."

Structure
Letter bowls wrap around internal triangles. (Fig. 9, dotted line)

Fig. 8 **Fig. 9**

The "V" family: V, W, Y

The "V" and "W" are enlarged lower-case forms. (See page 127)

Visual themes
- Entry: a shallow, rounded horizontal arc (Fig. 10).
- Downstroke: a diagonal which changes direction slightly for each letter in this family.
- Exit: a weighted stroke at the finish of a single-line diagonal which uses an adjusted angle (70°).

The hybrid family: A, X, Z, S, U

Since these characters do not share traits, they do not invite an overlay. See the individual forms in the alphabet model. The "X," "Z," and "S" are enlarged lower-case forms.

Notes
A, X and Z have diagonal hairline strokes that end in a weighted stroke. (Fig. 11)
U begins with the capital "I" entry (concave or convex) and continues with a neck connecting it to the lower-case "u."

Fig. 10

Design note: Serifs
Trapeze Caps and lower-case alphabets both feature small, short strokes called serifs. Although not integral to a letter's identity, they are a common feature in calligraphic practice. As a scribe, the calligrapher uses them to start and end the stroke, as a means of making and breaking contact with the writing surface. As a designer, s/he chooses or invents serifs to enhance the expressive character of alphabetic style and to give pleasure to the eye. In type, serifs are a legacy of the handwritten form and may make reading easier. (As a term, though, it did not enter the language until the 19th century.)

In Trapeze caps, the serifs are more ornamental than practical. However, they are a significant feature of this alphabet's character and style. They take the form of double-walled, horizontal entry arcs for I, J, M, and U and single-line base strokes for I, R, T, and Y.

Fig. 11

Word as image: all caps

Historically, mapmakers used all caps to label the names of newly discovered seas and oceans. (Fig. 1) These large, open spaces held no terror for scribes. Rather, they seem to have delighted in their own exploration—sailing downstrokes across guidelines and flourishing them with more or less restraint. This exercise first invites you to venture with similar lack of inhibition, letting your arm push and pull above and below the guidelines. Then, analyze your play and consider where to use restraint (or abandon it) in the number and length of extended strokes. These choices enhance legibility and/or serve expressive intent.

Tools: two-point, pencil for ruling
Paper: tracing vellum, marker/drawing/JNB

1. Choose a single word or short phrase. (Fig. 1)
2. Rule cap guidelines on tracing vellum with a pencil.
3. On this ruled paper, trace the letters of your text from the model alphabet.
4. Over this word, place another sheet of tracing vellum or marker paper.
5. Now explore opportunities for plasticity and/or letter variants—raising or lowering letter strokes.
6. Continue experimenting until you are pleased. (Take your time—stalling is part of the process!)
7. Cut out pieces of layout paper or tracing vellum to place over your designs for any further adjustments.
8. Trace or freehand a final draft.
9. If you wish to make this a finished piece, review pages 124-5.

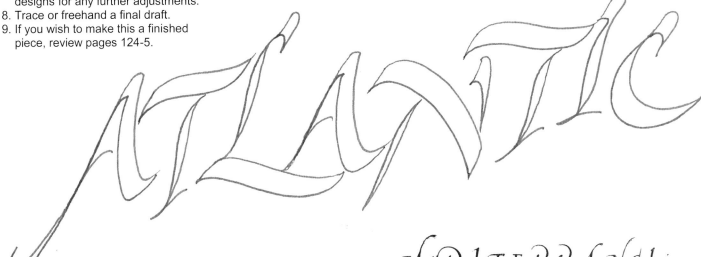

Fig. 1

Word as image:
caps and lower case

Tools and paper: as above

1. Choose a single word, name, or short phrase that includes a cap. (Fig. 2)
2. Rule guidelines for upper- and lower-case letters with a pencil.
3. Trace your text from the model on this paper.
4. Continue with steps 4 – 8/9 above.

"B" in "Basho" (Fig. 2)
1. Letter height: two body heights rather than one-and-a-half. (Fig. 3)
2. Downstroke: reverse curve.
3. Base: wider and nearer the downstroke than in the model.

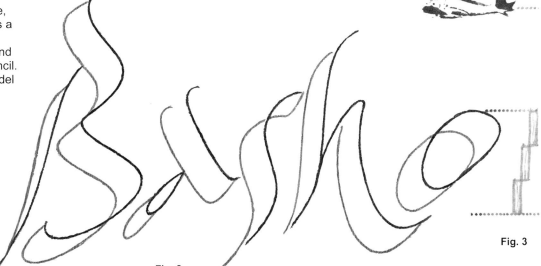

Fig. 2

Fig. 3

The Edged Pen

After having developed fundamental calligraphic skills, you are now pre-pared to handle the tool most identified with calligraphy: the edged pen. This tool creates solid strokes that are capable of great variation in thick-ness, shape, and expressive power. (Figs. 1, 2 and 3) The edged pen comes in two types: the traditional broad- or chisel-edged pen, which has fixed maximum breadth (Figs. 5 and 8, next page), and the relative new-comer known as a folded or ruling pen. This book explores the first and considers it a good foundation for the second.

Tool design and carrying ink: two types
The first comes ready to use, carrying its own mark-making substance, e.g., fountain pens and markers. The second requires "loading" with ink or paint and is commonly known as a dip nib. This book uses the dip nib because it offers greater potential for control and refinement. Ink-dipping methods are presented in detail to help you develop skill and confidence.

Nib brands: This book features three brands: Brause (which is presented in detail), Speedball, and the Automatic Pen. (Fig. 4) These are just three of many makes; later, you may wish to experiment with others.

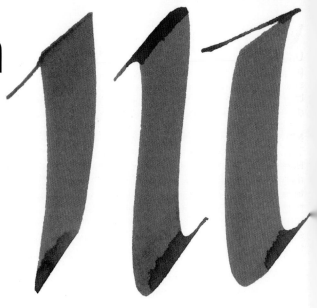

Fig. 1 Three downstrokes using a #6 Automatic Pen

Fig. 2 Free strokes (Automatic Pen)

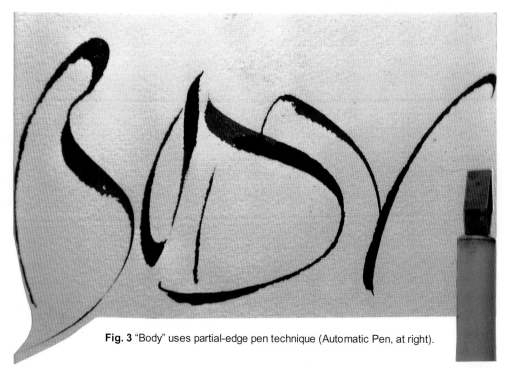

Fig. 3 "Body" uses partial-edge pen technique (Automatic Pen, at right).

Fig. 4 The Automatic Pen (side view of reservoir)

Visual character

Unlike the thick, open strokes of a two-point tool, the thicks of the edged pen are ink-filled and solid. Experience with the two-point nib—open space bounded by two points—prepares you for an edged nib bounded by corners. The following elements interact to form the shape, and endow the weight, of the edged nib's stroke.

Nib size

The size of a nib influences stroke weight and, thus, character. The Brause brand offers nine nib widths ranging from one-half to five millimeters. (Fig. 5) Fig. 6 translates nib size into letterforms. Fig. 7 shows the 3mm nib at play. As nib width varies, so does the touch appropriate to making the best surface contact. This tactile sensitivity also underlies stroke dynamics and the full expressive use of the tool.

Fig. 5 Brause nibs and their full-edge marks.

Fig. 6 The Italic "a" written at each nib size using a scale of five nib widths.

Nib angle

Within the constraints of nib size, variation in nib angle determines stroke weight when direction is constant. (Fig. 8) By steepening the angle, a large nib can make strokes as narrow as those of a smaller nib size. The calligrapher, holding the tool attentively, maintains a steady angle where desired, but is ready to steepen or flatten it for expressing stroke or letter character.

Fig. 7

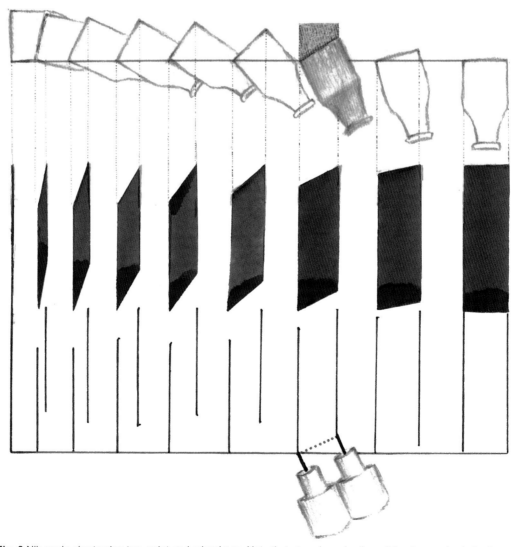

Fig. 8 Nib angle chart using two-point and edged pen. Note that at each angle, the solid, edge-made stroke forms a shape, either a parallelogram or rectangle. The tools: a ½ inch Automatic Pen and a two-point of the same width.

134

Stroke direction

Direction influences stroke weight and letter character in relation to nib angle. (Fig. 9) As Fig. 8, mid-section, shows, stroke weight increases when nib angle flattens and direction remains the same.

At a constant angle, strokes made in the same direction have the same width. (Fig. 9) Applied to alphabets, these fundamental relationships between direction and angle result in the harmonious, legible patterns seen in historical and contemporary texts.

Such fixed patterns, while useful, can also be boring to the viewer. Taken out of a book or other practical format and hung on a wall, they seldom fulfill the expectations of visual art. For the contemporary calligrapher, stroke direction is another of the variables for expanding artistic potential. Directional strokes, varying in width and friction, enlist tactile and rhythmic sensitivity.

Stroke length

Stroke length interacts with angle and direction. (Fig. 10) It makes manifest a formative sequence: stroke beginning, development, and end. In the time-space of these phases, through rhythmic, dynamic patterning, the living stroke emerges. This process also corresponds to attention: making strokes thus develops concentration and your ability to "stay with the stroke."

Fig. 9 Strokes at a constant 45° angle
Thins—Stroke direction coincides with nib angle and makes a hairline (a).
Thicks—Horizontal and vertical strokes are the same width (b); all other directions change the stroke's width (e.g. c, full edge). Thick strokes may vary in width within a stroke as a response to a change of direction (d and e, graduated).

Fig. 10 Long strokes with attitude: Such expressive strokes result as nib size, nib angle, stroke direction and length interact with intuition and skill.

Fig. 1 The edged pen: nib and holder

The edged pen

The edged pen consists of a nib and a holder. (Fig. 1) Using this tool begins with the basic experience of inserting and cleaning the nib. (See Preparing the tool, below)

> **Nib:** 3mm Brause
> **Holder:** One that holds the nib securely, such as the Universal.

"Brause?"

Of the available nib brands, the Brause offers the best balance between tensile strength (rigidity) and receptivity to pressure (flexibility) for the purposes of this book. To broaden your experience, however, the Speedball C-0 is used for one of the following edged-pen training alphabets. ("Satisfaction")

"Universal penholder?"

The choice of holder depends on its ability to grasp the nib securely. Of the many holder designs that are available—with their various weights and grips—I think the Universal penholder is best. If you wish to use another make, though, try to make the nib as stable and wriggle-free as possible. A wobbly nib interferes with your ability to exert pressure confidently and guide the pen. The holder should also feel comfortable to grip and lift. (Note: The Caran d'Arche holder is suitable, but no longer sold. If you have access to this holder, consult *Finding the Flow: A Calligraphic Journey*, p. 24, for help with its use.)

Getting acquainted

Let's start by examining how the reservoir attaches to the nib shank. Nib in hand, note that the reservoir clamps around the nib. (Figs. 2 and 3) Next, slide it toward and away from the nib edge. This sliding action allows you to adjust the flow of ink. (A little ridge keeps the reservoir within working range.) The pointed end of the reservoir should be directly over and aligned with the ink slit and a little way from the edge. You may need to force it into place. Now, try removing the reservoir and clamping it back in position.

The edge

The physical edge of the nib functions as both a full and a thin edge. (Fig. 4)
- **Full edge:** The maximum width of the nib which is used to create thicks. These strokes may be slightly widened by applying pressure to the ink slit.
- **Thin edge:** The thickness of the metal nib which creates thin strokes. (It may be slightly narrowed by making a bevel across the top of the edge—more often used on small nibs.)
- **Corners:** The boundaries which define the width of the edge. Cultivating their use is an integral part of calligraphic stroke technique.

Preparing the tool

Inserting the nib

Follow the instructions enclosed with the Universal penholder. As you position the shank of the nib, be sure the ridge is about a quarter of an inch from the top of the holder. (Fig. 5)

Cleaning the nib

Before using the nib it's necessary to remove the machine oils which result from its production. This involves dipping the nib into ink or water and drying it thoroughly. The method shown on the next two pages is the same as that for cleaning the nib after normal use.

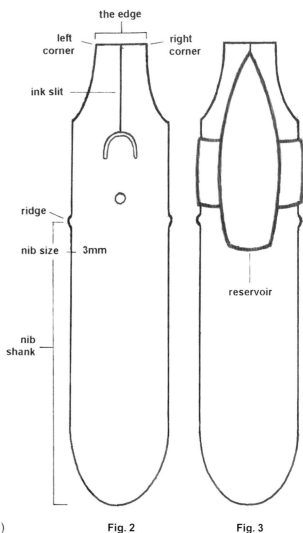

Fig. 2 **Fig. 3**

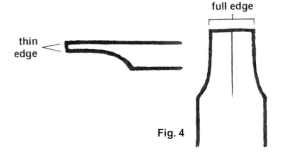

Fig. 4

Fig. 5 ridge

Cleaning the nib

Follow the easy steps below to prepare a new nib. Also, in normal use, when you put down a wet nib, even for only a short time, be sure to clean it. This will keep it sharp, free of corrosion, and extend its lifetime. (Nibs should be replaced when they lose sharpness.)

Equipment
1. wiper: paper towel/cloth
2. water (ink may also be used)
3. nib (in or out of a holder)

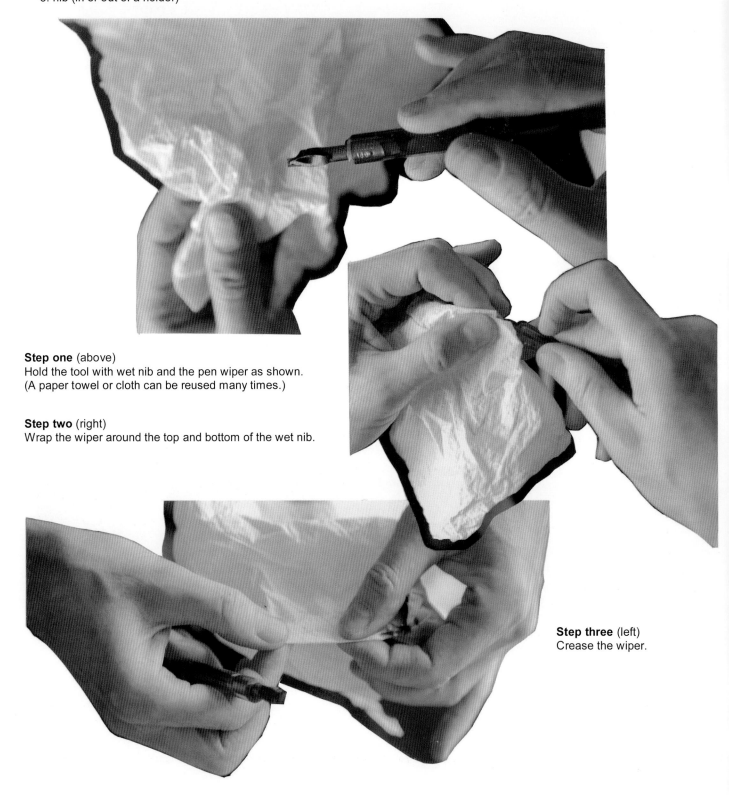

Step one (above)
Hold the tool with wet nib and the pen wiper as shown.
(A paper towel or cloth can be reused many times.)

Step two (right)
Wrap the wiper around the top and bottom of the wet nib.

Step three (left)
Crease the wiper.

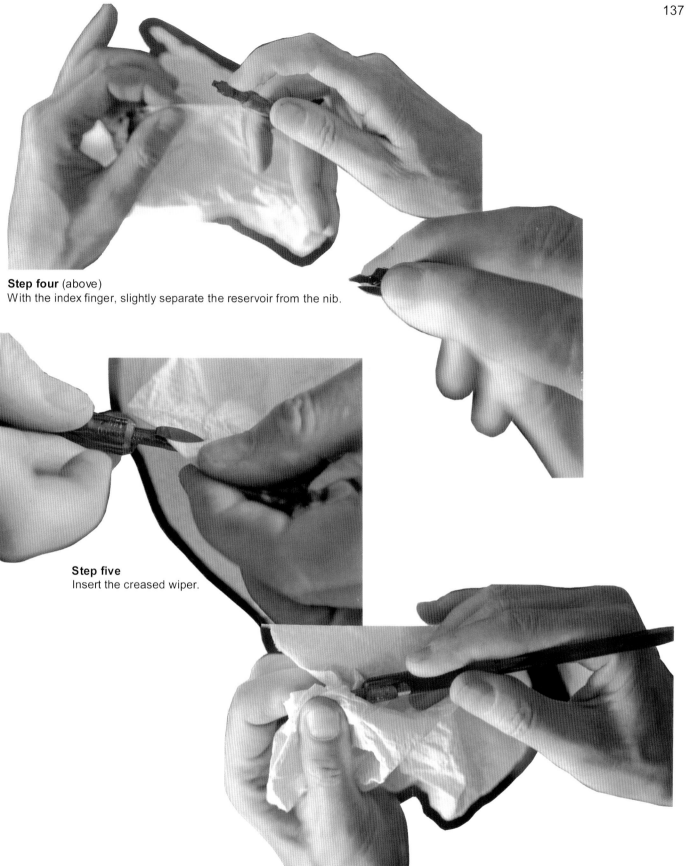

Step four (above)
With the index finger, slightly separate the reservoir from the nib.

Step five
Insert the creased wiper.

Step six (above)
Fold the wiper around the nib. Firmly dry the top and bottom.

Note: The nib is now ready to use, reuse, or store. It's helpful to buy a holder for each nib size you plan to use, especially if selecting the Universal holder.

Holding the tool

Hold the edged pen as you have the
one- and two-point tools: remember to
keep your fingers at least an inch
above the edge of the nib. Position the
shaft against the index finger near the
big knuckle, holding it as upright as
possible. (Fig. 1, top photo) The
thumb helps hold the tension from
surface contact.

Looking at Fig. 1
This sequence of photos begins at the
top—with the nib held at a 90° angle
and the shaft held upright, also at a
90°angle (or near to it). Each photo be-
low shows a slightly flatter nib angle.
The shaft tends to lower with each
change of angle. For nib turned stokes,
however, it will need to be held upright.

Exercise

> **Tool:** Automatic Pen (#4)
> Although this size is slightly lar-
> ger than most of the pen images
> in the photos, it serves the pur-
> pose of this exercise.

> **Note:** In this book the Automatic
> Pen is used without ink. This al-
> lows you to focus on the shoul-
> der, arm, and fingers as they
> hold and move an edged pen
> to make strokes and letters.

1. With a dry Automatic Pen, follow the
 sequence of nib angle changes di-
 rectly atop the pens in the photos.
2. Place the nib in alignment with the
 edge of the nib in the top photo.
 You'll need to turn the book clock-
 wise to hold the nib at a 90° angle.
3. Lift the nib and, without turning it,
 move the edge to the next photo,
 placing it atop the left black line.
4. Turn the nib clockwise to a slightly
 flatter angle, using the left corner as
 a pivot. This movement tends to
 slide the corner a little to the left.
5. Repeat the above actions with each
 photo.
6. Repeat the sequence, paying atten-
 to the position of the shaft. Try to
 keep it upright.

Fig. 1

Orienting the tool

The two exercises below further develop your understanding and use of nib angle—basically, the orientation of the nib to a horizontal line. Stroke making with an edged nib, like that with a two-point one, begins with the foundation skill of holding nib angle steady. Try this with the range of angles introduced below.

Thins

To make thin strokes with an edged pen, think of the nib edge as a straight line. Setting the edge at an angle (nib angle) and moving it up and down results in a directional stroke—the nib's thinnest. (Fig. 1) The angles of the red nib edges of the lower portion of the figure correspond to the red directional lines above them.)

> **Nib:** "dry," without ink; 3mm or larger, the nib need not be as wide as that in the diagram

1. Work directly on the book as above.
2. Place the nib edge in the lower left corner of the square at 90° (parallel to the square's left side).
3. Press-release and push the edge to the top of the square; press-release and pull the edge back to the corner. Note the position of your arm and elbow.
4. Pivot the edge clockwise to the first diagonal thin and repeat the pattern—pushing and pulling directional strokes from the different nib angles. (Inhale, up: exhale, down.

Note
Despite your effort of keep the shaft upright, as you flatten nib angle it may lower slightly. No matter, for now. Here, let nib angle be your primary focus.

Thin-to-thick

> **Nib:** as above

1. Place the nib at 90°, at the left side of the square, at the top of the thin black line. (Fig. 1, three squares above the horizontal red line)
2. Press-release and pull the thin stroke to the bottom line of the square.
3. Lift and replace the nib at the top of the first thin black diagonal line.
4. Press-release and pull the thin stroke until the nib covers the top of the thick black stroke.
5. Press-release and pull the full-edge downstroke to the bottom line of the square.
6. Repeat for the next two nib angles. For the last angle at 0,° start at the left of the black horizontal line and push to the top of the full-edge stroke.
7. Note the changes in hand-arm position.

Note: The diagram of "mini," Fig. 2, illustrates the impact of nib angle on letter weight: the flatter the angle, the thicker (heavier) the stroke.

Fig. 1
Nib angles and their corresponding thicks and thins.

Fig. 2

using ink

Dipping a nib into ink is a distinctly calligraphic action: its aim, first and foremost, is flow—the easy discharge of ink from the nib onto paper. When you're comfortable and confident with this process, you're ready to turn to its control and expressive potential. The following introduction presents the equipment you'll need and how to use it. To embolden your efforts in what for many is an unfamiliar realm, I recommend entering it in a spirit of exploration. Be assured, the ink will flow as you investigate the methods offered below.

- **What kind of ink? What kind of paper?**
 To start, choose *a new* bottle of free-flowing, non-waterproof ink such as Higgins Eternal.

 Ink storage: "Better a gritty ink than a slimy one." —Edward Johnston. Use a lid for the well (below) if you don't want it to precipitate (evaporate and darken). You may choose to trade a bit of slime for a darker ink.

 Paper: A discussion of ink is inseparable from one about paper. To enhance tactile feedback, calligraphers choose a non-absorbent paper with some tooth, such as Graphics 360 100% rag translucent marker paper (Bienfang) or the JNB practice pad. These papers also help you produce sharp strokes.

A pool of ink evokes the vital movement of all fluid media

All papers have their pros and cons. Some facilitate the release of ink but may not offer as "engaged" a stroke. Others make it more difficult to get the ink flowing, but offer a better "bite" for gripping the pen and sharpening the stroke. Paper preferences come with experience and may change as sensitivity and skill develop.

- **Ink setup**

 Ink (See above)
 Inkwell: A small container, preferably with a screw-on cap (photo at right), which retards evaporation. Suggestion: a small jar with cap (right) or a communion cup that may be set into a jar (left). I use an empty jar of Pro-White or other touch-up fluid.
 Water well: Another small container for holding water to clean the nib.
 Eye dropper/pipette: For adjusting the ink level in the well; it's useful to have more than one.
 Pen wipe 1: Non-fibrous cloth or paper toweling to clean and dry the nib.
 Pen wipe 2: You may want a second pen wipe to absorb excess ink from the reservoir.

 Note: Place the above equipment on a stable surface within easy reach. Always be aware of the possibility of ink to spill.

- **Preparing an inkwell**
 There is no need to plunge blindly into a bottle and wonder, "Have I dipped far enough?" "Have I overloaded?" Take the time to customize an inkwell for confident dipping.
 1. Choose a well and place it on the table.
 2. Take a pen with a dry 3mm Brause nib and place its edge at the bottom of the well, in contact with it.
 3. Looking through the glass, place your thumbnail on the outside just above the reservoir. Mark the well with tape or a marker at this height.
 4. Fill the well to this mark with an eye dropper/pipette. The ink well will then hold just the amount of ink needed to fully load the reservoir but fall short of submerging the holder. (This prevents rust

Below
Using a pipette to transfer ink from the bottle to a customized inkwell (a communion cup inside an empty Pro-White jar).

At right
Dipping a nib to submerge the reservoir (only!).

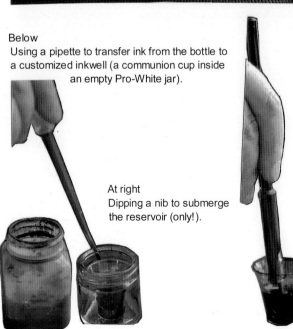

and future difficulty removing the nib.) Fill a well with water to the same depth as the ink well.

- **Loading the reservoir:** "Dip and flick"
 The two primary methods are dipping the nib or loading it with a brush. This book features dipping. Because this usually results in a little too much ink, it's adjusted by flicking off the excess—"dip and flick"—or removing some of it with a wiper. At this time, dip and flick is more suited to getting comfortable with ink. Give it a try:
 1. Fully load the nib—completely filling the reservoir—dipping it into the well with the nib edge touching the bottom.
 2. Remove the nib from the well and flick it once or twice above the well. (A small, energetic wrist movement.) Dip and flick a few times; then clean and dry your nib. (Note: Always do this when not using it.)

Controlling ink release
This refers to releasing the amount of ink needed to produce a particular quality of stroke. It's a skill that develops with experience. It includes the ability to create letters saturated with ink and ones displaying clean, sharp edges. (Fig. 1) The calligrapher also develops control of the values of ink: of a range from dark and dense to light and watery. (Figs. 1 and 2)

Body awareness
As before, the pressure of contact comes from the arm and shoulder. This awakens the fingers which can then act as antennae to sense the friction from surface contact. The amount of ink flowing from the nib also contributes feed-back about surface resistance.

- **Preparation:** Getting acclimated
 1. Place a sheet of marker paper on a padded surface squarely in front of you.
 2. Position the nib centered to your body, or slightly to the right.
 3. Loading the nib: dip and flick.
 4. Position the fingers about an inch from the nib edge; place the nib at a 45° angle, or a little flatter.
 5. With an ink-filled nib touching the paper, inhale and exhale a few times, in place. Let the pen shaft, hand, and arm rise and lower with your breath. On an exhale, pull a stroke. To further sensitize your fingers, imagine the ink flowing directly from them. (Experiment with pressure.)
 6. Repeat these downstrokes a few times.

- **Action:** ink-release methods
 Ink can be released from either the broad or the thin edge, as described below. Make a few strokes with each.

Broad edge releases: Three methods
1. Place the ink-filled nib: inhale and press-release; exhale and pull down. (Fig. 3a) If the start of the stroke is not clean, dip the nib again and make a more vigorous contact.
2. Use wrist "vibrato": place the nib and apply some pressure as you move the hand and wrist side-to-side as a unit. Do this in place and then pull the stroke. Repeat to get the feel.
3. Place the nib and push the full edge up, a short way, to the beginning of the stroke. (Fig. 3b) Press-release and pull the stroke. You may also begin by pulling the stroke down a short distance; check to see if the mark is clean and, if not, retrace; press-release at the top and pull the stroke again.

Thin edge release
1. Place the nib on the paper at a comfortable angle.
2. Push a short hairline stroke up and then pull down over it. Try this a few times. (Fig. 3c) Since this stroke is longer than the breadth of the stroke, it is either used to enter the stroke, becoming a serif, or for testing flow in relation to the character of the paper. For this latter purpose, use a separate sheet of paper and place it near the stroke.
3. To start a stroke: Pull a hairline down a short way and retrace it; pause. Press-release and pull a downstroke. (Fig. 3d) Repeat.

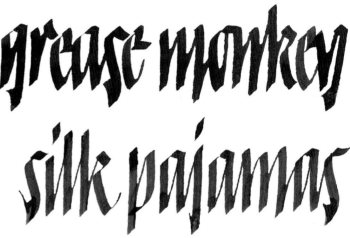

Fig. 1 Graphopoeia with heavy, dark ink, above and light ink, below. Figs. 1 and 2 use Moto, the first edged pen training alphabet. (p. 151)

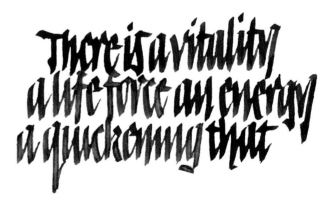

Fig. 2 …is translated through you into action, and because there is only one of you in all time, this expression is unique.
Martha Graham

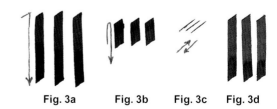

Fig. 3a **Fig. 3b** **Fig. 3c** **Fig. 3d**

Note: The above methods are not mutually exclusive. Feel free to experiment with their combination, or just see what happens.

Moving and marking – "thicks"

These exercises may be practiced as preliminaries to lettermaking, as a form of relaxation/meditation, or for the sheer enjoyment of calligraphic stroke making. They invite you to move "in the ink"—to participate in its flow—and experience your bodily movement as the source of the mark. They are guided explorations for engaging the meditative and dynamic facets of ink. Just as exercises with previous tools integrated breathing and sensory feedback, those with ink help create a new and expanded whole.

To make a full engagement between you, the nib and the paper, it's helpful to use a relatively broad stroke. While angles of 0° and 90° make the broadest vertical and horizontal strokes, they sacrifice comfort. (Figs. 1c and 2c)

Nib angle: The 25° and 65° angles of Figs. 1b and 2b provide a stroke that's sufficiently broad and more comfortable to make. Slightly flatter or steeper is fine. (Pay attention to tool hold.)

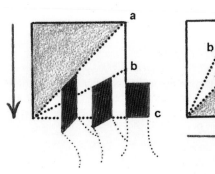

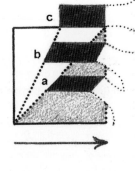

Fig. 1 a, 45°; **b**, 25°; **c**, 0° **Fig. 2 a**, 45°; **b**, 65°; **c**, 0°

Ink swatch series

In these exercises you experience the ink in motion at different speeds and in different moods: fast (energetic), moderate (deliberate), and slow (meditative and fully engaged with the breath).

> **Tool:** 3mm Brause
> **Ink set up:** ink and water wells, pen wipe within easy reach
> **Body:** shoulder pulling, fingers sensing
> **Paper:** drawing/marker paper/JNB
> **Loading the reservoir:** fully loaded
> The reservoir is completely filled—but not flicked.

Swatch 1 (Fig. 3)
1. Place the nib at a 25° angle (Fig. 1b) and move it quickly up and down in the air above the paper.
2. Land on the paper and continue making strokes, at least as long as those in Fig. 3.
3. Throw the strokes, lightly, with awareness of the shoulder bringing the nib into surface contact. The ink need not "stick" in this exercise.

Fig. 3 **Fig. 4** **Fig. 5**

Swatch 2 (Fig. 4)
1. Place the nib on an inhale with press-release.
2. Exhale strongly, pulling downward, deliberately, at a moderate speed. Use even pressure to engage the drag—the resistance to your motion.
3. At the end of each downstroke, inhale as you release pressure and "skate" the upstroke, gliding in the trail of the wet ink.
4. As you finish the inhale, slide slightly to the right.
5. Exhale and pull the next adjacent stroke. Repeat the pattern, dipping frequently to keep the strokes wet enough for ease in the upward glide.

Swatch 3 (Fig. 5)
1. Repeat Swatch 2 to use it as a wet surface for ease of gliding in this exercise. (A fully loaded nib is essential for this action.)
2. Place the nib at the start of the swatch.
3. Move slowly. Concentrate on sensation as you move the nib as above: down, up and over in the ink. Focus on pressure: a little more on the downstrokes, sensing the surface with your fingers. (Exhale, down; inhale, up.) This is a slow, meditative exploration.

In general, Western scripts emphasize verticality and the downstroke; however, you may wish to repeat the swatch sequence in the horizontal direction. (Especially if you are interested in Hebrew calligraphy which emphasizes the horizontal.)

Long-line swatches (Fig. 6)
1. Place the fully-loaded, unflicked nib: inhale, press-release; exhale, count "one" and pull a downstroke about an inch in length.
2. At the endpoint, release pressure, inhale, count "and" and return to the beginning.
3. Continue the pattern, counting: "two, and;" "three, and;" on "four," pull a double-length downstroke. On "and," inhale and return in a single-length upstroke and begin the second swatch.

Fig. 6

Introduction to long, single-line exercises
The shoulder activates the senses of touch and movement that awaken gesture and feeling—and engender spontaneity and creativity. Through exercises in edged-pen technique, the calligrapher becomes a medium for expressing life force.

Pressure patterns: even, end, start and center
As you work with the various patterns, try to spread pressure equally across the entire width of the nib.

Segmented long lines
The colored portion of Fig. 7 presents the movement pattern used for the long inked lines of the exercise below. The darker colored squares show "ink over ink." Here, attention focuses on touch—on tactile awareness and feedback.

Start—

 Tool: 3mm Brause **Paper:** large grid

Even pressure
1. Dip and flick or fully-load the nib.
2. First row (far left): On large-grid, place the nib at 25° at the start. (Fig. 7)
3. Inhale and softly push the nib directly up one square.
4. On the exhale, sink the shoulder and pull the stroke down three squares applying even pressure. The first square is over wet ink, work sensitively.
5. On the inhale, release the pressure and glide up one square into the wet ink.
6. Repeat a few times to find the rhythm and relaxation.
7. Second row: Enter as above; then pull down five squares and push up one; repeat.
8. Third row: Enter as above; then pull down nine squares and push up one; repeat.

End, start and center pressures
Try these pressure patterns in the segmented lines above and below.

Fig. 7 Movement pattern (left) and ink result (right).

Segmented long lines, continued

 Tool: 3mm Brause **Paper:** drawing/marker/JNB

1. Place a fully loaded nib at about 25°. (Fig. 8)
2. Make long lines composed of six or seven 1" segments.
3. After you are comfortable with the pattern, focus on en-acting the segmented line as a rhythmical gesture.
4. Repeat horizontally at about 65°.

Ink "flamingos"
"Flamingle" horizontal and vertical strokes in the play of ink.

1. Place a fully loaded nib between 45° and 90°.
2. Make a long narrow horizontal ink swatch in irregular strokes, without thinking too much. Just make some a little wider and some a little narrower. (Fig. 9, top)
3. Interrupt at some point and, in the wet ink, flatten nib angle. Pull a long stroke.
4. Anticipating the end of the stroke, apply a little additional pressure and, in its release, pull the nib off the paper.
5. Make another; they're sociable.

Continuous long lines

Straight
1. Place a fully-loaded nib at 25°. (Not shown.)
2. Press-release on an inhale; pause briefly and pull a long line. Sink the shoulder and let its weight pull you as though under the influence of gravity. Try pulsing to help you stay with the stroke.

Curved
1. Place a fully-loaded nib at 25°. (Fig. 10)
2. Pull alternating arcs: Press-release on a quick inhale; pause; exhale and pull an arc. Inhale and release pressure as you prepare to change direction. These changes can be subtle or dramatic, regular or irregular. Experiment with pressure patterns.

Fig. 8 **Fig. 9** **Fig. 10**

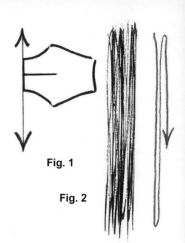

Fig. 1

Fig. 2

Moving and marking – "thins"

These freely moving lines and strokes result from the minimal resistance they meet using the thin edge of the nib.

Nib angle: The edge makes hairlines when nib angle is parallel to stroke direction. (Fig. 1)

Limbering up

Ink setup: ink and water wells, and pen wipe within easy reach
Body: shoulder pulling, fingers sensing **Paper:** drawing/marker paper/JNB

Releasing the ink. The thin edge, like the broad edge, releases ink through contact. You may need to coax the flow with a little more initial pressure or by moving the nib back and forth a bit. Remember to check the distance of the reservoir from the edge—moving the reservoir closer, without going beyond it, releases more ink.

1. Dip and flick. Place the nib at 90°. (Fig. 1)
2. For verticals: Move up and down at a deliberate pace above the paper before landing and continuing. (Fig. 2) Apply a little more pressure to the downstrokes.
3. Working more quickly, place the nib on an inhale; and, on the exhale, throw the edge up and down a few times.

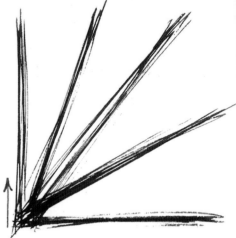

Nib angle shaft position

Make a quadrant of radiating thins. (Fig. 3) This exercise develops your ability to maneuver the pen.

1. Dip and flick. Place the nib at 90° and, radiating from this point, make thin strokes at different angles. Move from the vertical to the horizontal as you make multiline strokes at each angle setting. Keep your arm off the paper.
2. Begin with an upright shaft. As nib angle flattens, note changes in arm and shaft position. It's natural for the elbow and arm to move toward the body.

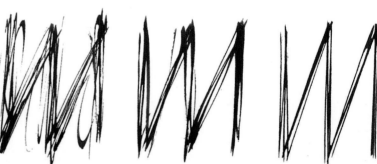

Fig. 3

Zigzag (Fig. 4)

The quality of any ink mark depends, in large part, on the interaction among paper, pen, and speed of stroke. The familiar zigzag pattern allows you to explore this interaction. Such exploration is an integral part of calligraphic development.

Note

Paper comes in a variety of finishes with different degrees of absorbency. These respond to pressure of contact and speed of delivery to produce a range of sharpness, from feathered to clean edged. Although the ink may not fully "stick" at high speeds, the gap between marks may itself be expressive.

Fig. 4 Fast, medium and slow speeds (bond paper)

1. Paper: Gather together three different sheets to test their absorbency. Suggestions: plain bond copy paper, drawing, JNB…what's on hand.
2. Ink: Keep the amount of ink constant for these tests. Try a fully-loaded and/or a dipped and flicked nib.
3. Speed: Move at three different speeds on each surface.
4. Pressure: Make contact using three different amounts of pressure.

Pressure and gliding (Fig. 5)

These single-line strokes further develop a oneness between the thin edge and the moving arm and shoulder. Think of riding or gliding with the stroke.

1. Inhale, place the nib at the top of the stroke; exhale and pull the stroke down, using a pressure pattern. Lift the nib and place it slightly to the right.
2. Inhale and immediately push the upstroke using even or start pressure.
3. Pattern: Alternate three verticals with three diagonals.

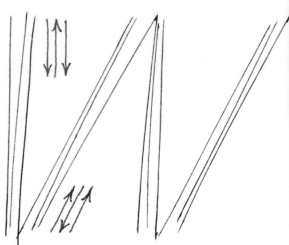

Fig. 5

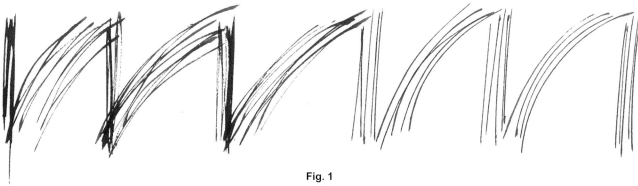

Fig. 1

Curved thins: wrist action

These thin-edged arcs change nib angle continuously as they move from relatively steep to relatively flat. The wrist acts like a fulcrum to pivot the nib. To prevent your elbow from pushing against your body for the flatter angles, try placing the paper a little to the right of its usual position.

Nib: 3mm Brause
Paper: marker/drawing/JNB
Ink: Compare fully loaded with dip and flick.

1. Alternate vertical throws with overhand convex arcs in multi- and single-line patterns. (Fig. 1) Keep your arm off the table as you move from the shoulder. Use the pinky to steady the action—brushing it lightly on the paper as you move. To help find the rhythm of the arcs, think of them in three phases: moving toward the bend/stretch point, negotiating the bend, and moving toward the end-point.
2. Make convex and concave single-line arcs. (Fig. 2) Lift the tool between each upward arc. Connect them with arced downstrokes. Note the wrist.
3. Glide the thin edge in shallow, long-line curves. (Fig. 3) Plan your ride—or let the pen, or your mood, take the lead.
4. Use the breath to stay with the stroke and keep it moving.
5. Try combining pressure patterns as you move down the stroke.

Fig. 2 Convex and concave single arcs.

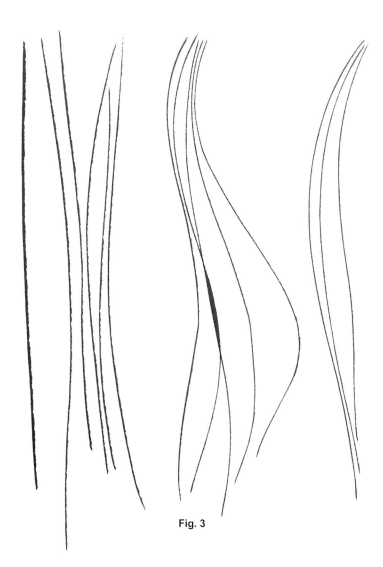

Fig. 3

Photo: A large cardboard nib with thumb and index finger rather than corners.

This bit of theater is intended to dramatize the connection between tool and body—between edged pen corners, thumb and index finger. Of course, partnering's connection is a mental one; calligraphically speaking, though, as powerful as a physical one. (See p. 88 and next page)

Stroke technique: edged pen partnering

The edged pen, like the two-point tool, employs partnering. (Fig. 1 and p. 88) Though the index finger and thumb now partner with nib corners rather than points, the benefits are the same: partnering enhances control of stroke direction and walls. Through partnering, you participate more fully in the tactile and dynamic feedback of stroke making.

Begin each of the following exercises with a dry, #4 Automatic Pen.

Zigzag corner walk

Tools: #4 Automatic Pen, 3mm Brause
Paper: drawing/JNB
Ink setup

Getting started - dry
1. Place the edge of the Automatic Pen at 45° on the paper.
2. Partner mentally—the right corner with the index finger (IF) and the left corner with the thumb (T). (Fig.1 and photo at left)
3. Rock from one corner to the other. (See "Rocking," p. 88)

Corners only - dry
1. Place the edge of a dry Automatic Pen at 45°.
2. Rock to the right corner, activating awareness of the index finger.
3. Pivot (off the paper) counter-clockwise, below the index finger, on this point.
4. Set the left corner down with thumb (T) awareness.
5. On this corner, pivot clockwise, above the thumb, and continue "walking" the corners across the paper. Watch the wrist, keeping it level as you move to the right. Pick up speed to make it a dance. (Fig. 2 shows this with ink)

Edge contact - wet
1. Fully load the Brause nib and place the edge at 45°.
2. Rock to the right corner (IF). Continue as above only with ink and a smaller nib.

Fans
1. Fully load the nib and place the edge at 45°. (Fig. 3)
2. Partner with the left corner (T) and, staying in edge contact, pivot counter-clockwise (wrist action).
3. Rock to the left corner (T) and move clockwise in the air to begin the next fan. Repeat a few times.
4. Reverse the process to make upward-opening fans.

"Combs" – cornered thins

In this exercise you drag a partnered corner from an ink pool to further sensitize your fingers to the nib's corners. Since the ink slit does not feed to the corners unless the full edge is in surface contact, corner-made thins must feed from an external source, as from wet strokes and ink pools. (Fig. 4)

Tool: 3mm Brause **Paper:** drawing/JNB
Ink set-up

1. Make an ink band: move a fully-loaded nib, held at a flat angle, up and down in short strokes as you move horizontally from left to right. (Fig. 4)
2. Single-tiered comb: Place the nib inside the left end of the band; rock to the left corner; pull a long thin stroke out of the ink. Replace in the wet ink; rock to the right corner and pull another long thin. Alternate corners to complete the comb.
3. Try a double-tiered comb.

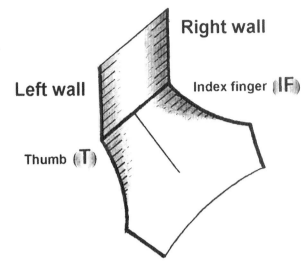
Fig. 1

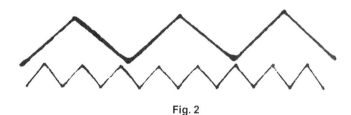
Fig. 2

Fig. 3 Fans

Fig. 4 Single- and double-tiered combs.

Partnering: broad strokes

This series develops the connection between partnered corners and stroke walls.

Tool: 3mm Brause **Ink setup** **Paper:** drawing/JNB, large-grid

Edge feeders – pressure applied to the thin edge feeds the corners
1. Fully load the nib and place it at a flat angle. (Fig. 5)
2. Press vigorously and rock to the right corner (IF).
3. On the corner, drag/stretch a thin downstroke. The ink released across the edge should feed the corner for this stroke; if not, press again or wiggle the thin edge.
4. Replace the edge at the same flat angle.
5. Press vigorously and rock to the left corner (T).
6. On the corner, drag/stretch another thin downstroke. Keep the right corner off the paper. This stroke is more challenging for the thumb than for the index finger. Try to position the thumb so it can press down on the shaft and get a better purchase.
7. Repeat these alternating, partnered, cornered thins and edge imprints to get the feel and develop a rhythm. Play with it.

Partnered pressure
1. Repeat 1-4 above.
5. Press-release and turn your attention to the right corner (IF). Pull a full edge downstroke applying slightly more pressure to the right corner (IF). (Fig. 6, partnered pressure shaded in red) Most of the pressure of contact continues to come from the shoulder, the rest, from the partnered finger.
6. At the end of the stroke, press on the thin edge and repeat the pattern of alternate cornered and edged strokes.
7. Do the same thing on the left corner. (Fig. 7, partnered pressure shaded in green)
8. Alternate the strokes. (Fig. 8)

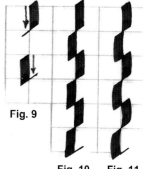

Fig. 5 **Fig. 6 Fig. 7** **Fig. 8**

"Zippers" – This exercise features the shift from broad to thin edge and from thin to full edge. It continues to develop partnering between a stroke wall, corner and partnered finger.
1. On large-grid paper, at a flat angle, place the nib's left corner (T) atop a horizontal grid line and against a vertical grid line. (Fig. 9)
2. Press-release and pull a one-square-long full edge stroke.
3. Press-release and pull the thin edge down one nib width to the left.
4. Focus on the right point (IF) and pull a one-square-long full-edge stroke.
5. Press-release and push the thin edge up one nib width to the right. Repeat to form a zipper pattern. (Fig. 10) Remember to partner with the full edge strokes.
6. Repeat this alternating pattern with very shallow arcs (hugging). (Fig. 11)

Fig. 9

Fig. 10 Fig. 11

Partnering: corners

Corners provide another way to shape the stroke and influence its visual character. Calligraphers use the corner to take ink from a wet stroke to alter its contour. This process, like that of sculpting, is one of discovery and exploration. Partnered corners, connecting the tool with the fingers, cultivate the edged pen's potential for refinement and expression.

All the shapes of Figs. 12 and 13 begin with a fully loaded nib.

Tool: 3mm Brause **Ink setup** **Paper:** JNB/drawing

Shaping: square to circle (Not shown.)
1. Make an ink pool: Place the nib at about 0° and make a rough, solid square as the base for a sphere.
2. Place the nib in the wet ink and rock to the left nib corner (T). Draw the corner in shallow arcs along the left and bottom sides of the square.
3. Return to the wet ink and rock to the right nib corner. Draw the arcs on the top and right sides of the square. If needed, place the edge back in the wet ink to recharge its supply. In general, depending on the size of the nib and the amount of ink in the reservoir, the ink will either flood the gap or it will need to be filled in.
4. Add ink from the pool, with a corner, until you are satisfied with the shape.

Fig. 12

Fig. 13

Experimenting
1. Make an ink pool, here, a rough, blobby shape. Try other geometric shapes and also non-geometric ones. (Fig. 12)
2. From these shapes, or new ones, draw corners into the surrounding space. (Fig. 13) Continue on the next page.

3. Use ink pools and nib corners to create imaginary life forms. (Fig. 14)

Fig. 14

Ink "toccatas"
The following exercises are inform-
ed by the term "toccata," a musical
keyboard piece showing touch
technique. (For more examples,
see Ink meditation, p. 244.)

> **Tool:** 3mm Brause
> **Paper:** drawing/marker/JNB
> **Ink set-up**
> **Body:** finger focus (some aware-
> ness of shoulder pressure)

Long lines
Compose these arcs in 1) regular,
measured segments and 2) irreg-
ular, unpatterned lines. (Fig. 15)
Breathe and relax as you ride these
long-line channels.

Use partnered pressure: experi-
ment with the amount of pressure
on the partnered corner—how much
before the other corner lifts off the
paper? Try changing partners as
you reorient the arcs from facing
right to facing left. Conclude with a
long-line vertical.

Partial edge
In this more advanced stroke tech-
nique, more weight/force is applied
to a partnered corner while the other
corner leaves the paper. This is pur-
posely done to create a ragged
edge. (Fig. 16) To get the feel, make
different-length lines and alternate
nib corners. Make couplets with
clean edges facing each other and
then ragged ones also facing each
other.

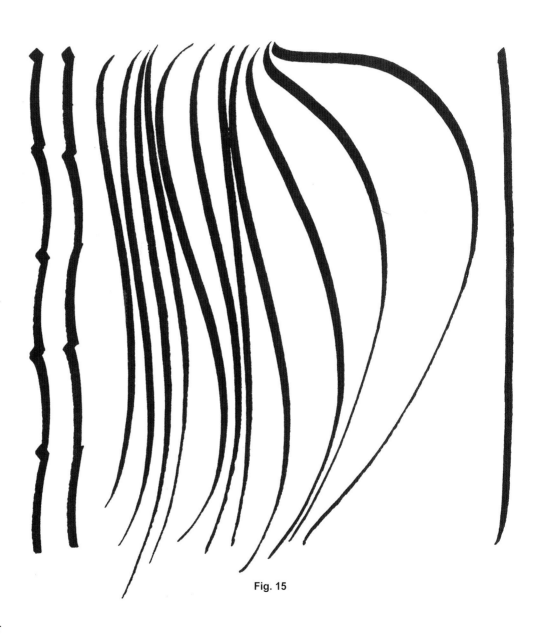

Fig. 15

Fig. 16

Modern Times

In his 1936 comedy film, Charlie Chaplin satirizes the machine age with its assembly line production.

In addition to the conformity and rebellion depicted in this film, the related "moods" of anxiety and anomie clearly persist in today's information age.

Training Alphabet 6: Moto

"Moto," short for movement and touch, is the first edged pen training alphabet. Its clean edged downstroke and rough cornered up-stroke help you explore the dual nature of ink—a medium equally capable of refined as well as casual strokes. Moto also exhibits the emphatic repetition of a heavy downstroke, minimal difference in letterform, and equal spacing within and between letters. For training purposes, these features give you the chance to get thoroughly comfortable using ink to make and space letters.

In addition, Moto's features display a distinctive graphic appearance. Although there are noticeable similarities between Moto and medieval Gothic script, today's zeitgeist is quite unlike the spiritual context of the historical script. My contemporary version is more likely to suggest conformity, anxiety, and relentless movement—as well as energy, strength, and mystery. In the last exercise of this alphabet, writing a multiline text, you learn to use the graphically expressive traits of Moto to embody a text.

Fig. 1 Moto

Design

Fig. 2

Characteristic angle

- Downstrokes: 35°. (Fig. 2, solid red line) This angle creates a slightly but signify-cantly bolder downstroke than one at 45°. Using this small variation in nib angle trains the eye to see and feel subtle differences in stroke/letterform weight. Note: Although the aim is 35°, actual hand movement produces slight variations. These don't read significantly if they are only a little steeper/flatter.

- Upstrokes: These thin strokes are made with the corner of the nib, independent of angle.

- Angle "icon": A square or rectangle that is a reference for nib angle. (Fig. 4) To keep to an intended angle, you'll learn to make this helpful diagram. (See p.152 for instructions.)

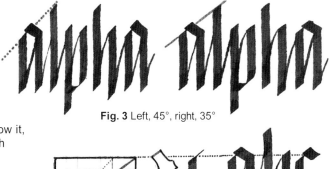

Fig. 3 Left, 45°, right, 35°

Guidelines

In Moto, both the waistline and ascender line are references for nib angle; the actual body height stands a little above the waist-line. (All Figs.) Placing the nib edge atop a guideline, rather than below it, helps you "find" nib angle more easily; expressively, breaking through guidelines creates a lively, staccato line of writing.

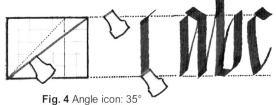

Fig. 4 Angle icon: 35°

Visual themes

- Stroke: Straight thicks and thins. Overall, Moto's strokes look straight as they combine into letters, words and texts. Not infrequently, how-ever, a hint of curvature enters the stroke. This does not undermine the collective appearance of straightness, but imbues it further with energy and liveliness.

Fig. 5

- Weight: The wide, heavy downstrokes (thicks) and narrow, light upstrokes create a highly contrasting text pattern. Cumulatively, the closely spaced downstrokes suggest repetitive, mechanical drive.

- Counters and Joins: Down- and upstrokes combine into an angular, zigzag pattern to cre-ate triangular counter shapes. (Fig. 6) The diagonal joins are a facet of Moto's ac-tive character.

- Serif: Moto uses only an exit serif, which either finishes a letter or, extended, joins it to the next (Fig. 3, see the first and last "a"). Though not necessary for legibility, these small strokes are an integral part of Moto's character.

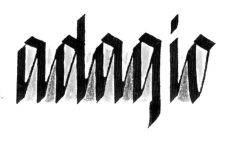

Fig. 6 Triangular internal and external counters.

Ductus and Dynamics

The "dry" pen: At first, use a pen without ink so you can focus, without distraction, on the letter itself—on its visual details, such as nib angle and stroke direction, as well as on tool hold and movement. The method of "dry tracing"—tracing directly over a figure with the same size tool—is recommended for all tools. The dry trace also helps you focus on bringing the pressure of contact from the shoulder and awakening touch in the fingers.

Using ink: The aim here is to develop fluency in dipping the nib and adjusting the release of ink. Cultivating this interplay of nib, ink and paper takes time and attention. Both the warm ups and the practice with letterforms, words and texts are designed with this in mind. (More detailed methods for ink use are presented in "Stroke Technique: controlling ink flow," p. 168)

Note about tools

1. **The #4 Automatic:** Dry tracing the large, Automatic Pen-made letters at the beginning of each letter family makes their details easier to see. Larger forms require larger movements; these prepare you for the more subtle ones of smaller letters. However, since it's not easy to use this pen with ink, I don't recommend it for the beginner. But if you are familiar with it, feel free to use it after the dry trace.

2. **The 3mm Brause:** This smaller tool provides a strong foundation for creating ink-made strokes with confidence. It encourages free movement, responds to the force of dynamics, and makes clean, sharp strokes.

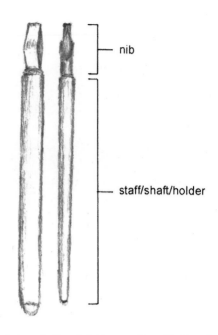

Automatic Pen, left; Brause nib and holder, right

Making an angle icon

For 35°, as for 45°, grid paper is an easy way to both measure and show nib angle. Here, small-grid paper also helps measure the 5/8" x-height of Moto. This makes it useful for ruling guidelines for a 3mm Brause nib. In addition, the verticals of small-grid paper offer a reference for Moto's upright downstrokes.

> **Tools:** 01 Pigma Micron for the icon,
> #2 pencil for guidelines
> **Paper:** small-grid, marker/JNB
> **Additional:** ruler (cork-backed), scissors,
> removable tape

Angle icon (Pigma Micron)
1. On small-grid, rule two vertical lines seven squares apart to form a column. (Fig. 1)
2. Rule horizontal lines 5/8" apart, stopping at the right vertical.
3. Rule diagonals from the lower-left corner to the upper-right, as in Fig. 1.

Making guidelines
Put aside the two sets of guidelines below for the exercises on p. 154.

1. On grid. On the same small-grid, continue from the horizontals of the icon. With pencil and ruler, draw over grid lines to make guidelines. (Fig. 1, dotted, arrow-tipped line)
2. On marker paper, rule guidelines. (Fig. 2)
 a. Cut out the column of angle icons and affix it to the left edge of a sheet of marker paper.
 b. Use a ruler and pencil to draw guidelines from the horizontals of the icons. To insure straightness, you may also need to set marks 5/8" apart on the right side of the paper.

Icon (drawn on grid paper) **Icon** (affixed to plain paper)

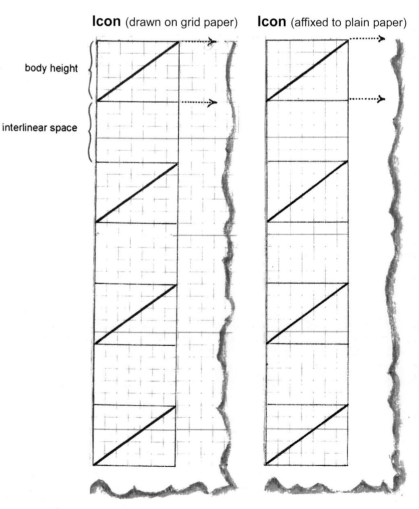

body height

interlinear space

Fig. 1 **Fig. 2**

Letter Family 1: the "l-n" (liunhm)

Moto combines the usually distinct "l" and "n" letter families because they both feature its bold, characteristic downstroke. (Fig. 1) Bringing these families together also underscores Moto's homogeneity: while its forms are legible, their similarity tends to make reading an effort. This is intentional—an invitation to explore another facet of calligraphy: the intrinsic tension between reading and viewing.

Visual themes

- Branching: The pointed arches of "n," "h" and "m" branch from their first down-stroke about midway between waist- and baseline. (Fig. 1, red dotted line between base- and waistline)
- Joins: Thin exit serifs and joins push out of down-strokes a short way above the baseline. (Fig. 1, red dotted line one square above the baseline)
- Triangular counters. (Fig.1, red and green) Note the difference between "u" and "n."

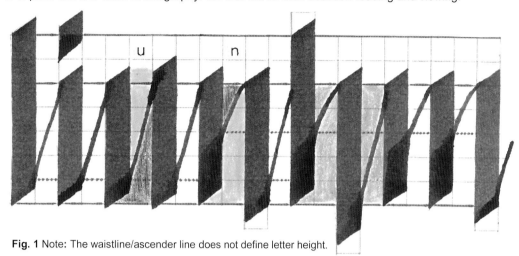

Fig. 1 Note: The waistline/ascender line does not define letter height.

Spacing: The space within letters is the same as the space between them. (Fig. 1, blue)

Warming up

Tool: 3mm Brause **Paper:** drawing/JNB **Ink setup, padded work surface**

Down-upstroke (Fig. 2)
1. Place a fully-loaded nib at a flat angle and limber up with an ink swatch. (See p. 146)
2. Make single down-upstrokes: place the nib on a quick inhale; exhale and pull a stroke; pause; inhale and push directly up in the wet ink. Lift and move to the next stroke. Repeat a few times.
3. Review the segmented long-line exercises on page 143.

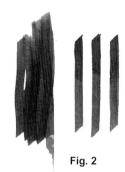

Fig. 2

Stroke technique: the cornered-thin exit serif & letter join

The edged pen makes its second type of thin stroke on the nib's corner rather than on the thin edge (the hairline stroke). A cornered thin upstroke emerges from a downstroke when a nib corner takes ink from the wet downstroke and draws it up. These exercises use ink and focus on rocking from the nib's full edge to its corner and back to full edge.

Tools: #4 Automatic Pen, 3mm Brause **Paper:** tracing vellum, marker **Ink setup Body:** shoulder and finger coordination

First, to get the idea and the feel, dry trace the sequence of movements in Steps one and two. Add ink in Step three, next page. Although the breath is included, you may wish to wait and add it after you're comfortable with ductus and dynamics.

Step one: Ductus and dynamics
1. Place the dry Automatic Pen above the waistline at 35°. (Fig. 3) To get your bearings: begin by placing the nib at 45°, then flatten it slightly, turning clockwise.
2. Downstroke: Inhale, press-release; exhale and pull down.
3. At the end of the downstroke, inhale, press-release and rock to the right corner (IF). Exhale, press softly on the corner.
4. Inhale and push the corner up the right wall of the stroke a short way.
5. Exhale, softly press again on the right corner; inhale and push the cornered thin up and out diagonally. A large blue dot shows the branch point. (Fig. 4)

Step two: Repeat the above and add partnering.
1. Downstroke: Place the nib. Inhale, press-release and partner with the thumb; exhale and pull the downstroke with thumb awareness. (Fig. 5. The partnered wall and exit stroke are shown in red.)
2. Exit stroke (or join): Inhale, press and rock to the right corner (IF); use thumb pressure to activate the wrist and assist it in rocking from edge to corner. Exhale; press softly on the right corner (IF); inhale and push the stroke up. Use the *thumb* to stabilize the push.
3. For support and balance: the fourth and fifth fingers can brush the paper as the hand moves.

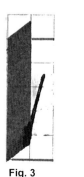

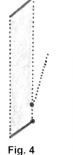

Fig. 3 Fig. 4 Fig. 5

Step three: "Thumb pushups". This exercise prepares you for Moto's characteristic stroke exit and join.
Using ink and a 3mm Brause, rock from broad edge to corner, pushing the corner up and out of the ink with the thumb.
1. Warm up: Make a short ink swatch. (Fig. 5)
2. Fully load/dip and flick and pull a short downstroke. (Fig. 6)
3. Follow Step one, 3-5, above.
4. Try different stroke lengths: Set target points and do thumb pushups aiming at these.
 (Fig. 7) *Remember to partner the right corner with the thumb for the upstroke.*

Note: Thumb pushups develop tactile awareness and sensitivity; work slowly to receive
sensory feedback and develop a fluid gesture.

Fig. 5 **Fig. 6** **Fig. 7"**

A word about straight strokes

You are now ready to make letters that use this sometimes intimidating stroke. The exercises below focus on building skill and
confidence; they are designed to reduce, if not eliminate, any trepidation. The subtle hint of curvature will be discussed at a later time.

Ductus and Dynamics

Tool: 3mm Brause **Paper:** tracing vellum, marker/JNB **Speed:** deliberate **Ink setup; a padded work surface**
Tool hold: Remember to support the shaft near the big knuckle (IF). Don't let your fingers creep down the nib.
Guidelines with angle icon (Fig. 1)
 Use the guidelines previously made on grid and marker paper
 (p. 152). Add an ascender line ¼" above the waistline.
Ink release: dip and flick

"I, i, and u" (Make three of each of the letters below.)

(I) Entry stroke
1. Place the left corner of the nib on the ascender line at 35°. (Fig. 2)
2. Inhale, press-release and/or use wrist vibrato to start the stroke.

Fig. 1 **Fig. 2** **Fig. 3** **Fig. 4**

Downstroke: Exhale and pull to the baseline, partnering with the left nib corner (T). Finish the exhale
by pressing a little on the full edge and rocking to the right corner.

Exit stroke: Inhale, press-release and push a short way up the vertical (thumb backed); then branch
into a diagonal exit less than half a body height. Exhale: in the air or atop the next stroke.

(i) Entry, downstroke, and exit
Place the left corner of the nib on the waistline at 35°. (Fig. 3) Repeat the downstroke and exit for "I."

Dot: Place the nib either above or below the ascender line and pull down a short stroke. (Fig. 4) Dot
the "i" after making the three downstrokes in Fig. 3.

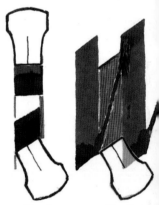

Fig. 1 **Fig. 2**

Spacing: Nib as measure

In previous alphabets, the distance between downstrokes was visualized with target points placed on
grid paper. In Moto, the nib itself serves as a readily available unit of measure, setting target points
within the flow of letter making. To begin, think of the distance between the two downstrokes of "u" as
the width of another 35° downstroke. (Figs. 1 and 2) Then, use a 3mm Brause on grid or marker paper:
First trace, dry and with ink; then work with ink independently.
1. Make an "i" downstroke. Inhale, lift the nib; exhale and place the left corner of the edge next to the down-
 stroke. The right corner is just below the waistline; the nib retains a 35° angle. (Fig. 3)
2. Inhale, press-release and push a hairline (thin stroke made with the thin edge rather than with a corner)
 one nib width above the waistline; exhale and pull a downstroke. Repeat a few times.

Fig. 3

Joined strokes: Setting a target point (Trace first to get the knack of this action.)
1. Inhale, press-release; exhale and pull a downstroke. (Fig. 4)
2. Inhale, lift the nib and, in the air, positon the left corner next to the downstroke and right corner
 at the waistline.
3. Still in the air, exhale as you rock the nib to the right corner and press it into the paper, leaving
 a bit of ink or a slight indentation (target point). Inhale and return to the bottom of the initial
 downstroke.
4. Exhale, press to release ink and rock to the right corner; inhale and push a thin cornered up-
 stroke to the target point. Exhale and place the left corner of the edge over the upstroke atop
 the waistline. Inhale, press-release; exhale and pull the next downstroke. Repeat a few times.

Fig. 4

(u)
1. **First downstroke:** As in "i."
2. **Upstroke:** As in the exit/join stroke of "i." Exhale and reposition the nib at 35° on the waistline; inhale, push up a short way; exhale and retrace to the waistline. (Fig. 7a)
3. **Second downstroke:** Inhale, press-release; exhale and pull to the baseline. (Fig. 7b)
4. **Exit:** As in "i.

Fig. 7a Fig. 7b

Joined letters: Ascenders
1. Make an "l." Use the nib as measure and place a target point at the waistline as in Fig. 4, p. 154.
2. Replace the nib at the base of the downstroke. Inhale, press-release and rock to the right corner (IF). Exhale and press softly.
3. Inhale and push a cornered upstroke to the target at the waistline. (Fig. 8)
4. Exhale, lift the edge and position it at 35° at the waistline, as if to begin a downstroke, keeping it off the paper.
5. Inhale and air stroke up to the ascender line; exhale and replace the nib. Inhale, press-release; exhale and pull down. Repeat.

Joining "l, i, and u": Use the width of a stroke made at a 35° angle to measure the distance between letters. Try to make all the movements smoothly—placing targets, shifting from edge to corner, and corner to edge—to develop a rhythmical, dance-like motion. (Fig. 9).

(in the air)

Fig. 8 Fig. 9

"n, h, and m"
Branch strokes of "n, h, and m" begin slightly higher than the exit joins of "l, i, and u." (Figs. 10-12) They also form the left side of an imaginary, symmetrical, pointed arch. (Fig. 11) You may prefer a higher or lower branch height, but try to be consistent after you make the choice. (Figs. 11, higher; 12, lower)

"n" arcade preliminary: Dry trace Fig. 10 with the Automatic Pen for reference.
1. Dry trace Figs. 11 and 12: inhale, press-release; exhale and pull a downstroke; inhale and push the full edge up, into the stroke's mid-section. (Fig. 11)
 a. The stroke continues: press (inhale) and rock (exhale) to the right corner (T).
 b. Inhale and push the corner along the stroke wall, up and over (one square) in a shallow arc to the waistline.
 c. Exhale and reposition the nib at 35° by lifting the edge or dragging the corner. (Fig. 13) Repeat a few times.
2. Rhythm: If you have a metronome, try making each change of hand position on a slow setting.

midsection

Fig. 10 Fig. 11 Fig. 12

Tip: To develop accuracy and consistency in branching, rule a branch guideline. Note: the branch begins before it comes out of the stroke. (Figs. 11 and 12)

(n) Dry trace "n, h, and m" with a 3mm Brause; then use ink.
1. **First downstroke** (as in "i") **and branch** (Fig. 13).
2. **Second downstroke:** Inhale, press-release; exhale and pull the right corner to the baseline. (The left dips below.)
3. **Exit:** As in "i."

Fig. 13 Fig. 14 Fig. 15

(h)
1. **Downstroke:** As in "l."
2. **Branch, second downstroke and exit**: As in "n." (Fig. 14) For legibility, make the second downstroke slightly longer than those of "n and m."

(m) Make the "n" with the second downstroke sitting on the baseline. Add a second arch. (Fig. 15)

Spacing
Moto expresses its machine-like personality, in part, through even spacing. The space between two verticals serves as the reference space for all letter combinations. (Fig. 1)

Fig. 1

Exploring space
It is as challenging to know where to aim a stroke as it is to get there. To develop your eye, make downstrokes in incremental steps, each a little farther from the last until the space is about the width of a stroke. Repeat a few times. Moto helps you develop reciprocity between hand and eye: the ability to see and gauge distance between letters while developing your hand.

Fig. 2

Fig. 1a Fig. 1b

Spacing: joining downstrokes

The thin upstrokes of Moto create similar spaces both within and between letters, but not without lots of target practice. Experiment with increasing and decreasing the distances between the stroke to vary the weight of their patterns. (Figs. 1a and 1b) Remember to use the nib as measure. (p. 154)

Use the letters "i, l, and u" to make two letter strings:
1. With a little less space than the width of a downstroke. (Fig. 1a)
2. With a little more space than the width of a downstroke. (Fig. 1b)

Bowing: spacing

The gestural movement of bowing enhances both straight and subtly curved strokes. (Review "Bowing," Jumprope, p. 62) Although variation in pressure is no longer directly visible, as it is with a pencil, bowing imbues strokes with an elastic flow.

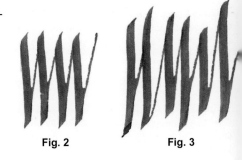

Fig. 2 Fig. 3

Tool: 3mm Brause **Paper:** marker/JNB **Ink setup**

Warm up
1. Make an ink swatch.
2. Make three long lines in one-inch segments. Use a different pressure pattern for each segment—e.g., end, start, center pressure.

Zigzag sequences
1. High-starting joins: make a downstroke and push part way back up before rocking to the right corner and pushing the join. Repeat. (Fig. 2)
2. Alternate high- and low-starting joins, first as a regular pattern and then, as in Fig. 3, a free one. Remember to cock your wrist for the upward diagonal thin and return to the original position for downstrokes.
3. Make zigzags experimenting with pressure patterns for the downstrokes.
4. Bow the entire "l-n" family in triplets. (Fig. 4, "n, h, and m" not shown)

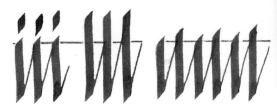

Fig. 4

More spacing

These bowed scats explore variations in horizontal and vertical space and in letter slope.

Fig. 5, top and Fig. 6, bottom

Tool: 3mm Brause
Guidelines: x-height: 5/8"
 ascender: ¼ "above the waistline
 descender: ¼" below the baseline

1. Bow a narrow "ninuhihumimu" scat, keeping the same space within and between the letters. (Fig. 5)
2. Repeat with wider spacing. (Fig. 6)

Tool: 2mm Brause **Guidelines:** 3/8"

1. Variation one: Rule lines above the waistline and the baseline the width of the nib. (Fig. 7a) Bow the "ninu…" scat with "i" and "u" coming between the added guidelines.
2. Variation two: Rule lines below the waistline and the baseline the width of the nib. (Fig. 7b) Bow the above scat with "i" reaching above the waistline (as above) and "u" now dipping below the baseline (both maintaining body height).
3. Variation three: Changing letter slope. (Fig. 7c) Focus on changing the position of the hand to make changes in letter slope—to alternate right with left leaning letters.

body heights —

Figs. 7a, top; **7b,** middle; **7c,** bottom

Letter Family 2:
the "a" (adgq)

Fig. 1

Visual themes

This family repeats the themes and dynamics of the "l-n" family. It adds:

- Bowls: Triangular (Fig. 1)
- "Roofs": Short, shallow diagonal top strokes that overhang initial downstrokes. (Figs. 1, 2, 3, and 7)

Guidelines and proportion: In conventional alphabets, guidelines contain the letterforms and impose a sense of constraint. In Moto, guidelines allow letters to breathe by helping the calligrapher create subtle differences in body height and proportion. Such "built-in" variations contribute to the vitality of words, lines and text.

The "a" family clearly shows the waistline's dual role in this alphabet. As in the previous letter family, it provides a reference for nib angle. In addition, it supports letter roofs which add to body height and gives "a" family letters a slightly narrower proportion. (Fig. 2)

Fig. 2

Warming up

The focus is on engaging the fingers and nib via arm and shoulder pressure while learning to make the "a" family roof.

Tools: #4 Automatic Pen, 3mm Brause **Paper:** tracing vellum, marker

1. With a dry Automatic Pen, trace Figs. 3a, b, and c.
 a. Place the left corner of the nib in a square above the waistline at 35°. Inhale, press-release; exhale and pull a hairline one square below the waistline. (Fig. 3a)
 b. Inhale, press-release and push the nib back to the start position. Exhale.
 c. Inhale, press-release and gently push the edge diagonally up a short distance. (Fig. 3b)
 d. Exhale, drop the shoulder and bow a short, shallow diagonal. (Fig. 3c)
2. With a fully-loaded 3mm Brause nib held at a 35° angle:
 a. Run hairline back and forth. (Fig. 4)
 b. Next, pull a hairline from upper right to lower left about an inch in length. Below it, bow a warm-up swatch at a right angle to the line. (Fig. 5)
 c. Pull another 35° hairline, about an inch in length.
 d. Place the nib on top of the hairline and make the "a" family roof: inhale, press-release and push up a short way; exhale and pull down bowing a short, shallow diagonal.
 e. Repeat moving down the line, finding the rhythm of this action. Try to engage the bicep in this full-edge action.

Fig. 3a **Fig. 3b** **Fig. 3c**

Ductus and Dynamics

Rule guidelines including a descender line ¼ inch below the baseline.

Tool: 3mm Brause **Paper:** marker/JNB **Breath:** as in the "l-n" family

Fig. 4 **Fig. 5** **Fig. 6**

(a)

1. **Entry:** Place the left corner of the nib at 35°, on the waistline. Press-release and pull a hairline one nib width below the waistline. (Fig. 7)
2. **First downstroke:** Press-release and pull a downstroke to the baseline (left corner touching).
3. **Upstroke:** Press-release, rock to the right corner (IF). Use the nib as a measure and place a target at the waistline. Push a cornered thin to the target.
4. **Roof:** Lift the nib and place it over the hairline entry. Push up and pull back to the hairline; press-release and finish the roof—pulling the left nib corner to meet the upstroke. This forms a triangular bowl (counter). Making the roof in two parts helps you pass over the hairline, here, a calligraphic speed bump. Try to incorporate this mid-stroke adjustment into your rhythm.
5. **Second downstroke:** Press-release and pull to the baseline.
6. **Exit:** As in "i."
7. Repeat a few times to find a rhythm for the pattern. Try to engage the bicep.

Fig. 7 The stroke sequence of "a."

158

(d) 1. **Entry, first downstroke and upstroke:** As in "a." (Fig. 8)
2. **Ascender:** At the waistline, lift the nib and air stroke to the ascender line. Place the left corner of the nib on the line at 35°. Air stroke from here to the thin upstroke at the waistline (target point) and back a couple of times. Return to the ascender line and land. Press-release and pull to the target. Press-release softly and pull to the baseline. Experiment with pauses and pressure.
3. **Exit:** As in "i."
4. **Roof:** As in "a." The roof closes the counter—be sure to fully imbed it in the ascender stroke.
5. Repeat the sequence to get the pattern and find a flow.

Fig. 8

(g) 1. **Entry, first downstroke, upstroke and roof:** As in "a."
2. **Second downstroke:** Press-release and pull the left corner of the nib to the descender line. (Fig. 9a)
3. **Exit stroke:** Press-release and pull a hairline, about half a nib width in length, below the descender line. Press-release and push the nib up to a little below the baseline. (Fig. 9b) The stroke overlaps the downstroke to a greater or lesser degree. The amount depends on how much weight/heaviness you want to give it. (9c)
4. Repeat the sequence to get the pattern and find a flow.

Fig. 9a Fig. 9b Fig. 9c

(q) 1. **Entry, first downstroke, upstroke and roof:** As in "a."
2. **Descender:** Press-release and pull the downstrokes a little below the descender line. (Fig. 10a)
3. **Exit:** Press-release, rock to the right corner and push the cornered thin to the baseline. (Fig. 10b)
4. Repeat the sequence to get the pattern and find a flow.

Letter string with scats

Tool: 3mm Brause
Paper: marker/JNB

Fig. 10a Fig. 10b

1. Work both with guidelines and freehand. (Fig. 11)
2. First focus on letter structure (the sequence and position of strokes) and second on gestural movement. Experiment with various pressure patterns and bowing. The ascenders/descenders can combine start and end pressures.

Fig. 11

Word as image: spacing

The first goal of spacing in Moto, as in Playball, is to create similar spaces both within and between letters. In this exercise, the space within letters, the distance between two vertical downstrokes, is also the reference space for the space between letters.

Tool: 3mm Brause **Paper:** marker/JNB

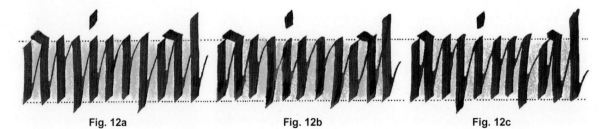

Fig. 12a Fig. 12b Fig. 12c

1. Rule 5/8" guidelines.
2. Make the following three spatial patterns (Fig. 12a, b, and c):
 a. Spaces similar within and between letters. (12a)
 b. Slightly less space between letters than within them. (12b)
 c. Slightly more space between letters than within them. (12c)
3. After writing a word, color the counters and interletter spaces; consider adjustments.
4. Rewrite with any adjustments just below the original word.
5. Experiment with ruling only a waistline, only a baseline or no lines at all. (Fig. 13)

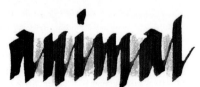

Fig. 13

Letter Family 3: the "o" (oce)

Although the diagonals that form this family's bowls are intended to be straight, they may show a hint of curvature (See figures). This subtle deviation occurs for a variety of reasons: you prefer it; previous experience with these letters encourages a certain roundness; or, the skilled and/or relaxed hand finds pleasure in this subtle gesture. For now, aim for a straight stroke.

Visual themes
- Strokes: Straight diagonals.
- Bowls: Triangular (Fig. 2).
- "Roofs": "o" and "c" (diagonal); "e" (elbow bend).

Proportion: "o" depends on where you measure letter width: from the closed bowl or from the roof (Fig. 2); "c" and "e": approximately 1:2

Warming up

Tool: 3mm Brause **Paper:** marker/JNB **Ink:** fully loaded
Stroke length: (ruled or unruled) about an inch

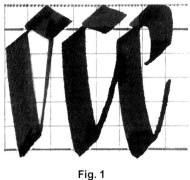

Fig. 1 Fig. 2

Free diagonals
1. At 35° make an ink swatch of verticals, slow to moderate in speed. (Fig. 3)
2. At 35°, make an ink swatch of diagonals, counting "one, and, two, and, three." On the next "and," push up vertically. (Fig. 4) Repeat the pattern a few times at slow to moderate speed.
3. Single retraced strokes (Fig. 5)
 a. First, make a steep diagonal: down, up, down. Pause.
 b. Second, push a vertical: up, down. Repeat a few times.
4. Variation: Merge the vertical with the diagonal. (Fig. 6)

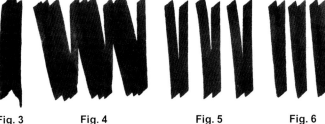

Fig. 3 Fig. 4 Fig. 5 Fig. 6

Ductus and Dynamics

To avoid making these letters lopsided, make the diagonal downstrokes particularly steep. "Straddling" is a technique I've devised for developing this skill.

Tool: 3mm Brause **Paper:** small-grid, marker/JNB **Guidelines:** 5/8" apart

Straddling technique (Fig. 7)
1. On small-grid paper, rule verticals two squares apart.
2. Place the nib at 35° with the left corner touching a vertical at the waistline.
3. Press-release and pull a hairline one nib width below the waistline.
4. Press-release; lift the nib off the paper and, in the air, move it to the baseline. Land the nib's left corner against the right side of the vertical. Press-release to make an ink imprint; use the energy of release to return the right corner of the nib to the left side of the vertical.
5. On the paper, press-release and pull the stroke. Repeat a few times.

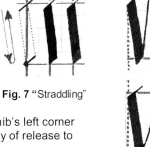

Fig. 7 "Straddling"

(o) 1. **Entry:** As in "a." (Fig. 8, top)
2. **Downstroke:** Pull a steep diagonal a little through the baseline.
3. **Upstroke and roof:** As in "a."

(c) 1. **Entry and downstroke:** As in "o." (Fig. 8, center)
2. **Upstroke-exit:** As in "a" only a little more open. Push diagonally up about one half an x-height. Lift and replace on the hairline entry.
3. **Roof:** Pull a roof a little shorter than that of "o."

(e) 1. **Entry, downstroke and upstroke:** As in "c." (Fig. 8, bottom)
2. **The eye:** Place the nib edge over the hairline entry and push left *horizontally*. Press-release; retrace the stroke, continuing to pull horizontally into an elbow bend. Travel down about one-third the letter's x-height. Pull slightly down and left to end the stroke.
3. On marker paper, make letter strings. (Fig. 9) First dry trace and then use ink. Letters that follow "o" tuck just beneath the roof overhang. Letters that follow "c and e," open bowls, allow slightly more space.

Fig. 8 Ductus: "o, c, e"

Fig. 9

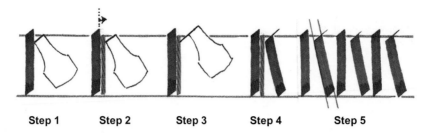

Step 1 Step 2 Step 3 Step 4 Step 5

Spacing: nib as measure

The nib, as a unit of measure, helps you space diagonals as well as verticals. First, dry trace Steps 1-5 above; second, rule guidelines and use ink.

Tool: 3mm Brause
Paper: tracing vellum, marker/JNB
Guidelines: 5/8" apart

Fig. 1 Fig. 2

Step 1: Make an "i" downstroke. Lift the nib and, in the air, place the left corner of the nib in line with the right wall of the downstroke and the right corner at the waistline. Keep the nib at a 35° angle.
Step 2: Still in the air, move the nib to the right about half the width of the stroke. Land.
Step 3: Press-release and push a hairline one nib width above the waistline.
Step 4: Press-release and retrace the hairline; lift the nib and air stroke the diagonal downstroke to the baseline and back. Pull the stroke.
Step 5: From the finished diagonal, lift the nib and move it to the right and up Repeat the pattern of alternating verticals and diagonals until you're fluent.

Spacing: scats and words

Here, letter parts—roofs and cornered thins—are used as aids in spacing.

Fig. 3 Fig. 4

Tools: 3mm and 2mm Brause nibs
Guidelines: Rule a baseline and a waistline: 5/8 inches (3mm), 3/8 inches (2mm)

Dry and wet trace, and then freehand.

1. **The roof: "o-i."** (Fig. 1) and all other roof-to-body height downstrokes. After pulling a roof, push up along the thin edge about a nib width above the waistline; pause and pull the downstroke. (Fig. 1, hatched lines, and 2)

Fig. 5

2. **The cornered-thin: "m-o,"** and all other straight-diagonal combinations.(Fig. 3 and 4)
 At the end of the downstroke, rock to the right corner and, inhaling, push a cornered thin, continuing to the waistline. From this position, use the nib as a measure as above. (Note the change in hand position as you change from pushing up the connecting thin to pulling down the diagonal downstroke.)
3. **Make scats.** Use the smaller nib and alternate an "o" with consonants and other vowels. (Fig. 5) Focus on making the distance between a roof and a downstroke as small as possible.
4. **Write words.** Give the open bowls of "c" and "e" a little more space than that between downstrokes. (Fig. 6) This helps keep them quite distinct.
5. **Bow words.** Work freely; begin with guidelines if you like. (Fig. 7)

Suggestion: When you're comfortable spacing letters using the nib as a guide, shift your attention to sculpting the space between letters into shapes with similar volumes. (See p. 24) This more intuitive method of spacing develops with experience; it complements the more mechanical method of adjusting distance.

Fig. 6

Fig. 7

Letter Family 4:
the "b" (bp)

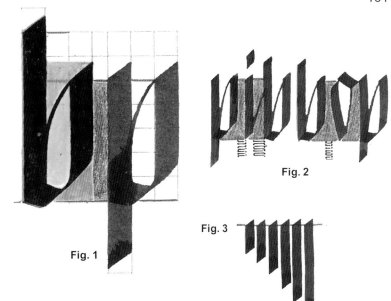

Fig. 1

Fig. 2

Fig. 3

Visual themes
- Bowls: triangular. (Fig. 1, green)
- External counters: triangular. (Fig. 1, blue)
- Spacing: Due to the external counter in the bowls of "b" and "p," letters adjacent to them are spaced more closely than two straight-walled strokes. (Figs. 1 and. 2)

Proportion: Approximately 1:2, measured from actual body height rather than from the waistline. (Fig. 1)

Warming up
Make an ink swatch; then work freely with a single guideline: consider it as a "waistline" and pull straights of increasing length from it. (Fig. 3)

Tool: 3mm Brause **Paper:** marker/JNB **Body:** shoulder awareness

Ductus and Dynamics
Dry trace the figures, following the instructions below, then use ink.

(b) 1. **Ascender:** Pull the "l" stroke. (Fig. 4)
2. **Bowl upstroke:** Push up inside the downstroke to about midway between the baseline and the waistline. Rock to the right corner; branch into a thin stroke up to the waistline using a target point about a nib width from the downstroke.
3. **Bowl downstroke:** Replace the edge at 35°, press-release and pull down to just shy of the baseline (dotted red line). Suggestion: Use the nib as measure to set a target. Press-release and pull a diagonal hairline down, one nib width, nicking the baseline. Pause.
4. **Base:** Press-release and push a short stroke up and left into the original downstroke to complete the counter. The bowl downstroke and base create a hinge join: two stroke corners that meet at a sharp angle. (Fig. 6) Note: Stoping before the baseline too soon, produces an "exposed" hairline; try to keep any exposure as short as possible. Going too close to the baseline, creates an overlap, which, if not pronounced, is acceptable (and sometimes unavoidable).

Fig. 4 Fig. 5

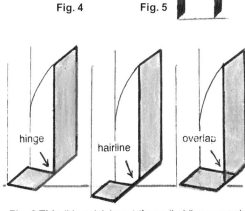

hinge hairline overlap

Fig. 6 This (hinge join); **not these** (hairline or overlap)

(p) 1. **Descender:** Place the left corner of the nib on the waistline; press-release and pull to the descender line. (Fig. 5, left corner touching) Lift the nib and replace it at the baseline, inside the downstroke.
2. **Bowl sequence:** Repeat strokes two through four for "b."

Spacing: letter string scats
With 3mm and 2mm nibs, alternate vowels (minus the "y") with "b" and "p." (Fig. 7)

pipupapope

Fig. 7

Line as image
Write words; aim to make word spacing as similar as possible. The reference space between two words, where verticals end and start the words, is about the space of an "n." (Fig. 8) Rewrite the words of your line to make any spacing adjustments.

Fig. 8

Letter Family 5: the "f" (ft)

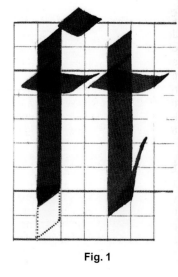

Visual themes
- Crossbars: Direction—shallow downward diagonals (Fig. 1)
- Crossbars: Legibility and expression—a narrow crossbar is enough to identify these letters, but a slightly wider one makes them more readable (Fig. 2, this page; Figs. 1 and 5, next page). The additional space of a slightly wider crossbar also creates small gaps in the text pattern. For a tighter, more even weave, the crossbars can be kept narrow, making the downstrokes more emphatic. It's your choice.

Warming up
Loosen up the wrist for bowing and shifting from edge to corner.

 Tool: 3mm Brause **Paper:** marker/JNB

Fig. 1

1. Make an ink swatch about an inch in length.
2. Pull long lines: first in inch-long segments; second, in one long line. Focus on the shoulder and using it to pull the stroke; first use even pressure, then partnered.
3. This is a good time to check pen hold: The fingers hold the shaft 1-1½ inches above the tip of the nib so the arm doesn't rest on the table. (The pinky may graze the paper for balance.) Keep the shaft nearly upright.

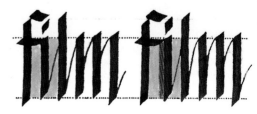

Roof/crossbar warm ups
1. Make a diagonal ink swatch. (See the "a" family warm up, p. 157)
2. Rule a horizontal line. Place the left corner of the nib on the line. Press-release and pull a diagonal hairline down one nib width. (Fig. 3)
3. Inhale, press-release and bow a shallow downward diagonal with center pressure. With the release of pressure, glide up diagonally above the line one nib width on a hairline. Repeat.
4. Make shorter strokes vigorously and rhythmically with start pressure.

Fig. 2

Fig. 3

Ductus and Dynamics

First, dry trace Fig. 1 (#4 Automatic Pen) and Fig. 4 (3mm Brause) following the instructions below. Focus on shoulder contact with the large nib and on finger awareness with the small nib. Then use ink.

 Tools: #4 Automatic Pen, 3mm Brause
 Paper: tracing vellum, marker/JNB
 Guidelines: 3mm Brause: 5/8" x-height; 3/16" ascender (a little shorter than previous ascenders)

Fig. 4

(f) 1. **Entry:** Place the left nib corner on the ascender line; exhale and pull a one-nib width-long hairline.
2. **Downstroke:** Inhale and press-release; exhale and pull the stroke: right nib corner touches the baseline or the left nib corner touches the descender line. (Fig. 1) The breath is especially helpful for staying with this long stroke. Press-release, lifting the nib and placing it atop the entry hairline.
3. **Roof:** Inhale and push left; exhale and pull right.
4. **Crossbar entry:** Place the left corner of the nib inside of the downstroke, just above the waistline. (Fig. 5) Press-release and pull down a nib-width hairline. (The right corner touches the left stroke wall.)
5. **Crossbar:** Press-release and begin a slightly downward motion: pull into the downstroke until the right nib corner touches the right wall. (Fig. 6) Note that there is a light resistance "in the ink" which naturally slows the stroke. Press-release and finish the crossbar, applying a little pressure as you continue to move across and slightly down. (To get the idea, make a vertical long line and move down it pulling crossbars. (Fig. 7)

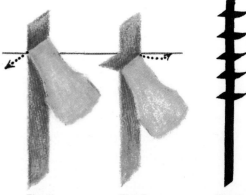

Fig. 5 **Fig. 6** **Fig. 7**

(t) 1. **Entry:** Place the right corner of the nib at the ascender line for "f," 3/16" above the waistline. (Fig. 8) Note: The "t" is a little shorter than "f."
2. **Downstroke:** Inhale and press-release; exhale and pull to just below the baseline.
3. **Exit:** As in "i."
4. **Crossbar:** See crossbar of "f".

Fig. 8

Spacing and Joining

Joining from "t" and "f" also involves a choice about spacing: to make the space similar to that between two verticals, or slightly larger to enhance readability. (Fig. 1) You also have options on how to connect "t" with the letter that follows: using the crossbar, the diagonal join, or both. (Fig. 2)

Letter scats (Fig. 3)

This exercise with "f" and "t" develops your ability to see subtle differences in interletter spacing. In it, you compare downstroke combinations: evenly-spaced with unevenly-spaced combinations, where the space after the "f" and "t" is larger.

Fig. 1 Top: all spaces similar; bottom: more space between "f" and "t"

Tool: 3mm Brause **Paper:** marker/JNB, ruled and unruled

1. Dry trace Fig. 3:
 a. Make the downstrokes of each combination before crossing the "t"s and dotting the "i"s.
 b. In each short scat, make the second "i/e" combination a little farther apart than the first.
2. Write the scats in Fig. 3 using ink and ruled lines,
3. Compare "t-i" and "f-i." Does using a thin upstroke join after the "t" influence the apparent size of the space?

Fig. 2

Fig. 3

Ligatures (Fig. 4)

1. Using tracing vellum, trace the double "t" and double "f." These two ligature possibilities are interchangeable: stepped crossbars ("t-t") and single-line ("f-f"). (Fig. 4)
2. Trace the "f-l" ligatures: a continuous "f-l" top-to-downstroke juncture and a broken one. (Fig. 4)
3. Using marker paper, write words with these ligatures, and experiment. In writing, cues from "context" influence the choice of ligature. Sensitivity to graphic environments develops gradually; practice and experience nurture the imagination.

Line as image

1. Use a 2mm nib and 3/8" guidelines and write the line of words in Fig. 5. Focus on the space within words and:
 a. Allow a little additional space following "f" and "t." The small red arrows of Fig. 5 indicate letter combinations with "f" and "t." Note the differences in spacing them in the top and bottom lines.
 b. Make all other spaces appear as similar as possible.
2. Focus on the space between words and make the spaces as similar as possible.

Fig. 4

Fig. 5

Letter Family 6: the "v" (vwx)

Visual themes

- Downstrokes: Note that those of this family depart from the straights of previous families. (Fig. 1) For the first strokes of "v, w and x," they become slightly concave arcs. For the second downstroke of "w," the stroke is a reverse curve.
- Counters: Internal and external triangular shapes. (Fig. 2)
- Entry: "Uptick" (See Note 1, below).
- Exit: Horizontal diamond lozenges to anchor the thin up-strokes.

Spacing: Letters following the "v" family letters nestle closely under their diamond exits, which act like the roofs of the "o" family. (Fig. 3)

Fig. 1

Warming up

Tools: red Pigma Micron/sharpened pencil, 3mm Brause
Paper: marker/JNB and small-grid **Ink setup and padded surface**

Angle to arc
In this sequence you move from an angled-bracket to a smooth arc to loosen up the arm. (Figs. 4, 5 and 6)
1. Place a fully loaded, unflicked nib at a flat nib angle.
 a. Pull a diagonal—down, up, down—to the right; pause. (Fig. 4)
 b. Pull a diagonal—down, up, down—to the left. Repeat the broken arc a few times, pausing at the change of direction. This juncture becomes the stretch point for making the smooth arch below.
2. Make an arced ink swatch (Fig. 5):
 a. Pull the first half of the arc to an imaginary stretch point. (Fig. 5, red dot) The angle of the broken arc becomes a stretch point for pulling a smooth arc.
 b. Continue pulling around it and complete the arc.
 c. Push up and pull down in the wet ink of the arc; repeat.

Fig. 2 Fig. 3

Hugging
1. On small-grid paper: with a Pigma Micron, rule diagonals five squares high and one square apart, from top to bottom. (Fig. 7) Set the lines two squares apart.
2. Use a dry pen to get the sequence of movements:
 a. Place the left corner of the nib at 35° at the top of the red line; inhale and press-release.
 b. Exhale, apply start pressure and pull an arc away from the diagonal to an actual or imaginary stretch point; inhale briefly; exhale finish.
 c. Make a framework of dots: start, stretch and endpoints along an imaginary diagonal. (Fig. 8) Pull a stroke away from the imagined diagonal "seeing" just a sliver of white as you move through the stretch point. Use partnered pressure on the left corner (T).

Fig. 4 Fig. 5 Fig. 6

Target practice
1. Set red dots for the start, stretch and end points of a diagonal, concave arc. (Fig. 8)
2. Connect the dots with shallow arcs.

Ductus and Dynamics
You are now ready to practice ductus with only a few notes. The dynamics of previous families also apply to this one. Use air stroking to help you visualize target points.

Fig. 7 Fig. 8

Tools: #4 Automatic Pen to dry trace Fig. 1;
 3mm Brause to trace with ink
Paper: tracing vellum, marker/JNB

Notes
1. **Uptick entry for "v, w and x."** Push a short stroke up to the waistline, or down and up to begin the letter. (Fig. 9, far left)
2. **Exit finish stroke:** After pushing the last cornered upstroke, replace the edge at 35° and pull a horizontal diamond shape. The left point balances atop the thin and adds definition with this weight. (Fig. 9, far right)

Fig. 9 Ductus for "v"

3. **Second downstroke of "w":** a reverse curve. (See Ductus for "w," right) Think of the curve in three parts (Fig. 2a): top—a shallow arc facing right; middle—a short, straight section; and bottom—a shallow arc facing left. Try some preliminary arcs with hugging. (Fig. 2b) Then join the three parts. (Fig. 2c)

4. **Cross stroke of "x"** (top, upstroke; see Ductus for "x")
 a. Pull a diagonal downstroke. Place the nib inside it, above center, at an angle steeper than 35°. (Fig. 3)
 b. Press the nib (to release the ink); rock to the right corner and push a cornered thin above the waistline.
 c. Make the diamond shape. (See the exit of "v" above.)

5. **Cross stroke of "x"** (bottom, downstroke; Fig. 4)
 a. Place the edge at 35°, inside the downstroke, above center.
 b. Press-release and pull left and down a hairline one nib width in length.
 c. Press-release and pull a downstroke, nicking the baseline, or reaching a little below it. Partner with the left corner (T).

Fig. 2a 2b 2c Ductus for "w"

Spacing

Combinations of "v" family letters create triangular interletter shapes. (Figs. 5 and 6) To make these spaces appear similar to those of rectangular shapes, bring the entry strokes of adjacent letters close to the overhanging exits that precede them.

Fig. 6 shows a word that has been written and then rewritten—letters moved closer together or farther apart—to make the areas between letters more balanced. This process becomes more intuitive, less-mechanical, with practice.

Fig. 3 Fig. 4

Ductus for "x"

Spacing: joins

Entry into a "v" or "w" depends on its position in a word. At the beginning of a word, where no thin upstroke precedes it, use the uptick; following a thin upstroke, lead into a diagonal downstroke with pressure-release and a slight movement to the right. (Figs. 6, 7, 10)

> **Tool:** 3mm Brause
> **Paper:** tracing and marker/JNB (ruled)

1. Make scats with the "v" family letters. (Fig. 7)
2. You can join "o" to "v" family letters by pushing a hairline up from the end of the roof and pulling a diagonal downstroke. (Fig. 8) Note the non-joining option. (Fig. 10, "oven")
3. Note: I don't recommend joining into/out of "x." (Fig. 9)

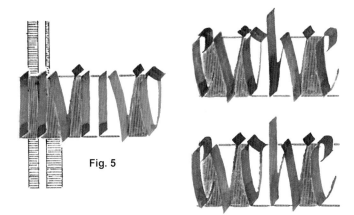

Fig. 5

Fig. 6

Spacing: word and line as image (Fig. 10)

1. Trace dry and using ink.
2. Freehand. Write a line of words making the spaces between them as similar as possible.
3. Analyze word spacing.
4. To make any adjustments, rewrite the line of words below the original. (Fig. 6)

Fig. 7 Sample scat Fig. 8 "o-w" join Fig. 9 Freestanding "x"

Fig. 10 More words

Letter Family 7:
"Hybrids"
(jrksyz)

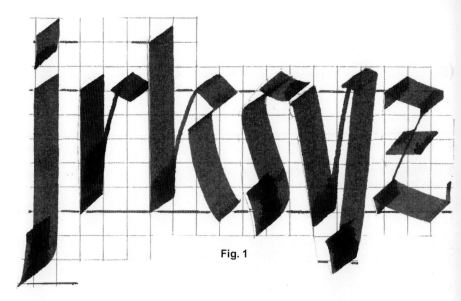
Fig. 1

Though these letters partake of the Moto spirit, each is distinctive rather than similar to one another. (Fig. 1)

Warming up
Review the ink swatch series and continuous long lines on page 143. Feel free to create your own warm ups.

Ductus and Dynamics

Apply dynamics and partnering to ductus below.

Tool: 3mm Brause nib
Paper: marker/JNB
Guidelines: 5/8" apart for body height
⅟₄" above the waistline for ascender height
⅟₄" below the baseline for descender depth

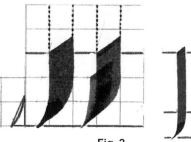

Fig. 2

(j) 1. **Downstroke:** As in "g," page 157. Note: The length of the descender can vary, as can the ending of the stroke: compare the square, bold exit of "g" with the tapered, more refined one of "j." (Fig. 2) In a text, combine the curved and square endings, or choose one and stick with it.
2. **Dot of "j":** As in "i," page 154.

Note on joining: Letters may join into but not out of "j, s, and y."

Fig. 3 Fig. 4

(r) 1. **Downstroke:** As in "i." (Fig. 3)
2. **Upstroke branch:** At the baseline, press, release slightly, and push the nib up into the mid-section. Rock to the right corner and push to the waistline staying close to the downstroke.
3. **Roof:** Lift and replace the nib just above the waistline at 35° and make a short roof.
4. **Double "r":** alternate taller and shorter "r"s. (Fig. 4)
5. Practice: Make a scat with "r" and keep spacing in mind. (Fig. 5)

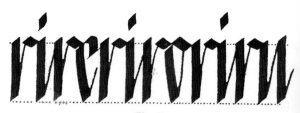
Fig. 5

(k) 1. **First downstroke:** As in "l." (Fig. 6)
2. **Branch:** At the same position as in "n."
3. **Loop of "k":** Lift and replace the edge atop the waistline at 35°. (Advanced students will push the corner into position.) Pull a short, downward diagonal. Pull a hairline to the left and down about a nib width, without touching the downstroke.
4. **Second downstroke:** Pull a steep, slightly arced diagonal to the baseline, or a little below.
5. **Exit:** If "k" ends the word, push a thin, cornered exit; within a word, let the particulars of the next letter help you decide whether or not to join.
6. Practice: Write words with "j, r, and k." (Fig. 7) Note the variations in "j."

Fig. 6

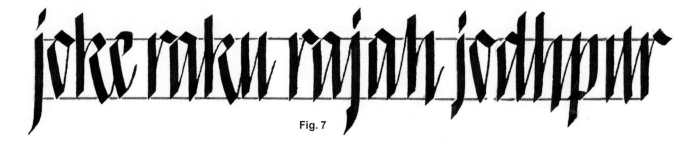
Fig. 7

(s) 1. **Downstroke:** Place the left corner of the nib at the waistline. (Not shown.) Press-release and pull a hairline (first segment) a nib width below the waistline. Press-release and pull a reverse curve with emphasis on the long straight part that connects the shallow top and bottom arcs. (Fig. 8a)

2. **Upstroke base:** Push a full-edged upstroke and partially overlap the downstroke. (Fig. 8b)

3. **Roof:** Replace the nib atop the hairline entry and make a short roof. (Fig. 8c; Brause example, Fig. 8d)

Fig. 8a Fig. 8b Fig. 8c Fig. 8d

(y) 1. **First downstroke:** As in "v," but begin below the waistline. (Fig. 9)

2. **Upstroke:** As in "v," but continue above the waistline.

3. **Second downstroke, entry:** At the end of the upstroke, set the left nib at 35°; make an extended lozenge; pause.

4. **Second downstroke:** Pull a steep diagonal to the descender line (or below) and push up and left to weight the stroke. This ending can be square, curved or omitted. Note: Use an entry uptick to begin a word.

(z) 1. **Top stroke:** Place the left corner of the nib atop the waistline and make an entry uptick. (See the first note of "v," p. 164) (Fig. 10)
 a. Pull a shallow diagonal to just below the waistline.
 b. Pull down, vertically, a very short way.

2. **Hairline diagonal**
 a. Rock to the left corner and pivot the nib counter-clockwise, to a steeper angle.
 b. Drop the right corner and pull the hairline to a little left of the letter entry (dotted red line).

3. **Bottom stroke**
 a. Rock to the left corner and pivot clockwise to 35°.
 b. Drop the right corner and push up and to the left a short way.
 c. Pause; pull a shallow diagonal, parallel to the top stroke, but slightly longer. (Make an exit stroke or not, depending on the letter that follows.)

4. **Horizontal crossbar:** This stroke strengthens the long hairline and keeps it visible.
 a. Place the nib on the thin diagonal, in alignment with it, a short way down the hairline; pull a little left and down.
 b. Pull a short horizontal to the right with start pressure.

Fig. 9

Fig. 10

Spacing: scats and words

Letter combinations with "k, s, and z" form irregular interletter shapes. Use plasticity to help space these letters according to your purpose. For maximum legibility, allow these letters the space that preserves their identity while integrating them with neighboring letters. To emphasize the potential of Moto for a strong downbeat, make these letters as narrow as possible.

Tools: 3mm and 2mm Brause
Paper: tracing vellum, marker/JNB (ruled)

1. For the "i" scat: use the space between "i-j" as the reference space. (Fig. 1) For the "o" scat: use the space between "i-i" for the reference space. (Fig. 2)

2. Write words, thinking about the spaces between them as well as those within them. (Fig. 3)

3. Try bowing the words using the 3mm and 2mm sizes.

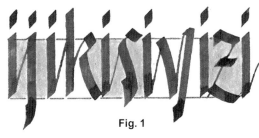

Fig. 1

Fig. 2

Fig. 3

Stroke technique: controlling ink flow

You are already familiar with two methods of loading and adjusting ink: fully loaded and dip and flick. Though these are useful for warming up, formal and expressive work requires a more nuanced approach. Through the additional methods given below, you learn to regulate the flow of ink with skill and finesse. The goals for now are a fine, sharp stroke and an even tone.

- **Loading:** There are two ways of placing ink in the nib reservoir:
 1. Dipping: immersing the nib directly in an ink well. Adjust the depth of the ink in the well to suit your purposes.
 2. Applying ink with a brush or dropper. (Not discussed in this book.)
 3. The amount of ink in the reservoir may vary depending on purpose, paper surface, type of ink and speed of writing. (Fig. 1)

 Type of ink
 1. Free-flowing, non-waterproof for practice, i. e., warm ups and exercises with letterform, and for layout roughs. (See p. 140)
 2. Sumi inks for formal/expressive work. (I sometimes use Sumi ink for warming up as well.)

- **Adjusting**
 The loading method discussed now requires wiping off excess ink. The pen wipe may be the same one used to clean and dry the nib or a different one.

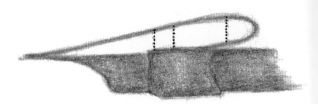

Fig. 1 The amount of ink in the reservoir reflects the interplay of material and design elements.

 Wiper materials
 1. A cloth rag, such as a square cut out of an old sheet (a colleague's favorite).
 2. Toilet paper, scrunched up to create facets for touching the nib (the author's favorite).

 Method of adjusting
 1. Flicking: As in dip and flick, but more gently, as a step before wiping.
 2. Wiping: After dipping, touch the nib, just the top, or both top and bottom, to the wipe. How long you touch it depends on the absorbency of the material (quite briefly for toilet paper) and how much ink you want in the reservoir.

Exercise: Compare methods.
Begin with a warm up using a fully loaded nib. (Fig. 2) Then, make a hairline diagonal and a thick vertical with each method below and compare. (Fig. 3)
1. No adjustment (fully loaded): Make the mark directly after the dip.
2. Flicking: 1) make a gentle flick or two and 2) make a vigorous flick or two.
3. Wiping: Place a wipe next to the ink well. After loading, wipe as above.
 Experiment with materials for the wipe and possibly its placement.

Fig. 2

- **Testing:** Does the amount of ink in the reservoir produce the stroke you want? Make a test mark:
 1. A short hairline or two. (Fig. 4)
 2. Sometimes a thick or graduated stroke as well.

 When, where and on what to make the test:
 1. Every time you load, test the flow before writing.
 2. For exercises: The same paper, next to where you plan to begin or at an edge of the paper.
 3. For formal/expressive work: A scrap of the finish paper close by, or on a "guard." (See p. 174)

Fig. 3

- **Re-adjusting**
 1. If you don't get a mark, try added pressure, wrist vibrato, or more ink.
 2. If you get too heavy a mark, try reducing the amount of ink, or pressure on the nib.
 3. If this fails, troubleshoot: Since every mark is an interaction, the cause may be one or a combination of:
 a. Speed: The slower the stroke, the more likely the ink is to absorb or spread.
 b. Paper: It may be too absorbent, or too hard/slick.
 c. Nib: It may be worn or rusted and need replacing.

Fig. 4

Exercise: Test and write, and reload.
After adjusting the ink, test the nib and write a line of words. (Fig. 5) You need not run out of ink before reloading. The amount you carry depends on how even you want to keep the tone, and how often you want to reload. Hatch marks indicate reloading.

Fig. 5

Alphabet design: word as image

In these exercises, the model alphabet, Moto, provides an entry into a creative, calligraphic process: giving a word/phrase visual as well as verbal meaning. (See Graphopoeia, p. 72-3) You'll use the familiar design elements of proportion and scale and the unfamiliar ones of ink and letter slope. The exercise with stroke gesture helps you take another step toward developing calligraphic empathy (p. 72).

Tool: 2mm Brause **Paper:** marker/JNB **Guidelines:** 3/8" body height

- **Proportion:** Usually, a change in proportion produces a change in weight.
 1. Choose a word/phase and write it using the model Moto alphabet. (Fig. 1)
 2. Rewrite, narrowing the letter and distance between strokes. (Fig. 2)

Fig. 1 Moto (model)

Fig. 2 Moto (narrowed)

- **Ink:** Edged-pen "graphopoeia"
 With the edged pen, ink treatment becomes an expressive visual element. The phrase below calls for a coarser handling, whereas the single word calls for a more-refined one. (Figs. 3 and 4). Ink usage, stroke gesture and speed tend to interact.

Fig. 3 Heavy ink and aggressive stroke. **Fig. 4** Light ink and sensitive stroke.

 1. Use the same word/phrase as above, or choose your own.
 2. For a coarser stroke/word image: Load the reservoir to maximum capacity (fully loaded, unflicked).
 3. For a more refined stroke/word image: Find the minimum amount of ink needed to make a few strokes.

- **Stroke gesture**
 1. Choose a word/phrase that suggests a quality of movement, such as "choppy" or "jerky," "smooth" or "flowing."
 2. Let your arm and hand, guided by your imagination, enact the spirit/feeling through a gestural motion suggested by the word as you write it. Play with the rhythm and speed; try closing your eyes.

- **Scale**
 1. Choose new words/phrases.
 2. Using the same size nib, write the word/phrase at two different heights. (Fig. 5) Note the influence of letter height on proportion. In the examples, and in general, the letter narrows as scale increases, and expands as scale decreases.

Fig. 5

- **Letter slope**
 1. Choose another word/phrase.
 2. Start with the Moto model. Vary the slope of individual letters or of the entire word. (Fig. 6)

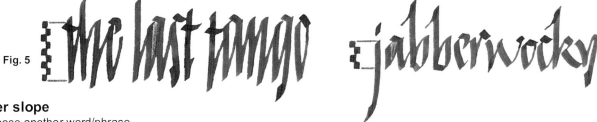

Fig. 6

the player piano
"spreading across America a
hundred years ago with its
punched paper roll at the
heart of the whole thing...
the frenzy of invention
and mechanization and
democracy and how to have
art without the artist..."

This text was written with the Moto hand using a 2mm Brause nib.
The lines are from *Agape Agape* by William Gaddis.

Practice text

We distinguish, here, between the practice text and that of a finished piece. The first difference is in the materials: a practice text uses practice materials, with which you are already acquainted, and a finished piece uses finish materials, introduced on pages 240-1. For practice texts, the focus is two-fold: on learning to construct a grid for writing, and on the act of writing a multiline work. Both develop your skills and calligraphic confidence as they prepare you for creating a finished piece.

Text as image and experience: the writing grid

To write a text with an edged pen, it is traditional to arrange the writing upon a grid of horizontal and vertical lines. A grid, as seen in the picture, still guides the sweep of the reader's eye—from left to right and top to bottom.

The printed page continues to rely on this centuries-old pattern; but, in today's text the linear structure is no longer visible. Whether or not a grid facilitates the eye's habitual act of reading, we do not want to abandon the grid at this point: it helps us conceive the written text as the design element of shape.

In addition, working with a multiline text allows time to develop writing as a rhythmical, spontaneous act—a fundamental calligraphic experience. Engaged in such practice, the process of writing, rather than its product, is foremost. This gives you the opportunity to focus your attention on the varied activities of writing—coordinating the breath with the directional strokes of letters, partnering with the nib, and applying the dynamics of pressure-release to enhance rhythm and flow.

Caps are unnecessary in this exercise. However, after learning Moto caps, you may wish to rewrite your text and incorporate them.

Detail. Thomas a Kempis writing out manuscripts in his monastic cell, Agnietenberg, c. 1481

Preparation

1. Purpose: To construct a grid and write a text using Moto.
2. Text:
 Let the character of the Moto alphabet help guide your selection. Consider its characteristics and connotations. (See p.151.) I've chosen the text at left because of one of its themes—mechanization. Also, because Moto's jagged letterforms seem to communicate the author's anger. Use this text, or choose your own. You may find other features in Moto to guide your choice.

Testing and making a grid

Tools: 2, 2½, or 3mm Brause
Ruling equipment: see pages 124-5
Paper: 9" x 12," 11" x 14" (or larger) marker/JNB
Text: line length, 3-6 words; text length, 8-10 lines

Step one: Setting letter height and interlinear space
The distance between a grid's ruled horizontals depends upon letter height and interlinear space. Either use the suggestions below, or determine your own measures by trying different letter heights and distances between lines.
1. Choose one of the nib sizes above.
2. Determine body height: either 2mm: ½"; 2½ mm: 9/16"; or 3mm: 5/8".
3. Determine interlinear space, either the same as body height (Fig. 1) or greater/lesser to change the feel, density, or legibility of the text image.

Step two: Making a short paper ruler
1. First, cut a strip of paper about 2½"-3" x ½".
2. Mark one or two line spaces (Fig. 2) along the right edge of the strip. (Fig. 3) Here, a line space is a unit of measure that combines a body height letter and an interlinear space.
3. Then set it aside.

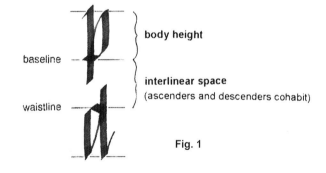

baseline

body height

waistline

interlinear space
(ascenders and descenders cohabit)

Fig. 1

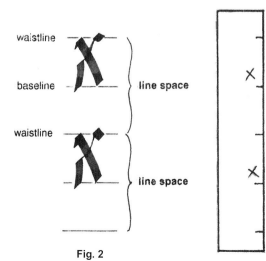

waistline

baseline

line space

waistline

line space

Fig. 2

Fig. 3

Step three: Setting the width of the side margins
Verticals for both the left and right margins are usually ruled, even when the text is left, rather than fully, justified.
1. Suggestion: For practice, use narrow margins, not more than 1" wide, to maximize the writing space.
2. Mark this distance directly on each side of the paper.

Step four: Setting the height of the top and bottom margins
For the same reason as above, keep these small as well—about 1" from the top and bottom edges of the paper.

Step five: A continuation of step two—marking a long, page-length paper ruler
1. Cut a strip of paper 12" x ½". Set the first mark 1" from the top.
2. Place the top mark (first waistline) of the short strip adjacent to the first mark of the long strip. (Fig. 4)
3. Mark line spaces on the long strip moving the short strip down its edge until a baseline is a little more than 1" from the bottom edge. This is an exercise. In a finished piece, the bottom margin is usually deeper than the top. (Fig. 5)

Step six: Ruling the grid
1. Tape the paper squarely to the table/board, using drafting tape.
2. Align the top of the paper ruler with the top of the paper and tape the paper ruler adjacent to the left edge of the paper. (See below, right)
3. Use a T-square and right triangle to rule the two verticals (See below, left). Since methods of ruling in scribal times did not permit easy erasure, the grid usually became part of the text image. This is an exercise and lines need not be erased. Make either an enclosed rectangular grid or extend the margin lines the length of the paper. (Fig. 5)
4. Read the next page for a suggested approach to writing your text.

Fig. 4

Fig. 5 Here margins display the traditional ratio of 2 (top); 3 (sides); and 4 (bottom).

Ruling vertical margins with a T-square and right triangle (left); ruling horizontals with a T-square (right).

Writing a text as meditation

We begin with a relaxation exercise: e.g., the ink swatch series on page 142. This preparation refreshes your capacity for alertness and attention. Allow yourself to focus on the process rather than the product. With this focus arise strokes and letterforms that reflect your vitality. Suggested approach: Use one or two lines of your text for each of the following facets of writing given below. First focus on one particular facet at a time.

Breathing: Coordinate the letter strokes with the breath using the familiar pattern: inhale, upstroke and exhale, downstroke.

Partnering
Sensitize the fingers: choose either a right or left partnered corner. Then try the other.

Pressure and Release
Concentrate on the shoulder, on its subtle gradations of pressure as it sinks, creates drag, and releases to propel and guide the stroke. Note changes in speed.

Spacing
Remember to use target points and the nib as measure (ps.154, 160) to develop consistent interletter and word spacing.

Pen hold
Check the following:
1) tightness of your grip: just tight enough to keep the tool, paper and hand in a tensile, but not tense, relationship.
2) placement of the fingers: sufficiently back from the tip.
3) position of the shaft: nearly upright.

Where the spirit does not work with the hand there is no art. Leonardo da Vinci

Combining facets: As you feel ready, direct your attention to bringing two of the above facets into awareness; add another to stretch your attention and further exercise the "muscle" of concentration. Work at your own pace.

Winging it: Write out the whole text, or part of it, without a grid. What changes does this make in your experience?

Making and using a guard

A guard is a separate sheet of paper, one placed over the paper you are working on to protect it from hand oils and potential accidents with ink. It can also be used for testing ink flow. If you intend to make finished pieces, a guard is a necessity. You may wish to get familiar with it at this point, to start making it a part of the writing process.

Paper: drawing/JNB
Guard: Cut the paper about the same width as the paper for the text.
 It should be deep enough for the heel of the hand to rest on it. (Fig. 1)
 Note: A guard is not needed for warming up.

1. Place the guard under the intended line of writing.
2. Load the nib and test it on the guard. (Some calligraphers prefer a separate piece of paper.) Is the stroke sharp enough? If uncertain, remove some ink; redip if you remove too much.

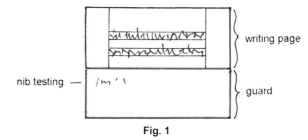

Fig. 1

Note: When writing with a guard, some prefer a fixed position—which requires taping and repositioning as you move down the paper; others prefer an unfixed guard that can be easily slid. Experiment; your choice may change over time or relative to the project.

3. Get the feel of using a guard: try to keep the act of writing directly in front of you—moving paper and guard to the left as necessary. Otherwise, verticals tend to become diagonals. The use of a guard may seem cumbersome at first; in time though, you'll develop the knack and make it part of the process.
4. Write a line of words focusing on ink-loading and testing, with and without a guard. Take your time.

Training Alphabet 7: Moto caps

Moto caps share the upright, regimental spirit of their Roman ancestor, but, due to significant differences in proportion and scale, not its grandeur. (Fig. 1) They are short, the same height as Moto lower case. (Fig. 2) They distinguish themselves by their heavier weight (flatter nib angle) and more complex forms. Unlike Jumprope and Trapeze caps, there are no replicas of their lower-case counterparts. As a training alphabet, Moto caps feature precision of detail and despite its bold character, a variety of subtleties which derive from nuanced technique.

Fig. 1 Moto Caps

Design

Characteristic angle: 20°—a flat nib angle. (Fig. 3)

Guidelines: The cap line is the same height as the waistline of Moto's lower-case letterforms. (Fig. 2)

Angle icon: 20°; add 35° with lower-case. (Fig. 3)

Visual themes

- Weight: Slightly heavier than Moto lower case, with minimal contrast between thicks and thins—no hairlines. (Figs. 1 and 2)

- Downstrokes: Straights predominate; bowls have shallow curves.

- Serifs and endings:
 Entry serifs: Short horizontal slab or uptick (e.g., "H," Figs. 1 and 4)
 Stroke endings: Expanded (top horizontals, e.g., "E" and "F," Fig. 1) and natural (retains nib angle, e.g., downstrokes of "F" and "T," Fig. 1)
 Exit serifs: Twist off and extended twist off (Figs. 1, second downstroke of "A," and 4)

 Note: The calligrapher first uses a model alphabet as a training guide, then as a point of departure. To better express the mood or spirit of a text, the calligrapher often searches for alternative serifs as well as letterforms. (Fig. 5, "H")

- Roofs: Horizontals ("A, C, E, F, G") and shallow diagonals ("B, D, P, R").

Proportion: Slightly wider than Moto lower case.

Letter families: Although the letters of this alphabet are more complex than the lower case forms, five families suffice to organize them visually and dynamically.

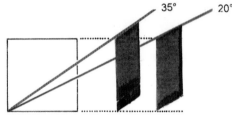

Fig. 2 Cap, 20°; lower case, 35°

Fig. 3

Fig. 4 Downstrokes with slab serif and uptick entries, and twist off endings.

Ductus and Dynamics

Numbered arrows accompany each letter family as do instructions for using pressure and release technique.

Fig. 5 Alternative entries to the second downstroke: natural, uptick, and slab (left to right).

Stroke technique

Moto caps, which employ a variety of stroke techniques, continue to develop your pen skills and expand your calligraphic possibilities. The techniques:

- Nib cornering, to produce square endings
- Nib turning, to widen and give weight to horizontal endings
- Change of angle between letters (cap to lower case, lower case to cap; Figs. 6, below, and 2, previous page)
 Writing words with Moto caps and lower case trains the hand to change position as nib angle changes from flat to steep, or the reverse.
- Ink adjustment

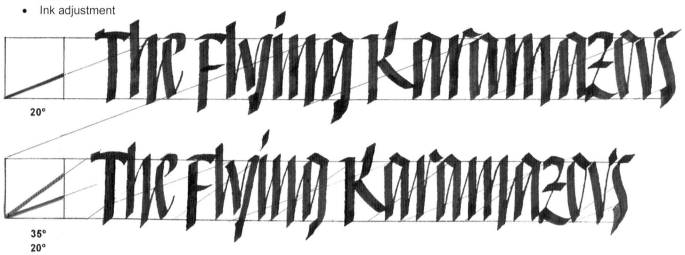

Fig. 6 Top: caps and lower case, 20°; Bottom: caps, 20°, lower case, 35°.

Using a protractor

Using a protractor provides an easy way to establish accurate angle lines. Angle lines offer a nearby reference for keeping nib angle. In contrast, with an angle icon it's necessary to lift the pen away from the writing to check angle (and more easily lose it). The angle line ruling below provides practice in developing this skill. It also produces work sheets for the stroke practice exercises on the next page.

Tools: sharp pencil and colored Pigma Microns **Paper:** marker/JNB **Protractor:** Use one made of clear plastic.
Ruler: cork-backed **T-square:** metal, if possible
Right angle **Drafting tape**

Establish angle

1. Place a sheet of paper on a table contrasting in color. (Fig. 7)
2. Align the protractor's bottom edge, 180° - 0°, with the bottom edge of the paper. Align the middle of the protracttor, 90° at the top, with the left edge of the paper.
3. Find and mark the desired angle(s) on the paper in pencil.
4. Rule a line from the lower left corner of the paper to the mark.

Rule horizontal guidelines

Draw these down the paper. Use a paper ruler with marks 5/8" apart. (See Step six: ruling the grid, p. 172)

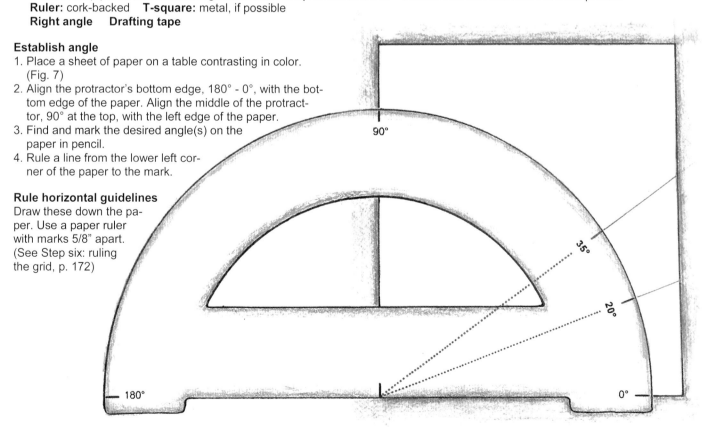

Fig. 7

Rule angle lines
1. Reposition the paper: align a ruled angle line with the T-square and tape it to the surface. (Fig. 8) Tip: Test the alignment before taping: hold the paper in place and draw over the angle line with a pencil.
2. Rule angle lines: place the T-square at the intersection of each horizontal line and the paper's left edge and rule across. (Fig. 9)

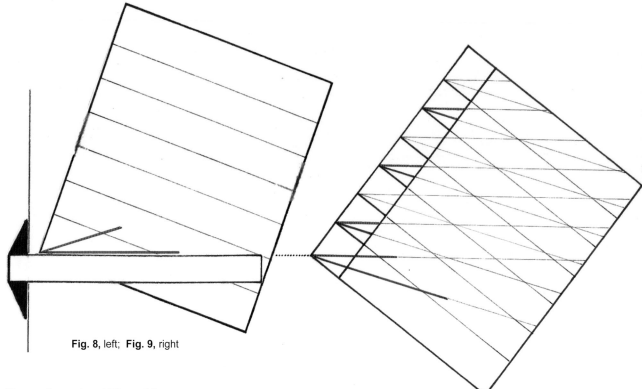

Fig. 8, left; **Fig. 9,** right

Options
1. Ruling with pencil or colored Pigma Microns.
2. Ruling angle lines for one angle (cap only) or two angles (cap and lower-case, Fig. 9).
3. Making an angle icon instead of, or in addition to, angle lines. (Fig. 9)

Note: Angle lines, like the training wheels of a tricycle, are useful as learning aids. Gradually, as the hand and eye learn to judge nib angles and their corresponding weights, you'll no longer need this assistance.

Stroke practice
Pulling the nib at a 20° nib angle calls attention to the body. At this angle, holding the shaft steeply, if not upright, brings the arm toward the body and pulls the wrist down a little and the elbow further in—a slight contrast to their positions at a 35° angle.

 Tools: 3mm Brause, red and blue 01 Pigma Microns
 Paper: marker/JNB **Guidelines:** 5/8"
 Nib angle icon (Fig. 9, above)**,** and
 Nib angle lines: Use a protractor (See above.) Rule the angles on
 two sheets of paper: 1) with only 20° angle lines (blue) and 2)
 with both 20° and 35°lines (red). (Fig. 10) These ruled sheets will
 be used later for letter practice.

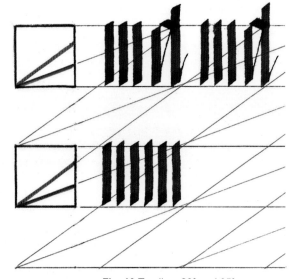

Pen hold experiment
Warming up practice is a good time to try things. Hold the pen shaft up-right, at 90° to the table surface, and pull downstrokes at 20°. Note tool hold and the position of the arm in relation to the body. Placing the paper a little to the right should make this more comfortable.

Exercises
Use angle lines and/or an angle icon. These are meant as aids when using more than one angle. If drawing more than one angle line is con-fusing, use an angle icon to represent the second angle.
1. Make a few downstrokes at 20° and then a lower case letter. (Fig.10, top line, left)
2. Make a few downstrokes at 35° and then a lower-case letter. (Fig. 10, top line, right)
3. Alternate 20° and 35° downstrokes. (Fig. 11)

Fig. 10 Top line, 20° and 35°
Fig. 11 Bottom line, downstrokes alternate: 20° and 35°

"I" Letter family
(IJHLEFT)

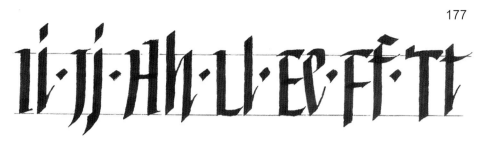

Visual themes (Figs. 1 and 2)

- Strokes: basically straight
- Entry serifs: slab and extended slab
- Stroke endings: natural, tapered, expanded, twist-off, uptick

Fig. 1 Upper and lower case

Warming up

Tool: 3mm Brause **Paper:** marker/JNB **Speed:** deliberate **Ink set up**

1. With a fully loaded nib, make a short vertical ink swatch at 20°. (Fig. 3)
2. Shallow steps (Fig. 4)
 a. Place the nib at 20°; inhale and press-release; exhale and pull a short vertical.
 b. Inhale, press-release and partner with the left corner (T); exhale and push a longer horizontal. Repeat the pattern. Despite the small size of this work, try to engage the shoulder and arm as well as the fingers.
 c. Focus some attention on keeping a firm wrist to support your movements.
 d. Look for the recoil, or "play," of the nib—a slight reverse motion at the end of each stroke.

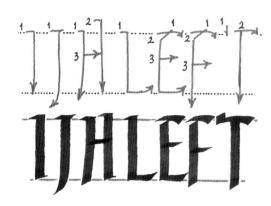

Fig. 2 Letters with ductus

Ductus and **D**ynamics

Use the breath, dynamics (pressure and release) and partnering to support the slabs and right angle junctures which typify this letter family. (Fig. 5)

Tools: #4 Automatic Pen, pencil, 3mm Brause **Paper:** marker/JNB **Ink**
Speed: deliberate **Guidelines:** pencil horizontals 5/8" apart

Fig. 3 **Fig. 4**

(I) 1. **Entry exercise:** slab serif—a short horizontal stroke
 Dry trace Fig. 5 with the Automatic Pen. Place the nib atop the line, with the right corner touching the black line. Partner with the left corner (T). Inhale and press-release; exhale and push until the left corner aligns with the black line. Inhale, press-release; exhale and pull a short vertical. Repeat the horizontal slab below the line; inhale, press-release and push a hairline up. Repeat the pattern.
 Ink: Rule a pencil line; place a fully loaded and flicked 3mm Brause nib atop it at 20°. (Fig. 6) Repeat the pattern in Fig. 5. Work rhythmically.

Fig. 5 Note the right triangles.

2. **Entry and downstroke:** With ink, place the nib atop the cap line. Inhale, press-release; exhale and push a slab serif with soft start pressure. Pause; inhale, press-release; exhale and pull the downstroke to the baseline. Make a few slab-serifed downstrokes. Stop and clean your pen.
3. **Twist-off action:** nib turning technique—"pivoting in place"
 Get the feel of a nib twist with prototool 2, a dry Automatic Pen, and an ink-filled Brause. Make a fan (Fig. 7): Starting at 90°, press and partner with the right corner (IF); in the release of pressure, twist the nib clockwise, pulling the right corner with the index finger. (This pushes the wrist to the left.) Softly press- release and lift off the paper. Repeat to get the feel. Make a closed fan at 20°. (Fig. 7, right)

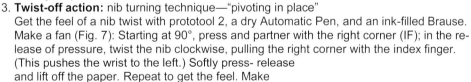

Fig. 6

4. **Twist-off exit**
 Dry trace a downstroke pulling it to the baseline. (Fig. 8) Finish with a twist-off action—twisting and pulling off in the release of pressure to make a short spur. Release from end pressure or apply pressure just before the twist.
 Ink: Repeat with a 3mm Brause.

90° 20°

Fig. 7

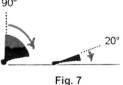

Fig. 8 Twist-off and extended twist-off exits

5. **Extended twist-off exit** (Optional ending to "I, H, F, and T"):
 Dry trace: At the base of the downstroke, press, partner with the right corner (IF); in release, twist off and push a slightly longer spur. Note: As technique develops, the release of pressure at the end of the downstroke leads into the twist.
6. **Entry, downstroke, exit:** Using ink and a 3mm Brause, make a few "I" caps, with or without the twist-off. (Fig. 9) Work as boldly as possible. At this stage it's more important to get the feel of pulling/stretching the stroke, engaging the resistance, than making straight strokes.

Fig. 9

(J) 1. **Entry exercise:** extended slab serif
Dry trace with the Automatic Pen (20° nib angle): Push the nib horizontally until the left nib corner forms an imaginary scalene triangle. (Fig. 10a) Rock to the right corner (IF) and pull a concave curved stroke to the cap line. (Fig. 10b) Staying on the corner, move up vertically. (Fig. 10c) Lower the edge back to the paper at 20°, inside the stroke. Pull a short downstroke. (Fig. 10d) Practice this sequence of moves a few times. (Fig. 13)

2. **Entry and downstroke:** First, using ink and a 3mm Brause, repeat the above sequence. Now, make the "J": inhale, press-release; exhale and push the extended slab serif (including the cornered curve). Inhale, press-release; exhale and pull the downstroke through the baseline, finishing in a short, tapered arc. (See p. 166, Fig. 2) Work slowly; stay open to sensation.

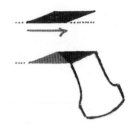

Fig. 10a The scalene triangle

Pen in hand (3mm Brause), read and dry trace the ductus below before using ink.

(H) 1. **Entry:** slab serif.
2. **Left downstroke:** Press-release and partner with the left corner (T). About one-third the way down the stroke pull slightly to the left, finishing just below the baseline.
3. **Second entry:** Place the left nib corner up and to the right of the first slab serif and make a second slab-serif entry. (Fig. 11)
4. **Right downstroke:** Pull vertically to the baseline and twist off (extended). The height of the second downstroke depends on the letter's desired presence/energy. (Fig. 12)
5. **Crossbar:** Place the nib inside the first downstroke, above the mid-point. Push the stroke horizontally, sensitively through the inked downstroke. Use soft start pressure and finish fully inside the second downstroke. (Fig. 12) Note: the mid-point measures from actual letter height, rather than from the cap line. (Figs. 11 and 12)
6. **Ink:** Repeat the above steps.

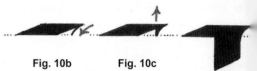

Fig. 10b **Fig. 10c**

Fig. 10d

Exercise: Write words with capital "I, J, and H." Use a 2½ mm Brause and 9/16" guidelines. (Fig. 13)

Fig. 11 **Fig. 12**

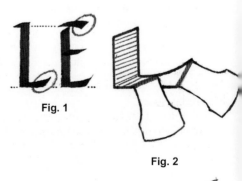



Hey Jude Izzy Jacqueline Udi Helga

Fig. 13

Note for advanced students: the subtleties of broad-edged pen use
Nib corners govern contact with the paper. On the downstroke you may have become aware of a push as well as a pull. Such a sensitivity, to the pushing sensation on the right nib corner (IF) and the pulling sensation on the left nib corner (T) enhances control of the vertical stroke. On the horizontal, the thumb pushes the left corner as the index finger pulls the right.

For all students. The leading corner pulls and the following corner pushes. It takes time to expand your awareness to include more than one focus. Be-gin by focusing on one cornered action at a time. As attention grows with practice, more can be held in awareness. Think of a juggler. For simplicity, ductus instructions continue to describe the downstroke as a pull and the horizontal as a push.

Stroke technique: Nib turning, the next step

This more-sophisticated move builds on the introduction to nib-turning in Trapeze. (See p. 113) The horizontal arms of "L, E, F, and T" end in an expanded stroke. (Fig. 1) To produce this refinement, both corners are rotated from a flat to a steeper nib angle as they push the horizontal stroke. (Fig. 2)

Exercise: Begin to get the idea and feel of this fine motor action by working large, dry tracing Fig. 3 with a #4 Automatic Pen. Place the tool at the intersection of the vertical and horizontal strokes. Work slowly. Inhale, press-release and partner with the left corner (T). Exhale and push the stroke using start pressure. In the release phase, pushing off, turn the stroke counter-clockwise with the left corner (T). Focus on the thumb as the "driver" of the turn; the index finger helps to guide.

Facilitate the action by supporting the pen shaft against the index finger, keeping it as upright as possible. Use enough pressure to make full contact: keeping both corners down. Be aware of any unneeded pressure. Use the last one or two fingers to support the action. Attention to the wrist helps stabilize the hand and carry energy from the arm. (See Nib turning exercises, pages 242-3, if desired.)

Fig. 1

Fig. 2

Fig. 3

(L) Horizontal exercise

Dry trace the horizontal stroke to prepare for making it with ink and a small nib. (Fig. 1a) Place the tool at the intersection of the vertical and horizontal strokes, atop the line. Work slowly. Inhale, press-release and partner with the left corner (T). Exhale and push the stroke using start pressure. In the release phase, pushing off, turn the stroke counter-clockwise with the left corner. (Fig. 1b) Remember to keep the staff upright and supported.

Fig. 1b

Ink: 3mm Brause. Make the above stroke a few times and then the full letter:
1. **Entry and downstroke:** As in "I."
2. **Horizontal:** As above. Make the entire letter a few times finding a rhythm within and between the strokes.

Fig. 1a

Note on precision in stroke length

Horizontal strokes of the same length can appear different in length when they taper or thicken and may result in an unstable form. (Fig. 2a) Here, lengthening the bottom stroke corrects for this illusion. (Fig. 2b)

(E) Top horizontal exercise

Dry trace the top horizontal stroke to prepare for making it with ink and a small nib. Place the Automatic Pen a little left of the downstroke. (Fig. 3a); press and partner with the left corner (T). In the release of pressure, move to the right and rotate the nib counter-clockwise. Remember to keep the staff upright and supported.

Fig. 2a **Fig. 2b**

Ink: 3mm Brause. Make the above stroke a few times and then the full letter:
1. **Entry:** Make the hairline entry of lower-case "a," but at 20°. (Fig. 3b)
2. **Downstroke and bottom horizontal:** See "L" above. This horizontal will be the longest of the three arms of "E." (Fig. 2b)
3. **Top horizontal:** Follow the instructions above for the dry trace. (Remember: This stroke is a little shorter than the bottom one).

Fig. 3a **Fig. 3b**

4. **Mid-bar:** Place the nib inside the downstroke on an imaginary mid-line, measured from actual height. (Fig. 4a) Since you are in wet ink, use a sensitive touch to move through the down stroke. Apply start pressure and push a short stroke, the same length as the top stroke. Optically, the tapered end slightly reduces stroke length.

(F) Tracing exercise:
Use the breath and dynamics above. With a 3mm Brause, dry trace the "F" before using ink. (Fig. 4b)
1. **Entry:** Make the hairline as in "E".
2. **Downstroke:** Pull through the baseline.
3. **Top stroke:** As in "E".

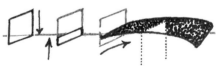

Fig. 4a Fig. 4b

4. **Mid-bar:** The mid-line of "E" also works for "F." However, place the nib just *below* it; make the mid-bar no longer than the top stroke. (Fig. 4b)

(T) Tracing exercise:
Dry trace the entry and horizontal top with the Automatic Pen:
1. **Entry:** Place the nib a little above the cap line. Press-release and pull a short downstroke until the right nib corner meets the cap line. (Fig. 5)
2. **Top stroke:** Push the nib up until the left corner is just below the cap line. (This care in positioning the nib will create a smooth arc.) Press-release and push the stroke across, turning the nib counter-clockwise. Keep the curve smooth as you gradually turn to the end of the stroke.

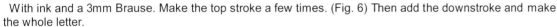

Fig. 5

With ink and a 3mm Brause. Make the top stroke a few times. (Fig. 6) Then add the downstroke and make the whole letter.
3. **Downstroke:** Center the nib fully inside the top stroke. Inhale, press-release; exhale and pull the downstroke to just below the baseline. Try using start and end pressure for this stroke. Remember to move sensitively through the wet ink at the top of the stroke.

Practice
1. Rule 5/8" guidelines. Include a mid-line based on the actual height of "E." Make the "E" and "F" a few times. Try the "H," noting any adjustments to mid-bar height.
2. Alternate the upper and lower case forms. (Ll, Ee, Ff, and Tt)
3. Write words with the upper-case "L, E, F, and T." (Fig. 7)

Fig. 6

Fig. 7

"O" Letter family (OCGQ)

This family focuses on the subtle stroke curvatures that create its open and closed bowls. (Figs. 1 and 2)

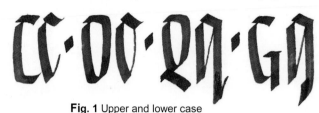

Visual themes
- Stroke: shallow curves
- Bowl: "soft," narrow triangle
- Juncture: overlap with no visible hairline (Figs.1 and 7)

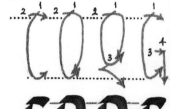

Warming up: "Almonds"

Fig. 1 Upper and lower case

Tool: 3mm Brause **Paper:** marker/JNB **Speed:** deliberate **Body:** arm-bicep

This is a relaxation-meditation exercise which uses a fully loaded nib. (Fig. 3)
1. First, focus upon the breath: Place the nib at a flat angle. Inhale, press-release; exhale and pull the left arc; pause briefly; inhale and retrace up in the wet ink. Repeat on the right side to complete the "almond." On the exhale, push a short horizontal arc to the next start point. Set a start point mentally or on the paper for the next almond. Pauses in the breath coincide with changes in stroke direction—usually a stroke ending. (Which often, is also a stroke beginning.)
2. Second, focus on the body and dynamics: Apply start pressure arising from the bicep to begin the left arc; pull the curve in the release, and finish the arc with end pressure. Use even pressure to retrace arcs, sensing this delicate movement with the fingers. ("Shut your eyes and see.") To get to the next almond, apply start pressure to the short horizontal arc.

Fig. 2

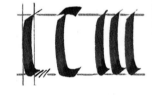

Fig. 3

Ductus and Dynamics

(C) 1. **Entry:** As in Moto "a." (p. 157, Fig. 7)
2. **Downstroke:** Inhale, press-release; exhale and pull a shallow, vertical arc to a little above the baseline; pause briefly and make a tight, elbow bend into the line. (Fig. 4) Experiment: use start pressure to begin, and again before the bend. Practice this stroke (Fig. 5) before continuing with the letter.
3. **Horizontal base:** At the end of the downstroke, apply a little more pressure, releasing it as you move to the right while steepening nib angle to complete the base. (Fig. 4)
4. **Curved roof:** Replace the nib atop the entry hairline; inhale and push to the left edge of the downstroke. Exhale and pull right, momentarily pausing at the hairline. Continuing the stroke, apply pressure and release it, turning the nib counter-clockwise, to slightly widen and end the stroke.

Fig. 4 **Fig. 5**

(O) 1. **Entry:** As in Moto "a."
2. **Downstroke:** The "C" downstroke but slightly diagonal. (Fig. 6)
3. **Horizontal base:** Continuing, apply a little pressure and pull a short, shallow arc, keeping nib angle steady. A short hairline results and acts like a "saucer" to receive the second downstroke.
4. **Top stroke:** Replace the nib atop the hairline; inhale and push left; exhale and pull right to the hairline. Inhale and pause briefly. Exhale and continue pulling a short horizontal arc, slowing into an elbow bend, and inhaling as you make the bend.
5. **Second downstroke:** Exhale and pull a shallow, slightly diagonal arc aiming just to the left of the hairline and overlapping it . (Fig. 7) This takes practice.

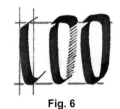

Fig. 6

Fig. 7

(Q) 1. **Entry:** As in Moto "a."
2. **Downstroke:** A shorter "O" downstroke. (Fig. 8)
3. **Horizontal base:** A little narrower than "O".
4. **Top and second downstroke:** As in "O".
5. **Tail:** Continue pulling the downstroke diagonally left and down, tapering to a hairline. (Fig. 9a) Push up and pause; then pull a shallow-arced diagonal tail through the baseline. (Figs. 8 and 9b)

Fig. 8

Fig. 9a **Fig. 9b**

(G) 1. **Entry, downstroke and horizontal base:** As in "O." (Fig. 10)
2. **Mid-horizontal:** Make a slab serif at or just above the midpoint—here, between the cap and baseline; pause. Slide the nib a little left in the wet stroke.
3. **Second downstroke:** Inhale, press-release; exhale, apply start pressure and pull the stroke just below the baseline.
4. **Curved roof:** See "C" above.

Fig. 10

Spacing: Upper & lower case

Keep upper and lower-case letterforms close together. Rather than by height, Moto caps are distinguished from Moto lower case by their design and their:

- weight—the bolder strokes of a flatter nib angle
- solidity—lack of hairline
- larger internal counters
- stroke character—curved rather than straight
- stroke endings—tapered or expanded

Tools: 3mm and 2mm Brause
Paper: marker/drawing/JNB
Guidelines: 5/8" (3mm); 9/16" (2mm)

1. Write words with both size nibs. (Figs. 8 and 9)
2. First write the words with ruled paper (not shown) and then ruled.

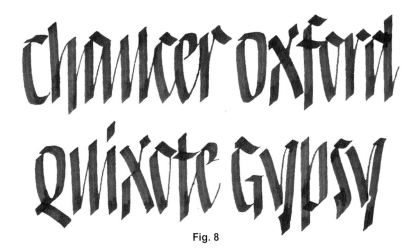

Fig. 8

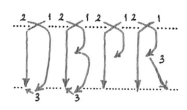

Fig. 9

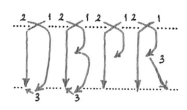

Fig. 1 Upper and lower case

"D" Letter family (DBPR)

Visual themes
- Stroke: straight and shallow curves (Fig. 1, 2 and 3)
- Bowl: narrow, unusual quadrilaterals (Fig. 3, red shapes)

Warming up

Tool: 3mm Brause **Paper:** marker/JNB

Fig. 2

Loosening up
1. Ink: dip and flick. Place the nib at 20° and move a hairline back and forth, like a metronome, steadily—slowly enough to feel the weight from the shoulder. (Fig. 4)
2. Ink: fully loaded. Place the nib at 20°. Inhale, press-release; exhale and pull a broad-edge stroke diagonally down. Inhale and glide up in the wet ink; exhale. Inhale and glide one nib-width to the right. Repeat.

Fig. 3

Note
Relax: feel the movement coming from the shoulder; feel the tactile sensation arising in the finger tips. Work slowly, as in meditation, coordinating the breath with changes in stroke direction.

Broad-edge pushups
1. Rule a horizontal line and a 20° angle line. (Fig. 5)
2. Ink: dip and flick. Place the nib at 20° atop the line at its base.
3. Inhale and push a short, broad-edge stroke diagonally up and to the left. (It's not necessary for the ink to stick.) Exhale. Inhale and let the breath lift the nib up but not off the paper. Exhale and retrace gently in the wet ink.
4. Inhale, press-release and lift the nib off the paper, moving it a little to the right. Exhale.
5. Repeat the pattern. When you are familiar with it, try to make the moves as subtle as possible.

Fig. 4

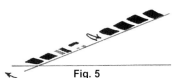

Fig. 5

Ductus and Dynamics

The unique feature of this family is the shallow, diagonal top stroke. Try the following exercise to get the idea and the feel of it. (Review "Negotiating the curve," p. 101.)

Fig. 1

1. Rule a horizontal line and place the nib at 20°. (Fig. 1)
2. As in the warm up, inhale, press-release and push a short diagonal up and to the left. Remember, the ink need not stick evenly.
3. Exhale, sink and pull back to the beginning of the stroke. Inhale, releasing the stroke's pressure; exhale and use start pressure to pull the stroke just below the line.
4. Inhale and pull around an imaginary point (red dot). Exhale.
5. Repeat; focus on finding the rhythm.

Fig. 2

Dry trace the following before using ink.

(D) 1. **Entry:** As in "a" but at 20°. (Fig. 2)
2. **Downstroke:** Inhale, press-release; exhale and pull to the baseline.
3. **Bowl:** Three strokes compose the distinctive bowl of "D":
 a. **Top:** Replace the nib atop the hairline; follow steps 2 through 4 above. Push the short diagonal a little left of the downstroke's left side. Note the triangle shape that forms between the top stroke and the downstroke. (Fig. 3)
 b. **Right side:** After pulling the elbow bend, exhale and apply start pressure as you pull the stroke almost to the baseline, keeping nib angle steady. Inhale, press-release; exhale and pull a nib-width-long hairline.
 c. **Base:** Inhale and push diagonally up and left to meet the downstroke. Exhale. Retrace if the ink doesn't stick.

Fig. 3

(B) 1. **Entry and downstroke:** Repeat those of "D".
2. **First bowl:** Make the top stroke above, only slightly shorter. Continue into the elbow bend. Apply start pressure as you come around and pull the stroke to mid-letter height—actual rather than x-height. Release pressure as you pull down and left, tapering to a hairline just shy of the downstroke. (Fig. 4)
3. **Second bowl:** Inhale, press-release; exhale and pull the stroke—parallel to the top stroke, but a little farther to the right. Inhale and pull into the bend; exhale and pull the stroke around. Apply start pressure and pull diagonally down, almost to the baseline.
4. **Base:** As in "D". The lower bowl is significantly larger than the top.

Fig. 4 **Fig. 5 Fig. 6**

(P) 1. **Entry:** As in "D."
2. **Downstroke:** Bring this stroke just below the baseline; choose either a twist-off or natural ending. (Fig. 5)
3. **Bowl:** Make the top bowl of "B", but slightly deeper.

(R) 1. **Entry:** As in "D."
2. **Downstroke:** As with "P." (Fig. 6)
3. **Bowl:** Make the top bowl of "B."
4. **Diagonal:** At the base of the bowl, pause and pull a diagonal to the baseline or kick a diagonal out above the baseline. (Fig. 7)

Fig. 7

Upper & lower case

1. Write words with 3mm and 2mm Brause nibs (5/8" and 3/8" guidelines). Try unruled as well as ruled paper. Extend the entrance to the letters of this family if greater energy and/or casualness are desired. (Fig. 8)
2. Look at a line of words upside down to train the eye to see strokes and spaces as directional lines and shapes. (Fig. 9) This helps you develop a graphic perspective.

Reminder: Change nib angle from 35° (lower case) to 20° (caps) to make the caps distinctly heavier. (This difference of 15° is not as noticeable at smaller sizes.) Flatten cap angle still more for greater contrast.

Fig. 8 3mm Brause

Fig. 9 2mm Brause

"M" Letter family (MNUW)

There are no diagonal strokes or triangular shapes in Moto's "M" family. (Fig. 1) Forming diagonals into triangular shapes with an edged pen requires advanced skill.

Fig. 1 Upper and lower case

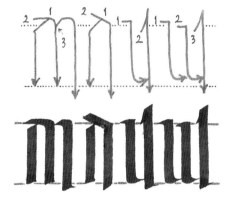

Visual themes
- Stroke: straight downstrokes and hint-of-a-curve short horizontals (Fig. 2)
- Entry: roof ("M and N"), slab and uptick ("U and W")
- Endings: twist-off and natural ("M and N")

Warming up
Loosen up with long and short swatches and hairlines, first with attention to the shoulder, then to moving the wrist in a fixed position. (Fig. 3)

Fig. 2

Tool: 3mm Brause **Paper:** marker /JNB

Stairs with "recoil" (Fig. 4)
Recoil is the action of making a stroke when, at the end, the hand pulls back a little from the direction of travel: a right moving stroke to the left, a downward one, upward.
1. Horizontal: Inhale, press-release; exhale and push the horizontal. At the end of the stroke, inhale and recoil.
2. Downstroke: Exhale and pull down. At the end of the stroke, inhale and recoil. Exhale. Repeat and make the stair pattern.

Fig. 3

Ductus and Dynamics

Begin with this elbow bend exercise. Use press-release to begin strokes.
1. Make a framework of verticals and horizontals with connecting hairlines. (Fig. 5)
2. Retrace the frame: apply a little pressure approaching the corner, release slightly and pull around it in an elbow bend; finish with end pressure. Lift and make the next one.

Fig. 4

(M) 1. **Entry and first downstroke:** As in "a"; make a natural or subtle twist-off ending. (Fig. 6)

Fig. 5

2. **Top stroke:** Place the nib atop the hairline entry. Inhale and push just left of the downstroke; exhale and push horizontally. As you approach the bend, inhale and pull around the bend. Preserve the empty triangle between the left downstroke and this stroke. (Fig. 6, red triangles)
3. **Second downstroke:** After rounding the corner, exhale and pull the stroke using start pressure. Exit the stroke with a natural or subtle twist-off ending at the baseline.

4. **Second top stroke:** Insert the nib in the second downstroke just below the cap line. (Fig. 6) Inhale, press-release and push a hairline one nib width above the cap line. Make the top stroke as above.
5. **Third downstroke:** Like the second, only finishing below the baseline. Exit as before.

Fig. 6

(N) 1. **Entry and first downstroke:** As in "M."
2. **Top stroke (roof):** Place the nib atop the hairline entry. Push diagonally up to a little left of the downstroke. Press-release and retrace the stroke. Press-release and pull a short, shallow diagonal. Recoil slightly. This action at the end of the stroke allows time to get set, in hand and mind, for a change of direction. (It also makes a stronger corner.)
3. **Second downstroke:** Press-release and pull to a little below the baseline. Exit with a twist off or natural ending.

Exercises
1. Make a few of each letter.
2. Alternate each cap with its lower-case version. (Fig. 1)
3. Write words. (Fig. 7)

Fig. 7

(U) Begin with an underhand elbow bend exercise:

1. Make a framework of verticals and horizontals with connecting hairlines. (Fig. 8)
2. Directly over the framework, apply end pressure to the short downstroke; release it slightly as you approach the corner (right angle), and pull around.
3. Press-release and push an upward hairline in the release. Repeat.

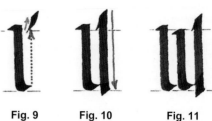

Fig. 8

1. **Entry:** slab serif (Fig. 9)
2. **First downstroke and bottom:** Use start and end pressure. Just before the baseline, slow and release the end pressure as you pull the elbow bend; continue across, less than a nib width, with a hint of curve; finish the stroke without a hairline. (Fig. 9)
3. **Second entry: a long uptick.** Lift the nib off the paper and move it directly up to the cap line. (Fig. 9, red dotted line) Move slightly to the left and place the nib on the paper. Push up, in a shallow arc, about two nib widths in length. Experiment with pressure.
4. **Second downstroke:** Pull down carefully, through the wet ink, and continue the stroke to just below the baseline. (Fig. 10) Exit with a natural or twist-off ending. Practice the uptick and downstroke apart from the letter to get the feel. Make the letter a few times.

Fig. 9 Fig. 10 Fig. 11

(W) This letter is literally two "U"s; the second one, though, starts just below the cap line. (Fig. 11) The "W" shares the same challenge as the "M": to make the two long, narrow counter spaces appear the same.

Upper & lower case

1. Practice the "M" letter family a few times.
2. Alternate upper and lower case versions.
3. Write words. (Fig. 12)

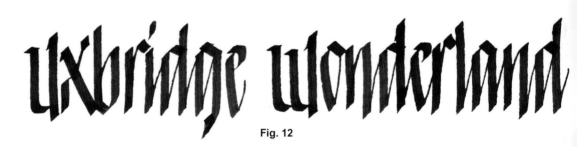

Fig. 12

"Hybrids" Letter family (AVYKSXZ)

Although letter strokes in this family may appear straight, they all partake of a subtle curvature. (Figs. 1 and 2) Developing the skill to make such strokes, as well as to see them, takes practice. (See the warm up exercise on the next page.) To begin, use a fully loaded nib to help you develop a line's slight but definite curve. Use a straight line and target/stretch points for reference; apply pressure patterns for energy and rhythm. In addition to curve quality, these letters display the spirit and many details of the other Moto caps.

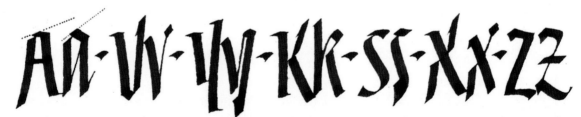

Fig. 1 Upper and lower case

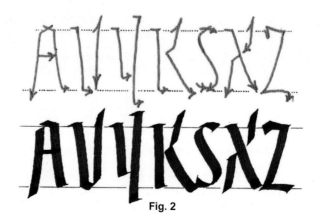

Fig. 2

Warming up

Exaggerating curves is a featured method for developing subtle ones.

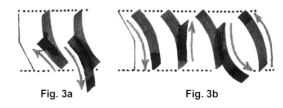

Fig. 3a Fig. 3b

Tool: 3mm Brause **Paper:** marker/JNB **Ink:** fully loaded
Guidelines: Use ruled and unruled paper. Consult your mood or flip a coin to decide which to start with. Fully experience each method.

Opposite-facing arcs (Figs. 3a and b)
1. Pull an arc down and to the right. As you make the stroke, imagine you are pulling an elastic band over an angled frame. (Fig. 3a)
2. Push back up and out of the arc, about halfway between start and end point. Bring the right nib corner to the left stroke wall.
3. Pull another arc partially over the first one: use the first arc's point of contact with the baseline as a target point. Bring the right wall of the second arc to and past this point. Repeat a few times.
4. Make sets in the other direction (Fig. 3b); then alternate the two. (Try inventing a warm up with the single curved upstroke at right.)

Ductus and Dynamics

Dry and wet trace the sequence of strokes composing each letter before working freehand. Also, experiment with dynamics while making the traces. Apply press-release to begin the strokes.

Tool: 3mm Brause **Paper:** marker/JNB **Guidelines:** 5/8" apart

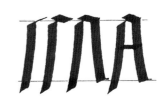

(A) Notes: An extended lozenge connects two slightly curved diagonal downstrokes to create a "soft" triangular form. (Fig. 4)

Fig. 4

The crossbar: Measure and set a midpoint using the letter's actual height. Set the crossbar close to this point and embed it in the downstrokes. Note; Its height, however, may be raised or lowered to change the attitude of the letter. Make a few "A"s and place the bar at a different setting for each. Note the differences in feeling.

A preliminary for "V" – The "soldered" hinge join

As in Moto "b," the second downstroke and base form a hinge join. Here, however, the strokes meet at slightly different angles. To bring them into alignment and stabilize the join, you solder it with ink. First, use a dry pen to trace Figs. 5a, b, and c according to the instructions below.

Fig. 5a Fig. 5b Fig. 5c

1. Place the nib at 20° atop a horizontal line. Pull a lozenge through it in a shallow diagonal. (Fig. 5a)
2. Lift the nib and change the angle to 35°. At this angle, just above the paper, place the nib's left corner at the right end of the lozenge (target point). (Fig. 5a, red arrow)
3. Move up a couple of nib widths. Return the nib to the paper and pull a stroke to the target. Press-release and pull a hairline that aligns with the bottom of the lozenge. (Fig. 5b)
4. Rock to the left nib corner (T), applying a little pressure on it as you do so. Push the corner up to meet the lozenge.

Fig. 6

5. Now use ink and a 3mm Brause to practice actual soldering. (Fig. 6) Note on using ink: In step 4, before rocking, press on the broad edge to release ink to the corner. As you push the nib corner up to meet the lozenge, it should draw a little ink in the process. Depending on nib size and the amount of ink deposited, this action should fill in, solder, the gap between the two different angles. (Fig. 5c)

(V) 1. **Entry:** slab serif at 20°
2. **First downstroke:** This stroke again determines letter posture. To make it sufficiently steep, use a nib-as-measure technique: the "plumb-line." Imagine a plumb line running from the beginning of the downstroke, at the cap line, to the baseline. (Fig. 7, left) Then, pull the stroke diagonally down, to about a nib width left of the plumb line; pause.
3. **Base stroke:** Pull a lozenge stroke through the baseline. Lift the nib and change nib angle to 35°. Align the left nib corner with the right point of the lozenge. (Fig. 5a) This now becomes your target point for air stroking: move up in a steep diagonal trajectory to the cap line—the start point of the second downstroke—back to the target, and again up to the start point. (See Air stroking, p. 44)

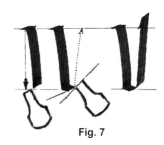

Fig. 7

4. **Second downstroke:** Just to the left, on the paper, make an uptick entry. Pull the downstroke to the base lozenge; when the two strokes meet, pause; pull a hairline and solder the hinge as above. (Steps 4 and 5 above)

(Y) 1. **Entry:** slab serif
2. **First downstroke:** Pull a steep diagonal, about three-quarters the depth of cap height, and make an extended twist off to end the stroke. (Fig. 8) Air stroke to set the trajectory or the second diagonal—a little above the cap line.
3. **Entry to second downstroke:** Place the slab serif a little to the left of the anticipated stroke.
4. **Second downstroke:** Press-release and pull a long, slightly arced diagonal, touching the ending of the first stroke (target) and continuing well below the baseline. Exit again with an extended twist off.

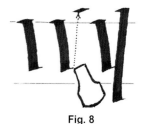

Fig. 8

(K) 1. **Entry and first downstroke:** As in "M."

2. **Top diagonal:** Place the nib at 35°, adjacent to the downstroke—at midpoint, or slightly higher. Push a short hairline upstroke a nib width in length. (Fig. 8) Lift the nib and move diagonally up to the cap line. Move a little to the left and push an uptick entry. Pull the diagonal down to the right end of the hairline (target point).

3. **Bottom diagonal:** Pull down and over the hairline; pause; pull the lower diagonal in a subtle arc to the baseline or just below it. (The letter that follows the "K" will help you decide.) Finish with a twist-off or extended twist-off ending.

Fig. 8

(S) Short top and bottom strokes overlap a long reverse curve to form pointed junctures and "lemon" counters. (Figs. 9 and 10) Dry trace the reverse curve of Fig. 10 with a #4 Automatic Pen. Dry trace the ductus steps of Fig. 11 with a 3mm Brause following the instructions below. Repeat using ink.

1. **Entry:** Place the nib on the cap line and pull a hairline down and to the left one nib width below the line.

2. **Diagonal downstroke** (Review the lower case "s" of Trapeze, p. 119.) Press-release and pull a short, shallow right-facing arc with end pressure. Use the energy of release to pull the diagonal section with end pressure. Release and pull into a slightly longer left-facing arc, ending with a hairline.

3. **Bottom stroke**
 a. Place the nib a little above the baseline, centered under an imagined plumb line. (Fig. 10, left red dotted line)
 b. Pull to the left and around in a tight curve; push to the right and overlap the hairline.

4. **Top stroke:** The same as that of "E" and "C." Pull into alignment with the right side of the diagonal, or a little shy of it. (Fig. 10, right red dotted line)

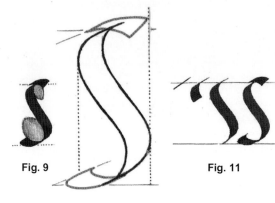

Fig. 9

Fig. 11

Fig. 10

(X) 1. **Entry:** Make a slab or uptick serif. (Fig. 12)

2. **Diagonal downstroke:** Pull a stroke with a twist-off exit. See Fig. 13 for possibilities.

3. **Right upstroke:** Place the nib at 35° inside the downstroke, a little above the midpoint (determined by actual letter height). Push a hairline one nib width in length; pause. Lift the nib and move diagonally up to the cap line. Move a little to the left, land and push an uptick entry a couple of nib widths. Pull to the target. (Fig. 12, red dot in the nib's left corner)

4. **Left downstroke:** Place the nib inside the initial downstroke at 20°. Pull a hairline down one nib width; pause. Pull to just below the baseline. This stroke is parallel to the top diagonal.

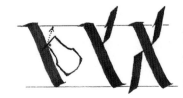

Fig. 12

The red dotted diagonals of Fig. 13 explore the potential of letterform to convey "attitude," or expressive posture, through variations in stroke direction. Changes in the entry and exit serifs contribute to such "character" formation.

(Z) 1. **Entry:** Place the nib just above the cap line and pull a short diagonal lozenge. (Fig. 14) Push diagonally back over this stroke and a little beyond it.

2. **Top stroke:** Pull a shallow diagonal to just below the cap line; flatten nib angle (a clockwise turn) to 0°, or as close as your hand will permit; pause.

3, **Downstroke:** Pull the diagonal—straight, slightly concave or convex. Work from the shoulder—there will be a lot of resistance. At the baseline, press-release and, in release, turn the nib counterclockwise back to a 20° nib angle.

4. **Bottom stroke:** Press-release and pull through the wet ink; press-release and continue pulling the stroke to just right of the juncture of the top stroke and the diagonal. To finish, press-release and pivot the nib counter-clockwise to 35°.

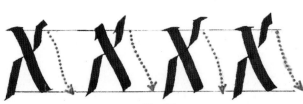

Fig. 13

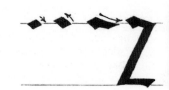

Fig. 14

Upper & lower case
1. Practice the Hybrid letter family a few times.
2. Alternate upper and lower-case versions.
3. Write words at a size of your choice. (Fig. 15)

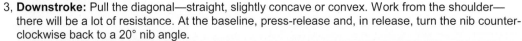

Fig. 15

Word as image

In this exercise, once again, allow the meaning of the word/text to suggest graphic ideas (graphopoeia, p. 72-3). To experiment with graphic potential, remember the design variables available for your use: scale/weight and size; plasticity and letter variants. (Fig. 1) Work slowly. Relax and enjoy the process.

 Tool and paper: of your choice

1. Write single words with upper and lower case letters. Start with the model letters.

Fig. 1

2. Choose your own text or use the one below. (Review Practice text, p. 171) This text, from *Tristram Shandy* by Laurence Sterne, combines a short text with a list.

Which shews, let your reverences and worships say what you will of it (for as for *thinking*—all who *do* think—think pretty much alike, both upon it and other matters—LOVE is certainly, at least alphabetically speaking, one of the most

A gitating
B ewitching
C onfounded
D evilish affairs of life—the most
E xtravagant
F utilitous
G alligaskinish
H andy-dandyish
I racundulous (there is not K to it) and
L yrical of all human passions: at the same time, the most
M isgiving
N innyhammering
O bstipating
P ragmatical
S tridulous
R iduculous—though by the bye the R should have gone first…

Stroke entry technique: press-release or press and release

Although you've encountered this technique in the previous two alphabets, before going further, let's focus on its particular action—one that sparks the energy for stroke and lettermaking as it initiates contact. All variations in stroke-entry technique have the intention of starting the flow of ink and connecting you to the stroke. This is a review and an exploration. Begin with the prototool, 1 or 2.

Press-release: as downstroke entry
1. Press-release is a concentrated point of pressure and its release—placed on an inhale—completed before starting a downstroke. The downstroke begins on an exhale and engages a stroke pressure pattern:
 a. Even pressure: This pattern begins, immediately after release, with a slight sinking of the shoulder—just enough to gain purchase for the stroke.
 b. Start, center, and end: Each of these begins at the start of the downstroke, as above, with a little sinking down. Or, instead of sinking, uses the release like a volleyball player: as a set-up for the stroke to come. In calligraphy, the initial act of throwing this stroke becomes the energy of pulling when sufficient pressure creates resistance to further progress.
2. Press, in place, on an inhale. Release on an exhale and, at the same time, throw-pull the downstroke into a pressure pattern.

Press and release: as upstroke entry
Inhale and place the nib. Exhale press; inhale, release and push a hairline up. You are ready to pull a downstroke.

Press-release: as stroke ending
1. At stroke end, a soft press-release helps you leave for another stroke (on/off the paper), initiate rocking to a corner, or begin nib turning.
2. This action allows you time to sight and take aim at a target point or points.

Note: As you've already discovered, skill in applying press-release—the timing, the amount of force, the breathing—develops slowly. The above patterns arose out of the raw material of my discoveries, which I happily share as a springboard to your own.

Training Alphabet 8: Satisfaction (yes, I get some!

After gaining a foundation through the previous alphabets, we now celebrate this accomplishment with Satisfaction and its dance-like character. (Fig. 1) As we have seen, the weighted downstrokes of Moto repeat to form fairly uniform letter structures. In Satisfaction,

Fig. 1 Satisfaction

we find letter structures with greater variation. Familiarity with such structural flexibility enhances your ability to create expressive letterforms. (Figs. 2, 4 and 6) To better appreciate the design element of structure, Satisfaction, with its diversity, groups letters by their structural similarity.

Fig. 2

Design

Characteristic angle

- Downstrokes: 30°—a little flatter than Moto (Fig. 3)
- Upstrokes: As in Moto, thin strokes are made with the corner of the nib, independent of angle.

Fig. 3

Visual themes

- Scale and proportion: A decrease in scale generally widens letter proportion. (Fig. 4)

Fig. 4 Moto, top; Satisfaction, bottom

- Stroke: Most have a subtle curve; a few letters—the "s, g and j"—display a more pronounced reverse curve.

- Stroke direction: In contrast to Moto's constrained parallels, Satisfaction offers lively directional variation. (Fig. 5)

- Counters, bowls, arches: Triangular shapes that are softened by making them with slightly curved strokes.

- Serifs: Entry—slab; ending—natural, but adding the finesse of touch (a hint of twisting off).

- Junctures: "Necks"—a narrowing between the top stroke and the second downstroke ("a, g and j"), and gaps—two strokes that usually meet are kept apart (e.g. "a").

Guidelines: In most letters, one or more strokes break through the waistline or baseline for a dance-like rhythm. (Figs. 1 and 6)

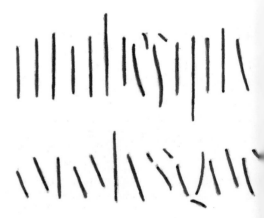

Fig. 5

slow down you move too fast

Fig. 6

1 Parallel verticals (ilft)

The slight curvature in Satisfaction's vertical strokes does not interfere with their being seen as "parallel." (Figs. 1 and 2)

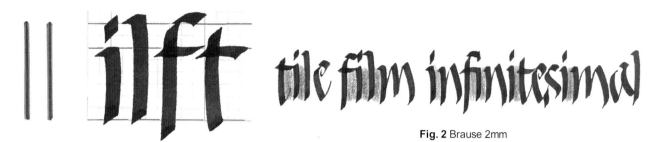

Fig. 2 Brause 2mm

Fig. 1 Speedball C-0

stretch —

end --

Fig. 3

Visual themes:
- Downstrokes: shallow arcs
- Crossbars: upward or downward facing

Spacing: The width of the slab serif serves as an aid to spacing. (Fig. 4)

Warming up

Tool: Speedball. This brand, a little less stiff than the Brause, broadens your experience with the dip nib. This size, C-O (larger than the 3mm), introduces you to working with a larger nib.
Paper: small-grid **Ink:** fully loaded

Ink swatch series (p. 142) Make strokes long enough to engage the shoulder as the driver.

Hugging
1. Rule a long vertical line on grid paper. Work on the right side of the vertical.
2. Set targets every four squares as alternating stretch and end points. (Fig. 3)
3. Inhale, press-release; exhale and sink a little in place, lowering the weight of the shoulder. Use even pressure, applying just enough pressure to feel resistance as you pull a shallow arc around the stretch point, and then to the endpoint. Repeat. Try to engage your bicep.

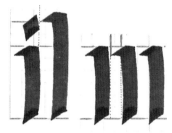

Fig. 4 **Fig. 5**

Ductus and Dynamics

To begin, dry trace the models following the instructions below; then use ink.

Tool: Speedball C-0 **Paper:** small-grid **Breathing:** Exhale strongly on the downstroke.
Guidelines: six squares (body height); eight (ascender height**)** **Angle lines:** 30°

(i) and **(l)** 1. **Entry:** Place the nib at 30°. (Fig. 4) For "i," pull a slab serif just below the waistline; for "l," pull the serif atop the ascender line.
2. **Downstroke:** Pull a shallow arc. Both letters nick through the baseline.
3. **Exit:** Press-release quickly and lightly at the base of the downstroke for a clean finish.
4. **Dot of "i":** Pull a short, slightly diagonal stroke.
5. Make a row of "i" strokes; use the entry slab as a gauge for spacing. (Fig. 5)
6. Alternate "i" and "l." After making the "i," lift the nib and, in the air, position the left corner adjacent to the top right corner of the stroke, at the waistline. (Fig. 4, red dotted line) Then, still in the air, move the nib directly up to the ascender line and pull the slab entry of "l." (Fig. 4)

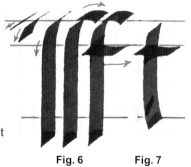

Fig. 6 **Fig. 7**

(f) 1. **Entry:** Place the nib atop the ascender line and pull a hairline one nib width below it. (Fig. 6)
2. **Downstroke:** Press-release and pull left a short way; pivot the wrist slightly to arc into the long vertical. As skill develops this may become a subtle reverse curve.
3. **Top stroke:** As in Moto cap "C" (See p. 180).
4. **Crossbar:** Use the "f" crossbar of Moto (See p. 162) or a downward-facing one by extending the top stroke of "f." (Fig. 1, crossbar of "t")

(t) 1. **Entry:** Place the nib just below the ascender line. (Fig. 7)
2. **Downstroke:** Press-release and pull to just below the baseline.
3. **Crossbar:** As in Fig. 6 or downward facing as in Fig. 1.

Rhythm exercise: Alternate "i" with each letter of this family.

Variants at play.

2 Vertical – right diagonal (nhmbp)

A letter's weighted strokes determine its structural framework. In this family, the vertical and right diagonal downstrokes are "weight bearing." A hairline, while an integral part of letter identity, is not. (Fig. 1)

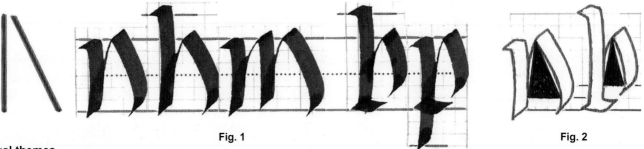

Fig. 1

Fig. 2

Visual themes
- Stroke: shallow arcs
- Arch: triangular counters (Figs. 2 and 3)
- Branching: above the x-height midpoint, close to the downstroke (Fig. 1)
- Proportion: Variable. Choice of a narrow, wide, or in-between "kick" width depends on the spirit or energy you wish to convey. (Figs. 3 and 5)
- Gap juncture ("b and p," Fig. 1): The diagonal comes toward the base but does not touch it, leaving the eye to connect the strokes.

Warming up
1. Make a quick ink swatch.
2. Practice hugging at 30°. (p. 164)

 Tool: Speedball C-0 **Paper:** marker/JNB
 Ink: dip and flick

Ductus and Dynamics
Before using ink, dry trace the figures following the instructions below.

 Tool: Speedball C-0 **Paper:** small-grid
 Guidelines: six squares (body height); eight (ascender)
 Angle lines: 30°
 Tool hold: Check the position of the shaft. Remember: tool hold mediates the pressure of contact.

Fig. 3 "Kick" width, the distance of the diagonal from the downstroke, corresponds to letter proportion.

(nhm) 1. **First downstroke:** See "i" and "l."

2. **Upstroke branch:** After pulling the downstroke, push about midway back up the stroke; rock to the right corner and branch, pushing a thin upstroke to the waistline. (Figs. 1 and 4) In this alphabet, branching is relatively high.

Fig. 4 Red line, path of air stroke; red dots, stretch and end points

3. **Diagonal downstroke:** First, dry trace the diagonal of Fig. 4 following steps a and b below:
 a. From the top of the stroke, air stroke a straight line to the lower point—the red dot, about three squares to the right and one above the baseline—and then back.
 b. Place the nib on paper; partner with the left corner (T) and pull a diagonal arc. Use the air-stroked straight line as an imaginary guide to pulling an arced diagonal—using an imaginary stretch point. Practice this stroke a few times to feel an elastic stretch.
 c. Dry trace the entire letter, then use ink and ruled grid paper.

Width training
First, experiment with a Speedball C-0 on small-grid paper with guidelines six squares apart; and second, with a 3mm Brause on marker paper with guidelines ½" apart. Alternate "i" with "n." Varying kick width also varies letter proportion. (Figs. 3 and 5)

Fig. 5 Kick widths:
top to bottom: medium, narrow, and wide

Ductus and Dynamics, cont.

The diagonals of "b" and "p" also produce bowls. Like the diagonals of "n, h, and m," they may also kick away from their downstrokes at different distances. (Fig. 9)

(b) 1. **Ascender:** As in "l." (Fig. 1, p. 190)
2. **Base:** At the bottom of the ascender, push the nib to the left until the right corner meets the left stroke wall. Pull to the right, a little down, and just into the baseline.
3. **Upstroke branch:** Replace the nib inside the downstroke, about midway between base- and waistline, and push it up a short way. Rock to the right corner and push the branch to the waistline.
4. **Diagonal:** This subtle arc completes the bowl. Be sure to stop the stroke above the baseline and slightly to the left of the bottom stroke base—and to leave a gap.

(p) 1. **Descender:** Place the nib just below the waistline; push a slab serif and pull the descender to the descender line. (Fig. 1, p. 190)
2. **Upstroke branch and diagonal:** As in "b."
3. **Base:** After finishing the diagonal, use the momentum to carry the nib to the left in the air. Place it as in "b," with the right corner at the left stroke wall. Pull to the right and a little down—just into the baseline and past the ending of the diagonal.

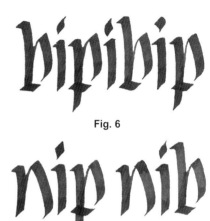

Fig. 6

Fig. 7

Spacing: words, scats, and kick practice
1. Alternate "b" and "p" with "i" (Fig. 6) and write words. (Fig. 7)
2. Make a scat using "i" after each letter of this family. Use a 2mm Brause with guidelines 5/16" apart (about four nib widths). (Fig. 8)
3. Kick practice: Make each letter at three settings; use air stroking to help place an "i" between each group. (Fig. 9)

Fig. 8

Fig. 9

3 Parallel diagonals (agducevw)

This structural framework includes letters which, in previous alphabets, were sorted into three different families: "a," "o" and "v." Here, organizing letters according to a structural similarity trains the eye to see from another perspective.

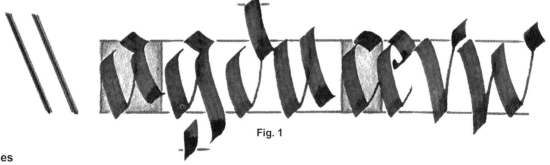

Fig. 1

Visual themes
* Strokes: subtle diagonal arcs and a reverse curve ("g")
* Counter: "triangular"
* Proportion: varies (Fig.1, red boxes)
* Junctures: neck (narrowing between the top stroke and the second downstroke of "a and g"); overlapping ("v and w"); and gaps ("a, g, and d")

Warming up: "Bowstring"

In this relaxation-meditation exercise, get the feel of the right-facing arc ("a, d, g, and u") by pulling it over an angle frame with a built-in stretch point. (Fig. 2)

Tool: Speedball C-0 **Paper:** small-grid **Ink:** fully loaded

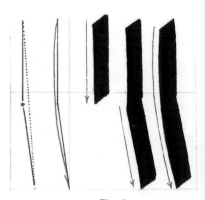

1. Set targets for the angle frame: A midpoint seven squares straight down; an end point, seven squares down and one to the right. The midpoint becomes the stretch point when the frame is complete.
2. Build the frame: Inhale, press-release; exhale while sinking the shoulder and, with even pressure, pulling to the midpoint. Inhale and push back to the top in the wet ink. Exhale. Inhale, press-release; exhale while again sinking from the shoulder and pulling with even pressure to the midpoint. Pause. Repeat this breath-stroke pattern to the endpoint. Pause. Inhale and push gently up in the wet ink to the top of the angle frame.
3. Stretch the arc: At the top, exhale, sink the shoulder and pull an arc to and around the stretch point, finishing at the end point. Repeat.

Fig. 2

Ductus and Dynamics

Before using ink, dry trace the models and figures following the instructions below. See p. 191 for models.

Tool and paper as above **Ink:** dip and flick

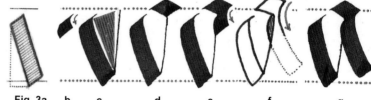

Fig. 3a b c d e f g

(a) 1. **Entry and first downstroke**
 a. Begin with an air stroke: just below the waistline and just above the paper. (Fig. 3a) Bring a straight diagonal through the baseline and retrace its path in the air.
 b. Make the stroke: Place the nib just right of the air stroke. Press; in release pull a short vertical arc. (Fig. 3b)
 Apply soft start pressure and pull a diagonal arc around the imaginary straight air stroke and through the baseline. (Fig. 3c)
 c. Note: If you wish to create a smooth stroke ending, see "Refinement," p. 197.
2. **Upstroke:** Press-release and rock to the right nib corner, scooting the corner a tiny way to the right. (Fig. 3c) Quickly swing the hand to the right and push up to the waistline. (Unlike in Moto's upstroke, the nib is no longer in wet ink.) If you need to pick up more ink return the full edge to the base of the stroke and press-release again. Lift the nib.
4. **Top stroke:** Place the nib at 30°—just above the waistline and a little to the right of the first downstroke. Inhale and push up a tiny way; exhale and pull an extended lozenge to the upstroke. (Fig. 3d)
5. **"Neck" juncture:** A narrowing between the top stroke and the second downstroke. (Fig. 3e) At the end of the top stroke, pause and pull to the left in a shallow vertical arc that overlaps the upstroke and enters slightly into the counter. (Fig. 3f)
6. **Second downstroke:** Continue parallel to the first to a little above the baseline. (Fig. 3g) Press and release the stroke with a little twist (clockwise) pull to the right. You'll get the knack with practice.

(g) 1. **Second downstroke:** The neck leads into a reverse curve and finishes a little above the descender line.
2. **End stroke:** Pull a short vertical from just below the baseline to just below the descender line. The space between introduces a variation on the gap juncture above and repeats the motif.

(d) 1. **Upstroke:** Continue past the waistline toward the ascender line. If the ink runs out, no matter.
2. **Second downstroke:** Replace the edge at 30° just above the descender line. Pull this downstroke parallel to the first, a little below the waistline.

(u) 1. **Entry and first downstroke:** Place the nib just below the waistline; press-release and pull an arced diagonal downstroke.
2. **Upstroke:** Push a cornered thin as in "a." Replace the edge above the waistline.
3. **Second downstroke:** Pull a diagonal paralleling the first stroke to a little above the baseline.

(c and e) 1. **Roof:** Pull a short convex arc; **Roof ending:** Experiment with applying a little pressure to the left corner (T) as you take the nib off the paper.
2. **The "eye" of "e":** Pull a roof a little longer than that of "c." Rock to the left corner; pull it diagonally down and then push it up. Leave a little gap between the short upstroke and the first downstroke.

(v and w) The second counter of "w" begins with the downstroke of "a."

Fig. 4 Family scat practice.

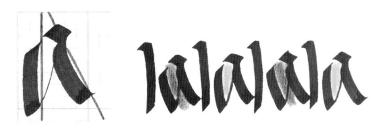

Fig. 5

Family practice

Tools: Speedball C-0 and Brause 3mm
Paper: small-grid and marker/JNB
Guidelines: C-0, 7 squares; 3mm Brause, ½"
Angle lines: 30°

1. Write this family a few times: first with the Speedball, then with the Brause.
2. Alternate each letter with an "i." Check spacing. Note the greater space after the open bowls of "c and e."
3. Write words. (Fig. 5) Suggestions: vigilant, deduce, garden, diva, educate.

Fig. 6 Fig. 7

Experiments

Variant structure
1. Make the first downstroke vertical and the second diagonal. (Fig. 6) (In the model "a," the downstrokes are parallel diagonals.)
2. Alternate the model with the variant, placing an "I" between them. (Fig. 7) Use tracing vellum and draw structural lines through your letterforms and/or color the counters.
3. Write words: First stay with one structure per word (Figs. 8a and b); then mix them up. (Fig. 8c) The letters "a, g, d, and u" are suited to this exercise.

Fig. 8a Fig. 8b

Fig. 8c

Overlapping strokes
Where one diagonal follows another, try placing the second over all or part of the first. (Figs. 9 and 8c)
1. Trace first to get the idea.
2. Remember that the plasticity of the second family—vertical and right diagonal—allows you to stretch the second downstroke beyond the "wide" kick width. (Fig. 9, "m")

Fig. 9 Overlapping strokes

Play
1. Trace Fig. 10 to get more ideas about stretching strokes.
2. Experiment with letter height, plasticity, and letter variants: start with exaggeration—subtlety develops from bold beginnings.

Fig. 10

Alternate upstroke

1. At the bottom of a diagonal downstroke, lift the nib and position it below the stroke at a steep angle.
2. Push a hairline up—straight, in an arc, or in a reverse curve—to the waistline; or,
3. Begin on the edge; push up and lift the right corner as you continue to the waistline. (Fig. 11)
4. Write words using this upstroke. (Fig. 12)

Fig. 11

Fig. 12 *amandine ambivalence diva*

4 Converging diagonals (oqy)

Although this structure resembles the "v" family of most alphabets, here, only converging full-edge *weighted* strokes characterize family members. (Fig. 1) (Note: the "q" takes the form of a capital letter.)

Visual themes
- Strokes: thicks—"weight-bearing" shallow arcs; thins—a feature of style rather than letter identity. Like ornaments in music, they add liveliness and a sense of play.
- Counter: soft triangle
- Juncture: gap (top and bottom of "o" and "q")

Warming up: facing arcs

Tools: Speedball C-0 and Brause 3mm **Paper:** marker/JNB

1. Fig. 2a: Place a fully loaded nib at 30° and pull an arc large enough to engage the shoulder. Push the upstroke slightly to the right—partially in wet ink.
2. Repeat this down-upstroke to make a swatch. (Fig. 2a) At the base of the last stroke of this swatch, arc up vertically and make a facing arc swatch.
3. Fig. 2b: Pull a single arc stroke; retrace about midway up the stroke. Rock to the right corner (IF) and push a thin up and over. Pull a facing arc. Retrace and repeat the pattern.

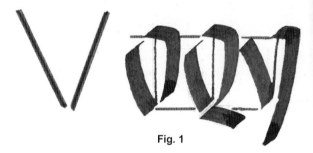

Fig. 1

Fig. 2a **Fig. 2b**

Ductus and Dynamics

Before using ink, dry trace Fig. 1 (Speedball C-0) and Fig. 3 (Brause 3mm). Focus, one at a time, on one of the aspects below. Then try combining them.

- Stretch the shallow arcs over imagined straight diagonals.
- For full-edge strokes: Apply even or patterned pressure to better direct and stay with the stroke, and to give it rhythm.
- For thin upstrokes: Rock to the right corner and push the upstroke (T). Coordinate the breath with changes of stroke direction—generally: inhale, up and exhale, down—with a brief pause between.

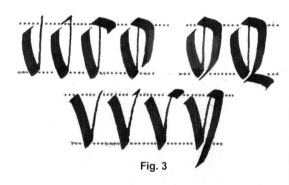

Fig. 3

Spacing

1. "Triplets": Place a vowel before and after each letter of this letter family. (Fig. 4, the "o") Aim for even spacing between letters and triplets.
2. Write words. (Fig. 5) First, focus on letterform; rewrite and focus on spacing.
3. Trace your own forms, or mine, to look for their rhythm. Remember to breathe: inhale, up; exhale, down.

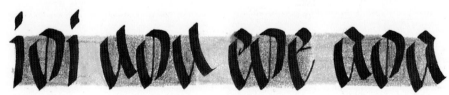

Fig. 4

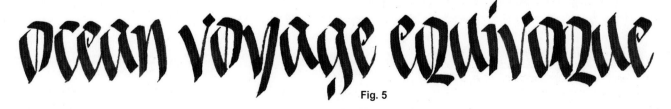

Fig. 5

5 Hybrid structures (szxrkj)

The letters of this family don't share the same structural pattern. However, they do share Satisfaction's characteristic nib angle, scale, and curvilinear stroke—as well as stylistic features (serifs, neck and gap junctures). (Fig. 1) Fig. 2 reveals the nuances of the curvilinear strokes by contrasting them with a straight blue line. This is a good way to find the farthest swell, or stretch point, of any stroke's curve.

Warming up

Choose a warm up for each letter based on one of its strokes. Review previous warm ups for ideas or create your own.

> **Tools:** Speedball C-0 and/or Brause 3mm
> **Paper:** marker/JNB
> **Ink:** dip and flick

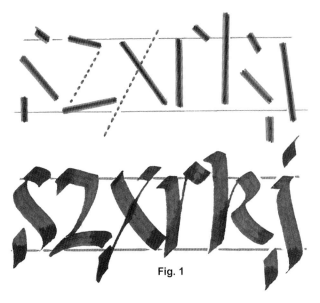

Fig. 1

Ductus and **D**ynamics

Using the instructions below, dry trace Fig. 2 with a Speedball C-0; then use ink and a 3mm Brause. Apply dynamics and breathing for dry and wet.

(s) 1. **Entry:** Begin a hairline downstroke just above the waistline and pull to just below.
2. **Downstroke:** Begin the reverse-curve diagonal just below the waistline and end at the baseline.
3. **Finish stroke:** The last stroke of "g."
4. **Top stroke:** As in "c."

(z) 1. **Entry:** Start with the nib's left corner on the waistline; pull a short way below it; retrace the stroke.
2. **Top stroke:** Pull a shallow diagonal, with a hint of reverse curve, to the waistline or just above it.
3. **Downstroke:** Pull a diagonal arc to the baseline; pause; push a little to the left and down and just through the baseline. The stroke will widen slightly with the change of direction.
4. **Bottom stroke:** Pull a shallow diagonal arc, ending a little above the baseline. (Note: The horizontal base stroke extends to the left and right of the top horizontal.)

(x) 1. **First downstroke:** Start just above the waistline; pull a shallow diagonal arc ending at the baseline.
2. **Second downstroke**
 a. Entry serif: Pull a short horizontal slab atop the waistline.
 b. Diagonal downstroke: Steepen the nib angle (pivot counter-clockwise) and pull a thin, curved hairline below the baseline—hopping over the double-walled downstroke. Lift the nib and set the right corner adjacent to the downstroke at the waistline (30°).
 c. Exit serif: Press-release and pull to the bottom of the downstroke.

(r) 1. **Downstroke:** Pull the "i" stroke.
2. **Branch:** Push up and out of the downstroke and through the waistline. Place the full edge at 30°, just left and on top of the branch.
3. **The "ear":** Pull a short stroke diagonally down: either ending it slightly up, as here, or down, as in the top stroke of "c."

(k) 1. **Downstroke:** Pull the "I" stroke.
2. **Branch:** At the base of the stroke, push up as in "r." Rock to the right corner and arc a cornered thin to the waistline.
3. **The loop**
 a. Lift and reset at 30°. Pull a short diagonal down; pause.
 b. Pull tightly around and down to just shy of the downstroke.
4. **The diagonal:** Pull a shallow diagonal arc and finish above the baseline.

(j) 1. **Entry:** Pull a short horizontal slab serif.
2. **Downstroke:** As in "g," including the neck juncture.
3. **Finish stroke:** The last stroke of "g" and "s."
3. **Dot:** Pull a short stroke in a shallow vertical arc as here, or see the "i" (p. 189).

Fig. 2

196

Spacing

Tool: 2mm Brause **Paper:** marker/JNB **Guidelines:** 5/16"

1. Make triplets using the hybrid family. (Fig. 3)
 a. Dry trace to help see the variation in the distance between strokes in the different letter combinations.
 b. In ink, write the three-letter units as though they were a word, with attention to the space between them as well as the space within them. First, work fairly quickly; then, rewrite and make adjustments more slowly.
2. Bow words; use a scale a little greater than 4 nib widths. (Fig. 4) Note the basically parallel structure used in "h." This emerges naturally with bowing.
3. Write words using this family. (Fig. 5)

Fig. 3

Fig. 4

Fig. 5

Alphabet design: plasticity and expression

Satisfaction shows that an alphabet, in addition to its characteristic angle, scale and proportion, may be recognized by the structural pattern/s of its letters. These design variables offer possibilities for graphically expressing some facet of a text's meaning. (Graphopoeia, p. 72-3) Write words and experiment with each variable in turn. Which trials bring you closer to a visually resonant meaning?

Fig. 1

Scale and proportion

Scale can be adjusted to support expressive purposes. (Fig. 1) Play with such words as "daffodil" and "peaches."

Variant structure 1:

vertical and left diagonal (Fig. 2) This structure, applied to "n, m, and h," creates a "squared" arch. Fig. 3 contrasts this structure with that of Satisfaction. The variant's left-pulled diagonal seemingly inflates the counters of "n" and "h" to suggest a rightward momentum.

Satisfaction's arch is more static, its triangular base giving a sense of stability.

Fig. 2

Fig. 3 Variant 2, left; Satisfaction, right

Tools: 3mm Brause, C-0 Speedball **Paper:** tracing vellum

1. Dry trace Fig. 2. To give similar weight to the diagonals and verticals it's necessary to flatten nib angle: turning the nib clockwise as you pull the bend into the diagonal, or just after. Note: Nib angle and stroke direction interact to determine stroke thickness. With nib angle constant, the three different directional strokes of Fig. 4 exhibit three different stroke widths.
2. Experiment with nib angle: try to make the three directional strokes of Fig. 4 similar in width.

Fig. 4

Variant structure 2:

diverging diagonals (Fig. 5) This structure may be applied to the "n, m, and h," as well as the "a," to create a sense of movement and expansiveness.
1. Dry trace the words with this letter structure. (Figs. 5 and 6, next page.)
2. Compare the word "magnificent," written with the model Satisfaction and with variant 2. Note changes in the feeling of the words.

Fig. 5

magnificent

magnificent

Fig. 6

Variant 2, cont.

1. Compare the two variants and the
 Satisfaction alphabet model. (Fig. 6)
2. Choose a word and write it using
 all three structures. (Fig. 7)

enigma enigma enigma

Fig. 7

Mixing it up

Fig. 8 contrasts changes in scale and combines a variety of structures. These include those of Satisfaction and its variants, and the parallelism of Moto's verticals. These verticals, however, incorporate Satisfaction's subtle curves.

1. Choose a word.
2. Use Satisfaction as a base for experimenting with scale/proportion/weight,
 letter structure, and line quality (curve, straight).

Writing as pattern

Here, we focus on using an alphabet for its distinctive visual character to create a decorative band. The variables of height, width and weight are used to express graphic meaning, which may/may not be related to verbal meaning.

1. Choose a phrase or sentence.
2. Try two different styles, such as Moto and Satisfaction, or two variations of
 Satisfaction. Compare their decorative impact.
3. Experiment: Impose a pattern. Fig. 9 uses a zigzag in which the thick diagonals abut each other at waist- and baselines. Some letters may refuse to conform. No matter. See what happens and decide if it "works." If you're not sure, give it time.

geranium

nasturtium

Fig. 8

wandered lonely as a cloud

Fig. 9

At play: "a wholehearted hand"

a wholehearted hand

Refinement: a smooth stroke ending

The natural ending of a stroke, such as that at the base of "a," may have a slight roughness and concavity. (Fig. 10, left) To smooth it, make a square or curved ending with cornering technique. At the base of the stroke, press-release and rock to the left corner. Draw the inked nib corner across the bottom of the stroke in a straight or arced thin. (Fig. 10, middle) Depending on the amount of ink and the size of the nib, there may or may not be a gap between the line and stroke ending. Use the corner to pull ink into the gap if necessary. This refinement is more common for slightly larger letters where it is more visible. It develops gradually.

1. Dry trace Fig. 10, following the above instructions, using an Automatic Pen to get the
 feel of the moves.
2. With ink, use a Speedball C-0 and 3mm Brause to make straight and curved stroke endings.

Fig. 10

Practice text

Text as image: shape

The object of this exercise is to fit a text within a square or rectangle. We now take advantage of calligraphic plasticity—stretching of contracting letter strokes—to create a justified text block. In the manuscript tradition, there is ample evidence of the scribe's desire for such alignment. However, given the exigencies of manuscript production, the only possibility was a just-in-time letter compression or extension executed at the right margin. Today's calligrapher, working under different circumstances and for different purposes, consciously shapes a text to help express its artistic intent.

To create a justified text block requires one or more preliminary roughs. These trials provide the time to discover and make adjustments in letter and word spacing, and letter extension or contraction. Through these trials we become aware of the script nuances of a particular text. (Those who use a computer will miss this experience!)

A fitted text is a challenge. Let excitement displace doubt! Let me guide you by instructions, in Roman print, and thoughts on my process in Italic print.

Preparation

1. Purpose: To construct a text shape—square/rectangle—using a grid and Satisfaction.
2. Text: Let the character of Satisfaction, and the spirit of the chosen text shape, help guide your selection. Some ideas:
 a. Satisfaction treated seriously—a text for which the connotations of a square might be appropriate.
 b. Satisfaction considered satirically—a light-hearted, playful text set within a geometric "lock up;" a mock set of instructions for making a device; or, a "notification" in which the absurd nature of the text undercuts the authority implied by the shape.

 My text is from an address by Chief Seattle (Sealth): This we know, all things are connected, like the blood which unites one family. All things are connected. Whatever befalls the earth, befalls the sons of the earth. Man did not weave the web of life; he is merely a strand in it. Whatever he does to the web he does to himself. Chief Seattle

Text shape

Whether a square or a rectangle, with its possible variation in proportion (Fig. 1), each shape has a different connotation. *In choosing a square I embraced the contradiction between square-as-foundation (upon which something—such as a new way of life—grows), and the square-as-box (a constraint upon change/creativity).*

Fitting: Fitting a text, like fitting a shoe, involves taking the measure of its length and width.

 Tools: 2mm, 2½ mm, or 3mm Brause
 Paper: marker/JNB and tracing vellum
 Use a fluid format for this exercise. Start with paper you think will be larger than the envisioned text.
 Ruling equipment: (See pages 124-5.)

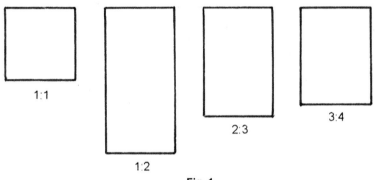

Fig. 1
Note: One might consider 1:1 stable and static;
1:2 active; 2:3 refined; 3:4 practical.

1. Count the number of words in your text. *There are 55 words in my text, including the author's name.*
2. Estimate the number of lines needed to fit this number into your text shape. *For a square, I started with a 1:1 ratio between the number of words and the number of lines. This yielded seven lines of eight words or eight lines of seven words. I tried the latter because it would leave shorter lines, ones that required stretching letters to fill out the square.*
3. Rule a base- and waistline, and write a line of text with the chosen number of words. *I wrote a line of seven words; body height—three eighths of an inch.* (Fig. 2, next page)
4. Estimate interlinear space: start with the default measure of a body height letter.
5. Cut a short paper ruler and mark two line spaces. (Fig. 2, p. 199) Cut a longer paper ruler and mark the estimated number of lines with the shorter paper ruler. *For my square—eight line spaces.*
6. Draw the shape these measures of width and length produce. *Mine created a horizontal rectangle.* (Fig. 2, p. 199, solid red lines)
7. If this does not yield the desired shape, continue to experiment with the line width and interlinear space. *A shorter line width was needed. Using the already written line, I measured the width of six words and marked out a new text length of nine lines (55 words divided by six equals 9 lines). This yielded a vertical rectangle (dotted red lines) and prompted me to juggle the numbers. First, I slightly decreased the interlinear space; then, using a six-word line as my new width (blue lines), I shaved off a sixteenth of an inch to correct a well-known graphic illusion. (An exact square appears slightly wider than it is tall.) This allows me to stretch the letters in lines that are too short, as is my intent. Ascenders, rising above the initial waistline, and descenders, dipping below the final baseline, complete the correction.*
8. When you have measurements for your line spaces, make a paper ruler.

Tip: I recommend placing small, lightly penciled numbers just left of each writing line to indicate which line of text and where it begins. These numbers will then correspond to the numbered lines of your text. This is a good habit: it will help ensure an accurate writing.

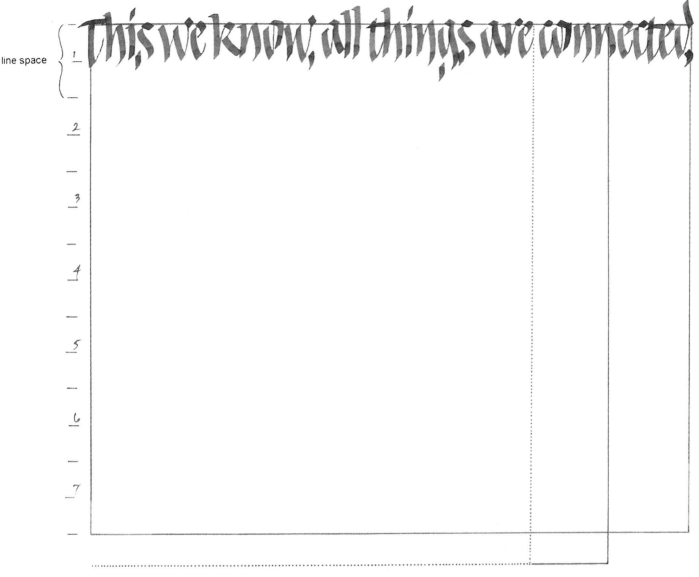

Fig. 2 The process of fitting text

First rough (of the full text)

I encourage you to make this rough in a relaxed spirit, freely, as raw material for further roughs.

1. Rule a grid: Mark text width and, with a right triangle, rule vertical margins. Tape the paper ruler next to the left edge of the paper and rule line spaces. *On this ruled paper, I inserted small, lightly penciled numbers to indicate placement for each line of writing.*

2. Write the text without making any adjustments to letter width. (Fig. 3)

3. To adjust the lines of writing that fall short of the right margin, consider letters suited to stretching and pencil a small check mark above them. (Fig. 3) One per word may be enough. Be sure to proofread.

4. Has the spirit of the text sparked any changes in letter design or suggested a ligature? *I changed the eye of "e" to present a more serious "demeanor," developed a ligature for "f-a" and a new "n-s" combination. (Fig. 4)*

Fig. 4

Fig. 3

200

Second rough (Fig. 5)

1. On tracing vellum, rule another grid.
2. Place this sheet over the first rough.
3. Write the second rough on the tracing vellum. Before beginning each line, consider the letters you have checked for stretching and experiment with them as you write.
4. Remain aware of the right margin, sliding the paper to the left as you work to keep track.
5. If graphic ideas arise for using plasticity, ligatures or variants, take another sheet of paper and explore them. *Here, I tested ideas for ligatures with "w-h" and 'w-e." (Fig. 6) The "w-h" succeeded but the "w-e" efforts were discarded for the finished piece. What works is ultimately the sum of your judgment at any stage in your development.*

Fig. 6

6. Partial roughs: Rewrite any lines that don't end at the right margin or distribute the space and extensions as you wish. When you are satisfied with the forms and their distribution, continue to the next full-text rough. Tape these line changes to the text rough.

Third rough

1. Rule the grid on marker/JNB paper.
2. Rough in hand, fold the paper a little below the first line.
3. Tape this line a little above the writing space. It now becomes a template for reference. When you write, refer to it frequently.

Note: Make more roughs until you are satisfied.

Tip: To avoid a tangle of descenders and ascenders in interlinear space:
- Approach 1: Rule a descender-ascender line in the middle of the interlinear space. (Fig. 7a)
- Approach 2: Without a ruled descender-ascender line, especially in a shallow interlinear space, one body height or less, leave the descenders incomplete at the baseline. Finish them after the ascenders are added—line by line or after finishing the text. (Fig. 7b)

Note: Take time after each rough to look at the text as a whole. From this broad perspective, you may decide against a graphic idea you are testing, spawn a new one, or recall an earlier solution. *After reviewing my first and second roughs, I decided to make a new "d," one that did not stand out but blended with the text. (Compare the ascenders of "d" in Figs. 5 and 8) I also minimized the stretching of some of the letters. These changes helped the text to speak with one voice. (Fig. 8)*

Fig. 5

Fig. 7a Fig. 7b

Fig. 8

Fig. 9
Note. Centering a square top to bottom: to appear centered, allow slightly more space for the bottom margin.

Composition

Tracing paper/vellum and frame strips

1. Place the text on a larger sheet of paper. Over both, place a piece of tracing paper/vellum the same size as the larger sheet.
2. Move the frame strips toward and away from the text to determine margins. This space surrounding the text does more than frame it. The relationship between the text and the field can evoke the significance of the text to you, to society. It can help express a mood: e.g., elegant (relatively large margins) or in-your-face (no margins at all). In general, extensive space around a text lends greater significance to it, perhaps even a sacredness. (Fig. 9)

Completion

1. Measure the opening—width and height—between the frames and cut the finish paper to these dimensions.
2. Rule and write.
3. Erase grid lines.

Training Alphabet 9: Satisfaction caps

More dancer than soldier, this variation of the Roman capital is a long way from its origin. In energy and spirit, Satisfaction caps close-ly resemble the companion lower-case letters: nearly half are the same or similar in design. (Fig. 1, red dots). The others use lower-case serifs, branching and gap junctures. These caps are slightly taller than lower-case letters. (Fig. 2)

Fig. 1 Satisfaction caps: a red dot over a character indicates an enlarged lower-case letter.

Design

Nib angle: 30°, or slightly flatter. Satisfaction's caps and lower case are quite similar in weight (Fig. 2), unlike those of Moto.

Fig. 2

Guidelines: To clearly distinguish these caps from the lower-case, the cap line rises above the waistline. (Figs. 2 and 3) Note: An increase in height also increases a letter's area.

Visual themes
- Stroke: a greater or lesser degree of curve.
- Cap-lower case ratio: As noted in Jumprope caps, this relationship is an expressive element; the "Rome" of Fig. 4d is a different one from that of 4a, b or c. Again, the cap line serves as a reference, not a ceiling.

Fig. 3

Fig. 4a, b, c, and d

- Entry serif: the short horizontal slab.
- Endings: natural, twist-off, and slightly manipulated (See p. 203, "Exiting a typical downstroke."
- Junctures: branching, overlapping, and gap—as in the lower-case forms.

Proportion: variable, but non-classical.

Part-to-whole: The letter-bowl-to-downstroke ratio is another design variable which expands your expressive options. (Fig. 5)

Letter families: grouped by structural pattern.

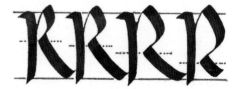

Fig. 5

Ductus and Dynamics

These caps build on what you know. (Fig. 1) Those using new techniques are described in the notes below. Warm up before making letters. Practice each new technique before making a letter.

Tool: 3mm Brause **Paper:** marker/JNB **Guidelines:** 9/16" **Angle lines:** 30° **Ink:** well-flicked or lightly wiped nib

1 Parallel verticals (IJLEHTF)

- **"Slide" junctures** strengthen the join between horizontals and downstrokes. At the base of "L" and "E," pause. Slide the nib to the left until the right corner touches the left wall of the downstroke. Pull sensitively through the wet ink and bow the lower horizontal. In the release of pressure, direct the stroke, with the fingers, slightly upward and to the right. For the top horizontal of "E" (and "F," if desired), place the nib atop the entry and slide back and across as above.

- **Cornered juncture of "F":** Place the nib in the wet ink of the downstroke where the slab joins the top stroke. Press-release and rock to the right nib corner and, with the thumb, push a short way above the cap line to produce a spur. Replace the nib at 30° and pull the top stroke downward.

 Exiting the downstrokes of "I," "H," "T," and "F": a couple of "touch tactics"
 1) At the baseline, press and partner with the left nib corner (T); release as you pull off the paper a little to the left and below the baseline.
 2) Finish the downstroke with end pressure applied by the thumb; as you release this pressure guide the exit with the index finger, down and to the left. As the nib leaves the paper, the hand follows it. This subtlety imparts a strong but nuanced finish. It is revealed to the eye as the hand achieves it.

2 Vertical – right diagonal (DPRB)

- **Branching:** After making the downstroke, lift the nib and steepen nib angle. Replace the nib about midway up and inside the stroke. Rock to the right corner (IF) and move up the right wall with the corner, to about one-third the stroke length from the top. Branch to the cap line staying close to the downstroke. Replace the nib at 30°. Repeat this sequence of actions, trying to make them as one fluid motion.

3 Converging diagonals (OQY)

"O" and "Q" omit the lower-case vertical thin. The Y retains it.

4 Parallel diagonals (CEVW)

The "C," "V," and "W" are enlarged lower-case forms. This "E" is a modified lower-case form. Its short mid-bar emerges from the junction of a thin diagonal with the downstroke.

5 Diverging diagonals (AM)

- **Left downstrokes:** Place the nib at a steepened angle just below the cap line. Press-release and apply start pressure as you pull an arced diagonal to the left and downward. Hold nib angle steady as you make the shallow curve. (Also used in the downstrokes of "N" and "Z.")

6 Hybrids (NGUXSZK)

The second downstroke of "N": steepen nib angle; use air stroking and an uptick entry. Compare "K" with "R."

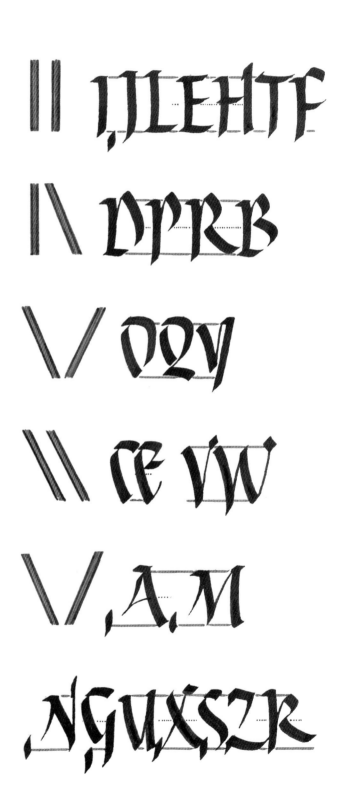

Fig. 1 Satisfaction Caps

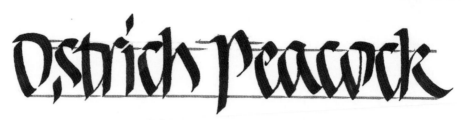

Fig. 2

Upper & lower case
1. Practice each cap family a few times.
2. Alternate Satisfaction's upper- and lower-case (e.g., Aa, Bb, Cc).
3. Write words using the model alphabets. (Fig. 2)

Word as image
To create a word as an expressive image and go beyond choosing one particular alphabet style, experiment with the variables below.

Style
Although today we design caps and lower-case alphabets in relation to each other, this convention arose only after the development of type. Calligraphers are free to combine and vary upper and lower-case alphabets in accord with their intents and purposes.
1. For reference, write a word using Satisfaction with its own caps. (Fig. 3)
2. Combine Satisfaction lower-case letters with Trapeze caps. Because Trapeze is a two-point alphabet, it can easily be adapted for the edged pen. To balance its slightly lighter forms (Fig. 4), make the cap at a flatter nib angle (Fig. 5) or use a larger nib size. (Fig. 6)
3. As an experiment, try Moto caps with Satisfaction lower-case.

"Support"
Texts, whether single words or multiple lines, conventionally use straight horizontals to support their arrangement. For the calligrapher, the various curves of the arc offer additional possibilities. (Fig. 7, symmetrical, asymmetrical, and straight)

Letter height and interletter space
Here, you may wish to abandon two other conventions of legibility: even spacing and regular letter height. For this exercise, try plasticity and letter variants as desired. Consider subtle or more dramatic variations in letter height and interletter spacing. (Fig. 8) In the process of designing one word or a short phrase, the use of tracing vellum or marker paper is invaluable, as are white out and clear removable tape. Make at least five roughs, testing new ideas as they arise.

Fig. 3

Fig. 4

Fig. 5

Fig. 6

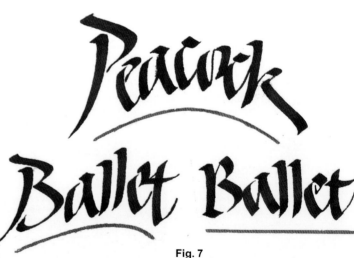

Fig. 7

Fig. 8

Numbers and ampersands

The visual themes of an alphabet also infuse the
numbers and ampersands that accompany it.
Sharing traits among all written characters
helps to unify the design of a text.
The examples below from Moto and Satisfaction
illustrate this principle. (Figs. 1 and 2)
Harmonizing numbers and ampersands to an alphabet
is inherently challenging.
It involves translating from one formal idiom into another—
most extremely from the constraints of Moto's
straight strokes to the generous curvilinear design
of Arabic numerals. (Fig. 1)

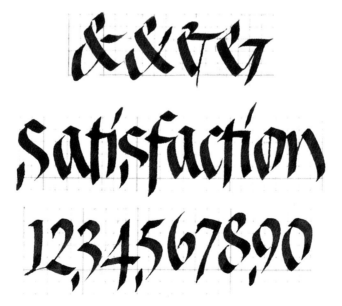

Fig. 1 Numbers and ampersands at Moto's 35° characteristic angle.

Fig. 2 The play of line in Satisfaction makes its translation into
numbers and ampersands somewhat easier.

Introduction to Italic

Italic is not an invented script, but an inherited one. Today, woven into our culture as a style of handwriting, a calligraphic script and a class of type font, Italic serves a number of practical purposes. As an alphabet originating in the Renaissance, it also connotes the spirit and values of that time. A contemporary calligrapher can choose an historical style like Italic and enliven it with the spirit of our own age.

In the course of its development, Renaissance scribes evolved different versions of Italic. It retains that protean quality today. Contemporary calligraphers vary its design purposely to express a variety of intentions. The following training alphabets, Upright Italic and Proteus, are designed to introduce you to Italic's sophisticated forms and dynamics. As training alphabets, they aim to further develop your skill and enrich your feeling for letterform.

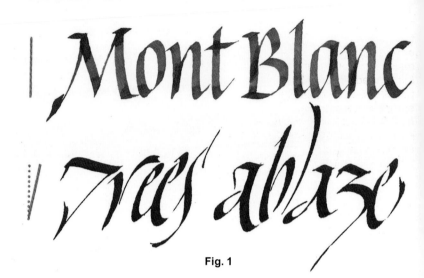

Fig. 1

Design

Each of the Italic training alphabets sprung from my desire to calligraphically express a poem, "Mont Blanc" by Shelley, and a song, "Autumn Fire" by Mick Read. Each is designed, using the elements of nib angle, slope and branch point, to reflect a facet of the poem's/song's spirit. (Fig. 1)

Characteristic nib angle: Upright Italic, 40° and Proteus, 40° and 60°. (Figs. 1 and 2)

Visual themes

- Stroke: graduated (Fig. 5 and next page).

Fig. 2 40°, red; 60° blue

- Letter posture (Fig. 1): As with the human body, a letter's posture has connotations. Upright Italic, with its vertical posture, may connote formality, authority, strength, and profound thought. Proteus, with a slope of 12°, may connote energy, speed, haste, and vigor.

- Structure: Italic is based on the oval, rectangle and triangle. Its branching also expresses felt qualities: the higher the branch, the greater the sense of solidity; the lower the branch, the greater the sense of dynamic motion. (Fig. 3)

- Refinement: thinned and shaped stroke endings. (Fig. 4)

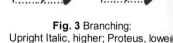

Fig. 3 Branching:
Upright Italic, higher; Proteus, lower

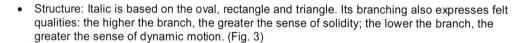

Fig. 4 Starting left, strokes one and four use characteristic angle (red check); the other examples are the result of more sophisticated pen techniques.

Ductus

Changes in stroke direction create the subtle narrowing or expanding of stroke width. (Fig. 5)

Dynamics

Graduated stroke dynamics focus on the skillful shifting of the nib's edge and its corners: a calligraphic technique I call "edge shifting." These dynamics are governed by the directional movements of the pen in its clockwise and counter-clockwise motions. In Fig. 5, the red arrow shows a counter-clockwise shift—"added" edge—which graduates a stroke from thin to thick. The exercises in the following pages develop the skill of edge shifting technique: the nib adding or losing edge to increase or decrease stroke width. Edge shifting is rooted in partnering: pairing nib corners with fingers. The exercises also offer the pleasure of more fully engaging in the dynamic act of calligraphic stroke making.

Fig. 5 The graduated stroke: the change from a hairline stroke (nib corners in alignment with stroke direction) to an expanding stroke (nib corners not in alignment with stroke direction).

The Graduated Stroke

Using the edged pen to graduate a stroke—to smoothly expand or narrow it—is an essential calligraphic skill.

The Italic "o"

The letter "o" is well suited to a thorough investigation of the graduated stroke because it contains four basic stroke gradations. (See pages 208-210.) Moreover, since some facet of the Italic "o" is echoed in nearly every letter, this letter offers an excellent preparation for the alphabet itself.

The Italic "o," like all letters in this book, is considered from the standpoint of both form and flow—the visual and the physical.

Form

The analysis of form serves as a foundation for calligraphic practice. The two-stroke Italic "o," a seamless elliptical form, divides into four distinct stroke shapes for the purpose of exploring its dynamics and rhythm.

Structure

Either a rectangle or a trapezoid can structure the internal counter of the "o." A trapezoid, with a base that's slightly narrower than the top, imbues the form with a greater sense of movement. The four sides of the rectangle/trapezoid each correspond to one of the four stroke shapes composing the two-stroke "o." The rectangle/trapezoid also offers a framework for stretching strokes.

Flow

This term refers to the muscular movement and tactile sensitivity which create a living stroke. Flow, by integrating breath, movement, and touch, develops the rhythm and gesture of vital letterform.

Dynamics: the big "o"

In the next alphabet, Upright Italic, the four stroke shapes are enlarged and shaded to help you see and better grasp the pressure-release patterns of edge-shifting technique.

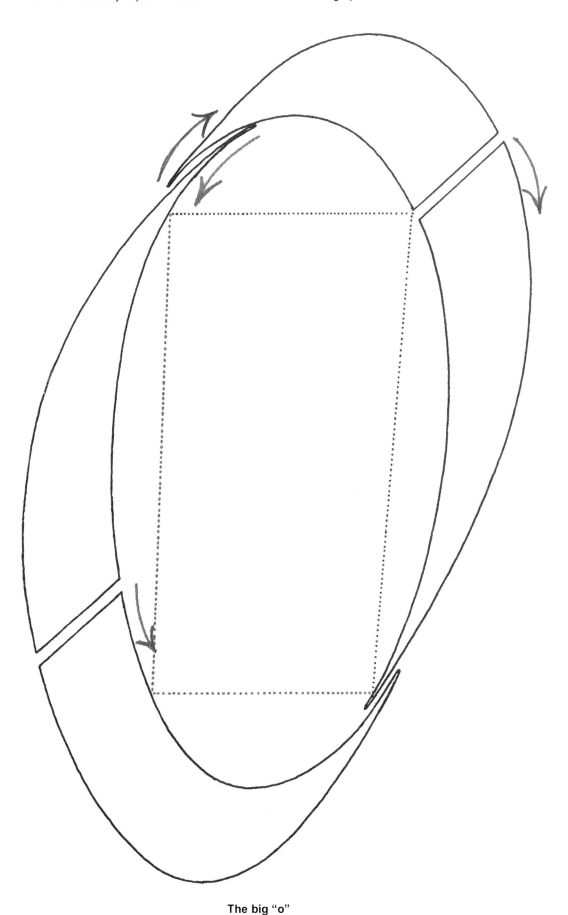

The big "o"

Training Alphabet 10: Upright Italic

My upright version of Italic allows you to concentrate on the subtleties of Italic form and dynamics before adding the challenge of slope. (Fig. 1) We start with the "o" because at least one of its graduated strokes features in nearly every letter of the sloped Italic, Proteus.

abcdefghijklmnopqrstuvwxyz

Fig. 1 Upright Italic

Edge-shifting technique

To graduate a stroke successfully, the nib must overcome the resistance it meets in directing curved strokes. This technique addresses the challenge by using the "o" and its its four stroke shapes—assigning each its own distinct gesture. For example, the long shallow arc of the left stroke of "o" "plunges" down and to the left. (Fig. 3) To help you develop skillful edge shifting, the exercises focus on this as a preliminary to letterform. Further, they integrate the breath with the hand in its course of sensitive, energetic stroke making.

Fig. 2 Left to right: 40° angle icon; saw-tooth patterns a. and b.

Preparation: Getting acquainted with a 40° nib angle and a larger Brause nib.

Tool: 4mm Brause **Paper:** marker/JNB **Ink:** dip and flick **Ink setup, padded surface, ruling equipment**

1. Rule guidelines ½" apart and angle lines at 40°. (Fig. 2, red)
2. Warm up: make full-edge ink swatches.
3. Saw-tooth patterns. Start at the baseline and press-release.
 a. Hairline upstroke (T, push); vertical downstroke (IF, pull).
 b. Hairline upstroke (T, push); diagonal downstroke (IF, pull).

Edge shift 1: The "waterfall" stroke

Here, the nib springs away on the hairline and adds edge as it plunges into a shallow-arced broad stroke. (Fig. 3) Pressure on the left nib corner overcomes the paper's resistance. Exercises 1 and 2 prepare the fingers for the waterfall stroke's edge shift. Exercise 3 makes the fully graduated stroke. Dry trace the figures (Automatic Pen) and then use ink (Brause).

Tools: #4 Automatic Pen, 4mm Brause
Paper: marker/JNB
Ink: dip and flick

Exercise 1: Angle bracket (Fig. 4, hairline to broad edge)
1. Place the ink-filled Brause nib at 40°, above a ruled line. (Fig. 4)
2. Inhale, press-release and partner with the right corner (IF); exhale and pull a hairline two nib widths long; pause.
3. Inhale, press-release; exhale and pull a short downstroke (IF).
4. For dexterity, partner with the thumb on the next bracket.
5. Repeat the brackets a few times with this alternate partnering.

Exercise 2: Arc bracket (Fig. 5, shifting from hairline to broad edge)
1. Create a bracket as above.
2. Inhale and place the nib atop the hairline. Exhale, press-release and pull a hairline half a nib width long.
3. On an inhale: press, partnering with the left nib corner—and release—springing down and away a short distance. (Action is briefly suspended.) Exhale and, pressing slightly on the partnered corner, "grab" the paper and pull into a short downward arc. (Fig. 5)
4. Repeat and partner with the right corner (IF).
5. Repeat; focus on the feel and rhythm of the shift.

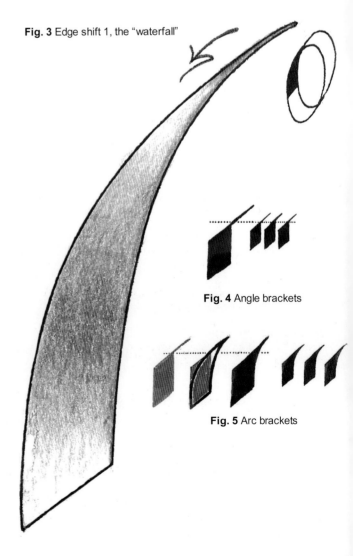

Fig. 3 Edge shift 1, the "waterfall"

Fig. 4 Angle brackets

Fig. 5 Arc brackets

Exercise 3: The waterfall stroke: taking the plunge
After making the shift from hairline to broad edge, which begins the gradation from thin to thick, apply a little start pressure and launch the waterfall, pulling a long, shallow-arced downstroke. Imagine this action as a force of nature, as a waterfall, feeling the stroke's momentum as a sense of water plunging downward. Enjoy the ride! (Fig. 6)

Fig. 6 The waterfall stroke

Edge shift 2: The "dip" stroke
In this shift, the nib pushes off from the full edge and "loses" edge as it transitions from a full-edge stroke to a hairline. The second stroke shape emerges from the first to dip into a narrow arc and form the base of the first stroke of "o." (Fig. 7)

> **Tools:** #4 Automatic Pen, 4mm Brause
> **Paper:** marker/JNB
> **Ink:** dip and flick
> **Guidelines:** 5/16" apart

Warm up: At a 40° angle, make narrow counter-clockwise ovals. On the downward arc, apply weight from the shoulder; on the upswing, use the energy of release to complete the oval. Work deliberately, in place and then traveling.

Dry trace (Automatic Pen) and then use ink (Brause) and marker/JNB paper with guidelines.

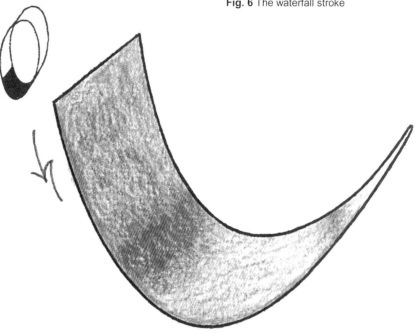

Fig. 7 Edge shift 2

Exercise 1: Right-angle bracket (Figs. 8 and 9, left)
1. Place the nib at the top of the vertical.
2. Inhale, press-release and partner with the left nib corner (T). Exhale and pull a short vertical stroke to the horizontal line; pause.
3. Inhale, press-release and continue to partner with the left corner (T); exhale and push a short horizontal stroke.
4. Repeat a few times; experiment with pressure patterns and their rhythms.

Fig. 8 Right angle and cup hook brackets

Exercise 2: "Cup hook" bracket (Fig. 8, middle; full edge to hairline)
1. Use the right-angle bracket as a scaffold. (Figs. 8 and 9, middle)
2. Place the nib at the top of the downstroke.
3. Inhale, press-release and partner with the left nib corner (T).
4. Apply pressure as you move down to the right and into the curve: release and accelerate as you approach the edge shift. (Fig. 7)
5. At the point of shifting edge, press slightly on the right nib corner (IF) and push into the hairline. This corner pressure helps you stay focused on directing the stroke and maintaining nib angle.

Fig. 9 Angle-to-arc sequence

Exercise 3: Taking a dip
Repeat the above sequence of movements as a calligraphic gesture in different sizes and speeds. (Fig. 10) Look for the rhythm in this "underhand" gesture.

Fig. 10 The dip arc at play

Combining edge shifts 1 and 2
The first two stroke shapes now combine into the first stroke of "o"—its left side. (Fig 11) As a gesture, this stroke combination recurs in many other letters and serifs. The red dots appear at places where pressure can help you guide the stroke: at its top, to make the first shift; a little below, to launch the waterfall downstroke; near the bottom for moving into the dip; and, near the end of the stroke to shift from full edge to hairline.
1. Combine the stroke shapes and their shifts: the waterfall and the dip. (Fig. 11)
2. Experiment with speed: where to accelerate, where to slow down.

Fig. 11 Stroke 1 of the "o" family

Edge shift 3: The "vault" stroke

Here, the nib adds edge as it springs upward from a hairline, graduates into a broad stroke, and forms a narrow arch. (Fig. 1)

Tools, paper and ink: p. 208 **Guidelines:** 5/16" apart

Warm up: At a 40°angle, with/without guidelines, loosen up by throwing narrow, clockwise ovals, in place; then loops, traveling.

Dry trace (Automatic Pen) and then use ink (Brause) and marker/JNB paper with guidelines.

Exercise 1: Right-angle bracket (Figs. 2 and 3, left)
1. Place the nib below a ruled line and pull a hairline one nib width down.
2. Inhale, press-release and push (T) a hairline back to the line; exhale.
3. Inhale, press-release and partner with the left nib corner (T). Exhale and push a short distance across.
4. Inhale, press-release; exhale and pull a short downstroke.

Exercise 2: The vault stroke with arc bracket (Figs. 2 and 3, center)
1. Use the right-angled brackets as scaffolds.
2. Place the nib atop the hairline.
3. Inhale, press-release and partner with the left nib corner as you push up a short way; exhale. Inhale, apply a little pressure to the left nib corner and grab the paper. Release a little pressure and push up into the arc. The corner pressure helps you overcome resistance and shift from hairline to full edge (edge shift 3, clockwise). Continue to the top of the arc.
4. Exhale; apply a little start pressure to carry the nib over and around; finish with end pressure.
5. Inhale, release and pivot the nib from 40° to approximately 50° (counter-clockwise). (Fig. 1)

Exercise 3: The vault stroke
1. Make the arc freehand (Fig. 3, right) and repeat it. (Fig. 4)
2. Remember to engage the shoulder as well as the fingers. Check tool hold: grip the tool, but not so tightly you can't receive tactile signals.

Edge shift 4: The "dive" stroke

This shift loses edge as it contours a long, tapered arc. (Fig. 5)

Warm up: At a 50° angle, throw clockwise vertical loops. As you reach the bottom of the loop, rock to the right point, apply a little pressure to the point, and spring left and up to complete the loop. Replace the edge and repeat. Try to make the moves in a fluid sequence.

Exercise 1: Angle bracket (Figs. 6 and 7, left)
1. Place the nib at 50°. Inhale, press-release and partner with the left nib corner (T). Exhale and pull a diagonal stroke down and to the right.
2. Inhale, press-release; exhale and pull a hairline down and to the left (a little to the left of the broad stroke—note plumb line).

Exercise 2: Arc bracket (Fig. 6, center and Fig. 7, second from left)
1. Use the above bracket as a scaffold. Place the nib atop the broad downstroke. Press-release (shoulder and fingers) and partner with the left nib corner (T). In the release, move into the arc.
2. Apply start pressure as you move to the stretch point; release and pull the arc, guiding the stroke with the partnered corner.
3. Approaching the baseline, apply a little pressure to the left nib corner, pulling down and into the hairline, shifting from full to thin edge.

Exercise 3: The dive stroke (Fig. 8)
Repeat the above stroke pattern several times to get the dynamics and rhythm. When you are ready to speed up, push off from the bend, making this the final burst of pressure and release. Increasing speed tends to thin the stroke. Guide with either the T or IF.

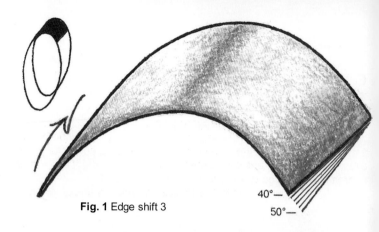

Fig. 1 Edge shift 3

Fig. 2 Right-angle bracket sequence

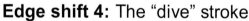

Fig. 3

Fig. 5 Edge shift 4

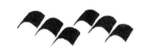

Fig. 4 Vaulting

Fig. 6 Angle bracket to arc

Fig. 7

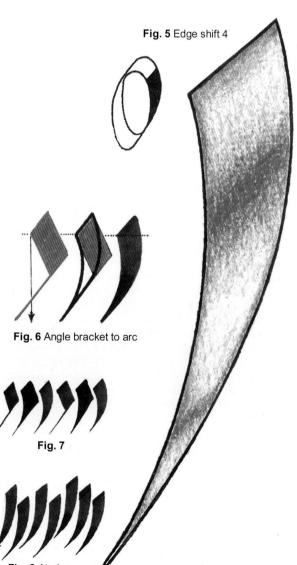

Fig. 8 At play

Combining edge shifts 3 and 4

This combination comprises the full gesture of the second stroke of "o." It also recurs in other letters and serifs.

1. Combine the stroke shapes and their shifts—the vault and the dive. (Fig. 9) The red dots show places for applying pressure: to edge shifts and in the body of the stroke.
2. Experiment with speed: where to accelerate, where to slow down.
3. Use an imagined or actual stretch point (Fig. 9, red dot under arch) to help pull the arch into an arced downstroke. As you engage the resistance of nib contact, the sense of pulling the stroke like an elastic band continues to develop into a felt muscular action (bicep).

Fig. 9 Stroke 2 of the "o."

"O" Letter family (oce)

The letters of this family begin with a counter-clockwise gestural stroke and its edge shifts—the waterfall and dip.

Remember: Drivers of the larger, gestural actions are the shoulder and arm; discriminators of the smaller, finely tactile edge shifts are the fingers. Working together, they can create vital letterform.

Nib angle: First stroke, 40°; second stroke, nib angle steepens slightly at the end of the vault edge shift.

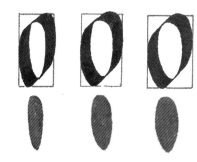

Fig. 1, top; **Fig. 2,** bottom

Proportion: Note the possible variations in Fig. 1 (from the left): narrow (1:2); typical, between narrow and wide; and wide (2:3). This Italic alphabet features a typical version. The open bowls of "c" and "e" are slightly narrower than the closed bowl of "o." (Figs. 6 and 7, next page)

Visual themes
- Counter of "o": an asymmetrical, tapering (almond-like) shape, wider at the top than at the bottom. (Fig. 2, red shapes) To better get the idea of this shape, use tracing paper and color the counters within the letter strokes.
- Junctures: overlapped. (Fig. 3) The beginning of the second stroke overlaps the start of the first, and the end of the second stroke overlaps the end of the first. There is no visible hairline. The overlap is slightly angular.

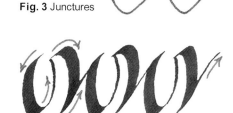

Fig. 3 Junctures

Warming up

Work freehand, without guidelines.

Tool: 4mm Brause
Paper: marker/JNB
Ink: dip and flick

Fig. 4

1. Pull the first stroke of "o"—the combined waterfall and dip. (Fig. 4)
2. At the hairline exit: press-release and rock onto the right nib corner; partnering with the thumb, push the corner up and around to nearly the top of the first stroke; pause.
3. Lift and replace the edge—the left nib corner touches the thin upstroke. Press-release and pull the second stroke of "o": the combined launch and dive. Pause briefly.
4. Press-release and rock to the right corner; push a thin stroke diagonally up. Replace the full edge. Repeat these strokes rhythmically, feeling their continuity and flow, distributing the action among the shoulder, arm, and fingers. Use the breath.

Ductus and Dynamics

Tools: 4mm Brause, sharp pencil or fine roller-ball (005 or 01) for ruling
Paper: marker/JNB
Ruling equipment: ruler, T-square, drafting tape, protractor

Guidelines: A grid of proportional frames and angle lines. (Fig. 5) Since proportion plays a large role in guiding stroke direction, use a grid that includes horizontals (¾" apart), and verticals (5/16" and 3/16" in alternation.) To help you maintain nib angle, rule angle lines at 40°. (See p. 176.)

Fig. 5

212

Suggestion: Dry trace all figures with even pressure to get comfortable with stroke direction. Then use ink (dip and flick). If the thin strokes look "blobby," touch the nib to the wipe (See Ink, p. 168).

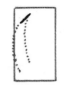

Fig. 5 **Fig. 6** **Fig. 7**

"o," Joining strokes 1 and 2 (Fig. 5)

Stroke 1: Place the nib within the proportion frame, below the waist-line and a little to the right of the left wall. Make the counter-clock-wise gestural stroke—the combined waterfall and dip.

Stroke 2: Place the nib atop the hairline entry of stroke 1. Make the clockwise vault and dive strokes. Use the top and right sides of the proportion frame as stretch points for the top and side arcs of this stroke. Finish by overlapping the exit hairline of stroke 1.

"c," The top stroke (Fig. 6)

After stroke 1 of "o," a little wider at the base, pull a short horizontal arc; toward the end, press-release and pivot the nib counter-clockwise to widen the ending. Press and lift off.

Fig. 8

"e," The "eye" (Fig. 7)

Make stroke 1 of "o," adding a little width to the base. Place the nib over the stroke entry. Vault into a narrow arch and pull down in a shallow arc. Rock onto the left nib corner and push it down and left—ending above the midpoint between base- and waistline.

Dive dynamics

Begin with reviewing the flow of pressure for the combined stroke shapes of strokes 1 and 2. (pages 209-11) Then make facing arcs. First focus on their gestural movement, then on edge shift 4, the dive. Allow the energy of release to carry this stroke over the baseline. (Fig. 8)

Fig. 9a **Fig. 9b**

Spacing: Letter strings

Aim for an even distribution of white space between open and closed bowls. Use the nib to help space the next letter. (Figs. 9a and b)

Closed bowl – Dry trace Figs. 9a and b, following steps 1 and 2 below.

Step 1: In the air, place the nib a short distance from the furthest right point of stroke 2. (Fig. 9a)

Step 2: Move up and a little to the right. Place the nib and start stroke 1 of an "o." (Fig. 9b)

Using ink, follow this method to make a string of evenly spaced "o"s.

Open bowl – Dry trace Fig. 10 using the directions below.

Step 1: Make a "c." After finishing the top stroke, move slightly right, returning the nib to 40°.

Step 2: Make the "o." Stroke 1 enters the proportion frame of the "c." (Fig. 10)

Using ink, alternate "c" with "e" and "o"; "o" with "e" and "c"; and "e" with "o" and "c."

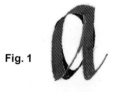

Fig. 10

"a" Letter family (adgqf)

All letters in this family use the waterfall stroke and edge shift 1.

Fig. 1

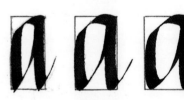

Proportion: The "o" and "a" counters are nearly identical in width. (Fig. 1) Compare the three variations in Fig. 2: narrow, typical, and wide.

Visual themes

- Counter of "a": The first stroke, hugging the left wall of the proportional frame, makes the counter even more asymmetrical than that of "o" (Figs. 1 and 3)—even wider at the top than at the bottom. To better get the idea of this unusual shape, use tracing vellum and color in the counters.

- Structure: The "a" counter is built around a rectangle atop a triangle. (Fig. 4, red lines) In addition to the fully enclosed triangle, the "a" also creates three additional triangular spaces (blue): 1) between bowl and second downstroke, 2) in the exit serif, and 3) between the letter and the proportion frame (top left).

- Junctures: Overlap (top left); pivot (bottom left) and "square" (top right).

Fig. 2

Nib angle: The characteristic 40° and an adjusted angle of 60°. At the base of the water-fall stroke, the nib pivots to the steeper angle. (Fig. 4, dotted blue lines)

Fig. 3

Fig. 4

Warming up: The waterfall stroke (Fig. 5)

Tool: 4mm Brause **Paper:** marker/JNB **Ink:** dip and flick

1. Place the nib at 40°.
2. Make short waterfall strokes with end pressure (Fig. 5, left column, pages 208-9). At the base of a stroke, in the release of pressure, hop a little to the right. Repeat.
3. Double the length of the stroke and repeat. (Fig. 5, center)
4. Make long strokes: Experiment with pressure patterns, including pulsing, to stay with the stroke. Enjoy the ride.
5. Focus on breathing: a quick inhale with the initial pressure-release; a strong exhale as you move into the down-stroke. Feel the weight of the shoulder pulling the stroke; be aware of the drag—of "stretching" the stroke.

Note: While there are many versions of Italic and its "a" counter, the detailed analysis below prepares you for success with Upright Italic, as well as the numerous historical and contemporary variations available today.

Fig. 5

The "a" counter

We now take time out to focus on the "a" counter which, through its unique design, contributes significantly to Italic's character. As it happens, however, this form is also one of the most sophisticated in the calligraphic repertoire. Despite this, Italic is often taught, unsuccessfully, to beginners. In this course, you are no longer a beginner as you take on Italic's nuances and technical challenges. (Four letters of the "a" family contain this counter.)

Tool: #4 Automatic Pen **Paper:** tracing vellum **Ink:** dip and flick

First, use the Automatic Pen to dry trace the strokes of the large forms in Fig. 1, following the description below.

- **Stroke 1** (Fig. 1a, left wall)**:** Pull the waterfall stroke to the baseline using end pressure. In the release of pressure, steepen nib angle to 60° as you pivot the nib counter-clockwise. (Fig. 1a) This change of angle cuts through the baseline. The pivot helps you create the deep triangle that slims and tapers the "a" counter.

- **Stroke 2** (Fig. 1a, right wall) **:** Push an upward arc out of stroke 1. To help you shift edge from hairline to broad stroke, maintain the steeper angle and apply a little pressure on the left nib corner (T). Stroke 2 below focuses on this shift.

- **Stroke 3** (Fig. 1b, top stroke)**:** Place the nib over the entry hairline; press-release and push diagonally up, into a shal-

Fig. 1 The three strokes that build the walls of the "a" counter.

low arc, and across to meet stroke 2. Here, edge shift 3 graduates the stroke and sculpts the top left portion of the counter. The counter is complete, but note the "dimple" where the top stroke, ending at 40°, meets the angle-adjusted upstroke. To smooth the counter, end the upstroke with a spur: when the arc (right nib corner) reaches the waistline, rock to the left corner (T) and push up a short way. (Fig. 1c, short black line)

Second, through the following exercises, develop the above strokes with ink, a 4mm Brause, and guidelines ¾" apart.

Tool: 4mm Brause **Paper:** marker/JNB **Ink:** dip and flick **Angle lines:** 60° and 40° (or angle icon)

- **Stroke 1:** Make the waterfall stroke. At the baseline, steepen nib angle as you pivot counter-clockwise. (Fig. 2) The tip of the stroke dips slightly below the baseline. Repeat this move to get the feel of it. As hand facility develops, try incorporating the nib turn as part of a continuous motion, beginning a little above the baseline.
- **Stroke 2:** Adding edge—from hairline to broad edge (counter-clockwise and up). To get the feel of maintaining a steep angle while pushing an arced upstroke, begin with an angle bracket (Fig. 3a):
 1. Place the nib at a 60° angle on the baseline. Inhale, press, partnering with the left nib corner (T); in release, push a hairline about halfway between the guidelines. Exhale. Inhale, press; in release, push sensitively up to the waistline. Imagine the stroke being pulled from above.
 2. For the arc (Fig. 3b): Use a sustained inhale for this arc. Make the hairline as above, but continue into an arc. Apply pressure to the left nib corner (T) to grab the paper as you shift edge and move from a hairline to a full-edge stroke.
 3. Add the spur (Fig. 3c): See Stroke 3 above.

Fig. 2.

You are now ready for the "a" letter family.

Fig. 3a **Fig. 3b** **Fig. 3c**

Ductus and Dynamics

To make the letters of the "a" family, begin with dry tracing; then trace with ink; and finally, work independently. Use proportion frames to help structure the letter. Use the breath as previously—inhale, press-release; exhale, pull—or to suit yourself.

Tool: 4mm Brause **Papers:** tracing vellum, marker/JNB **Ink:** as desired **Guidelines:** proportion frames - 3/4" x 7/16"

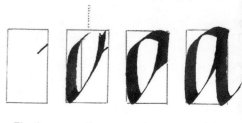

(a) **Preliminary:** To help structure the narrow counter of "a," set a target for the up-stroke at the right wall of the proportion frame Place the nib at 40° along the right side of the frame towards the waistline. (Fig. 1a) The second downstroke hides the target. This target is omitted when making the letter without a frame.
1. **First downstroke:** Make the waterfall stroke, starting a little below the waistline as in "o," but about midway between the left and right sides of the proportion frame. (Fig. 1b) At the end of the stroke, or toward the end, pivot to a steeper nib angle. Finish on the baseline or just below it.
2. **Upstroke:** Push a graduated arc up, with the spur. (Fig. 1b)
3. **Top stroke:** Place the nib at 40° over the entry hairline; press-release and pull a shallow arc from hairline to broad edge (edge shift 3). Stop at or a tiny bit past the wall of the proportion frame; pause. (Fig. 1c)
4. **Second downstroke:** Press-release to begin this subtle arc. Move sensitively down in the wet ink, partnering with the right nib corner (IF). (Fig. 1c) With a soft press-release, continue the stroke on dry paper to a little above the baseline.
5. **Exit serif:** Continue into a narrow arc (edge shift 2). (Fig. 1d)

Fig. 1a 1b 1c 1d

(d) 1. Use a two-story proportion frame. (Fig. 2a) Make strokes 1 and 2 of the "a" counter, but without the spur. (Fig. 2a) Reset the nib at 40° near the waistline.
2. **Entry serif of the ascender:** Lift the nib and place it about midway between the guidelines (Fig. 2a, red dotted line—also the ascender line) along the right side of the frame and a little to the left. Press-release (inhale); exhale and pull a hairline half a nib width down; inhale and retrace. As you develop facility, this becomes a recoil action.
3. **Downstroke of the ascender** (a subtle arc): Press-release; partner (T) and pull to overlap the "a" counter upstroke. Move sensitively through the wet ink. On dry paper, apply gentle start pressure and continue pulling to a little above the baseline. (Fig. 2b)
4. **Exit serif:** As in "a" (Fig. 2c)
5. **Top stroke:** As in "a." Be sure the nib is fully inside the descender stroke. (Fig. 2c)

Fig. 2a 2b 2c

(g) 1. Make the complete "a" counter. (The right nib corner is at the waistline.)
2. **Downstroke of the descender:** Press-release at the top right juncture. Pull the downstroke, overlapping the arced upstroke. Continue in a gentle reverse curve below the baseline; end short of midway between the guidelines. (Fig. 3a)
3. **End stroke of the descender:** Lift the nib and move in a shallow arc to the left, just breaking through the frame. Place the nib on the paper. (Fig. 3b) Press-release and move up in a short hairline. Retrace. (Makes a tiny tic.) Apply start pressure in-to the shallow arc and overlap the descending stroke.

(q) 1. Make the complete "a" counter.
2. **Descender:** Pull through the baseline, below midway between the guidelines; pause. (Fig. 4)
3. **Exit serif:** As in the "i" of Moto. (See pages 153-4)

Fig. 3a 3b Fig. 4

(f) A long waterfall stroke qualifies the "f" for inclusion in this family.
1. **Descender:** Begin about midway between the waist- and ascender lines (Fig. 5, red dot-ted line), placing the nib at 40°. Make a long waterfall stroke, pulling through the waistline and baseline. This stroke can descend well into the descender space, or only a short way.
2. **Crossbar:** Slightly flatten nib angle and place the right nib corner just below the waistline at the left wall of the downstroke. Pull the crossbar sensitively through the ink; on or close to dry paper, apply a little start pressure and continue the stroke. Finish with a short, slight-ly upward hairline. Note the triangular shape resulting from the juncture of the crossbar and downstroke. (Fig. 6)
3. **Top stroke:** As in "c."

Fig. 6

Note: As the fingers gain tactile and muscular sensitivity, they are likely to create stroke nu-ances that are difficult to articulate. Sophistication with dynamics seems to impel the fingers, spontaneously, to turn and press the nib in ways that may (or may not) be pleasing to the eye.

Fig. 5

Speed and dynamics

Increased speed and exaggerated dynamics help knit strokes into tensile, rhythmic forms.

 Tool: 3mm Brause **Paper:** marker/JNB **Guidelines:** ½" **Ink**
 Speed: Write letters of the "a" family slowly, at moderate speed, and quickly. The aim is not precision, but feeling the gesture of your movement. (Try to engage the bicep.)

1. Review "a" family dynamics by using Prototool 2 (See p. 88); then use pen and ink.
2. Next, exaggerate the dynamics of the waterfall stroke at each speed. Be athletic (images: trampoline, diving into home base, etc.); be theatrical.

Note on spacing

The aim is to distribute the space evenly between letters. (Fig. 7) In Playball (See pages 12, 16, and 18), the primary combinations create simple, familiar shapes: rectangle, hourglass and half-hourglass. Although these also underlie the interletter shapes of Italic, the edged-pen imparts its character to the the shapes as well. (Fig. 8) In the next exercise, discover the interletter spaces of Italic.

Spacing and size

Alternate "o" with the letters of the "a" family using three different nib sizes. (Fig. 9)

 Tools: 4, 3 and 2mm Brause nibs **Paper:** marker **Guidelines:** ¾", ½", and 3/8" **Ink**

Fig. 7 Italic

Fig. 8 Playball and Italic

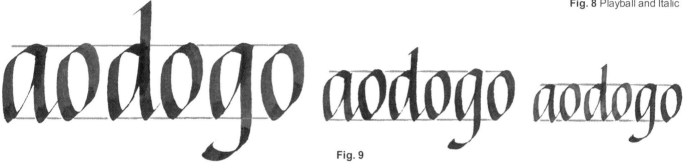

Fig. 9

"i" Letter family (iltu)

Warming up: **Tool:** 4mm Brause **Paper:** marker/JNB **Ink:** fully loaded
Work quickly on the broad and thin edges (Fig. 1) and slowly making long lines.

Fig. 1

Ductus and Dynamics

(i) 1. **Entry serif:** hairline. (Fig. 2) Inhale and place the nib just below the waistline at 40°. Exhale and pull a hairline about two nib widths long with end pressure; in release, inhale and retrace the hairline (a recoil action) to just above the waistline. Exhale.
2. **Downstroke and exit serif:** Inhale, press-release; exhale, apply start pressure and pull a shallow arced downstroke. Inhale as you near the baseline; exhale and reapply pressure as you continue to the baseline and into a narrow arc (edge shift 2). Try the full action on a long exhale.
3. **Dot:** A short downstroke, pulling slightly to the left. Toward the end of the stroke, you may apply a little pressure and, in release, steepen nib angle to taper it slightly.

(l) 1. **Entry serif:** Place the nib at the ascender line, 3/8" above the waistline (one and one-half body height). (Fig. 3) Make the serif as in "i" above.
2. **Downstroke and exit serif:** As in "i."

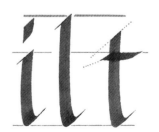

Fig. 2 **Fig. 3** **Fig. 4**

(t) 1. **Entry:** Place the nib above the waistline. This stroke is shorter than "l." (Fig. 4)
2. **Downstroke:** As in "i"; **exit serif:** as in "i"; and **crossbar:** as in "f."

(u) 1. **Entry and first downstroke:** As in "i." (Fig. 5a)
2. **Upstroke:** As in "a" until about one nib width shy of the waistline. Lift the nib and replace it just above the waistline at 40°. Or, continue by pushing up with the thumb (pivoting clockwise) to flatten nib angle back to 40°. (Fig. 5a)
3. **Downstroke and exit serif:** As in "i" (Fig. 5b)

Fig. 5a **Fig. 5b**

Rhythm and space

1. Stroke rhythm (focus on dynamics): Alternate "i" and "l." Keep them close together, with exit serifs touching the next downstroke or overlapping it.
2. Graphic rhythm (focus on space): Make the rectangular shapes between letters as equal in size as possible
3. Write the whole family focusing first on stroke then on graphic rhythm. Next, try to integrate them.

Fig. 1

"n" Letter family (nmhbprk)

The "n" family's characteristic arch can be narrowly arced (Figs. 1-4 and Fig 3, next page) or rounded as in the warm up on the next page. Whichever arch you use, the entry serif is generally similar to it. Use edge shift 3, the launch, when useful.

Fig. 2

Proportion: The "n," nearly identical to the "o," fits within the typical Italic proportion frame. (Figs. 1 and 2) Although hairline entry and exit serifs extend beyond its walls, their lightness does not alter proportion.

Visual themes

- The arch counter: This shape emerges from the first downstroke in a continuous, unbroken line. Upon reaching the waistline, it makes a hairpin turn (the narrow arch featured here) and, via the second down-stroke, descends to form an asymmetrical arch. (Figs. 2, 3, and 4) To get a better idea of this basic letter shape, use tracing vellum and color in the counters.

Fig. 3

- Structure: The arch counter is built around a right triangle atop a rectangle. The two serifs and the top counter echo the triangular motif. (Fig. 4)

Nib angle: Characteristic, 40°, and adjusted, 60°. After finishing the first downstroke, before branching, the nib pivots to a steeper angle. (Fig. 4, dotted blue lines and Fig. 3, next page).

Fig. 4

Warming up

Tool: 4mm Brause
Paper: marker/JNB
Ink: fully loaded

1. Get out the kinks: Work quickly on the broad and thin edges (Fig. 1, p. 215).
2. To relax, first make an ink swatch. Then place the nib atop the swatch at 40° and, in the wet ink, make clockwise ovals, sensitively, using edge shifts 3 (launch), and 4 (dive).
3. Partnering practice (Fig. 5): Trace first, pulling strokes of different lengths in different directions. To help guide the strokes, partner with nib corners: left (T); right (IF).

Ductus and Dynamics

To prepare you for "n" and its relatives, the strokes composing it are covered in detail below.

Tools: #4 Automatic Pen, 4mm Brause
Paper: tracing vellum, marker/JNB
Ink: dip and flick
Guidelines: Rule guidelines with proportion frames (as in "a") and 40° angle lines.

(n) 1. **Entry serif**
Although proportion frames are not available in the act of writing, at this stage their verticals help you learn letter width and guide the serif's narrow course.
 a. First dry trace (Automatic Pen) using the description below; then, use ink (4mm Brause).
 b. Make the following moves to position the nib:
 1) Place the nib at 40° inside the top left corner of the propor-tion frame to form a triangle. (Fig. 6)
 2) Move a nib width down and to the left. (Fig. 7)
 c. The hairpin bend (Fig. 8): Inhale, press-release and push the nib diagonally up, a short way; exhale. Inhale, press-release, partner with the left corner (T) and push up to the top of and around the hairpin bend (edge shift 3).

2. **First downstroke:** Exhale, apply start pressure and continue pul-ling the stroke in a shallow vertical arc. Hug the frame as you move toward the baseline. (Fig. 9)

Fig. 5

Fig. 6 **Fig. 7** **Fig. 8** **Fig. 9**

The arch of "n"

We now take time out to focus on the "n" family's asymmetrical arch. The stroke that branches into this arch, unlike the cornered thins of Moto and Satisfaction, graduates from thick to thin. The added weight from this initial thickness gives greater solidity to the form. Thus strengthened, the Italic arch, with its sense of movement, represents a vital tension between action and stability. Construction techniques are carefully detailed below in preliminary exercises. Note: The arch in these exercises is rounder than in the finished letter of this alphabet— beginning with a broader, rounder arch prepares you for the narrower, more restrained one.

These exercises help you get comfortable with changing from a flatter to a steeper angle and the reverse. Begin by dry tracing the figures according to the instructions below.

> **Tool:** 4mm Brause
> **Paper:** tracing vellum, marker/JNB **Ink**
> **Guidelines:** Rule waist- and baselines, and 40° angle lines.

Step one: Angle shift
1. Place the nib at the waistline (40°). Use the rounder entry serif of Fig. 1 and pull the downstroke.
2. Inhale, press-release and lift the nib. In the air, pivot it counter-clockwise to a steeper angle. Exhale and land just to the right of the downstroke. (Fig. 1)
3. Upstroke: Inhale, press-release and push up into an arc—a tapering stroke—a little short of the waistline. Exhale.
4. Inhale and lift the nib. In the air, move up and to the left, above and behind the previous stroke.
5. Exhale and reset the nib at 40°. Inhale, press-release and partner with the left nib corner (T) as you push up a short way; exhale. Inhale, apply a little pressure to the left nib corner and push to the top of the arc (vault edge shift).
6. Exhale and apply a little start pressure to finish the arc. Inhale, press-release (soft); exhale and pull the downstroke to the baseline.
7. Make the above sequence a rhythmic pattern. Work slowly; first loosely, exaggerating the dynamics; then aiming for greater precision.

Step two: Upstroke branch in wet ink (Figs. 2 and 3)
1. Make the entry and downstroke as above.
2. At the base of the downstroke, inhale, softly press-release and pivot the nib in the wet ink (angle steepens, the arm swings out). Push the upstroke out of the wet ink as in 3. above. This becomes fluent with practice.
3. Repeat 4-6 above.

Step three: The arch
This step returns the nib to 40° as it connects the upstroke to the arch.
1. Make the entry, downstroke, and upstroke branch of Step 2.
2. At the end of the branch, below the waistline, inhale, press-release and rock to the right nib corner (IF); exhale. Inhale and push a cornered thin arc to the waistline (rotating the wrist slightly). (Fig. 4)
3. Exhale and replace the full edge at 40°. (Fig. 5)
4. Inhale and move into the arch. Note: As the full edge is placed atop the cornered thin, this meeting, at different angles, may create a slight projection— no matter. (Figs. 6 and 7)
5. Continue pulling around and into the downstroke without changing nib angle.
6. Make an "arcade" to practice the above sequence of dynamics. This unique set of movements develops calligraphic "legerdemain"—no other word does it justice. Practice the moves a number of times to get the pattern and its flow; no matter if the moves are choppy at the beginning.

> **Upstroke branch note:** After steepening nib angle at the base of the downstroke, keep the right nib corner in line with the stroke wall as you push up and into the arc. Position the hand as needed. The branch starts below midway but appears above it. (Fig. 3)

Step four: Completing the "n"
1. Make proportion frames: ¾" x 7/16".
2. Make the entry, downstroke and upstroke branch, and arch as above.
3. **Second downstroke:** Exhale and pull down, keeping the stroke taut.
4. **Exit serif:** A little before the baseline, pull down slightly to the right and into the exit arc. Use edge shift 2 (dip) to transition from broad edge to hairline. The exit serif is smaller than the entry serif.
5. Practice a few "n"s with and without proportion frames.

Fig. 1

Fig. 2

Fig. 4

Fig. 3

Fig. 5

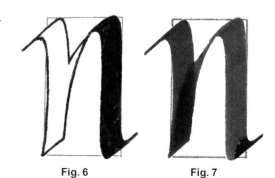

Fig. 6 Fig. 7

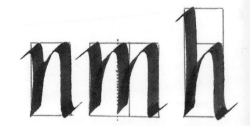

(m) 1. **Entry, first downstroke, upstroke branch and arch:** As in "n." (Fig. 8)
2. **Second downstroke:** Pulls to the baseline.
3. **Second upstroke and arch:** Repeats the first.
4. **Third downstroke and exit serif:** As in "n" above. The "m" is essentially two "n"s.

Practice a few "m"s making the counters as similar as possible; alternate "n" and "m." As a practice strategy, alternate your attention between Ductus (stroke direction) and Dynamics (pressure patterns, rhythm, and variations in speed). Remember to breathe.

Fig. 8 **Fig. 9**

(h) Entry: The long strokes—the ascenders of "h," "b," and "k" and the descender of "p"—begin with an angle serif, moving from hairline to full edge without gradation. (Fig. 9) The full edge pulls the downstroke directly from the hairline. An angular rather than a curved entry serif adds strength to these long strokes.

Fig. 10 Curved and angular serifs

Practice the angular entry of Fig. 10
1. Place the nib at 40° just below the ascender line. Inhale, press-release; exhale and pull one nib-width down and to the left to make a stroke two nib widths in length; pause.
2. Inhale, press-release and retrace the hairline, just breaking through the ascender line.
3. Exhale, pulling down and a little to the right. When you get the feel of this entry, continue below.

1. **Entry and downstroke:** Make the above entry, but swing a bit less to the right. As you continue the downstroke on the exhale, apply a little start pressure and pull to the baseline.
2. **Upstroke branch, arch, second downstroke and exit**: As in "n."

Practice: Make a few "h"s, first with proportion frames, then without. Alternate "h," "n," and "m" without frames.

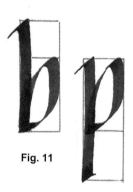

(b) 1. **Entry and downstroke:** Make the angle serif and pull the ascender to the baseline. (Fig. 11)
2. **Bowl**
 a. **Upstroke branch:** As in "n."
 b. **Arch:** As in "n."
 c. **Right side:** From the arch, partner with the left nib corner (T), pull a shallow arc down, to just short of the baseline (edge shift 4). Keep nib angle steady to help ensure a smoothly graduated, tapered stroke.
 d. **Bottom stroke:** This short, slightly tapered stroke can be pulled from, or pushed to, the down-stroke. (Fig. 13) A pushed stroke is easier to make with a smaller nib.
 1) Pulled: After the hairline of the arc appears, lift the nib and place it a tiny bit behind the downstroke. Inhale, press-release; exhale, pull to the right and overlap the hairline.
 2) Pushed: After the edge shift and the appearance of a nib-long hairline, partner with the right nib corner (IF) and push the stroke to the left in a slight arc. (Fig. 13) Since the paper's resistance is greater for wider nibs, more slowly and sensitively. If necessary, retrace to clean the stroke walls.

Fig. 11

Fig. 12

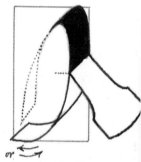

(p) 1. **Entry and Descender:** Begin just below the waistline and make the ascender stroke. Twist off to exit.
2. **Bowl:** Branch and right side as in "b." The base begins/finishes inside, not left, of the downstroke.

Practice: Make a few "b"s and "p"s, first with proportion frames, then without. Alternate the above letters of the "n" family with "i."

Fig. 13

(r) 1. **Entry and downstroke:** As in "n." (Fig. 14)
2. **Upstroke branch:** This is a high branch, becoming visible decidedly above the midpoint.
3. **The ear:** Replace the edge at 40° (Or, push the nib, corner or edge, into the 40° angle position). Press-release and pull to the right and slightly down through the waistline. This is a short stroke—a slightly extended lozenge. The ear meets the upstroke at an angle. Make a few "r"s.

(k) 1. **Entry and downstroke:** As in "h." (Fig. 15)
2. **Upstroke branch:** As in "n."
3. **The loop:** Press-release at the top of the branch, partner with the left corner (T). Push up into a narrow arch and pull a tight curve toward the downstroke, losing edge (edge shift 4) and becoming a hairline—stopping short of the downstroke.
4. **Diagonal:** Press-release atop the hairline and pull to the baseline. The width/direction of the kick depends on its position in a word and/or the letters that follow. (Fig. 16)
5. **Exit serif:** Continue into a short arc (edge shift 2, full edge to hairline). Practice the "k."

Fig. 14 **Fig. 15**

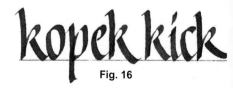

Fig. 16

Spacing: Letter string: alternate "n" with each letter of the "n" family. Then write words with this family.

"V" Letter family (vwy)

The first stroke of these letters begins with the clockwise vault gesture (edge shift 3).

Proportion: The tops of the diagonal strokes of "v" extend to the left and right of the proportion frame. (Fig. 1)

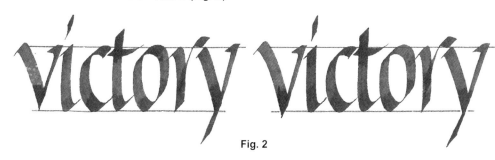

Fig. 1

Visual themes
- Counter: This triangular shape balances on a pointed, overlapped juncture. It breaks the baseline to preserve the area of its counter and conform to the other letters. (Fig. 2)

- Junctures: Diagonals overlap; the top right serif pivots into the second downstroke.

Nib-angle turns: Within the first downstroke and between the top right serif and second downstroke. (Fig. 3)

Fig. 2

Warming up

Tool: 4mm Brause **Paper:** marker /JNB **Ink:** fully loaded

1. Get out the kinks with quick diagonal full-edge and hairline strokes. (Fig. 4)
2. Slow down with a rhythm pattern. (Fig. 5) Pull a full-edge stroke diagonally down and up to a count of "one-and-two-and-three." On the final "and," rock to the right corner (IF) and push up, vertically, to the top. Drop the left nib corner and make hairline diagonals down and up counting, "one-and-two-and- three-and," ending at the top. Repeat. Apply a little more pressure to the downstrokes than to the upstrokes.
3. Find a breath pattern to accompany the above rhythm pattern.
4. Bow the rhythm exercise above with attention to tactile and muscular sensation.

Fig. 3

Stroke technique: Nib turning within a stroke

To create the refinements of the "v" family—their tapered points and thinned diagonals—we focus on turning the nib within a stroke. The exercises below help you cultivate the needed finger dexterity. As it develops, so do rhythm and fluency. Listen to your fingers.

Tools: #4 Automatic Pen, 4mm Brause **Paper:** marker/JNB
Ink: dip and flick
Dry trace: Figs. 6 and 7a-c with the Automatic Pen
Use ink: Figs. 8a-e with the 4mm Brause

Fig. 4 **Fig. 5**

Nib turn 1: Fans (Fig. 6)
1. Place the left nib corner (T) at 40° on the red line. (Fig. 6)
2. Press-release and pivot, counter-clockwise, pulling the corner down and to the right with the thumb. Be sure to steady the shaft, which is nearly upright, near the large knuckle. The index finger helps guide the pivot. This is finger work. Repeat to get the feel of the turn.

Fig. 6

Nib turn 2: Square dot turn (Figs. 7a, b, and c—finished shape)
1. Place the left nib corner on the line and pull a short, diagonal stroke. The right nib corner finishes on the line.
2. Place the nib over the dot: pull the left nib down with the thumb while pushing the shaft against the large knuckle for support. The right nib corner also moves down a little in this traveling pivot.

Nib turn 3: Ink sequence, Figs. 8a-e, with a 4mm Brause
1. Place the nib atop a ruled line. Make fans as above. (Fig. 8a)
2. Make square dots as above. (Fig. 8b) Place the nib over a wet dot. Press-release and pull the left nib corner (T) down, counter-clockwise, as you pivot the nib. (Fig. 8c)
3. Pull the turned stroke without an initial dot. (Fig. 8d) Repeat.
4. Pull a longer stroke while pivoting the nib in a continuous turn. (Fig. 8e) Make several of these strokes to get the feel.

Fig. 7a **Fig. 7b** **Fig. 7c**

Note: Apply the above technique used in Fig. 8e to the first downstroke of "v," next page.

Fig. 8a **Fig. 8b** **Fig. 8c** **Fig. 8d** **Fig. 8e**

Ductus and Dynamics

Rule guidelines, proportion frames, and 40° angle lines. First, dry trace to get the pattern.

Fig. 1 **Fig. 2** **Fig. 3**

(v) 1. **Entry serif to the left diagonal**
 a. Place the nib's right corner a little below the waistline at the proportion frame's left side. (Fig. 1) On a sustained inhale, complete the next two steps (which don't take much time).
 b. Throw a hairline half a nib width down and immediately retrace it, in a recoil action, to the start position. (Fig. 2)
 c. Press-release and launch into edge shift 3: pushing up to the waistline and pulling into an arc. (Fig. 2) You are now in position for the downstroke.
2. **Left diagonal**
 a. Exhale as you apply start pressure; continue partnering (T) and pull the shallow, arced diagonal about three-quarters of the frame's length. (Fig. 2)
 b. Without stopping, apply a little pressure and, in release, pivot until you break through the baseline. (Fig. 3) Practice this stroke many times. (Fig. 4)

Fig. 4

Interrupt the letter: Practice a technique for making the second entry serif. This thins the second diagonal downstroke and produces a clear contrast in downstroke weights. (Fig. 5)

Stroke technique: Nib turning between strokes (traveling pivots)

This technique involves pivoting nib angle as you move from one stroke direction to another.

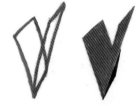

Fig. 5

Dry tracing (Automatic Pen): traveling pivots. Place the nib in alignment with the red dotted line of Fig. 6a. Press-release and partner with the left nib corner (T). As you push to the right and pull down, steepen nib angle, moving counter-clockwise. Focus on the thumb pivoting the nib as it travels. Repeat a few times.

Using ink (4mm Brause)
1. Rule a horizontal line and place the left nib corner (T) on it at 40°.
2. Press-release and pull a horizontal stroke. (Fig. 6b)
3. Place the nib at the start of the stroke and, in the wet ink, make the pulled pivot above. (Fig. 6c)
4. Repeat. Emphasis is on the thumb pulling and turning; the index finger pushes in support.

Fig. 6a **Fig. 6b** **Fig. 6c**

Continue the letter: Make the left entry and downstroke, as above, then:

3. **Entry serif to the right diagonal**
 a. At the base of the first downstroke, press-release and lift the nib. Move diagonally upward to the waistline, to the corner of the frame. (Fig. 5)
 b. Move a little left and place the nib at 40°. Press and partner with the left nib corner (T); in the release of pressure, make a traveling pivot as above.
4. **Right diagonal:** Apply start pressure and pull the right diagonal down to overlap the left downstroke. (Figs. 5, right; and 7) Due to the nib's square corners, a sliver of a triangle results. (Fig. 8) This small "bump" is a natural imprint of the edged pen, when it is not turned.

Fig. 7 **Fig. 8**

Speed: Through speed you can make subtle changes in stroke character and energy. Increasing speed at the end of the stroke thins or adds a slight curve to it. First, try this with vigorous, unserifed strokes to get the feel. (Fig. 9a) Begin with press-release; then, lean into the stroke and push off, accelerating. Next, use more control and begin with serifed entries. (Fig. 9b)

Fig. 9a **Fig. 9b**

(w) 1. **Entry serif:** As in "v." **First diagonal:** Steeper than "v." (Fig. 10)
2. **Second diagonal:** Lift the nib and place it a little below the waistline at a steepened angle. Pull the stroke as in "v." (As you relax, it's natural for a hint of reverse curve to emerge.)
3 **Third diagonal:** Lift the nib and place it over the previous stroke, just below the waistline, at 40°. Pull a subtle reverse curve and break the baseline.
4. **Fourth diagonal:** As in the second diagonal of "v." Note: This letter is slightly narrower than two adjacent "v"s. (Fig. 10)

(y) 1. **Entry serif, first diagonal, and entry serif to the second diagonal:** As in "v." (Fig. 11)
2. **Second diagonal:** This is a long, subtle reverse curve; slow at the juncture with the first downstroke to move through the wet ink. Pull to the descender line, or below.
3. **Exit serif:** Twist off.

Fig. 10

Fig. 11

Spacing

1. Dry trace the word "vivacity" noting the spatial shapes that form between the letters. (Fig. 12)
2. Using ink, write words in Italic using the "v" family. Note: "v" family letters start close to, or touch, those they follow.

The **"Hybrids"** (jszx)

Each of these letters features a stroke combining a clockwise and counter-clockwise gesture into a reverse curve: subtle in "j," "x." and "z," and more pronounced in "s." (Figs. 3-6)

Warming up

Tool: 4mm Brause **Paper:** marker/JNB **Ink:** fully loaded

1. Get out the kinks with quick ovals, counter-clockwise and clockwise.
2. Slow down. Make the counter-clockwise first stroke of "o." Just beneath it, make the clockwise second stroke of "o." (Fig. 1)
3. Slowly, in the wet ink, make an "s" reverse curve, moving over the directional strokes. (Not shown.) Experiment with variations in pressure and speed.
4. Pull a single long reverse curve and shorter ones side by side. (Fig. 2)
5. Repeat the sequence.

Ductus and **D**ynamics

First focus on the letter's individual strokes; then on the rhythm and flow of the complete form.

Tool: 4mm Brause **Paper:** marker/JNB **Ink:** dip and flick

(j) 1. **Preliminary:** Make a few downstrokes, exaggerating the reverse curve. Fig. 3a)
2. **Entry serif:** As in "i."
3. **Descender:** The counter-clockwise start of the curve is quite restrained; the lower, clockwise portion, is graduated (edge shift 4) and creates a slight swell. (Fig. 3b) Its length may vary.
4. **Bottom stroke:** As in "g." (Fig. 3c)

(s) Dry trace using the directions below; then use ink. (Fig. 4)
1. **Entry:** Place the nib just below the waistline.
2. **Diagonal** (reverse curve): Press-release into edge shift 1—pulling the waterfall into a short vertical arc. Slow a little to get your bearings. Apply start pressure and move into the diagonal. In release, continue into the lower vertical arc and edge shift 4. The resulting hairline finishes at the baseline.
3. **Bottom stroke:** Lift the nib and move slightly to the left of the letter's proportion frame. (Fig. 4) Pull a shallow horizontal arc to the hairline of the reverse curve and overlap it.
4. **Top stroke:** Place the nib over the hairline entry. Inhale, press-release and push a short, shallow arc. To end, press-release and steepen nib angle slightly.

(z) 1. **Entry serif:** Place the nib just below the waistline. Prepare the nib to release ink (press-release or vibrate). Rock to the left corner (T) as you pull a short stroke down and left. Replace the full edge where you began. (Fig. 5)
2. **Top horizontal:** Inhale and press-release, pushing up and to the right. Exhale, pulling across and a little down, ending at the right side of the frame.
3. **Diagonal** (reverse curve): Inhale, press-release and flatten nib angle to nearly 0°. Exhale; apply start pressure and pull the left facing arc of the reverse curve into a straight diagonal (or complete the reverse curve). Finish with end pressure at the baseline.
4. **Bottom horizontal:** Inhale and ride up a short way in the wet ink, turning the nib back to 40°. Exhale and push across and into the baseline, steepening nib angle a little toward the end of the stroke and continuing into a short hairline (edge shift 2) to exit the stroke.

(x) 1. **Entry, left diagonal and exit:** Make an angular entry and pull the diagonal. Toward stroke end, make edge shift 2 and exit to the right of the proportion frame. (Fig. 6)
2. **Entry, right diagonal and exit:** Begin with an uptick entry, starting a little below the waistline and pushing a little above it. Apply start pressure and pull the diagonal with a hint of reverse curve. Slow down through the first downstroke and continue a little way through the baseline. Twist off to end the stroke.

Fig. 12

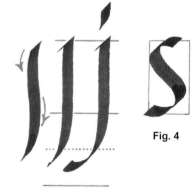

Fig. 1 **Fig. 2**

Fig. 4

Figs. 3a, b and c

Fig. 5

Fig. 6

Word as image: spacing and graphopoeia

In spacing this family, treat the "j" like other single-stroke verticals. The "s," "z," and "x," with their open, unwalled sides can be narrowed or widened in response to their neighbors.

1. Make a scat with each hybrid letter, alternating it with each vowel. Or, make up tongue twisters on the lines of "she sells seashells…"
2. Write words. Try to include at least one hybrid. (Fig. 7)
 a. Use the model alphabet. Try different sizes and speeds.
 b. Experiment with graphopoeia using the graphic elements of stroke direction, nib angle, scale and proportion with expressive intent. (Fig. 7) You may want to begin with a one-point tool to explore stroke gesture and direction.

Fig. 7

Proportion

Choose a nib size and a letter family. Make letter strings in two proportions. (Fig. 8)

Fig. 9 Narrow caps (Moto) with narrow Italic

Fig. 8 Typical and narrow proportions

Proportion and size

Choose a book title and experiment with these elements. Figs. 9 and 10 combine Upright Italic lower case and Moto caps. Fig. 9 shows a subdued cap profile, with the caps slightly taller than the accompanying lower case. Fig. 10 accentuates the caps by making them both significantly taller and in a larger nib size. What do you think of the lower-case letter proportion chosen for these titles?

Fig. 10 Two nib sizes (caps, 2mm; lower case, 1½ mm)

Practice text

Preparation

- **Purpose:** To solidify skill in constructing a grid and to gain more experience using the graphic character of an alphabet to guide the choice of a text.
- **Choosing a text:** To begin, consider the characteristics of Upright Italic: vertical, distinct, readable letter forms featuring subtlety and restraint. These features suggest dignity and the desire to communicate in a civilized voice. Consequently, I have chosen Upright Italic for writing Shelley's poem, "Mont Blanc," with its hymn to the intertwining of nature, solitude, and the human imagination. (See a few lines from the poem, next page.)

Testing

Begin by constructing a grid. (See pages 171-2) Then make tests for letter size (body height) and interlinear spacing.

Tool: 2mm, 2½mm, or 3mm Brause **Paper:** 9" x 12," marker (larger if needed), or 11" x 17," JNB **Ruling equipment**
Text: line length: 3-6 words; text length: 8-10 lines.

Preliminary exercise: Text making integrates the various facets of letter making—design, ductus and dynamics. Focus on each, separately, before writing your full text. Use the letter size chosen in Testing and write a line of your text three times, one with each focus.

1. **Design** (letterform): Analyze your work in terms of adherence to proportion, nib angle and branch height.
2. **Ductus** (the line of writing): Try to make the spaces within and between letters as similar as possible.
3. **Dynamics:** Use the pressure patterns, partnering, and edge shifting to help you stay with the stroke and discover its rhythm. Explore the pleasure of timing a letter as you put its strokes together to complete a form.

Composition

Set margins, rule guidelines, and write a flush-left text. Enjoy forming the letters as you relate one to the other.

Caps and lower case

For the calligrapher, using caps with lower case goes beyond the demands of convention: the element of contrast enhances the potential for creative text design. Even when sharing the character of a lower-case alphabet, caps usually contrast in size, weight, complexity, and spatial area. Given these basic differences, a calligrapher can juxtapose cap and lower-case forms to help express the spirit of a particular text.

As the manuscript tradition shows, our predecessor, the scribe, began mixing caps and lower case centuries ago. At that time, scribal choices were shaped by historical forces; today, the calligrapher chooses with conscious intent. I now invite you to experiment with Moto or Satisfaction caps as a companion to an Upright Italic text. If you have experience with Roman Caps, try them if appropriate to your text. In the lines below, I have used a version of Roman Caps. (Note: The study of Roman Caps, which is beyond the scope of this book, is essential to appreciating the full breadth and depth of Western calligraphy. See "Bibliography" for suggestions.)

1. Rewrite the previous practice text using the caps suggested above.
2. Consider the height of the cap and lower case in relation to each other. (Figs. 9 and 10, p. 222, and Jumprope caps, p. 74)
3. Consider nib size: the cap/s can be of a larger size than the text if suitable. (Fig. 10) Experiment.

Mont Blanc yet gleams on high—
the power is there
And what were thou,
and earth, and stars,
If to the human mind's imaginings,
Silence and solitude were vacancy.

Using a 2mm Brause, I have written a few lines form the concluding verse of Shelley's long poem, "Mont Blanc."

Alphabet variant: slope

Now that you have the basic Italic strokes and shapes in hand and mind, try this alphabet at a slope. Or wait until slope lines are introduced. Slope lines provide a framework to help you develop skill in writing letters at a consistent slope. (See p. 227) Giving it a go now, though, should alert you to the challenge!

Tool: 3mm Brause **Paper:** marker/JNB **Guidelines:** horizontals ½" apart, nib angle lines at 40°

1. Make a few "i"s at different slopes, and choose one of the slopes.
2. At the chosen slope, make a line of alternating "i"s and "l"s. Try to make their downstrokes parallel.
3. Write a line of words trying to keep them consistently sloped. Look for the axis lines of letters without straight downstrokes, such as the "o" and "v," and make these lines parallel to the line of slope.

Training Alphabet 11: Proteus

The name of the Greek god Proteus, who represents the changing nature of the sea, seems apt for an alphabet characterized by a fluid array of weights and forms. (Fig. 1) It emerged from my attempt to express the song "Autumn Fire," written by singer-songwriter Mick Read. (See p. 239.) To connote its energy and vigor, I chose a more pronounced letter slope of 12°—the far end of Italic's customary 5° to 12° slope range. To express the unpredictable, spontaneous nature of fire, I decided letter variants would be an integral part of its design, rather than an added element. To signify the flickering quality of fire, Proteus varies the weight of its letterforms in a dramatic break with scribal tradition.

In Proteus, the calligrapher is deeply engaged in the flow of writing, choosing weights and forms for their visual relationships to the preceding and following letters. Now, the act of writing, whether a word or line of words, is a creative process drawing upon all of a calligrapher's resources as designer-artist, at any stage of her development. It's a process that fully engages mind, body, and feeling.

Fig. 1 Proteus:" a – f"

Proteus is actually three alphabets. Proteus 1, at 40°, has a flatter nib angle—greater weight—and wider proportions (Fig. 2a); Proteus 2, at 60°, has a steeper angle—lighter weight—and narrower proportions (Figs. 2b); and Proteus itself, which alternates Proteus 1 and 2. (Fig. 2c) Such alternation of angle trains the hand to make changes in stroke weight—to steepen and flatten nib angle—at will. The nib angles specified below create a particular relationship between heavy and light strokes. If desired, this relationship can be changed by using a flatter angle for heavier strokes and a steeper one for lighter strokes. (See Fig. 2, p. 239.) Additional angles may be used if a more shaded weight spectrum would serve your artistic purpose; or enlisted purely from the desire to experiment.

Design

Nib angle
Proteus 1: 40°, Proteus 2: 60°, or steeper; Proteus 3: 40° and 60° in alternation. (Fig. 2) For advanced students: nib angle may also vary within strokes.

Visual themes
- Slope: 12°: The axis of a bowl generally follows the line of slope, but it may also be different from it. (Fig. 1, third "a")

- Proportion: Wider, flatter-angled forms intermix with narrower, steeper-angled ones. Variants may be wider still. (Fig. 1, third "a," first "c")

- Weight: There is an alternation of heavier and lighter letters, and sometimes strokes within a letter.

- Embellishments: These details, such as added hairlines, are not needed for reading, but like musical ornaments, can add liveliness and/or refinement. (Fig. 2c)

Fig. 2 A few words from Mick Read's "Autumn Fire"
a Proteus 1 (top) at 40°, **b** Proteus 2 (center) at 60°,
c Proteus (bottom) at alternating angles of 40° and 60°

- Space: In Proteus, the white spaces between strokes (the gaps of Satisfaction), are used to signify energy and movement.

Guidelines

For Proteus, the grid of guidelines now includes ruled horizontals, angle and slope lines.

- The base- and waistlines are ¾" apart (approximately 5 nib widths).
- Ascender/descender lines are 3/8" above and below the waist- and baselines. These extended strokes may rise above or dip below their guidelines with greater freedom than the body-height forms.
- Angle and slope lines. The information these lines provide is definitely useful. However, three diagonal lines (two angles and one slope) crossing a grid of horizontals may be more confusing than helpful. See the suggestions below.

1. Use an angle icon displaying both angles and rule slope lines 1" apart.
2. Use an angle icon for one angle and rule a line for the other angle 2" apart. Make the slope lines 1" apart.
3. Rule all lines but vary the distance between them, e.g., angle lines 4" apart and slope lines 1" apart.

Our multi-cultural world

In an age of cultural diversity and fusion, calligraphers often look to other calligraphic traditions and art forms to stimulate their graphic imagination.

This example of Chinese calligraphy shows a 17th century artist varying the weight of the characters to express a poem he has written. Despite not being able to read the poem, the Western eye enjoys such variation, in addition to the sense of movement and energy conveyed by the strokes. Proteus, too, experiments with variations in weight. For me, its play of light and dark also creates a strobe-like effect recalling the energy of the dance floor. Its strokes and forms, like those in the Chinese poem, convey the life force by endowing them with a sense of movement.

Layers upon layers of greenwood shade,

 the birds are singing:

Wild grass and fragrant flowers

 despoiled by the night's rain.

The heavens disperse the drifting clouds,

 until wholly swept away;

Allowing one, along the road,

 to see the azure mountains.

 Cha Shih-piao (1615 – 1698)

226

Ductus

Proteus orients its downstrokes along a slope line rather than along a vertical. Whether vertical or sloped, this line also provides a stretcher for curved downstrokes. But, even as these strokes pull away from the line, they should appear parallel to it. Refer to Guidelines on the previous page.

Dynamics

Pressure patterns continue to help you stay with a stroke and reach its target point/s. In Proteus they also help you to shape the stroke itself. By turning the nib in the release of pressure, the stroke may expand or contract in width; pressure applied to only part of the nib tapers or roughens stroke character. The exercises in Proteus help you develop this advanced-level stroke technique with all its rhythmical nuance and pleasure.

Fig. 3 Proteus: "g – z"
As you see in Fig. 2 (previous page) the alphabet model is a starting point. The imagination of the calligrapher works freely but within constraints. A different text may inspire a new graphic concept and lead to further experiments in alphabet/text design. (See Fig. 2, p. 239)

Introducing Slope

The vertical is a familiar reference, but a 12° slope is not. The first step is to rule slope lines using a protractor. (Fig. 1) Use the same method as for ruling angle lines. (See pages 175-6) Note: When you're writing, slight deviations from an established slope will still read. Since the challenge of controlling nib angle continues, it's helpful to rule angle lines, or make an angle icon, as well.

Tool: 4mm Brause
Paper: marker/JNB
Ink: fully loaded
Guidelines:
12° slope lines
 (1/4'" apart)
horizontals
 (3/4" apart)
40° angle lines
 (2" apart)

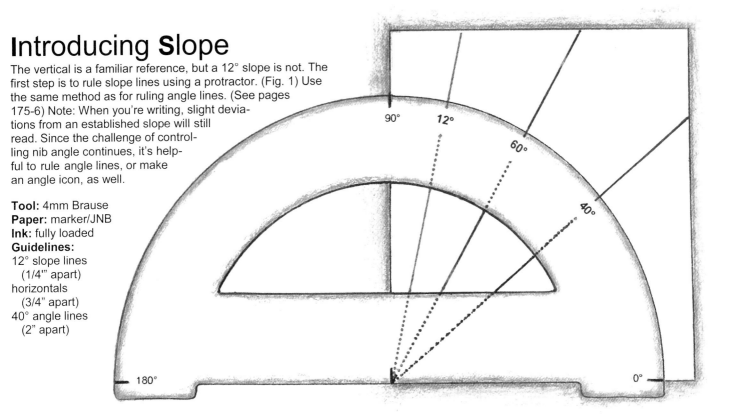

Fig. 1 Proteus uses slope lines at 12° and angle lines at 40° and 60°.

Warming up

1. In the air, quickly move the ink-filled nib up and down above a ruled slope line. At the top of the throw, pause and inhale. Exhale and throw the nib onto the paper, continuing the motion at a slower rate. (Fig. 2) Use the breath: inhale, up; exhale, down).
2. Zigzag: Place the nib below the waistline at 40°, to the right of a slope line. Inhale, press-release; exhale, sink the shoulder and pull down along the slope line. At the baseline, inhale, press-release and rock to the right corner; push up to the next slope line (at the waistline). Repeat. (Fig. 3)
3. Bow this pattern focusing on feeling and shoulder contact. Use the breath.
4. Make the strokes separately. (Fig. 4)

Practicing the 12° slope

1. To get the idea of writing at a 12° slope, use the familiar, straight-line Moto alphabet. (Fig. 5)
2. Use a 3mm Brause and rule base- and waistlines (5/8" apart), and slope and angle lines as above.

Throwing arcs

1. Use guidelines, slope and angle lines.
2. Counter-clockwise: At a slow to moderate pace, using end pressure, throw arcs around a slope line: pulling down to the left and pushing up to the right of it. (Fig. 6) Continue throwing these arcs, moving to the right and maintaining slope. (Fig. 7) Let the hand move with the nib: if it remains "planted," maintaining a consistent slope may prove elusive. Use a fully loaded nib.
3. Dynamics: Throw separate arcs with end pressure. Near the baseline, vigorously release the stroke—leaving the paper in a tight, upward curve. (Fig. 8)
4. Clockwise: Repeat 2 above. (Fig. 9)
5. Dynamics: Make the body-height entry and downstroke of Upright Italic, but at a slope. (Fig. 10)

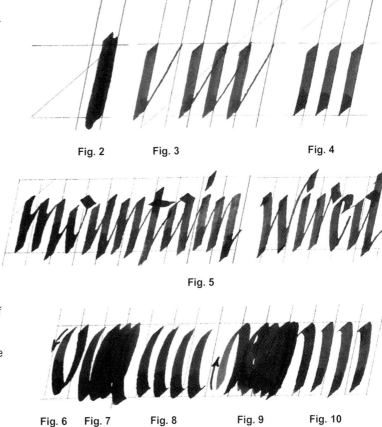

Fig. 2 Fig. 3 Fig. 4

Fig. 5

Fig. 6 Fig. 7 Fig. 8 Fig. 9 Fig. 10

The Reverse Curve

This stroke, used in Jumprope and Trapeze, plays a prominent role in Proteus. Here we focus on the "splice": a straight section that connects two opposite facing arcs, and gives them stability. Note the reverse curves of Figs. 1, 2, 3, and 4: Fig. 1, facing arcs loosely connected; Fig. 2, facing arcs slightly overlapped; and Figs. 3 and 4, facing arcs joined by a splice. The length of the splice and the relative size of the arcs can also be used expressively. (Fig. 6, next page)

The symmetrical reverse curve

The top and bottom arcs of this reverse curve are of similar length. Dry trace Fig. 4, following the instructions below.

> **Tools:** #6 Automatic Pen (Or, you can reduce the figures on a copy machine for use with a #4 Automatic Pen.)
> **Paper:** tracing vellum

1. **Left facing top arc** (clockwise)
 Place the nib at the top of Fig. 4. Inhale, press-release; exhale, pull a steep vertical arc—down and a little to the right with end pressure. Stop a short way from the line of slope (black dotted line), about one-third of the length of the stroke.
2. **The "splice"**
 Inhale briefly and release a little pressure; exhale and pull the splice using start pressure, moving down and to the left, back to the line of slope. As you reach the end of this section, about three-quarters the length of the stroke, slow and inhale.
3. **Right facing bottom arc** (counter-clockwise)
 Exhale and pull a steep vertical arc a little to the right using end pressure. Release and lift off.

Note: The splice may not appear straight because the hand often anticipates the bottom arc which slightly "softens" the straightness. It should not, though, curve noticeably enough to undermine stability. The splice is not parallel to the slope line; its length can be variable.

Structure of the symmetrical reverse curve

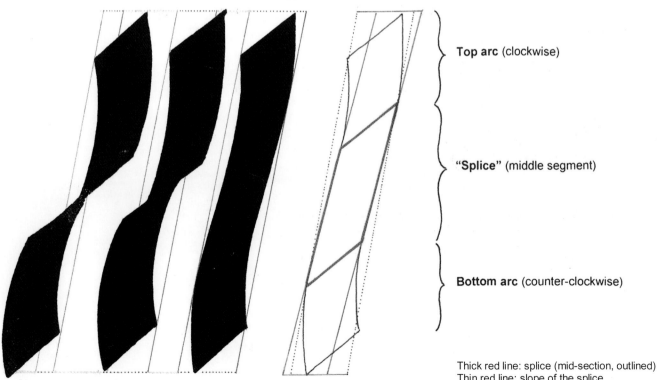

Top arc (clockwise)

"Splice" (middle segment)

Bottom arc (counter-clockwise)

Fig. 1 Tangential, **Fig. 2** Overlapping & **Fig. 3** Spliced arcs **Fig. 4**

Thick red line: splice (mid-section, outlined)
Thin red line: slope of the splice
Black dotted line: slope line

Developing the reverse curve

The following exercise sequence develops the reverse curve. First dry trace, then use ink. Warm up the fingers with a partnering exercise. (p. 148)

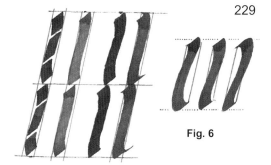

Tool: 4mm Brause **Paper:** tracing vellum, marker/JNB **Ink:** dip and flick
Framework: (Fig. 5a): horizontals (3/4"); slope lines (1/8" apart); angle lines, separated comfortably, or an angle icon (40°)

1. The reverse curve in segments (Fig. 5a): Place the left corner of the nib against a slope line. Inhale, press-release; exhale and pull a short left-facing arc steeply down and to the right (first segment). Inhale, lift the nib and move a short way; exhale, land. Inhale, press-release; exhale and pull a straight stroke (middle segment). Inhale, lift the nib and move down a short way; exhale, land. Inhale, press-release; exhale and pull a right-facing arc steeply down to the baseline.

Fig. 5a b c d

2. Connect the segments (Fig. 5b): Retrace the above segments as an exercise in relaxing and sensitizing. On an inhale, place the nib at the top of the reverse curve; exhale throughout the length of it. Keep the dynamics soft.
3. Make a freehand reverse curve, with awareness of the three segments, within the slope lines. (Fig. 5c)
4. Attention to the start and finish: begin and end with a short entry or hairline. (Fig. 5d)
5. Experiment with relative arc size. (Fig. 6) The ratio of top arc to bottom, influences both stroke direction and character.
.

Proteus 1: Body-height letters

Proteus 1, (Fig. 1) like Proteus 2, is a complete alphabet; brought together, though, they comprise the distinctive energy of Proteus itself. In all three versions, the organizing principle is letter height, unlike the directional gestures of Upright Italic, the structural frameworks of Satisfaction, or a prominent theme such as Moto's straight verticals.

Fig. 2

Fig. 1

i, u, t

The downstrokes of "i" take three forms: a left- and a right-facing arc, and their splice into a reverse curve. (Fig. 1) These strokes also comprise many other body-height letters: "u" (two right-facing arcs, Fig. 5); "t" (a single extended arc, Fig. 7a), first stroke of "r," "n," and "m" (left-facing arcs, p. 230).

Tool: 4mm Brause **Paper:** tracing vellum, marker/JNB **Ink:** dip and flick

(i) 1. Preliminary: use the above framework and make opposing arcs. (Fig. 2, above right)
 a. Left-facing—pull the entry and downstroke of "n" (Upright Italic).
 b. Right-facing—pull an arced downstroke and an exit without a hairline.
2. Make the three "i"s (40°, 12° slope lines), noting the arc's relation to the slope line (Fig. 3)
3. **Hairline exit and Dot of "i":** Practice these hairlines as below before adding them.
 a. The exit upstroke: Place the nib at 40°. Apply a little pressure with the thumb; in release, push the edge up (T) in a shallow arc. As you finish, lift the right nib corner. This serif can begin a short distance from the end of the downstroke. (Fig. 3) At a steeper angle, this stroke can also be used to dot the "i." (Fig. 4a)
 b. The dot as downstroke: Place the nib at a steep angle; press-release; and, with the index finger, push down a hairline using a brisk motion. (Fig. 4b) The left corner lifts.
 c. Practice these strokes and then dot the "i"s.

Fig. 3

Fig. 4a **Fig. 4b**

(u) 1. **Entry serif and Downstroke:** Make a right-facing arc "i." (Fig. 5)
2. **Upstroke:** As in Upright Italic (p. 215, Fig. 5a); it can be attached to the downstroke or separate. Note on detachment: One separation per letter is usually enough.
3. **Second downstroke:** Reset the nib at 40° and pull a slightly longer, right-facing "i."
4. **Exit serif:** May be separate or attached.
5. **Alternate first downstroke:** A hint of reverse curve. (Fig. 6)

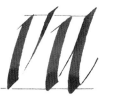

Fig. 5 **Fig. 6**

(t) 1. **Downstroke:** Make the right-facing arc "i" stroke. Begin a little above the waistline and pull to a little below the baseline. (Fig. 7a) This distance may vary slightly.
2. **Alternate downstroke:** Make a reverse curve and an alternate ending. (Fig. 7b)
3. **Exit serif:** May be separate or attached.
4. **Crossbar:** Experiment with nib angle: the flatter the angle the thinner the stroke.
5. **Reminder:** If the ink needs coaxing, vibrate the nib a little.

Fig. 7a **Fig. 7b**

r, n, m

Here, the branch emerges from the stem but does not continue into the arch.

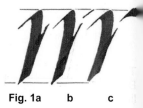
Fig. 1a b c

(r) 1. **Downstroke:** The left-facing "i."
2. **Upstroke branch:** At the baseline, steepen nib angle and push back up the stem. About midway, rock to the right nib corner, and push up and away, with the thumb, a short distance. (Fig. 1a)
3. **The ear:** This short stroke introduces the technique of "partial edge." See below before completing the "r."

Stroke technique: Partial edge

This technique allows you to narrow or graduate a stroke by applying increased pressure to the left or right half of the nib. You can use it to create a variety of strokes from short, small shapes, such as the ear of "r," to long, upward strokes that gradually widen, as in the upstroke of "o." (See next page, Fig. 8) Partial edge moves out of a hairline or a thick stroke. The finish is often rough and slightly unpredictable. (Fig. 2b) You may smooth the stroke with a nib corner if roughness is not desired. (Fig. 2c)

Fig. 2a b c

Partial edge (short): from a hairline, up and to the right
- Place an ink-filled nib at 40° just below a horizontal line. (Fig. 2a) Press-release and push a hairline up one nib width above the line. Repeat.
- Start a hairline (Fig. 2b) and, about half a nib width up, apply enough force to the left nib corner to split the nib at the ink slit. Pull this partial edge up and to the right; ease off to finish.
- Try this several times to get the feel and timing. Notice the variety of shapes. To smooth a jagged ending: As you ease off, continue on the left nib corner and outline the shape you wish. To fill in any gaps, use the corner to drag ink from the stroke, here the ear "r," to fill it in any gaps. (Fig. 2c)

Fig. 3 Fig. 4 Fig. 5

4. **(r) continued:** Reset the nib at 40°, a short distance above the branch (Fig. 1b), and make the partial-edge ear. (Fig. 1c)

(n) The "n" combines the left-facing "i" and the reverse-curve "i." (Fig. 3)
1. **Downstroke and Upstroke branch:** As in "r." (Fig. 4)
2. **Arch and downstroke:** Reset the nib at 40°, just below the waistline, and make the reverse-curve "i" finishing at or below the baseline. Remember, the splice in not in alignment with letter slope.

(m) 1. **Downstroke and Upstroke branch:** As in "r." (Fig. 5)
2. **Second downstroke:** Reset the nib at 40°, just below the waistline, and make the left-facing arc "i" with an upstroke branch.
3. **Third downstroke:** Reset the nib at 40°. Make the reverse-curve "i."

o, c, e

Begin with the long partial-edge stroke (below) before making the "o.

> **Tools:** 05 Pigma Micron, 4mm Brause
> **Paper:** JNB small-grid **Ink:** fully loaded

Partial edge (long, up): (Figs. 6a, b, c, and d) With a Pigma Micron:
- Warm up: Throw counter-clockwise ovals quickly about 1" high.
- Frame: Draw 1" high counter-clockwise loops. (Fig. 6b)

1. Align the nib with the loop's right side; push a short hairline. (Fig. 6b)
2. Apply pressure to the left nib corner (T), pushing up a short way to shift edge. Then apply pressure again to the same corner, forcefully, splitting the nib, while moving up along the loop and gradually widening the stroke. (Fig. 6c) As the thumb pushes the left side of the nib into an arc, the shaft, supported by the large knuckle, lowers toward the paper.
3. Continue to guide the push with the thumb, releasing pressure toward the top of the loop, and finally breaking contact at the top. (Fig. 6d)

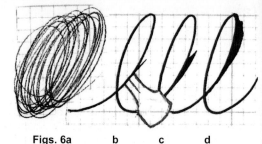
Figs. 6a b c d

Tip on partial-edge technique

Before splitting the nib for a partial edge stroke that begins with a hairline, edge shift from the hairline to full edge.

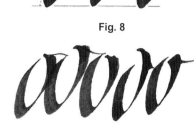

Fig. 8

(o) 1. **Downstroke arc:** Place the nib at 40°, about a nib width below the waistline. Inhale, press-release; exhale and pull counter-clockwise—using the pressure-release patterns of the waterfall stroke. Note: The red axis line of the bowl of "o" is parallel to the slope line. (Fig. 8)

2. **Upstroke arc:** Make the long partial-edge upstroke. Leave it rough, or smooth it. In Fig. 8, red arrows show upstrokes with three different finishes.

3. Practice the "o": Alternate it with an "'i" of your choice and aim for even spacing.

4. Play with the "o": String "o"s together with a cornered thin. (Fig. 9)

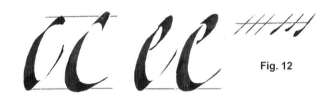

Fig. 9

The "c" and "e" each have two versions: narrower and wider. (Figs. 10 and 11) The latter is discussed below in stroke technique.

(c) 1. **Downstroke:** As in "o." (Fig. 10, left)

2. **Top stroke:** As in the ear of "r."

3. **Exit stroke**: Although the "c" reads without this stroke, it helps to balance the letter, and adds energy. The exit stroke can be attached or separate.

(e) 1. **Downstroke and Exit stroke:** As in "c." (Fig. 11, left)

2. **The "eye":** Place the nib atop the downstroke and just left of it. Push up and into a narrow bend, and down and into a shallow graduated arc, ending with a cornered thin. (Fig. 11, left) Or add a little weight (partial edge, below) to the ending. (Fig. 11, right)

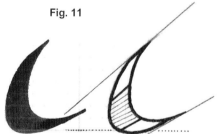

Fig. 12

Fig. 10 Fig. 11

 Partial edge (short): from a hairline, down and to the left (Fig. 12)

- Place the nib at 40° and pull a hairline down to the left a few times.
- Pull a hairline. Toward the end of the hairline, apply pressure to the right nib corner as you continue to curve down and left into a short, slightly thickened ending.
- Guide with the index finger.

Stroke technique: Nib turning

Here, you flatten nib angle to widen the downstroke and thin the horizontal arc—rotating the nib from 40° to about 20° as you move toward the baseline and shift direction. (Fig. 13)

1. Dry trace the Fig. 13 (right) with a #4 Automatic Pen.

2. Use a fully loaded 4mm Brause to get the feel of turning the nib while pulling the stroke down. Get momentum for the turn: apply some pressure going into the bend of the stroke; in release, keep the thumb active, as a moving pivot, turning the nib clockwise and pushing the flat horizontal arc. Look for a speed and pressure pattern that helps you make the turn.

This relative of the "u," with its two parallel, right-facing arced downstrokes (Fig. 1), also sports a stylistic embellishment particular to Proteus: the weighted, lozenge-like shape at the top-right stroke juncture.

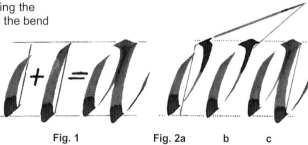

Fig. 1 Fig. 2a b c

(a) 1. **Downstroke arc:** Place the nib at 40°, about a nib width below the waistline. (Fig. 1) Inhale, press-release; exhale and pull a shallow arc almost to the baseline. Press slightly, make an abbreviated dip, and release quickly to finish the stroke. (Omit any significant entry hairline.)

2. **Upstroke:** Reset to a steeper nib angle. Inhale, press-release and push a long partial-edge stroke, thinner than that of "o," to the waistline. (Fig. 2a) Exhale. This stroke uses less edge due to a steeper angle—only expanding the hairline slightly. (Fig. 3a)

3. **Top stroke:** Place the nib atop the upstroke (Figs. 2a and 3a), to the left, at about 20° to thin the stroke. (Fig. 2a, heavy blue line.) Inhale, press-release; exhale and pull diagonally down and to the right. (Fig. 2b)

4. **Second downstroke and Exit serif:** Inhale, press-release and pivot back to 40°. (Fig. 3b) Exhale and pull the second downstroke—a right-facing "i." (Fig. 2c)

Fig. 3a Fig. 3b

V, W

In these letters, the axis of their triangular counters may or may not be parallel to the line of slope. (Figs. 1c, parallel, 3b, unparallel) Use a clockwise entry to vault into the initial downstrokes.

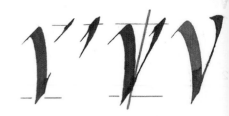

(**V**) 1. **Downstroke:** The cornered spur at the base of the stroke is optional. (Fig. 1a) From the base of the downstroke, you can air stroke to find the start of the uptick entry.
2. **Uptick entry and Second downstroke** (Figs. 1b and c). At 40°, place the nib below the waistline and push a short, upward arc. (The length may vary.) Use the edge shift from hairline to full edge, applying pressure to the left nib corner. At the top of the uptick, apply pressure to the full edge; in release, pivot and steepen nib angle, applying start pressure as you pull the second downstroke in a gentle reverse curve. End by overlapping the first downstroke. (Fig. 1c)
3. **Variant:** A one-stroke "v" with partial-edge exit. (Fig. 2) At the base of the downstroke, pivot counterclockwise and steepen nib angle. Push a thin diagonal (T). Moving toward the waistline, apply pressure on the left nib corner and make a short, partial-edge stroke. Smooth if desired.

Fig. 1a b c Fig. 2

(**W**) 1. **First downstroke:** Pull a nearly upright stroke through the baseline. (Fig. 3a)
2. **First upstroke:** Retrace the downstroke; rock to the right nib corner (T) and push a cornered thin a little shy of the waistline. Reset the nib at 40°, or slightly steeper, just below the waistline.
3. **Second downstroke:** Pull a diagonal reverse curve through the baseline. (Fig. 3b)
4. **Entry and Third downstroke:** Make the uptick entry of "v." Pull the stroke with energy and stop short of the downstroke, or with deliberation and overlap it as in "v".

Fig. 3a Fig. 3b

X, Z, S

These open-sided letters use subtle, and not so subtle, reverse curves.

(**X**) 1. **Left downstroke:** Pull a steep diagonal with the hint of a reverse curve. (Fig. 1)
2. **Right downstroke:** Make a shorter, slimmer entry uptick, at a steeper angle, than that of those above. Pull to just shy of the first downstroke. Practice the partial-edge stroke below—the second part of the downstroke—before the completing the letter.

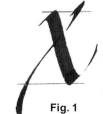

Fig. 1

Partial edge (long, down)
- Pull diagonally down on the hairline, a nib width or so, before forcing the right nib corner (IF) into the stroke. The wrist helps pull the stroke into the arc; in leaving the stroke, add a bit more pressure and pull briskly off the paper. (Fig. 1)
- Practice a few of these strokes, then make a few "x"s, varying the distance the long partial-edge strokes dip below the baseline.

Fig. 2a b c d e

(**Z**) 1. **Top stroke** (Fig. 2a): Push a hairline into the waistline; pause briefly and pull a short diagonal with end pressure. In release, let the nib ride up a tiny bit as you steepen nib angle.
2. **Diagonal downstroke** (Fig. 2b): Apply start pressure and pull a long reverse curve to the baseline.
3. **Full-edge uptick** (Fig. 2c): Press-release and push a short, shallow-arced stroke up.
4. **Bottom stroke** (Fig. 2d): Softly press-release and pull to the diagonal downstroke. Pause briefly, apply start pressure and pull the stroke a little way through the baseline.
5. **Mid-horizontal** (Fig. 2e): Place the nib within the steep downstroke near the top. Pull down and left, pivoting clockwise to flatten the nib angle. Apply start pressure, pulling to and across the downstroke.

(**S**) 1. **Diagonal** (Fig. 3): Place the nib a little below the waistline. Pull a reverse curve to, or just through, the baseline. The trajectory of the straight part (splice) is quite steep.
2. **Bottom stroke:** Continue as though making the partial-edge ending of the eye of "e." This can vary in weight (thickness) and length.
3. **Top stroke:** Push an arc a short way; to finish, turn the nib counterclockwise and pull off the paper.

Fig. 3

Variants for different moods
Fig. 4: An arcing hairline upstroke sets a refined tone. The steepness of the hairline influences the width of the letter; the length and direction of the splice helps shape the reverse curve.
Fig. 5: A long asymmetrical arc abruptly turns into a short nearly horizontal splice to create an assertive tone. To make the top serif: press-release and pull down and off sharply on the right nib corner. This rough ending gives the letter a raw energy.

Fig. 4 Note the different counter shapes. **Fig. 5**

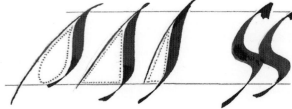

Two "sauces" using the variables of nib angle, inking and variant form.

Word and line as image

1. Trace Fig. 1 with attention to form and spacing.
2. Write a line of words of your own choosing and analyze them as well. Aim for "judi-
cious" spacing. Adjust the spatial shapes/volumes of the white shapes between letters by adjusting distance, distinguishing open bowl/walled letter combinations from walled ones.
3. Rewrite with attention to the shapes of the spatial volumes themselves. (See p. 24)
4. Rewrite, focusing on dynamics, rhythm, and stroke gesture.

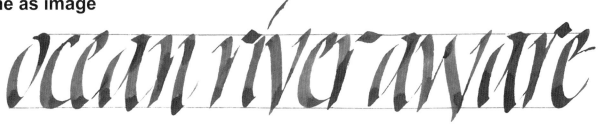

Fig. 1

Fig. 2 Fig. 3 Fig. 4

Plasticity and letter variants

1. Plasticity: In Fig. 2 the model "a" widens as the bowl swings to the left.
2. Variants: In Fig. 3, the bowl is significantly reduced in height and the second downstroke pulls to the right. In Fig. 4, a cornered arc pulls down from the top stroke to make a top bowl.

Proteus 1:
Ascenders and descenders

The various forms of "l," like those of "i," display the pro-tean nature of this alphabet. The long "l" stroke also pro-vides the basis for branched letters (h, k, b, p) and those with counter-clockwise bowls (d, g, q). These extended strokes also help develop concentration: an increase in length calls for more sustained attention.

Note on guidelines: Ascenders generally sit on the baseline; their heights, however, may vary within the interlinear space above the waistline. Descender depth may also vary in this way. Feel free to explore the graphic possibilities of such variability, or set the length of ascender/descender by ruling guidelines.

Warming up

Tool: 4mm Brause **Paper:** JNB **Ink:** fully loaded

1. Shoulder: Throw vigorous broad strokes and hair-lines. (Fig. 1)
2. Shoulder: A relaxation-awakening exercise. Pull long lines, first in 1" segments, then in a single long line.
3. Fingers: A partnering exercise. First trace Fig. 2, then repeat freehand and invent your own. (See "Ink toc-catas," p. 149)

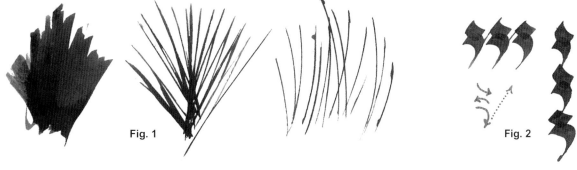

Fig. 1 Fig. 2

l, h, b, k, p

These ascenders and descenders can vary in height. For now, make them one-half body height.

Tool: 4mm Brause **Paper:** tracing vellum, marker, JNB **Ink:** dip and flick
Guidelines: x-height, 3/4"; ascender/descender, 3/8" above and below the waist- and baselines.

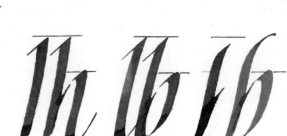

Fig. 1a Fig. 1b

(l) This long stroke includes the three directional possibilities of "i" (Fig. 1a) and adds a subtle, reverse curve. (Fig. 1b)

1. Dry trace each "l": note the changes in pressure as you navigate the stroke. Move from the entry (press-release) into the stroke and then into the mid-section (start/center pressure). Anticipate the exit (a little pressure), and then exit the stroke (release from pressure).
2. Use ink: repeat each version of "l" a few times.
3. Couple each "l" with its twin "i."

The first downstroke of these letters begins with a version of "l." From this stroke, the letters branch into arches, bowls and a variant of "k."

(h) 1. **Downstroke** (the left-facing "l") **and Upstroke branch.** (Fig. 2)
2. **Arch and Second downstroke:** As in "n".
3. See Fig. 10, below, for alternates.

Fig. 2 Fig. 3 Fig. 4

(b) 1. **Downstroke:** The right-facing arc of "l." (Fig. 3)
2. **Upstroke branch:** After finishing the "l" stroke, reset the nib inside the downstroke and make the branch.
3. **Bowl:** Reset the nib as in all detached arch forms, at 40°. Push the overhand bowl (edge shifts 3 and 4) and meet the downstroke.
4. **Alternate "b"** (Fig. 4): Pull a reverse-curve downstroke, starting below the ascender line. Start the bowl as above; finish it with a partial-edge ending near the downstroke.
5. **Curved head:** If you wish to add this stroke, place the nib atop the beginning of the downstroke. Push briefly on the hairline and then onto the left nib corner. Loop the corner over and around the hairline to add a little weight. Practice this ending—it can be extended and thickened or pulled into an arc with partial-edge technique. (Fig. 10)

Fig. 5 Fig. 6

(k) 1. **Downstroke:** (the left-facing "l") **and Upstroke branch.** (Fig. 5)
2. **Loop:** After the branch, reset the nib at 40° and continue into the loop—a partial up-side-down teardrop that ends about a nib width before the downstroke.
3. **Diagonal:** Reset the nib at a steeper-than-40° angle, in contact with the end of the loop, staying a little to the right of the downstroke. Pull to or through the baseline.
4. **Alternate "k"** (Fig. 6): After a reverse-curve downstroke, set the nib just above mid-body height, a short distance from the downstroke, at a steeper-than-40° angle. Push a hairline into a partial-edge stroke (ear of "r," p. 230). Place the nib atop the base of the hairline and pull the diagonal.

(p) 1. **Entry:** Push an uptick, an alternate entry for long strokes, through the waist-line. (Fig. 7)
2. **Downstroke:** Pull a left-facing "l" to the descender line or below.
3. **Bowl:** As in the alternate "b."
4. **Alternate "p"** (Fig. 8): Finish the downstroke with partial-edge, as below.

Fig. 7 Fig. 8

Partial edge (long or short): from a full-edge, straight downstroke
This stroke may vary in the length of its taper and in its roughness.
- To get the feel (Fig. 9): Place the nib; press-release and pull a long line in seg-ments. Apply pressure to the right nib corner (IF) while lifting the left.
- Most of the pressure comes from the shoulder. The fingers hold the tension and guide its release.

5. Continue the letter: make the upstroke branch. Pull the bowl diagonally and finish with partial edge.

Fig. 9

"h" variants

These feature subtle detail and changes in proportion. The choice of one of these variations, or your own, depends on the mood you wish to express. (Fig. 10)

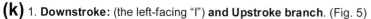

Fig. 10

d, g, q

These letters end with a long stroke (except the variant of "q"). The first version of "g" and "q" begin with the "a" counter, the second, with a smaller "o" counter.

(d) 1. **Arced downstroke:** As in "a."
2. **Upstroke:** Reset the nib at a steeper angle; push up in a thin, partial-edge stroke to a little short of the ascender line. Or, continue up on the left nib corner. (Fig. 1a) Lift the nib and reset it just left of the intended downstroke, and below the ascender line.
3. **Uptick entry, ascender and exit:** Push an uptick serif and pull the downstroke (right-facing "l").
4. **Close the bowl:** Finish inside the downstroke.
5. **Variant:** The round "d." Push a broad, partial-edge upstroke for the ascender. (Fig. 1b).

(g) 1. **Arced downstroke:** As in "a"
2. **Descender** (right side of the "tear-drop" shaped lower bowl): Pull a long, shallow reverse curve through the baseline. (Fig. 2a)
3. **Descender** (left side of the lower bowl): Pull the thin, lower-left partial-edge stroke of "x." (p. 232)
4. **Variant:** (Fig. 2b, double-bowl "g")
 a. Begin with a small "o"—about two-thirds the body-height space.
 b. Reset the nib at the bottom of stroke 1; press-release and rock to the left nib corner (T).
 c. Pull a cornered thin to the left into a short, shallow arc, stopping above the baseline.
 d. Lift the nib and reset it over the thin at a very flat angle.
 e. Press-release and pull left into a hairpin bend; apply start pressure and pull a reverse curve diagonnaly to the right and through the descender line.
 f. Finish the open bowl with the partial-edge stroke of "x."

(q) 1. **Bowl:** As in "a."
2. **Descender:** Press-release and pull a long, subtle reverse curve through the descender line. (Fig. 3a)
3. **Exit:** At the base of the downstroke, pause; press-release, rock to the right nib corner (T) and push up (T) and out in a shallow arc. End below the baseline.
4. **Variant:** (Fig. 3b)
 a. Make an "o" slightly larger than that of the double-bowl "g."
 b. The tail: At the base of stroke 1, rock to the left nib corner and pull a cornered thin (T) to the baseline.
 c. Reset the nib just left of it and pull the tail down in a shallow diagonal arc, below the baseline. Steepen nib angle slightly at the end of the stroke.

f, y, and a variant of z

(f) 1. **Ascender-descender:** Begin this stroke a little below the ascender line. Throw a long waterfall downstroke with either the hint of a reverse curve (Fig. 4a), a right-facing arc with twist-off exit serif, or a short, cornered thin. (Fig. 4b) To help stay with this long stroke, try a strong exhale and experiment with pressure patterns.
2. **Crossbar:** Place the right corner of the nib against the left wall of the downstroke at a flattened nib angle. Pull across as in previous crossbars.
3. **Top:** Reset the nib atop the downstroke entry; push up into a smoothed partial-edge stroke (fig. 4a), or end as in Fig. 4b. (See Fig. 5, bottom of page 232)

(y) 1. **First downstroke:** As in "v."
2. **Descender:** This stroke is a long reverse curve. It connects to the first downstroke in three different versions: 1) the first and second strokes are attached (Fig. 5a), 2) detached (Fig. 5b), or 3) the second stroke follows a cornered thin pushing out of the first downstroke. (Fig. 5c)
3. Practice the long, thin diagonal reverse curve without nib turning. Or with: Steepen nib angle toward stroke middle and flatten toward stroke end. The thumb and index finger are active partners in turning and driving the nib. (Fig. 5d) This is advanced technique and takes lots of practice.

(z) This letter combines a wide, shallow "z" (about one-third body height) with a long, arced tail. The connecting thin stroke is a hairline. (Fig. 6)

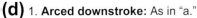

Fig. 1a Fig. 1b

Fig. 2a Fig. 2b

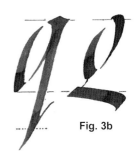

Fig. 3b

Fig. 3a

Fig. 4a Fig. 4b

Fig. 5a Fig. 5b Fig. 5c Fig. 5d Fig. 6

Word as image

This exercise is about play: getting absorbed in the interplay between the meaning of a word and its expression in stroke, letter and word (See Grapho-poeia, p. 72-73). Developing empathy with a word—its meaning or some aspect of it—comes with practice. Close your eyes and try to experience the spirit of the word in terms of energy, whether it suggests activity or stillness, and mood, whether it connotes heaviness or lightness. The aim is a calligraphic reading.

Tool: 4mm Brause **Paper:** tracing vellum, marker/JNB **Ink**

1. Dry trace each word looking for it as an expression of some facet of its meaning. (Fig. 7) How does it achieve this—stroke direction, endings?
2. Choose a word that suggests action, feeling, or mood. Write it using the model. Then,
3. "Translate" a quality of this action/feeling/mood into a word image. Let the word's meaning stimulate experiments with the various graphic elements in your repertoire: stroke direction, letter structure, space, weight, plasticity and variants. Consider: relationships between letter width and height (proportion), letters and guidelines; detail (beginning and exit serifs); and whether to use ligatures. Use play and experimentation to help you find correspondences between word meaning and calligraphic expression.

Practice text

Using Proteus 1, create another text to encounter the pleasure of moving with awareness as you fit stroke, letter, and word to each other.

Preparation

- Purpose: To construct a grid and write a text using Proteus 1.
- Text: For this exercise, choose a text that is meaningful to you. Feel free to use your own or another's words. If you choose a poem or song, I suggest reading or singing the lines aloud before writing them.

Testing

If caps are needed, Trapeze caps can be adapted to pen work. I offer three examples. In Fig. 1, the cap of "Dance" uses partial-edge to swing the bowl beneath the downstroke. In Fig. 2, the cap of "Ballet" makes a downstroke in a thin, steep-angled reverse curve; the bowl at bottom is joined to it by a shallow diagonal made at a flat angle. Fig. 3 shows more examples.

Fig. 7

Writing

Review "Writing" p. 173.

Note on Fig. 3

In this rough for a song title, please note my use of the various techniques discussed in this book including 1) partial-edge strokes, 2) cornered thin serifs, and 3) hairline upstroke embellishments.

Fig. 1 **Fig. 2**

Fig. 3

Proteus 2: All letters

Although Proteus 2 has the same basic forms as Proteus 1, it here qualifies as a distinct alphabet based on its significantly steeper nib angle. (Fig. 1) This angle creates letters that are markedly narrower in proportion and lighter in weight than Proteus 1.

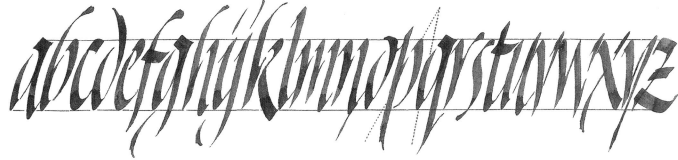

Fig. 1 Proteus 2

Nib angle: 60°

Visual theme: Thin downstrokes punctuated by short, thick horizontals. (Fig. 1: top strokes of "a," "g," and "q," and the crossbars of "t" and "f"). The ear of "r" could also be a thick stroke.

i and l
Practice the three versions of "i" and "l" at 60°. (Fig. 2)

Tool: 4mm Brause **Paper:** marker/JNB **Guidelines:** ¾" apart **Slope and angle lines**

Note on "a," "g," "q"
Be sure to start the first downstroke well enough below the waistline to leave room for the thick top stroke and a small gap between the two strokes.

Fig. 2

Proteus 2 practice
1. Write the full alphabet.
2. Write the letters of the alphabet alternating with an "i."

Practice text

Preparation
- Purpose: To construct a grid and write a text using Proteus 2.
- Text: Let the character of the alphabet again guide your selection. Consider the character of Proteus 2: the slim downstrokes and narrow letter proportion combine to give a feeling of elongation. These features my suggest elegance, lightness, flickering, exaltation, flimsiness, weakness, shakiness…

Testing
Use the same height for guidelines in Proteus 1, or experiment with letter height and interlinear space. Try to echo the proportion of the letter in the proportion of the text block. Review "The writing grid," p. 171.

Writing
Review "Writing a text as meditation," p. 173.

Energy and flow

Proteus

The next two exercises introduce you to combining Proteus 1and 2. The challenge is to keep your attention on two facets: the changes of nib angle and its corresponding changes in letter proportion.

An abecedary

Write the alphabet alternating Proteus 1 and 2. E.g., "a," Proteus 1, "b," Proteus 2.

Word as image

Write a word/text as below (Fig. 3):
- a. 40° nib angle (Proteus 1)
- b. 60° nib angle (Proteus 2)
- c. Alternating 40° and 60° angles (Proteus)
- d. Try a more extreme contrast of angle. (Fig. 2, p. 239)

Fig. 3 Top, Proteus 1
center, Proteus 2
bottom, Proteus

A finished piece

This piece applies the lessons of the previous practice texts. It is not an exercise but a performance. I encourage you to approach it as meditation, in a state of relaxed alertness. Recognize any doubts or fears, breathe, and enjoy yourself!

Preparation

- Purpose: To create a finished piece writing Proteus in a multiline text.
- Text: Let the character of the alphabet guide your choice. Consider the nature of Proteus: an unconventional design of changing weights and variations in form. *Since these features suggest the energy and flickering of fire, I chose a verse from the song "Autumn Fire," written by my husband, singer-songwriter Mick Read.*

Finish materials

In making a finished piece, the nuances of paper and ink contribute to both the quality of the writing experience and a work's "presence." This latter quality, real though hard to describe, distinguishes an original work from its reproduction. Only in an original can the expressive properties of paper and ink, subtle but discernable, be felt. Moreover, no matter how sophisticated the technology of reproduction, only an original connects us to the actual writing: the calligrapher grappling with ink on a surface to produce letterform. Finish materials are investigated below, before proceeding to the finish piece.

Paper

In choosing a writing surface, calligraphers consider its ability to satisfy a visual intention and to enhance the pleasure of writing. For exercises, we need only a paper that holds a hairline. For finished work, in addition to meeting this requirement, other facets to be considered include durability, weight, texture, and color. These attributes are provided by mold-made, handmade, and some machine-made papers. All of these are 100% rag, for longevity, and sold in large, single sheets. Test a variety to see which you prefer for your piece. Some mold-made brands include: Strathmore, Fabriano Artistico, Saunders and Zerkall. Finding handmade writing papers will take research. Testing paper is testing ink.

Handmade papers are distinguished by their deckle edges.

Ink

Although this book focuses on the writing medium of ink, calligraphers also experiment with other media, such as watercolor. In choosing a medium, we consider its visual interaction with the paper, as well as the feel of working with it. The free-flowing inks of exercise work may not be sufficiently black for a finished piece. Finish inks, generally less free-flowing and a bit more challenging to use, include Chinese and Japanese bottled and stick inks. (See Suppliers, p. 247)

Testing materials

1. Select and purchase two or three different papers and inks.
2. Cut swatches from the papers and identify them in light pencil.
3. Use a 3mm Brause; test each ink on each paper. Take notes on hairline sharpness, the feel of making contact, the ease of working on it.

Note: Using higher quality papers and inks increase writing challenges, but also enrich the experience of writing and making calligraphic contact.

Pen and paper: Nib size also influences the choice of a paper surface: generally, the smaller the nib the smoother the paper. A small nib fights with a highly-textured paper both visually and physically.

Testing: making roughs

Prepare for making roughs: warm up with the selected tools and materials.

Caps: Use Trapeze or Satisfaction caps. (Try the Uncial hand if you're familiar with it.)

Size of writing

1. Rule guidelines for a single line of text for a couple of nib sizes. Use Proteus's characteristic scale (measured in nib widths) or experiment.
2. Ascenders and descenders: will roam freely in interlinear space or have their own dedicated area.

First rough: flush left layout (p. 170)
1. Rule two line spaces. For a poem, write the first and longest line. For a prose passage, write a couple of lines six to eight words in length.
2. Construct a grid. (See p. 171-172)
3. Pencil desired angle or slope lines.
4. The distance between verses depends on interlinear space. Try one body height and decide if this separates the verses/paragraphs sufficiently to make them distinct but not disconnected.
5. Write the text and proofread it.

Second rough: an unjustified (staggered) layout (Fig. 1)
1. Read the text and break the lines according to sense.
2. Write these lines and cut them out. Place them on the same kind of paper, staggering the lines to balance the side margins. If you're not satisfied, experiment further. Use removable tape (Scotch) and tape the cut lines in place. Photocopy to preserve a layout for reference. Try different positions and possibly different line lengths. Repeat this process until you are satisfied.

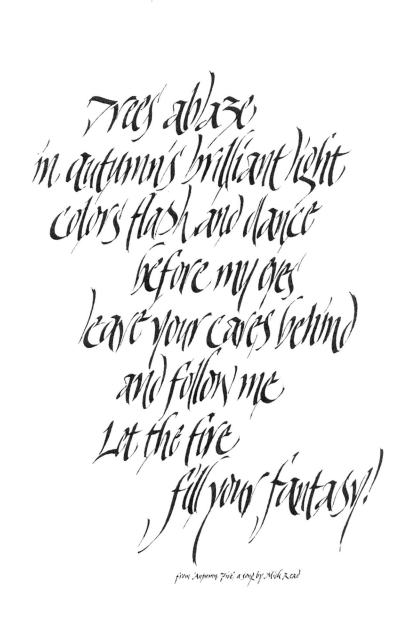

Fig. 1

Fig. 2

240

Additional text elements: e.g., author, title
1. Make roughs using one or two different small nibs. Since you're probably not familiar with using a small nib, take time to explore it.
2. Cut the rough out as a strip and experiment with its position, usually a little below the text and toward the right edge. (Fig. 3)

Second rough for both layouts: This rough gives you the opportunity to experiment with text proportion, letter variants, plasticity, interlinear spacing, and nib angle (e.g., Fig. 2, previous page). And with indentation for the unjustified layout.

Note
The endeavor to make a finished piece is an exploratory process of trial, analysis, and response. The discoveries it yields are your own.

Composition: centering a flush left/unjustified text
Here, your aim is to balance the spatial volumes of the side margins for 1) a flush left layout (Fig. 3) or 2) a staggered layout where both margins are ragged. (Fig. 1, p. 239) Unlike using a fully-justified text, "equalizing" these volumes cannot be achieved through measurement. The methods below help develop your eye for balancing side margins for flush left and unjustified text designs.

Black frame strips Tracing paper Final rough and a large sheet of this paper Finish paper

Flush left (Fig. 3)
1. Choose the finish paper and have it ready.
2. **Side margins: fixed format.** Draw a rectangle the size of the finished piece. Place the final rough, one that fits the format, inside the rectangular frame. Place a piece of tracing paper, at least this size, over the rough.
3. **Side margins: fluid format.** Place the rough on a sheet of paper as large as you imagine the finished piece might be. Place tracing paper, the same size, over the rough.
4. **Equalizing the margins with frame strips.** Begin with the left frame strip and set it a little to the left of the text. Move the strip toward and away from the text. Set it at a distance you think might sufficiently frame the piece. Then, create an equal spatial volume for the right margin with one of the methods below.
 a) If there is not much difference in line length, pencil a right vertical margin between the shortest and longest lines. Measure the width of the left margin. Set the right frame at this distance from the penciled line. The final test is your eye: do the margins appear similar in spatial volume?
 b) If there is a sizable difference in line length, set a right vertical frame strip the same distance from the longest line as the width of the left margin. Move the strip slowly to the left, in search of a position where margins balance each other.
5. **Paper ruler:** measure the distance from the left edge of the rectangle to the left margin and mark it on a paper ruler. (See ps. 171-2)
6. **Top and bottom margins: fixed format.** Move the rough up and down within the rectangle using tracing paper and strips to establish these margins. In contemporary spacing, these margins appear about the same as the side margins, but can be greater than the sides if called for by the constraints of the format. For classical spacing, see page 172, Fig. 5. When you are satisfied, measure and mark a paper ruler.

*Beginning my studies
the first step pleased me so much,
The mere fact consciousness,
these forms, the power of motion,
The least insect or animal,
the senses, eyesight, love,
The first step I say
awed me and pleased me so much...*

Walt Whitman

Fig. 3

7. **Top and bottom margins: fluid format.** Move the strips about until you feel the top and bottom spacing are compatible with the side margins and suit the spirit of the text/occasion. How does the composition feel with the different spatial relationships between the margins? When you're ready, make a paper ruler.

Proteus1: Numerals and ampersand

Unjustified (staggered) (Fig. 1, p. 239)

As with the flush left text design, this layout can use a fixed or fluid format. (See previous page.)

1. **Side margins**
 a. Set a frame strip left of the line nearest the left edge of the paper. Move the strip away from the beginning of the line until the words of the line cohere as in a necklace.
 b. Set another frame strip about this same distance from the end of the text line extending farthest to the right. Looking at the whole text, if the right and left marginal volumes don't feel balanced, move the strips toward and away until they do.
2. **Top and bottom margins.** Move the strips until you find the amount of space for these margins that, in conjunction with the side margins, gives a sense of flow, or one that suits your desired sense of spatial balance.
3. This is a challenging design. Work in a relaxed way, persistently, to find what works.

Ruling and Cutting (If using a fixed format, you may wish to cut the finished paper before ruling.)

- **Ruling:** Add any slope or angle lines in light pencil.
- **Cutting:** Check measurements for accuracy. Be sure the cutting surface is free of any previous cutting grooves, and that everything is clean.
- **Note:** If you intend to frame a piece, add one-quarter of an inch to the dimensions of your piece. This allows for the frame's lip.

Writing: Finish paper, ink, writing guard (and testing swatch if desired)

Protect your work

Although accidents are inevitable at some point, a calligrapher does everything possible to prevent them. A guard sheet is recommended. (See p. 173) For large or complex pieces it's a good idea to make a protective sleeve. I call this working surgically. Place a sheet of durable paper, such as butcher paper, over the entire work; cut a window flap about ½" from the right and left side margins, and a little above the topmost portion of the text. Bend this flap down as you write—you may wish to also use it as a guard.

Testing and warming up

Before you start, warm up with the same type of ink and paper you're using for the finished piece. Then, use these to write one or two lines of the text to get comfortable.

Write the text

1. Proofread the text.
2. Work slowly but try to complete the text in one day, though not necessarily at one sitting. Today's rhythm and sensitivity may be quite different tomorrow or next week.
3. Write the tribute line (and title).
4. Remove the guard or sleeve and check for errors.
5. Make sure the ink is dry and erase the guidelines.

Correcting errors

Success depends on the quality of the paper, the erasing tool(s), patience, a careful touch, and a watchful eye. I use a surgical blade to scrape off the unwanted ink, in combination with a plastic eraser. (Some calligraphers prefer an electric eraser.) Not all blades are equally effective: I prefer those made by Cincinnati Surgical (CS) #23. After the erasure, smooth any roughening of the paper surface: 1) place tracing vellum or paper over the area and 2) take a bone folder and sensitively press and rub the roughened fibers until they are smoothed as much as possible. Protect the work as needed.

Congratulations!

cultivate your garden

More exercises

The following exercises build on previous work and give you more opportunities to develop calligraphic technique and explore design.

Nib turning

These exercises focus on the wrist's role in developing a fluid motion while turning the nib within a stroke. Nib turning falls into three basic categories which are presented below. Begin with prototool 2 to get the idea; then use a dry tool, and finally ink. This skill develops gradually!

The Lilliputian series: This nib-turning exercise uses a word, such as Lilliputian, with at least one ascender and descender.

> **Nib angle:** flat (0°-20°) and steep (80°-90°) angles
> **Nib:** 4mm Brause **Paper:** marker/JNB
> **Ink:** for warming up: fully loaded;
> for the exercises: dip and flick, and wipe off excess ink
> **Guidelines:** single line for single strokes; waist- and baselines for words
> **Partnering:** Both corners are now partnered in awareness. The nib corner that leads the stroke—the driver—takes primary attention while the corner that follows is secondary.

Flat to steep: tapers the stroke

This sequence is designed to help you get both the idea and the feel of turning in place and traveling.

"Corniced" fans: turning in place (Not shown.)
1. Place the nib at a flat angle (0°-20°). Inhale and push a horizontal stroke to the right, about 1" in length.
2. Exhale and pivot in place, counter-clockwise, to a steep angle (80°-90°). (See making a fan, p. 219.) Inhale.
3. Exhale and pull a vertical hairline about 1" long. Repeat a few times to get the flow of arm, wrist, elbow, and hand as a moving unit.
Note: Horizontal and vertical hairlines will be slightly diagonal, which is fine, if nib angle is not 0° for the horizontal and 90° for the vertical.

"Wedges": turning while traveling (Fig. 1)
These casual movements help you engage the wrist and get the idea of the traveling pivot before focusing on more precise aspects.
1. Use a fully loaded nib and place it at a flat angle as above.
2. Pull hairlines down, right to left, steepening angle with each stroke to form a long wedge.
3. Focus on pivoting the wrist to make the angle changes. Start slowly and then work more quickly. Make as many angle changes as you can while fashioning the wedge.

Traveling pivots/cornices: more refined strokes (Fig. 2)
Place the nib at a flat angle (0°-20°). Inhale, press-release and pull the left nib corner (T) right and down into a wide left-facing arc—the right corner (IF) pivots counter clockwise. Make "cornices" of increasing size.

Downstrokes (Fig. 3)
1. Place the nib at a flat angle; inhale, press-release and push a short hairline entry; exhale.
2. Inhale, press-release and begin the pivot, pulling and turning as you travel down to shape a long, pointed spike.
3. Pull short and long strokes with less extreme pivots.
4. Write a word, such as Lilliputian. (Fig. 4)

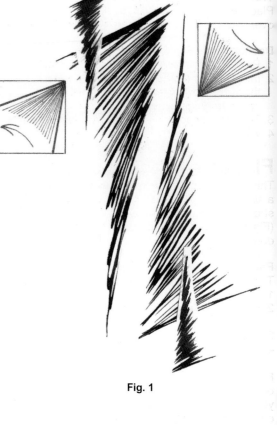

Fig. 1

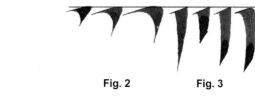

Fig. 2 Fig. 3

Fig. 4

Fig. 5 Fig. 6

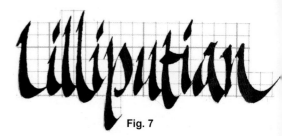

Fig. 7

Steep to flat: broadens the stroke

Traveling pivots (Fig. 5, p. 242)
Place the nib at a steep angle (80°-90°). Inhale, press-release and pull the right nib corner (IF) down and over into a wide right-facing arc—as the left corner (T) pivots clockwise. Make "cornices" of increasing size. **Fig. 8**

Downstrokes (Fig. 6, p. 242)
1. Place the nib at a steep angle and partner with the left nib corner (T).
2. Inhale, press-release; exhale and turn the nib clockwise as you pull the stroke downward. Focus on the thumb as a moving pivot, while the index finger shepherds a continuously flattening angle.
3. Try stroke shapes: a long, narrow triangle and less extreme shapes.
4. Write a word, such as "Lilliputian." (Fig. 7)

Flat to steep to flat

This stroke combines the previous two turned strokes (Fig. 8) to make a single stroke that narrows in its midsection. (Fig. 11d-g) Calligraphers call this "waisting." To use a waisted stroke expressively, consider where you will narrow it and whether the narrowing is subtle, moderate, or extreme. (Fig. 9, moderate) Begin by waisting toward the middle of the stroke. The exercises below help you develop this double-turned stroke.

Partnering: sensitization (Fig. 10)
This exercise focuses on partnering—sensitizing the finger-shoulder-corner relationship—to facilitate turning.
1. Inhale, place the nib at a flat angle and partner with the left nib corner (T). Exhale.
2. Inhale, press-release; exhale, sink and pull a half-inch stroke. Focus awareness on shoulder contact and the partnered corner.
3. At the base of the stroke, inhale, release pressure and guide a one-nib-width-long hairline, down and to the left.
4. Repeat step two, partnering with the right nib corner (IF).

Partnering: turning (Figs. 11a-g) The exercises below give names to stroke shapes, or the space the strokes form. Seeing them as something already familiar may aid you in achieving them. Create your own exercises when you're ready. When you're comfortable with this turning category, write a word such as "Lilliputian." (Fig. 9)

1. Inverted cornices (Fig. 11a) Make alternating cornices: flat to steep; steep to flat.
2. Hourglasses (Fig. 11b) Stack the cornices one atop the other.
3. Corniced boxes (Fig. 11c)
 a. Pull cornices to create figures—focusing on the white shape within them.
 b. Try this with partial edge, applying pressure to the side of the nib that forms the internal shape.
4. Elongated hourglasses (Fig. 11d) Turning the nib over a longer distance is a challenge for the mind and the fingers. Work slowly to get the feel and then more quickly. To continue from one hourglass to the next, push a one nib-width-long hairline up and to the right.
5. Hourglass as slalom (Fig. 11e) Give long or short hourglasses a sense of swing. Press-release and spring into the initial turn. Engage the wrist to help turn the nib. Finish the second turn with end pressure.
6. Long hourglasses, stacked (Fig. 11f) Leave a little space between these figures or omit it.
7. Waisted strokes, stacked (Fig. 11g) Pull slightly waisted strokes.

Fig. 9

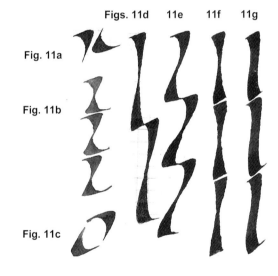

Fig. 10

Figs. 11d 11e 11f 11g

Fig. 11a

Fig. 11b

Fig. 11c

Words (Figs. 12a, b, and c) Dry trace the Lilliputian series of Fig. 12a, b and c using nib angles from Proteus: Fig. 12a, 40°; Fig. 12b, 60°; and Fig. 12c, alternating the two angles. Experiment using angles flatter than 40° and steeper than 60°.

Fig. 12a, top left; **12b,** top right; **12c,** bottom

Ink meditations

These long line exercises focus the mind through the act of perception: mentally receiving and interpreting signals from the eye and the senses of touch and movement. Through these fully embodied exercises you can cultivate feelings of relaxation and alertness.

The long lines allow you to develop a visual-kinesthetic theme by means of repetition or variation. To engage the motion as a gestural expression—as felt movement—it's a good idea to work large. Fine tactile-motor sensitivity develops through both large and small nib sizes.

Tools: 3mm Brause, C-0 Speedball, or experiment
Paper: drawing/JNB, or experiment
Ink: fully loaded
Body: Send your attention to different areas of the body as you work: shoulder, arm (bicep), wrist, and fingers (partnering).

Warming up

Get the kinks out first with some initial pen movement on the thin and full edges. This generates energy and promotes confidence for calligraphic play and experimentation. (See Edged pen, pages 142-5, or invent your own.)

Long lines: vertical

These exercises combine all aspects of flow: rhythmical movement, energy, and tactile sensitivity. Some ideas:
1. Pull long lines (4" - 8") in one go or in segments—the same or different lengths. (Figs. 1 and 2)
2. Make curves and straights.
3. Use partnering.
4. Be aware of the breath.
5. Dramatize the action: e.g., choppy, flowing (bird on the wind), and athletic (slalom). Work boldly/tentatively, depending on your mood.

Long lines: horizontal bands

Tools: 3/4mm Brause, C-0 Speedball, or experiment
Paper: drawing/JNB, or experiment **Ink:** fully loaded
Body: relaxed, alert
Speed: slow and deliberate

1. Choose one of the edged pen alphabets (or invent your own, as in Fig. 3, left to right: "awareness," "breathe," and "Shambala."
2. Choose a few words. Start with short ones—the aim is to finish the word before the ink dries.
3. Place the fully loaded nib on the paper at a very steep angle, 80°-90°.
4. Pull two parallel, horizontal bands the length you imagine the word will be. The lower band is about two to three nib widths below the top one.
5. Place the nib at the left end of the top wet band. Pull letter strokes from the wet ink to/into the lower band.
6. You may wish to experiment with the letters of your word before writing it.
7. Rewrite the word a few times until you have a word image you like. Then, rewrite it a few more times, each version focusing on a different facet such as:
 a) the breath,
 b) the feeling of working in wet ink,
 c) the gesture/movement/feeling of making the stroke.
8. Be open to the process and feel free to follow any suggestions it makes.

Note: The strokes below are made with both steady nib angle and nib turning. There is no right or wrong here. In this exercise, the sculpting of white counters is more apparent—the black strokes and white spaces more clearly seen as shapes. Try to arrange them into a balanced visual and/or readable design.

Fig. 1 Written on smooth paper.

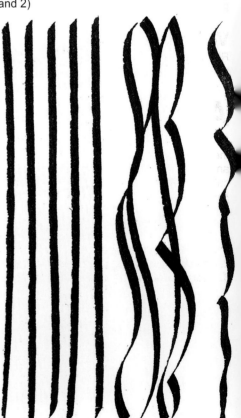

Fig. 2 Written on textured paper.

Fig. 3

Fluent in pressure: the language of contact

Patterning pressure, applying different amounts for different lengths of time, becomes a language for calligraphic contact which we articulate through stroke making. (See Stroke technique, pages 31-33)

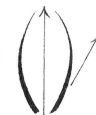

The aim of this exercise is to become more fluent in this language. To do so, we now engage the patterns—start, center, and end—in a "leaf" design: two facing arcs joined together by a cornered thin upstroke. (Fig. 1) Although pressure has no immediate visual consequence, it is a powerful support for engaging the stroke as a rhythmical, gestural act—a direct, felt connection manifested as the living stroke.

Fig. 1

Tools: 3mm Brause **Paper:** drawing/JNB **Ink:** fully loaded
Body: relaxed, alert **Speed:** slow and deliberate

Horizontal rows

1. Work without guidelines or rule guidelines of different heights. The longer the arc, the more gradual the pressure application. You might try using guidelines ½", 3/4" and 1" apart and comparing the experiences.
2. Place the nib at a comfortable angle; usually between 30° and 45°.
3. Follow the schemas of Figs. 2a, b, and c. Begin with start pressure, 2a.
4. Connect the lobes of the leaf by rocking to the right nib corner and push-Ing the singe-line thin up to begin the second downstroke arc.
5. Connect the leaves on the cornered thin as well.
6. Repeat the forms to get the feel of the patterned pressure in relation to stroke direction. Look for the rhythm as you connect pressure with direction.
7. Continue with the other two pressure patterns: center and end. (Figs 2b and c)
8. Try making a leaf with reverse-curve gestural arcs. (Fig. 1)
9. Try other designs such as the lotus. (Fig. 3)

Fig. 2a **Fig. 2b** **Fig. 2c**

Vertical rows

Repeat the above, moving downward rather than across. At the end of the second downstroke arc, pause and continue down to make the first arc of the next leaf.

Fig. 3

A practice format

For many centuries, the Turkish and Persian calligraphic traditions have recognized the importance of warming up by giving a name to their practice sheets: "Karalama" (Turkish) and "siyal mashq" (Persian). Such a sheet offers the calligrapher an opportunity to test ink and paper and, in the process, attune to the energy which the pen's movement and touch generates. Produced by a highly skilled calligrapher, these pages become artworks themselves and may be found mounted in exhibitions or held in art collections. Often characterized by repetition of the elements of writing, even overlaying and tuning the page, they need not be readable.

Let's adapt this practice format to Western calligraphy! Suggestions:
1. Take a sheet, scrap, or strip of paper (practice or finish). Test tools and materials by filling the paper with strokes/letters/words using repetition and variation. (Fig. 4)
2. Through repetition, explore the gesture-rhythm of a stroke/letterform/word.
3. Designate the sheet as a playground for working spontaneously, in-the-moment, creating strokes/letters/words.

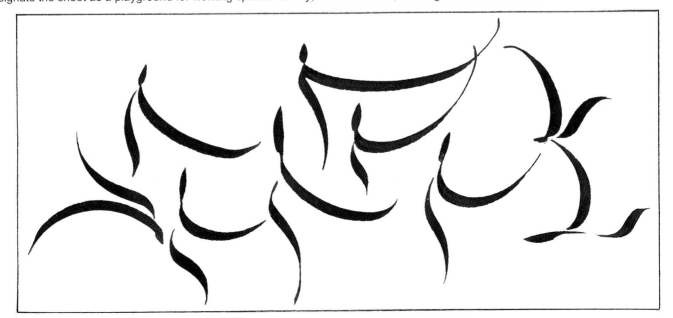

Fig. 4

Alphabet design: visual themes/motifs

In this exercise you design—or, perhaps more accurately, redesign—an alphabet. By changing one or more of an alphabet's visual themes, e.g., a letter join as in Figs. 1 and 2 or stroke direction as in Fig. 3, you also change its character, attitude, energy, or mood. In the guided exploration below, you engage in the process of alphabet design.

You can start with either an alphabet you know or work "from scratch." In the examples below, I begin with Upright Italic—slightly modified by Moto's cornered upstroke, used here to join letters and make a one-stroke "o."

Begin by tracing the examples.
1. **Fig. 1,** visual themes: a shallow, rounded horizontal join rising slightly above the waistline; a cornered thin exiting at the baseline moves into a variant of "a."
2. **Fig. 2,** visual theme: a thick, slightly scalloped horizontal connects letters at the waistline.
3. **Fig. 3,** visual themes: reverse curve downstrokes in "n," "m," "a," "p," and the eye of "e"; an ornamental "o"; and short entries to downstrokes.
4. **Fig. 4,** visual theme: decrease in scale; a variant downstroke exit of "p"; and a tapered horizontal join.
5. **Fig. 5,** visual themes: wider proportion; irregular spacing; variation in horizontals; and a variant of "a." Draw a base and waistline on tracing vellum and place it over the word to see the subtle rising and lowering of letters in relation to the guidelines.

Experiment
The aim here is to translate some aspect of a word's/phrase's/sentence's meaning into graphic language.
1. Choose a word, phrase, sentence. Does its meaning, or some aspect of its meaning, suggest a motif? Or, consult your mood—e.g., serene, agitated, etc.—and think of a word to express it.
2. Choose one of the edged pen alphabets as a starting point, as described above.
3. Consider the graphic elements of stroke direction, space, weight, slope, and size. Think about each in relation to your text and translate/test your ideas by making roughs.
4. Choose one of the roughs and consider whether your chosen theme/s register as a cohesive design.
5. Create a complete alphabet using ideas in the above exercise, from another alphabet, or from scratch. (Fig. 6, motifs from Fig. 3)
6. Write a longer text with your alphabet and observe it in this written environment. Does this suggest adjustments to any of the forms to improve neighborly relationships? Could any adjustments make it more visually expressive—more tuned to the text's meaning?

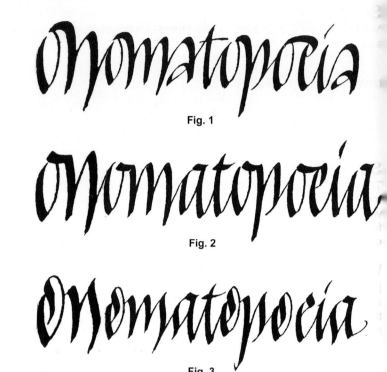

Fig. 1

Fig. 2

Fig. 3

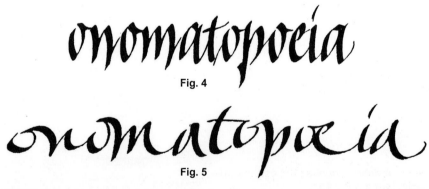

Fig. 4

Fig. 5

Note: An alphabet may be created for two different purposes. In the first, as a pure design, visual concerns are paramount and letter combination/order is fixed (Fig. 6, and the Training alphabet models). In the second, as a "working" alphabet, the act of writing—relating letters to each other in diverse combinations—activates plasticity and generates variants.

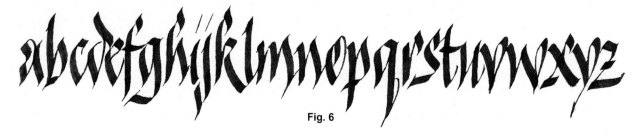

Fig. 6

Suppliers, Societies, & Workshops

Suppliers

Most of the supplies needed for calligraphy—tools and materials and more—can be found in the catalogs/websites of the following supply companies. Many of these supplies are not available in art stores.

John Neal, Bookseller: Supplying calligraphers, lettering artists, illuminators, bookbinders, and papercraft enthusiasts with books, tools, and materials since 1981. John Neal also publishes a quarterly catalog and journal, "Letter Arts Review."
Phone:800-369-9598; Web: www.johnnealbooks.com
Paper and Ink Arts: For calligraphy, bookbinding and art supplies. Paper and Ink Arts publishes an annual catalog.
Phone: 800-736-7772; Web: www.paperinkarts.com
Daniel Smith Artists Materials: For art papers and supplies. Web: www.danielsmith.com

Societies/Guilds

There are calligraphy societies/guilds located in cities large and small throughout the United States that sponsor workshops and meetings for furthering your calligraphic education. Annually, one of these societies sponsors an international conference with workshops and exhibits, vendors, and many opportunities to meet others who share a passion for calligraphy. These groups generally focus on letterform ductus and learning historical/contemporary alphabets. They are a good way to broaden your form vocabulary and enter the rich tradition of Western calligraphy.

Workshops and talks

I am happy to offer workshops and talks on topics in my book, *Calligraphy as Art and Meditation*, and gladly tailor these to suit the interests of a particular group. Please contact me by email at gina.jonas@gmail.com

Photos & Manuscripts

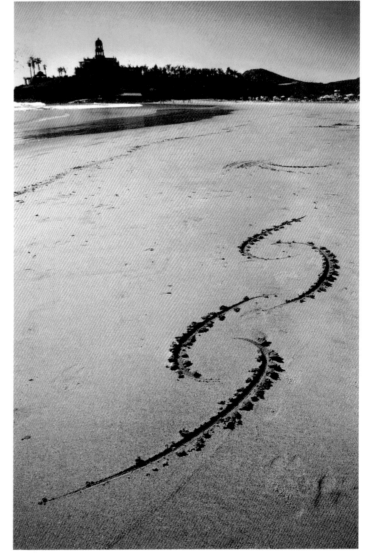

Photography by Laurie Pearce Bauer
As you will have noted, the images in this book do not always present calligraphic content directly. They are offered for inspiration as well as instruction.
Pages: 1, 2, 4, 5, 10, 32, 34, 36, 40, 47, 51, 62, 68, 69, 70, 71, 85, 89, 101, 124, 125, 132, 136, 137, 138, 140, 146, 172, 173, 228, 230, 233, 237, 238, 247

Facing page 1: Leonardo da Vinci drawing (used for tracing); *The Mechanics of Man*, J. Paul Getty Museum
p. 5: Eadwine, "prince of scribes"; Cambridge, Trinity College; Ms R. 17.1, fol. 283v
p. 6: Scribe with pen and knife; Bibliotecha Apostolica Vaticana; Ms. Barb. lat. 570, Fol. 124v, Barberini Gospels
p. 30: Cover photo, stone hand; *Touching Enlightenment, Finding Realization in the Body*, Sounds True, Reginald Ray
p. 66: *The First Writing Book, Arrighi's Operina* (16th century writing manual), p. (24), John Howard Benson
p. 93: Clip art, Trapeze
p. 97: Clip art, small child; *High Style*, The Metropolitan Museum of Art; fashion model
p. 102: Ad for the New York City Ballet, *The New Yorker*
p. 122: Manuscript s.n., fol. 7v; Private collection, Switzerland; An Annunciation from a Dutch Book of Hours, c. 1440
p. 150: Clip art, Charlie Chaplin
p. 170: Vienna, Osterreichische Nationale Bibliothek, Cod. 1576
p. 227: Chinese calligraphy by Cha Shih-piao (161-1698) *The Embodied Image*, p. 188, The Art Museum, Princeton Univ.

All diagrams, drawing and calligraphy by Gina Jonas

Cerritos Beach, Baja California

The apprenticeship of calligraphy is not primarily visual, but kinetic. *The Chinese Art of Writing,* Jean Francois Bileter

Bibliography

Manuals & Reference
Benson, John Howard & Carey, Arthur Graham. *The Elements of Lettering.* McGraw-Hill, 1950
Harris, David. *The Art of Calligraphy.* Dorling Kindersley Ltd., London, 1995
Hufton, Susan. *Step-by-Step Calligraphy.* Sterling Publishing Co., New York, 1995
Johnston, Edward. *Writing & Illuminating & Lettering*, 1906
 Formal Penmanship. Hastings House, New York, 1971
Knight, Stan. *Historical Scripts.* Oak Knoll Press
Mediavilla, Claude. *Calligraphy*, 1996 (Manual and overview)
Stevens, John. *Scribe: Artist of the Written Word,* 2013
Waters, Sheila. *Foundations of Calligraphy*, 2006

Perspective/History
Abram, David. *The Spell of the Sensuous: Perception & Language in a More-Than-Human World.* Random House, 1996
Anderson, Donald M. *The Art of Written Forms.* (Historical overview)
Catich, E. M. *The Origin of the Serif.* The Catfish Press, 1968.
Clayton, Ewan. *The Golden Thread: The Story of Writing.* Atlantic Books, 2013
De Hamel, Christopher. *Medieval Craftsmen: Scribes and Illuminators.* University of Toronto Press, 1992
 A History of Illuminated Script. Phaidon Press Ltd., 1994
Gray, Nicolete. *A History of Lettering.* David Godine, 1986
 Lettering as Drawing: The Moving Line. Oxford University Press, 1970
Itten, Johannes. *Design and Form: The Basic Course at the Bauhaus and Later.* Thames and Hudson Ltd., 1975
Jackson, Donald. *The Story of Writing.* Taplinger Publishing Co., 1981 (Historical overview)
Rowland, Ingrid and Charney, Noah. *The Collector of Lives: Giorgio Vasari and the Invention of Art.*
 W. W. Norton & Company, Inc., 2017
Shaw, Paul, ed. *The Eternal Letter: Two Millennia of the Classical Roman Capital.* Massachusetts Institute of Technology, 2015
Wilson, Frank R. *The Hand: How its Use Shapes the Brain, Language & Human Culture.* Random House, 1998

Approaches to Work/Philosophy
Barrass, Gordon S. *The Art of Calligraphy in Modern China.* University of California Press, 2002
Billeter, Jean Francois. *The Chinese Art of Writing.* Rizzoli International Publications, Inc., 1990 (USA)
Burgert, Hans-Joachim. *The Calligraphic Line.* (John Neal, Bookseller)
Dissanayake, Ellen. *Homo Aestheticus: Where Art Comes From and Why.* University of Washington Press, 1995
 What is Art For? The University of Washington Press, 1988.
Huizinga, Johan. *Homo Ludens: A Study of the Play Element in Culture.* [1938] Beacon Press, 1955
Ingmire, Thomas, Editor. *Codici 1.* Scriptorium St. Francis, 2003
Langer, Susan K. *Feeling and Form: A Theory of Art.* Charles Scribner's Sons, 1953.
Nachmanovitch, Stephen. *Free Play: Improvisation in Life and Art.* Jeremy P. Tarcher/Putnam, 1990.
Reynolds, Lloyd J. "Notes on Movement Involving Touch." From *Calligraphy and Palaeography: Essays Presented to*
 Alfred Fairbank on his 70th Birthday, ed. A. S. Osley. October House, 1966
Ruskin, John. Chapter: "The Nature of Gothic," from *The Stones of Venice.*
Shahn, Ben. *The Shape of Content.* Vintage Books, 1957

Meditation & Mindfulness
Davey, H. E. *Brush Meditation, A Japanese Way to Mind and Body Harmony*, 1999
Dza Kilung Rinpoche. *The Relaxed Mind.* Shambhala Publications, Inc., 2015
Gibbs, Nancy, ed. *Mindfulness: The New Science of Health and Happiness.* Time Magazine Special Edition, 2016
Goleman, Daniel. *The Meditative Mind.* Jeremy P. Tarcher/Putnam, 1998
Hanh, Thich Nhat. *The Miracle of Mindfulness.* Beacon Press, 1975
Langer, Ellen J. *The Power of Mindful Learning.* Da Capo Press, 1997
 On Becoming an Artist: Reinventing Yourself Through Mindful Creativity. Ballantine Books, 2005
Ray, Reginald A. *Touching Enlightenment, Finding Realization in the Body.* Sounds True, Inc., 2008
Siegel, Daniel J. *The Mindful Brain: Reflection and Attunement in the Cultivation of Well-Being.* W. W. Norton & Company, Inc., 2007

Articles by Gina Jonas: www.ginajonascalligapher.com Publications section, bottom
"Calligraphy as a Spiritual Way," Alphabet, 2007 and "Nib Contact: The Case for a Touch-Sensitive Writing Board," Alphabet, 2011

A few modern masters: Denis Brown, Ewan Clayton, Thomas Ingmire, Brody Neuenschwander, John Stevens, Julian Waters.

Index

250

Selection from
The Chinese Art of Writing
(See Bibliography)

The practice of calligraphy has, first of all, the advantage of imposing a discipline. It calls for an integral mobilization of the body and an unfailing presence of mind. By compelling us to reorient and focus all our forces, it puts an end to the state of dispersion in which we live most of the time. It recomposes us and again makes a whole being of us, whole because wholly absorbed by the gesture performed. The calligrapher who practices regularly feels that he has a daily rendezvous with himself. As soon as he takes up his brush, he forgets the concerns that have preoccupied him all day. Anxiety, worry and brooding, which are the main causes of fatigue, cease as if by magic. If circumstances prevent him from practicing, he will feel the dire want of it. He will feel keenly what Stendhal says of writing at the beginning of his *Memoirs of an Egotist:* "Without work, the ship of human life has no ballast."

The exercise is also a moment of truth, for the brush is a seismograph that infallibly reveals our weaknesses. Chou Hui-chun, a young lady calligrapher well known in Shanghai, tells the story of how her master Kung Te-lin one day asked her to write a few columns of characters to observe her progress. She set to work, holding her breath and taking great pains to make a good impression. "This is not good," her master said as soon as she had put down her brush. "First of all, it is not good for your health to write while holding your breath, without breathing freely. Then you wanted to please me, you wanted me to praise you. This is not reasonable. In our art as in life, it is vain to posture and even vainer to yearn for reputation. In other words, all that counts is the work done and the mastery gained from it, that inalienable possession which the Chinese call *kung-fu.*

In today's world, the exercise also takes us back to ourselves and gives us back a taste for the gratuitous gesture, performed for its own sake. Our daily activity, dictated by machines, is being reduced more and more to programmed, stereotyped movements carried out with indifference, without any participation of the imagination or sensibility. Calligraphy remedies this atrophy of the gesture by reawakening our sluggish faculties. It restores our taste for play and calls back to life aptitudes which, though they may have no immediate "utility," are none the less essential.

Acknowledgements

I am deeply grateful to all those who helped me bring this book into your hands.

My friends and family believed in me and wholeheartedly supported the work. It was many years in the making and their continuing interest helped to sustain and fuel my efforts.

My editors wed their belief in the book to their expertise. Jennifer Klamm, my Seattle editor of four years, brought both a calligraphic and an art background to the task. It was invaluable to begin with an editor who was passionately interested in my topic. Conversing with Jennifer gave me the opportunity to test and develop my ideas. Michael Read, my St. Augustine editor of the last year-and-a-half, helped me bring the book to fruition. He always worked to make the exercises clear for all readers. As my husband, Michael also doubled as caregiver during my recovery from open-heart surgery this past year. The book and his love sustained me.

When I met my photographer, Laurie Bauer, at a Buddhist talk in Todos Santos, Mexico, I was just beginning to write what became *Calligraphy as Art and Meditation*. From the images on her website, I was thrilled to see she could communicate the spirit of form as well as content. On our first shoot, camera in hand, she followed me down the beach as I drew calligraphically in the sand. Working with her energized me. I am grateful to Laurie for enhancing my own calligraphic adventure, as well as for the enrichment I fully believe the images will give to my readers.

I would also like to thank my bookdealer John Neal who has supported my book writing efforts and will now be my distributor.

For assistance with the design of the book's cover and introduction, and their expert preparation for printing, I am grateful to graphic designer Regine de Toledo.

The teams at Four Colour Print Group and FCI Digital made this book a far better work than I had a right to hope. Indeed, they took my pasted-up pages—a format not seen in ten years, I was told—and transformed them into a book!